EGON SCHIELE

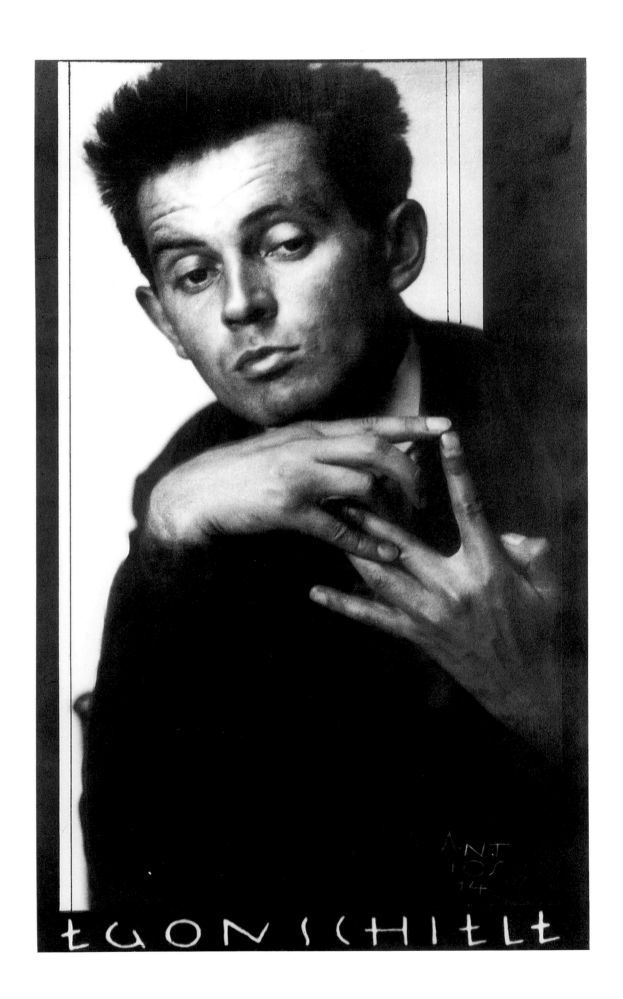

EGON SCHIELE

EGON SCHIELE

The Leopold Collection, Vienna

texts by
Magdalena Dabrowski
and
Rudolf Leopold

DuMont Buchverlag in association with
The Museum of Modern Art, New York

English-language edition published on the occasion of the exhibition *Egon Schiele: The Leopold Collection, Vienna,* organized by Magdalena Dabrowski, Senior Curator, Department of Drawings, The Museum of Modern Art, New York, October 12, 1997–January 4, 1998

This exhibition is sponsored by ROBERT LEHMAN FOUNDATION, INC.

Additional generous support is provided by Jo Carole and Ronald S. Lauder.

The Museum gratefully acknowledges the assistance of the Österreichische Nationalbank (Central Bank of Austria), the Austrian Mint, and the Austrian Cultural Institute, New York.

An indemnity for the exhibition has been granted by the Federal Council on the Arts and the Humanities.

Edited by Joanne Greenspun
Designed by Peter Dreesen
German texts translated by Russell Stockman

Originally published in German by DuMont Buchverlag, Cologne, in 1995

Library of Congress Catalog Card Number: 97-073503
ISBN 0-87070-061-8 (paperbound, The Museum of Modern Art)
ISBN 0-300-07322-4 (clothbound, Yale University Press)
Published by DuMont Buchverlag, Cologne, in association with
The Museum of Modern Art, 11 West 53 Street, New York, New York 10019

English-language clothbound edition distributed throughout the world by Yale University Press

Front cover: *Mourning Woman* (detail). 1912. See plate 67
Back cover: *Reclining Boy (Erich Lederer)* (detail). 1912. See plate 82
Frontispiece: *Portrait of Egon Schiele.* 1914. Photograph by A. Josef Trčka

Printed in Germany

Contents

Foreword 6

Preface and Acknowledgments 6

Egon Schiele: Master of Expressive Form
 Magdalena Dabrowski 8

Introduction *Rudolf Leopold* 32

Plates and Catalogue *Rudolf Leopold* 40

Biography *Rudolf Leopold* 344

Bibliography *Romana Schuler* 354

Exhibitions *Romana Schuler* 357

Index of Names 362

Photograph Credits 363

Foreword

Egon Schiele is one of the most important artists to emerge from the first years of the twentieth century in Austria. Despite a brief career, which barely spanned a decade, Schiele produced an extensive body of work in an innovative and personal manner. Using unprecedented combinations of color and quickly drawn, often sharply angular and febrile lines, he created highly original and startling expressionistic paintings, drawings, and watercolors. Schiele's Expressionism, however, was a tortured one, and his idiosyncratic works are frequently imbued with a crude but intense eroticism and a profound sense of isolation and alienation that poignantly reflect the intellectual and psychological climate of turn-of-the-century Vienna.

Because of its often difficult subject matter, Schiele's work has long been underappreciated outside his own country. Indeed, his principal patrons have been Austrian collectors, and the majority of his œuvre remains to this day in Viennese public and private collections. Among them are the Graphische Sammlung Albertina, which constitutes the greatest repository of Schiele works on paper, and the Österreichische Galerie and the Historisches Museum der Stadt Wien, which house many of his oils. Foremost among the private holdings is the Viennese collection of Dr. Rudolf Leopold, which consists of more than 150 oils, gouaches, watercolors, and drawings by Schiele. These works, assembled over a period of many years, form the nucleus of a comprehensive collection of Austrian art of the nineteenth and twentieth centuries that will soon be housed in a new museum in Vienna. They have only recently been made available to the public and are virtually unknown to viewers in the United States.

This publication accompanies the exhibition *Egon Schiele: The Leopold Collection, Vienna,* presented at The Museum of Modern Art in New York. We are particularly grateful to Dr. Rudolf Leopold for making his collection available to us. The quality of the work, as well as its scope, which encompasses all phases of Schiele's career, give the viewer a unique opportunity to assess the artist's achievements. Dr. Leopold also kindly allowed us to translate and publish his texts for this catalogue, and we greatly appreciate it. Our thanks are also due to Dr. Klaus A. Schröder, Managing Director of the Leopold Museum, for his cooperation during the various stages of this project. We wish to thank Elisabeth Gehrer, Austrian Federal Minister for Education and Cultural Affairs, and the Austrian Cultural Institute, New York, for its contribution to the support of the exhibition and the educational programs. We are most grateful to the Robert Lehman Foundation, Inc., for their generous support of this exhibition, and to Jo Carole and Ronald S. Lauder for their major commitment to this project. We are grateful to the Federal Council on the Arts and the Humanities for providing an indemnity for the works of art in the exhibition.

I also wish to thank Magdalena Dabrowski, Senior Curator, Department of Drawings, who enthusiastically embraced this project and worked tirelessly to ensure its success. Her knowledge and understanding of Schiele are revealed in her introductory essay to this catalogue and in her thoughtful and inspired selection of the contents of this exhibition.

Glenn D. Lowry, Director
The Museum of Modern Art, New York

Preface and Acknowledgments

Among the avant-garde movements of the early years of this century, Austrian Expressionism occupies a place of special importance. As an outgrowth of, and a reaction to, the elegant, ornate forms of the Secessionist style–that Austrian version of *Jugendstil,* which was based on the fluidity of line and a profusion of decorative detail that often dissolved the figurative form–Austrian Expressionism rejected the conventional concept of beauty and introduced the element of ugliness and exaggerated emotion as the fundamental traits of its pictorial language. The two principal proponents of this style, Egon Schiele (1890–1918) and Oskar Kokoschka (1886–1980), focused on the expression of human emotions through a bold, individual language of form and body depiction. The master of this transmutation of form into a highly expressive and personal idiom was undoubtedly Schiele.

Arguably, one of the greatest talents of his time, Schiele, who died at the early age of twenty-eight, created an absolutely prodigious output: his total œuvre is said to include more than 3,000 works on paper and some 300 paintings. Schiele was, first and foremost, an exceptional draftsman; in fact, even his paintings rely on drawing as their principal structural component. Color is used to enhance the expressiveness and the mood of the pictures and, occasionally, to structure space. Schiele's principal subjects include portraits (among them, numerous self-portraits), figural/allegorical works, and landscapes. These works often make use of symbolic representation and metaphor to convey the malaise of modern man in all its raw and painful truth.

Schiele's work can be divided into four phases: the early formative years, 1906–09, which were dependent on the influence of Klimt and the Secessionist style; the

development of his personal idiom in 1910, which continued through the end of 1913 and introduced his characteristic jagged line and contorted poses; the years 1914–15, when new ideas appear in terms of line and form; and the period 1915–18, which represents his maturity as an artist. At this time, Schiele introduced a new inflected line and a naturalistic approach to the figure. The most prolific years by far and the most experimental in terms of style and subject matter were 1910–15.

Schiele's often explicitly erotic and sometimes even shocking subject matter has fascinated, provoked, disconcerted, and even offended those who look solely at its superficial aspects; on a human level, these works are haunting, refreshing, and profoundly moving Opportunities in the United States to study and assess Schiele's work have, until recently, been limited. The present exhibition offers, to those unfamiliar with this artist, a chance to study a remarkable and representative group of his watercolors, gouaches, drawings, and paintings; those who are conversant with Schiele's work will find many surprising and awe-inspiring creations.

All exhibitions, including this one, are the result of the enthusiasm, generosity, and close cooperation of many individuals. I wish especially to thank Dr. Rudolf Leopold for so generously lending his extraordinary collection of Schiele's work. Both he and Mrs. Leopold were my gracious hosts in Vienna, and they offered me the opportunity to study the works in depth and to benefit from their warm hospitality and their enthusiasm for the artist. Dr. Klaus Albrecht Schröder displayed unwavering commitment to this project and facilitated its realization. Romana Schuler, Curator at the Leopold Museum, has most kindly aided us in the many organizational intricacies that have arisen. My thanks to Wolfgang A. Waldner, Director of the Austrian Cultural Institute in New York, for his enthusiastic assistance on this project.

I wish also to acknowledge those curators at Viennese museums who helped in my research by allowing me access to their own Schiele collections: Dr. Konrad Oberhuber and Dr. Barbara Dossi at the Graphische Sammlung Albertina; Dr. G. Tobias Natter at the Österreichische Galerie; and Dr. Ursula Storch at the Historisches Museum der Stadt Wien. I am grateful to Peter Weibel, Curator at the Neue Galerie am Landesmuseum Joanneum in Graz, who was most helpful during the planning stages. A very special expression of gratitude is owed to Philip Isles, whose enthusiasm for the project and the artist was crucial in securing funding for the exhibition. His commitment to the success of this project is greatly appreciated. Thanks are also due to Paul C. Guth of the Robert Lehman Foundation, who oversaw all the contractual details. I am also deeply indebted to Jo Carole and Ronald S. Lauder for their special support of this exhibition.

At The Museum of Modern Art, many individuals were involved in both the exhibition and the catalogue. In the Department of Drawings, my most profound thanks are owed to Mary Chan, who assisted me in this project with the greatest professionalism, talent, and intelligence. She mastered manifold complexities and subtleties on a broad range of problems, and her efficiency, accuracy, competence, and commitment to excellence were always exemplary. She was a true collaborator, and I am inexpressibly indebted to her. Petra Saldutti effectively handled numerous responsibilities with unfailing good will and dedication. Her help and enthusiastic support deserve my sincere thanks. While organizing her own exhibition, Margit Rowell, Chief Curator of the Drawings Department, read my essay and offered insightful suggestions, for which I am most grateful.

In the Publications Department, my warmest appreciation goes to my editor, Joanne Greenspun, for her invaluable contribution to the text. It was a great pleasure to work with her and avail myself of her good judgment and advice. Harriet Bee, Managing Editor, provided support throughout every phase of the catalogue's preparation. Marc Sapir, Production Manager, oversaw the sometimes challenging reprinting of the colorplates with his customary expertise. Nancy Kranz, Manager of Promotion and Special Services, has ably dealt with all matters pertaining to the English edition of the catalogue. Special thanks to Russell Stockman, who translated the German catalogue entries with particular skill and grace. At DuMont, I thank Volker Gebhardt and Anita Brockmann for their continuous cooperation.

On the administrative side, Jennifer Russell, Deputy Director of Exhibitions and Collections, together with Linda Thomas, Coordinator of Exhibitions, expertly supervised the myriad details of bringing these works to New York. I am enormously grateful to them both. We have benefited from the assistance of Eleni Cocordas and Maria DeMarco, Associate Coordinators of Exhibitions, the former most importantly in the indemnity application. Carey Adler, Senior Assistant Registrar, arranged the shipment of the works from Vienna with admirable efficiency and professionalism. Also in the Registrar Department, my thanks to Peter Omlor, Manager, and his staff, who once again proved their care and adeptness in the handling of the artworks. Jerome Neuner, Director of Exhibition Production, and his staff worked tirelessly in the design of the gallery space and installation. Jody Hanson, Director of Graphics, and Emily Waters, Assistant Director, devised the visual materials for the exhibition. I wish to express my gratitude as well to Mary Lou Strahlendorff, Press Representative in Communications; Monika Dillon, Director of Major Gifts, Development; Patterson Sims, Deputy Director of Education; Josiana Bianchi, Public Programs Coordinator; and Stephen Clark, Assistant General Counsel, for their contributions.

I gratefully acknowledge the opportunity to consult with two preeminent Schiele scholars, Alessandra Comini and Jane Kallir. The latter most generously gave of her time and expertise from the beginning of this project. Special thanks are also due Sabine Rewald for reading the essay and catalogue entries and providing insightful comments. Finally, I wish to express my gratitude to our director, Glenn D. Lowry, for his strong commitment to this exhibition. The friendly support of all these individuals helped bring this project to a successful completion.

Magdalena Dabrowski

EGON SCHIELE: MASTER OF EXPRESSIVE FORM

Magdalena Dabrowski

FORMATION OF AN ARTIST: 1906–09

Turn-of-the-century Vienna, the backdrop for the formation of the artistic personality of Egon Schiele, was, according to the writer Robert Musil, a "city of dreams."[1] It was also a city of great paradoxes.[2] As the capital of the Austro-Hungarian empire it embodied on the surface all the glamour, excitement, hedonism, and charm of a modern metropolis. But the harsh realities of life, the disastrous social situation, the ubiquitous housing shortages for the working class as well as for the middle class, widespread corruption, and the strained economic situation represented the other side of the myth of the "happy" Vienna. In this context Vienna was the locus of many diverse and often contradictory social and intellectual tendencies. On the one hand, the bourgeois establishment, ruled by the aged emperor Franz Josef, outwardly held to entrenched traditional values, while inwardly reveling in its hypocritical mentality and corrupt morality, with emphasis on the material world, opulence, and sensuality. On the other hand, this corrosive climate allowed for an exceptional flourishing of the arts, architecture, literature, and philosophical and scientific thought. There was an explosion of creativity before this era of greatness ended, marked by the death of the emperor in 1916 and the removal of Austria-Hungary from the map of Europe in 1918 at the conclusion of World War I.

Extraordinary personalities converged at this time, resulting in the effervescence of Austrian modernism. Sigmund Freud developed his psychoanalytic theories; Ludwig Wittgenstein began to formulate his philosophical ideas; avant-garde composers such as Arnold Schoenberg, Anton von Webern, and Alban Berg offered innovations in music, while Gustav Mahler's compositions enjoyed renewed interest; writers such as Arthur Schnitzler, Hugo von Hofmannsthal, Karl Kraus, Robert Musil, and Stefan Zweig created new plays, poems, and prose; Otto Wagner, Adolf Loos, and Josef Hoffmann proposed novel architectural concepts; the decorative designers of the Wiener Werkstätte, and the Secessionist style, best exemplified in the art of Gustav Klimt, evolved as a reaction against traditionalism and the reigning academic art. Against this background developed the extraordinary, personal, and emotionally charged art of Egon Schiele, whose virtuosity of drawing and exceptional richness and breadth of creativity resulted in a radical new pictorial form and the powerful style of Expressionism.

Schiele (1890–1918), the son of a railroad official assigned to Tulln, near Vienna, grew up in the atmosphere of the bourgeois establishment in which the proper career choice would have been to follow the family tradition, in his case possibly becoming a railroad engineer. However, since his early childhood Schiele had demonstrated an exceptional ability for drawing, which resulted in an even greater passion than his fascination with trains. This ability was finally channeled in 1906 into traditional artistic schooling at the Vienna Academy of Fine Arts, where stilted methods of instruction and constraints on individual creativity made him drop out after three years, without receiving his certificate of master painter.[3] A boy and then a young man of a very sensitive nature, he was always extremely self-centered, moody, and brooding but also strong-willed. By all accounts, including those of his sisters and

collectors of his work, he was not a deviant obsessed with sex and eroticism, but simply a product of his milieu: the hypocritical Viennese bourgeois society fascinated by sex and sexual practices no matter how prudishly concealed. It was this veil of secrecy and censorship, these societal taboos, that Schiele was able to expose through his Expressionist style.

Stylistically, in the early years Schiele was greatly attracted to the art of Gustav Klimt, the high priest of Secessionist style, and he attempted to assimilate that influence into his own idiom. His works of that early pre-1908 period include many portraits of family members, self-portraits, and landscapes, often executed in gouache on cardboard with additions of pencil and/or charcoal, as well as some works in oil.

Schiele's initial drawing style, until about 1908, was decidedly skilled but unexceptional. It showed academic correctness in turning the model into an idealized subject, as is evident in the *Portrait of a Young Girl* (pl. 2), for example. The great change came around 1909, when the artist's impersonal precision of rendering gave way to a more personal style based on observation that translated into a line of different inflection, more emphatic than just simple contour. That change, as Albert Elsen has pointed out, resulted from Schiele's assimilation of Auguste Rodin's special manner of drawing, newly invented about 1895–97, which Elsen defined as "continuous drawing." Based on direct observation of the subject, it was executed without the artist taking his eyes off the model (fig. 1).[4] Drawing in this manner created a completely new line, different from the sinuous line of *Jugendstil*. The contours were now drawn with

1. Auguste Rodin. *Reclining Woman.* c. 1900–08. Watercolor and pencil on paper, 9 7/8 x 12 7/8″ (25 x 32.5 cm). The Museum of Modern Art, New York. Bequest of Mina Turner

quick strokes of a pencil or pen, and the flesh tones were subsequently filled in with watercolor. This method gave to the drawings a lively freshness and, through placement of the figure in the center of a page, an almost abstract and monumental aspect (see pl. 11).

The influence of Rodin, however, was only one of many that Schiele eventually absorbed into his own expressive idiom. Some of his early drawings, such as the portrait of his mother (pl. 3), indicate a strong affinity with the decorative linear style of the Viennese Secession. Other artists whom he admired and to whom he was indebted included Henri de Toulouse-Lautrec, Vincent van Gogh, the Northern Symbolist painters Ferdinand Hodler and Edvard Munch, and the Belgian sculptor George Minne.[5] Schiele was not only interested in the stylistic elements their work had to offer but he also felt a kinship with certain subjects that fascinated them, for instance, death, loneliness, or anxiety. These subjects, so often encountered in the early works of Schiele, were predominant in the oeuvre of Munch. The attenuated, androgynous figures characteristic of Schiele's nudes and self-portraits of 1910–11 bear striking resemblance to the melancholic, introspective youths of Minne (fig. 2).[6] These formal

9

2. George Minne. *Kneeling Youth.* 1898. Original plaster, 31 7/8 x 7 3/4 x 17 3/4" (80.8 x 19.8 x 45.2 cm) including base. The Museum of Modern Art, New York. Gift of Mr. and Mrs. Samuel Josefowitz

characteristics and moods derived from Symbolism pervaded Schiele's early work and can be attributed, in part, to the adolescent artist's psychological makeup and the realities of his family situation, in which death, illness, insanity, and poverty were a constant, daily presence.[7] Three of Schiele's siblings, for instance, died before he was born, the fourth when he was three years old. All of these deaths were the result of his father's venereal disease, which was transmitted to his wife. In 1904, when Schiele was only fourteen, his father, having already succumbed to insanity, died from the consequences of untreated syphilis contracted in his youth.

The death of Schiele's father had a profound effect on the young artist at the time of his own budding sexuality. The associations of sex and death, sexuality accompanied by guilt, as well as a voyeuristic attitude toward depictions of his models or himself have often been cited as significant factors in the formation of Schiele's

concept of the erotic and his personal idiom of Expressionism. That idiom, as Rudolf Leopold has pointed out, highlights tragedy and ugliness–unlike Art Nouveau and its Viennese counterpart, *Jugendstil,* which were oriented toward the representation of the superficial aspects of beauty.[8] Schiele's Expressionism, in its insistence on structure rather than on a painterly manner, is striking throughout his œuvre. He favored contorted bodies, strange poses, nervous, often jagged, contours, and unusual combinations of colors to define parts of the body and convey moods or the character of a figure. All of these aspects of Schiele's Expressionism are in marked contrast to the work of the German Expressionists and of his compatriot, Oskar Kokoschka.

Schiele is, first and foremost, an exceptionally talented draftsman. Even in his paintings his primary emphasis remains the structural element of the composition. His use of color is not for the purpose of modeling, but for expressiveness. Internal, psychic moods are communicated through vivid, surprising colors, such as blue, red, or green as well as deep browns and blacks. Any decorative function is essentially banished from the colors, in decisive contrast to the works of the Viennese Secessionists and particularly the work of Schiele's role model, Klimt.

KLIMT AND SCHIELE

One of the primary stimuli in Schiele's art was his admiration for and friendship with Klimt, whom the artist reportedly met in 1907 and who two years later invited Schiele to participate in the second *Internationale Kunstschau* exhibition.[9]

Klimt's work at that time was in its highly decorative phase, especially evident in his painting *The Kiss* (1907–08). Schiele, inspired by Klimt, imitated the *Jugendstil*-derived line in some of his compositions, including the 1908 *Nude Boy Lying on a Patterned Coverlet* (pl. 8). Yet, despite the Klimt-related ornamentation of the drapery and the use of a gold background, Schiele's drawing has an entirely different visual impact from the work by Klimt. This difference is primarily due to a more angular treatment of the figure as well as a distinct separation of the figure and the background, clearly nonexistent in Klimt, who combines object and surrounding space into an almost abstract composition in which flatness and depth alternate in the perception of the viewer.

Schiele's interest in Klimt was more complex than merely wanting to absorb his artistic style, especially during the years 1907–09. For Schiele, Klimt, who was twenty-eight years his senior, represented an older statesman, the dean of progressive art, and was the quintessential example of a successful artist. Schiele also admired Klimt's lifestyle. On a more personal and psychological level, Klimt symbolized for him a father figure. It was, as Danielle Knafo has demonstrated, a relationship that was crucial to the enhancement of Schiele's self-esteem and the stimulation of his creativity.[10] Having lost his father at an early age and receiving no praise for his artistic efforts from either his mother, who was always alienated from her children, or his uncle-guardian Leopold Czihaczek, Schiele was searching for encouragement from someone who represented a figure of authority both on a human and an artistic level.

He found that figure in Klimt, who early on recognized Schiele's talent.[11] Klimt occasionally bought Schiele's drawings, provided models and patrons, and arranged for a temporary job with the Wiener Werkstätte when Schiele was financially strapped. During the early period of 1907–09, many of Schiele's works were compositionally and stylistically modeled on those by Klimt. Even the latter's characteristic long format was occasionally used. An excellent example of Klimt's influence can be seen in Schiele's drawing *Male Figure Facing Right (Self-Portrait)* of 1909 (fig. 3), in which Schiele appropriates Klimt's characteristic attire of a long caftan (fig. 4)–a monk's robe or prophet-like dress. That influence is further illustrated in Schiele's *Two Men with Halos,* also of 1909 (fig. 5), and its preparatory drawings. In this work the compositional arrangement is clearly reminiscent of Klimt's *The Kiss* (fig. 6). Although a certain decorative element is present, the outline of Schiele's figures is much more angular and the composition itself more stylized than Klimt's. Schiele, in fact, never used so completely the sinuous line of *Jugendstil* or the profusion of decorative detail that dissolves the figure in Klimt's portraits or allegorical compositions, such as the *Beethoven Frieze* or the University panels of Jurisprudence, Philosophy, and Medicine.

The year 1909 was the last one in which Schiele was still under the spell of Klimt. By 1910 he had begun to establish his own Expressionist idiom. It was about this time that Schiele dropped out of the Vienna Academy and also left his family. His uncle Czihaczek, who was dissatisfied with the young man's progress, his difficult personality, and his unconventional lifestyle, decided to end his financial support. Schiele's feelings of being victimized by life and circum-

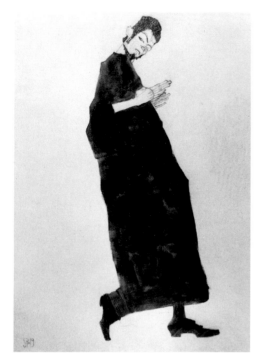 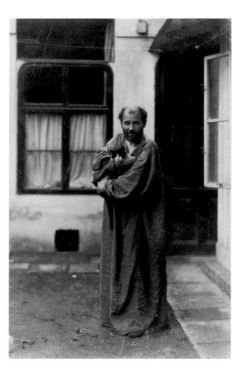 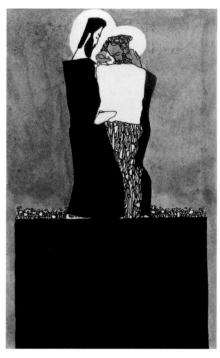

3. Egon Schiele. *Male Figure Facing Right (Self-Portrait)*. 1909. Watercolor, colored crayon, and pencil on paper, 17 3/4 x 12 1/4″ (45 x 31.1 cm). Private collection

4. Gustav Klimt, c. 1912, in the garden of his studio in the Josefstädterstrasse

5. Egon Schiele. *Two Men with Halos*. 1909. Ink, wash, and pencil on paper, 6 1/8 x 3 7/8″ (15.4 x 9.9 cm). Graphische Sammlung Albertina, Vienna

stances began to be reflected in his self-depictions. His works at this time, primarily self-portraits, reveal a preoccupation with the self, in keeping with his still-adolescent and narcissistic nature. They express his desire to establish his independent identity.

Schiele's early style had shown certain recognizable characteristics: the figures conveyed the impression of withdrawal and isolation, enhanced by the exaggerated color and unusual color combinations. The primary vehicles of expression now became the attitudes and postures of the figures, often with missing or stump-like extremities. Gestures, in general, were exaggerated and almost theatrical or frequently spasmodic. The contour of the body was drawn in a distinctive manner, and its organic unity was effectively destroyed through the use of eccentric coloristic contrasts. It has often been underscored that at that time Schiele was fascinated by the painter and mime Erwin Dominik Osen, also known as

Mime van Osen, with whom, for some time, he shared a studio. Osen's pantomime gestures as well as those of his companion, the dancer Moa, captivated Schiele and provided a lexicon for his pictorial vocabulary.[12] In the process of evolving his own original Expressionist style, the artist introduced a crucial change, a different concept of beauty (or rather ugliness) in the form of expressive distortion. This distortion conveyed psychological states of mind and replaced the traditionally recognized ideal of beauty as embodied in the conventional academic renderings of the model.

Other subjects of 1910 included numerous drawings of adolescent nudes, for many of which his younger sister Gerti posed; still others were portraits of Mime van Osen and Moa or of proletarian children, male and female, infants, and mothers with infants. All are striking in their immediacy of expression. Often the long, angular figures with exaggerated thin limbs and

unusually large, bony hands exist in their own world, and through their attitudes and facial expressions they provoke the viewer. The diversity of moods emanating from the artist's self-portraits can be appreciated in several examples in the Leopold Collection: *Kneeling Male Nude (Self-Portrait)* (pl. 15), *Seated Male Nude (Self-Portrait)* (pl. 17), *Self-Portrait in Shirt* (pl. 31), *Self-Portrait* (pl. 32), and *Grimacing Self-Portrait* (pl. 39). They range from an almost grotesque depiction of an emaciated youth, introspective in the manner of the Symbolist kneeling boys of Minne, to a bony, angular, X-ray-like figure with hollow eyes and cut-off extremities, obliquely positioned within the pictorial field, to two works similar in their emphasis on the gentle, intellectual, and questioning side of his personality, and finally to the angry, disheveled, almost degenerate face with only two sharp teeth protruding from the grimacing mouth.[13] The varying moods are reinforced by certain aspects of line and changing palette. The strong contrasts of bright orange, blue, acid green, and different shades of ochers or browns add up to a plethora of visual and expressive effects. There is also a fluctuating density of the mediums—from transparent to opaque—a device which again diversifies his expressive modes.[14]

A remarkable feature in some of Schiele's works is his use of the bare ground of the paper support as a form-creating and light-reflecting element, masterfully shown in the *Self-Portrait in Shirt* (pl. 31) and *Self-Portrait* (pl. 32). It brings to mind Henri Matisse's incomparable ability to use unshaded line to create form and a suggestion of volume, which began with some of his Fauve drawings and recurred throughout his career.

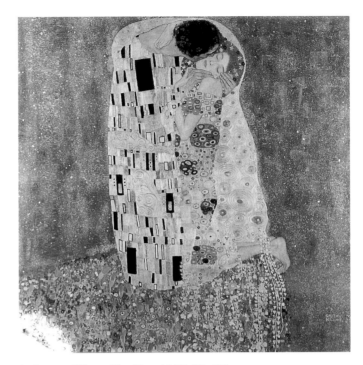

6. Gustav Klimt. *The Kiss*. 1907–08. Oil on canvas, 70 7/3 x 70 7/8" (180 x 180 cm). Österreichische Galerie, Vienna

Furthermore, by placing the figure either directly in the center of the sheet but facing sideways or on a diagonal, as in the painted self-portrait (pl. 17), Schiele gives his compositions an exceptional force. That force of expression is heightened by another formal device which Schiele began to use in 1910, namely, the application of a thick white halo in gouache around the outline of the figure, as seen in *Kneeling Female Nude* (pl. 30). Here the white gouache aura gives to the figure a more pronounced spatial definition and a greater contrast than in previous works. It isolates the figure and makes it stand out against the background while, at the same time, emphasizing its volumetric form.

As Jane Kallir has pointed out, Schiele's models during that year came primarily from his closest circle.[15] Besides his favorite model–his sister Gerti–other sitters included patients (frequently pregnant) of the gynecologist Erwin von Graff, who was an acquaintance of Schiele and who generously allowed the artist to draw at his clinic. An example of one of these subjects is the

watercolor *Pregnant Woman in Red* (pl. 21), in which the blood-red color, the mask-like face, and the stump-like extremities create a shocking image of suffering and death. Birth and death, for Schiele, were two closely related aspects of human existence. This concept haunted him during the early years of his career, conditioned by the experiences of his unhappy childhood, when, as previously noted, birth was often synonymous with death.

One painting which dramatically embodies the theme of birth and death is *Dead Mother I* (pl. 41), executed in the fall of 1910, after the artist's return from a vacation in Krumau, his mother's birthplace. The composition of this work, despite Schiele's clearly personal idiom, brings to mind paintings by Klimt, particularly his *Mother with Children* (shown in Venice in 1910), with its characteristic inclination of the mother's head. Schiele's painting is especially striking in its coloristic and formal contrasts. Deep darkness envelops both mother and child; additionally, the womb effect around the child accentuates it like a radiating icon. It is a profoundly moving picture of a tragic subject. It is also remarkable for its technique. The scraping effect within the dark areas looks back to the Munchian depictions of images of anxiety and jealousy, but Schiele gives it a personal touch by suggesting a whirlpool-like circular motion. The morbid effect of the image is enhanced by the introduction of the infant's blood-red hands and lips and the mother's elongated skeleton-like hand. The work is unquestionably the most important statement by the artist during that year.

Other subjects that occupied Schiele in the course of 1910 and especially during the artist's stay in Krumau, from May through the fall, were representations of street children, which he continued to make upon his return to Vienna. These adolescents, some of whom were just a few years younger than he, lingered around his studio for hours, enabling him to capture their natural poses and attitudes. In particular, the depictions of pubescent girls were a frequent subject. Their latent sexuality corresponded to his own feelings and his attempts to find answers to the questions that so fascinated him.[16] The poses of the models were almost always sexually explicit and were presented with such fetishistic attributes as stockings, garters, skirts lifted high to expose the model's genital parts, or open blouses displaying their bare chests. The most striking element of these drawings is the line: jagged, energetic, tension-revealing. Sometimes, however, color becomes the sole structural agent, as in the watercolor *Red-Haired Girl with Spread Legs* (pl. 36) in which the exceptionally handled medium and brash colors create a powerful effect.

Although depictions of adolescent girls were also a common subject among the German Expressionists of the *Die Brücke* group (fig. 7), it must be emphasized that they never displayed an overt, raw, and disturbing sexuality, so characteristic of Schiele. Their poses and the details of the body contained sexual overtones but were never explicitly focused on genital parts or sexual acts. They were closer in spirit to the depictions of young girls by Munch rather than to those by Schiele. In this respect, Schiele's Expressionism is unique.

By the end of 1910, Schiele had come into his own. He abandoned the sensuous line characteristic of Klimt and the *Jugendstil*, as well as decorative aspects, and replaced them with his per-

sonal, often raw and shocking, emotionally charged, style. Yet, he always remained the master of the subtlety of line as a highly expressive pictorial device. The presentation of the figures defies conventional beauty and accepted standards of depicting a nude. Schiele's nudes, in fact, become naked, not nude; convincing in their attitudes and in their directness of communicating with the spectator, they could claim descendence from Manet's *Olympia* (1863), in which the model–albeit, unlike Schiele's, academically correct–looks defiantly at the viewer, allowing him or her the visual invasion of her body. But where Olympia, in breaking the taboos of her era, still covers her sex with her hand, Schiele's nudes of some fifty years later display their genitals without shame and express their sexual attitudes through explicit poses and full body contortions suggestive of sexual invitation, high excitement, or arousal and ecstasy.

As we have seen, many of Schiele's models were children or adolescents. The use of child or teenage models was for Schiele not only a necessity (since his generally precarious financial situation did not allow him to hire professional models) but also a sign of his identification with what they represented for him: innocence yet fascination with themselves; sexual awareness and its unabashed display.[17] Additionally, in turn-of-the-century Vienna the cult of a child-woman, a *femme fragile*, androgynous and prepubescent, had come into vogue.[18] Such a type was a symbol of the new, just budding eroticism, freshness, and vulnerability. She was naked, innocent in a psychological sense; the architect and critic Adolf Loos referred to her as unornamented.[19] The exploration of the phenomenon of the child-

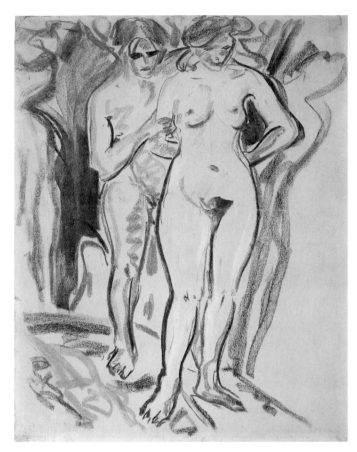

7. Ernst Ludwig Kirchner. *Two Nudes in a Landscape.* c. 1909–10. Pastel, crayon, and charcoal on paper, 35 1/4 x 27 1/8″ (89.5 x 69 cm). The Museum of Modern Art, New York. Gift of Marshall S. Cogan

woman was also connected to the studies of hysteria then highly popular among the doctors and psychologists of Vienna. It was believed that one of the principal causes of hysteria among young married women was the lack of sexual satisfaction.[20] Numerous books containing photographs of hysterical patients in various contortions circulated among the Viennese intelligentsia. The most popular of them were Albert Borée's *Physiognomische Studie* (1899), Johann Lavater's theories on physiognomy, Paul Régnard's study on hysteria and epilepsy, and Eugen Bleuler's work on schizophrenia (1911).[21]

The fascination with hysteria and its symptoms became particularly well documented in the three-volume publication, *Iconographie photographique de la Salpêtrière*,[22] edited by D. M. Bourneville and Régnard. The journal *Nouvelle icono-*

8. Phase in an attack of hysteria, from Paul Richer, *Etudes Cliniques sur la Grande Hystérie ou Hystéro-Epilepsie* (Paris: Adrien Delahaye et Emile Lecrosniers, Editeurs, 1885)

graphie de la Salpêtrière, edited by Jean-Martin Charcot and Paul Richer and published between 1888 and 1918, and Richer's book, *Etudes Cliniques sur la Grande Hystérie ou Hystéro-Epilepsie* (1881 and 1885), visually documented different phases of hysterical attacks (fig. 8). A number of these images bring to mind the contorted poses of Schiele's sitters.

Prior to some of these studies, in 1895, Freud, in collaboration with his colleague Josef Breuer, had published *Studien über Hysterie,* in which they discussed the correlations between art and hysteria. As Patrick Werkner states, hysteria was considered a catalyst for creativity.[23] Psycho-analysts accorded a kind of "beauty" to the physical aspect of an hysterical attack, similar to contemporary readings of fits of ecstasy among revelers in Dionysian cults. These ancient Greek cults were believed to underlie the origins of art and drama because the ecstatic state mirrored the actor's submerging of himself into a character. The Austrian playwright and journalist Hermann Bahr drew upon Freud and Breuer in his analysis of Greek tragedy as a forum to act out repressed hysterical emotions. Parallel to the adoption of the ideal androgynous female form in Expres-

sionist art, expressive free dance thrived in the performances of Grete Wiesenthal and Ruth Saint Denis, among others.[24] Many of the poses and attitudes of Schiele's and Kokoschka's models could have been inspired by these dancers.

SELF-PORTRAITS AND NUDES: 1911–13

Within the course of 1911, watercolor began to dominate Schiele's work. He mastered the fluidity of this medium, and, as a result, his palette acquired greater variety. Compositions became more harmonious and flowing, and there were now more subtle contrasts between different parts of the human body. Abrupt disjunctions caused by extravagant combinations of colors were no longer evident.[25] There also occurred a visible change in the organization of space: frequently the figure fills the sheet almost to the edges and consequently different sections of the body are cut off by the support. The paint surface takes on a more modulated character, adding greater formal articulation to the composition and enhancing its expressiveness. These aspects are equally present in the nudes and in the self-portraits. As Alessandra Comini pointed out in her pioneering study of Schiele, by 1911 he introduced in his work the "existential" formula[26] characterized by the environmental isolation of the figure or figures, a frontal presentation and central axis, and an emphasis on eyes (frequently surrounded by lighter color orbs) and hands, which were oversized and gnarled. The total effect of the manipulation of these exaggerated features introduced a disquieting element and a sense of pathos.

Werkner, agreeing with Comini, states that in 1910–11 "[Schiele] makes the leap from fin-de-siècle and Jugendstil to an erotic art without pretense, from aestheticism to existentialism."[27] Certainly his self-portraits, many of them depicting him in the act of masturbating and clearly executed in front of a mirror, convey through facial expressions as much as through bodily contortions, the angst, apprehension, guilt, curiosity, and surprise at the depth of his emotions, be they passion, ecstasy, or tragic isolation and psychological tension. Knafo contends that Schiele's propensity to portray himself masturbating was for him a way of coming to terms with his sexuality, which was achieved through the scrutiny of his image in the mirror and through the process of depicting that scrutiny and intensity of emotions in his art.[28] This autoerotic process was an attempt to evolve and establish his identity as a male and thus achieve a proper identity in the full sense of the word, as he had earlier, in 1910, established his identity as an artist. The elements of castration–for example, stump-like extremities–evident in Schiele's autoerotic depictions were, in psychological terms, the unavoidable result of his feelings of guilt and shame caused by these physical explorations. Such explorations probably also brought back to him the reality of his father's sexual exploits, which had caused his syphilis. Gouaches such as the 1911 *Eros* (Private collection) and the *Self-Portrait in Black Cloak, Masturbating* (fig. 9) convey these emotions in a very poignant manner. Schiele's probing of his psyche situated itself within a more general context of Viennese society's preoccupation with sex, the self, and with his own psychological state as it

9. Egon Schiele. *Self-Portrait in Black Cloak, Masturbating.* 1911. Gouache, watercolor, and pencil on paper, 18 7/8 x 12 5/8″ (48 x 32.1 cm). Graphische Sammlung Albertina, Vienna

related to the current Freudian theories of psychoanalysis. In Schiele's case that probing translated into works connected thematically to his mother and father and his relationship to them and to society.

One of the important oils of 1911 is *Poet* (pl. 45), which, in a structural way, through the position of the head, recalls the *Dead Mother I* (pl. 41) of a year earlier. In the later work, however, the picture itself is completely devoid of any Klimtian

connotations, and the model's attitude, the combination of somber colors juxtaposed with touches of vivid hues, and an expressive, vibrant brushwork convey a sense of suffering, torture, and loneliness. The body of the artist–it is evidently a self-portrait–is distorted and presented in an awkward position; the facial grimace and the enormous, bony hands emphasize the sense of horror and trauma. Knafo, in her psychological analysis of Schiele's works of this period, points out that the self-portraits produced between 1910 and 1911 present images of "confusion, decay, and narcissistic trauma," expressed through the fragmented–that is, physically damaged–body. The artist was then undergoing a tumultuous questioning of his identity and desperately sought the viewer's attention, inviting him to experience his own most intimate emotions.[29]

Coming to grips with these emotions, with his sense of self, and feeling deprived because of his father's death and his uncle's rejection, Schiele struggled with his male model/father figure. This struggle took the form of several double portraits, in which he created a doppelgänger (his double). These double self-portraits were, in effect, a second self in the guise of a protector or an imaginary companion. The painting *Self-Seer II* (pl. 46), otherwise referred to by the artist as *Death and Man,* presents such a fusion of multiple meanings. The concept of a double portrait of man and death has numerous art-historical precedents, to name only Arnold Böcklin's *Self-Portrait with Death Playing the Violin* of 1872 (fig. 10) or, much closer in time, Klimt's *Hope I* of 1903. The multiple layers of meaning in the *Self-Seer II* reveal the interchangeability of the self, the father figure, and death.

From a psychological point of view, such self-portraits indicate Schiele's "revival" of his father, a complete identification with him. This merging of identities, as it were, is very troubling and unsettling to the artist.[30] At the same time, the identification of the father with death relates to Schiele's search for his own identity. While Schiele realized that it was his father who was the sower of death in the family, a fact that he found difficult to accept, he also idealized his father. A rather complicated relationship with his mother, by whom since the early years he felt victimized and neglected, may have contributed to this idealization. On the one hand, in *Self-Seer II* Schiele loses his sense of separateness from his father; on the other, he unifies both images, thus creating a stronger self. Schiele's equating the skeleton-like figure bearing the mask-like face of his father with death is indicative of the artist's ambivalent attitude toward him and toward his own self. Because of the nature of his father's death, as already noted, Schiele lived in terror of the possibility of his own insanity and death related to his sexuality. On a pictorial level, the image is frightening yet intriguing, forcing the viewer to explore his own emotions as much as those of the artist. The expressive power of the painting is emphasized through the use of the tumultuous brushwork, the ghostly aspect of the doppelgänger, and the sense that the figures emerge out of an abstract space.

Among the double-portraits, the oil *Hermits* (pl. 65) deals again with the issue of transference of personality. It is one of the most beautiful and haunting works of 1912, and it is a statement about Schiele's relationship with Klimt. Stylistically, the painting is in part a return to the artist's

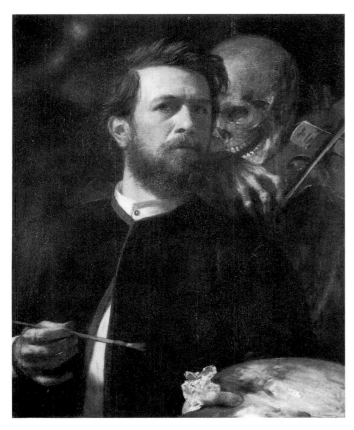

10. Arnold Böcklin. *Self-Portrait with Death Playing the Violin.* 1872. Oil on canvas, 29 1/2 x 24" (75 x 61 cm). Staatliche Museen zu Berlin, Preussischer Kulturbesitz Nationalgalerie

early *Jugendstil*-influenced style, especially in the presentation of the two men shrouded in black robes, which recalls the decorative treatment of figures in Klimt's compositions. Here, however, the effect is sober, devoid of the decorative aspect. The two dark silhouettes emerge in an almost three-dimensional way from a light, thinly brushed background but are locked into the picture plane through the use of delicate touches of red recurring throughout the composition: the wreath of red flowers on Klimt's bent head; Schiele's red lips; a red triangle on his voluminous sleeve; traces of red on his right hand; and the two red flowers at the lower left of the canvas. The expressive quality of the picture is conveyed through the postures and the faces. Standing in front of Klimt, Schiele displays an air of apprehension but also of defiance, even though he portrays himself as a victim, a sufferer bearing a crown of thorns. Klimt, wearing a

crown of red flowers, appears as a blind man, leaning sorrowfully on the younger disciple. Such a presentation of the two easily identifiable figures is rather curious, given the fact that Schiele, at that point, was still in financial difficulties and strongly depended on commissions and patrons provided by Klimt or other friends while Klimt was a wealthy, highly recognized master and society portraitist. It should not be forgotten that Schiele thought of Klimt as a father figure, and this fact adds another interpretive layer to the work. Schiele, in a son-like manner, considers himself an heir to the aged Klimt. As Comini points out, viewed in this context Schiele retaliates against the older man by depicting him as sightless, thus rendering him helpless.[31] Such multiple interpretations make Schiele's Expressionism complex emotionally and psychologically.

In addition to these metaphorical portraits, the years 1911–12 saw the creation of some of the most provocative depictions of female nudes, both in pencil and watercolor, exemplified by *Black-Haired Girl with Raised Skirt* (pl. 50). The period also marked a return to landscape and the representation of nature. Like many artists before him–in France and Germany[32]–Schiele felt that closeness to nature inspired creativity. Possibly the fact that in 1911 he spent much of his time in the country, first in Krumau (May through August) and then in Neulengbach, a small town about twenty miles west of Vienna, and hence was more exposed to nature, prompted him to take up landscape as a subject. But there is a great difference from previous years in the way in which Schiele approached nature in stylistic terms. Even his images of trees, such as *Autumn Tree in a Gust of Wind* (pl. 80), exude the senti-

ment of decay, loneliness, despair, and impending disaster. This theme echoes a connection to Symbolism, and the peculiarity of rendering brings to mind Piet Mondrian's paintings of a few years earlier, which for him created a stepping-stone to a more abstract pictorial composition. Schiele's images of trees or sunflowers (a clear reference to the influence of van Gogh) stress the expressionistic and anthropomorphic aspect of nature, imbued with morbid, desolate qualities that can also be identified with death.

Although the predominant themes of 1911 besides the female nudes were death and a continuing search for a masculine identity, on a personal level Schiele's life took a happier turn. He began a liaison with a young woman named Valerie Neuzil ("Wally"), who continued to be his companion and primary model until his marriage in 1915. She was the subject of a multitude of erotic drawings that were in demand among Viennese patrons and that provided Schiele with a means of support. By 1912 there was also a change in his drawing style as, to paraphrase Elsen, Schiele perfected his own version of Rodin's "continuous drawing." As a result, his works revealed a sharper characterization of the model and a greater penetration of the individual's privacy.[33] Schiele's mode of drawing thus became "figuratively invasive" and showed much greater intimacy with the body and also a great intensity of gaze on the part of the artist. His style was now less self-conscious and acquired the quality of a contour comparable to the artist's finger moving along real flesh.

One can assume that Schiele's own liberated eroticism, resulting from his stable relationship with Wally, freed him as well from earlier

constraints of style and technique. He reportedly created the diverse poses in which he depicted his models by observing them from above (using a stool or a ladder) while they reclined on a low couch expressly built by him in his studio for this purpose.[34] Occasionally he drew from below, in a crouching position. As a result, the human form becomes strangely foreshortened, in complete opposition to the academic canons of beauty and visual harmony. Many fragmentary figures were created by such foreshortening, which gave them a highly expressive quality. In fact, such figures bear analogies to the sculptures and drawings of Rodin (fig. 11). Schiele's drawing style, stressing fluidity of form, is almost reminiscent of Rodin's works in soft materials such as clay. In many works of 1912, however, the gentle, harmonious line is abandoned in favor of an abrupt, harder one that breaks up the continuity of the form. Schiele also introduces small cross-hatchings or spirals that effectively deemphasize the flat surface of the support and provide a great spatial energy for the composition.

The paintings of 1912, such as *Self-Portrait with Chinese Lanterns* (pl. 77), its companion piece *Portrait of Wally* (pl. 78), as well as *Cardinal and Nun (Embrace)* (pl. 75), show a different spirit from the oils of the preceding year or even the city views and landscapes of the same year. Kallir suggests that they were all executed in the later part of 1912, after Schiele's unfortunate imprisonment for twenty-four days in April and early May on charges of immorality.[35] The first two paintings, by comparison with many earlier works, are striking in the lightness of mood and the near-serenity of the subjects' expressions. While Wally appears solemn and

melancholic, Schiele shows himself in a theatrical pose. Depicting himself in a bust portrait in a three-quarter view, he looks at the viewer with a defiant eye and sorrowful countenance; the cheerless, dejected expression is deepened by the unusual modeling of the face with the blue-and-reddish areas and lines alternating throughout. The medium itself is handled with great dexterity, structuring the composition and conveying a variety of painterly effects. Wally, for example, emerges out of a neutral background of grayish crisscrossing strokes while the front of her black dress seems to have been done with a much drier, scratchy brush. In the self-portrait there is a masterly treatment of the face, strongly modeled with different combinations of colors, while the green of the garment parallels the treatment of Wally's background. The psychological complexity of the works is intensified by the painterly accomplishments.

The interest in allegorical double portraits exemplified in the earlier part of 1912 by the *Hermits* (pl. 65) continues in the rather unorthodox subject of cardinal and nun (pl. 75). As Comini suggests, this audacious work was Schiele's challenge to the establishment following his imprisonment and to the society that did not understand him and did not appreciate his talent.[36] The artist himself is shown embracing Wally, the faithful and comforting model for *Mourning Woman* (pl. 67), who brought him solace and support during his incarceration. The composition is a parody of Klimt's celebrated painting *The Kiss*. The subject and its presentation, implying intercourse between the two protagonists–the cardinal and nun, personified by Schiele and his lover Wally–were shocking and

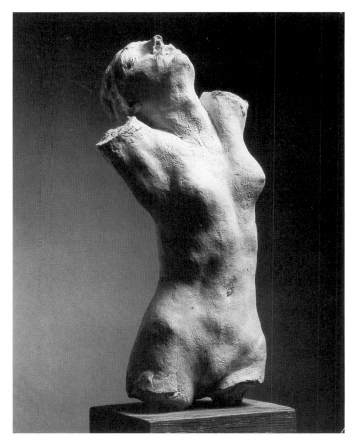

11. Auguste Rodin. *Torso of the Centauress.* c. 1884. Terracotta, 8 1/2 x 4 1/8″ (21.5 x 10.3 cm). Musée Rodin, Paris

appeared sacrilegious to the secular as well as to the ecclesiastical communities. The physicality of the scene was heightened by the use of vibrant "ecclesiastical" colors; the manner of depiction is simplified, almost abstract. The protagonists create a triangular or pyramidal form emerging from the dark, suggestive background. While the earlier double portraits, such as the *Hermits* or *Man and Death*, could be seen as carrying homoerotic overtones, here the statement is clearly heterosexual, proof, as it were, that the artist had finally found his sexual identity and felt the same urge to portray his passion as he did in numerous earlier autoerotic pictures.

Despite his satisfactory relationship with Wally, Schiele continued in 1913–14 to be absorbed in himself, and his self-portraits again present him in the anti-social guise of a monk or a hermit. Stylistically, there is a slight change in his expression following his trip to Munich in August 1912

in preparation for the Secessionist exhibition, to be held there at the end of the year. His notebook from the trip indicates that while in Munich he saw the work of the German Expressionists: Kirchner, Schmidt-Rottluff, Marc, Macke, Jawlensky, Klee, Kandinsky, and numerous other contemporary artists, as well as Gothic, Oriental, folk, and primitive art. He seems to have been interested in Cubism as it was translated into the work of Macke or Feininger, but he had no feeling whatsoever for the Cubism of the Picasso-Braque type. Yet, he did not attempt to incorporate these influences into his own work, possibly because he found them quite alien to his emotional, self-oriented nature, which was interested in the bold expressiveness of body language and not in dislocation and dissection of the human form.

CHANGES OF IDIOM: LATE 1913–15

During the years 1913–14 the subjects of Schiele's work do not change drastically; they remain self-portraits, nudes, and landscapes. But there is a change in the quality of line, which turns angular, harsh, and full of inflection. In addition, the figure is presented in a new way: volume is suggested by the bare background of support. The decisively drawn line now implies volume through the whiteness and light-reflectiveness of the paper, as is clearly visible in *Standing Female Torso with Olive-Green Shirt* (pl. 87), *Female Torso Seen from the Back* (pl. 89), and *Nude Girl with Crossed Arms* (pl. 91). The portraits and self-portraits, often modulated in bold combinations of bright blue and red as if the figure had undergone

flagellation, again display theatrical gestures. Now, however, their faces are not frontal but in profile or hidden from view. The expressive quality is enhanced either by the placement of the figure at an angle, as in *The Dancer* (pl. 95), or through constricted gestures of the figure placed in the center of the sheet, as in the *Preacher (Nude Self-Portrait with Blue-Green Shirt)* (pl. 97). The latter picture also represents the new type of line that will be used frequently throughout 1914–a thin, quick line, which, for emphasis, is overdrawn with a spiral pattern. Another new element also enters the composition: the figures–full or fragmented–are presented in vibrantly colored garments, intensely brushed so as to reveal the individual strokes. In *Preacher* (pl. 97), for example, the brushstrokes are clearly visible. This device carried over into the works of 1914, such as *Crouching Woman with Green Kerchief* (pl. 101). Here the kerchief and the blue drapery on which the model is seated set off the figure, which is rendered in harsh, thick contour lines that emphasize its three-dimensionality. But again the unpainted support, punctuated by the dots of color, in this case the red nipples and a red patch on the model's right elbow, serves as the vehicle for conveying mass.

Kallir notes that "as in late 1913, Schiele's drawing style [of the following year] suggests an underlying structure of muscle and bone, and his coloring technique reflects these concerns."[37] In 1914 his interest focuses on plasticity of form that allows and requires a certain spatial dislocation. At times he almost reverts to conventional realistic depiction, although the poses of the figures are often quite unnatural, as for instance in *Crouching Nude Girl* (pl. 106). The integration of

contour and volume is achieved through a combination of linear and pictorial aspects. There is also a change in the choice of models: they are predominantly adult women, much more full-bodied than the adolescents of the earlier years. Fetishistic attributes such as rolled-down stockings or shirts hoisted up to the neck or open are still frequently present. In some of the works these attributes take on the greatest prominence as pictorial elements, as is the case in *Seated Nude with Red Garter, Seen from the Back* (pl. 113). The red garter immediately catches the viewer's eye and serves as an accent that draws attention to the powerfully rendered body, whose pose is sexually suggestive. The plasticity of that body is conveyed through bold, unusual combinations of browns, touches of red and blue, as well as the whiteness of the paper support. Such coloristic combinations are remote echoes of the striking, vibrant symphonies of the Fauves.

In 1914, while still feeling that he was insufficiently appreciated as an artist and financially strapped, Schiele tried his hand at etching, particularly making portraits, but regrettably without great success. He also returned to drawing landscapes, especially views of Krumau. Most of these are executed in rapid strokes of unshaded, volume-creating line that render with great accuracy the smallest details of the scene. These are among his most sober yet highly expressive works, in which the absence of color communicates a desolate, nostalgic mood, most likely reflecting his own psychological sense of isolation and anxiety.

It was about this time that Schiele's fortunes began to improve. In addition to those who had previously supported him, he had a growing circle of collectors, including Arthur Roessler, Carl Reininghaus, Heinrich Benesch, and Dr. Oskar Reichel. Through Klimt he befriended a family of wealthy Hungarian Jews, the Lederers, who commissioned him to paint several portraits of their son Erich and his sister. They also asked Schiele to provide Erich with drawing instruction. That same year he was commissioned to execute a portrait of a wealthy young society lady, Friederike Maria Beer (fig. 12). It was the only life-size portrait he ever made. Commissions of this type were generally the province of Klimt. The outcome of the Beer's portrait was not overly successful, as Schiele's style, intensely expressive but without emphasizing the sitter's beauty in a conventional sense, was not well suited to society portraiture. The strangely posed figure, viewed from the back but turning to look at the spectator and floating in mid-air with her arms raised and fingers curled, is attired in a patterned dress of Wiener Werkstätte design.[38] She is expressively awkward and is light-years away from the same sitter as depicted by Klimt.

Schiele's numerous self-portraits at this time mirrored the poses of many of the photographs taken of the artist by the portrait photographer Anton Josef Trčka in March 1914. These portraits introduce Schiele's new idea of himself. He now follows a dual course: he presents himself either as a martyred saint–the next step, as it were, from depictions of himself as a monk or hermit–or he approximates the pantomime-like poses assumed for the Trčka photographs, always focusing on the face and hands (see frontispiece). Manipulation of the body remains the tool for heightened expressiveness. The latter feature is visible not only in the self-portraits but also in

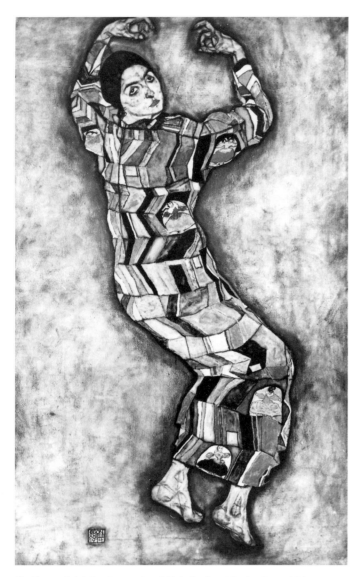

12. Egon Schiele. *Portrait of Friederike Maria Beer.* 1914. Oil on canvas, 74 3/4 x 47 1/2" (190 x 120.5 cm). Private collection

THE FINAL YEARS: 1915–18

The outbreak of World War I did not affect Schiele's life until later in 1915.[39] That year was especially eventful for him personally. On June 17 he married Edith Harms, a "proper" young woman from a petit bourgeois family whom he had met in early 1914 and began courting seriously after the marriage of his favorite, younger sister Gerti in November 1914.[40] The Harms family, which included two daughters, Adele and Edith, were Schiele's neighbors, living across the street from his studio at 101, Hietzinger Hauptstrasse in the remote Viennese district of Hietzing. The second important event of that year was Schiele's induction into the army four days after his marriage. Both of these events influenced the style as well as the subject matter of the works of his final period of creativity. Since, reportedly, Schiele's peculiar way of wooing the Harms sisters was by showing them his drawings through his studio window, this inevitably resulted in a flurry of self-portraits, again in theatrical poses, as seen in the *Self-Portrait in Jerkin with Right Elbow Raised* (Private collection). Schiele also executed other figural works, many of them erotic, and he continued the depictions of double portraits and landscapes.

The figural compositions include such works as *Mother with Two Children II* (pl. 125).[41] Here, Schiele again returned to a subject that had preoccupied him in the early years, as seen in such images as *Mother and Child* of 1909, *Dead Mother I* of 1910 (pl. 41), *Woman with Child on Her Arm* (pl. 69) and *Mother and Child* (pl. 70), both of 1912, and *Blind Mother* of 1914 (pl. 104). The psychological underpinnings of this subject

various drawings of intertwined couples, be they lesbian or heterosexual, as exemplified by the *Two Girls Embracing (Seen from the Back)* of 1914 (pl. 109), *Lovers* of 1914/15 (pl. 119), or *Act of Love* of 1915 (pl. 121). The aggressively applied, often modulated, color intensifies the volumetric quality of the bodies depicted and contributes to the originality of the artist's style.

clearly relate to Schiele's family history and his relationship with his mother as well as to the abortion, in 1910, of his own child, conceived with a lover known only by her initials, L.A. All these images share the same joyless quality, the expression of quiet resignation, hopelessness, and detachment of the mother from the children–a situation so familiar to the artist from his own childhood. In these depictions, there is never any warmth or human contact between the mother and her offspring, only alienation and despair. One is struck by the pain of the experience.

The works of 1915, most of which were purportedly executed in the early part of the year[42] before Schiele's military service, whether self-portraits or nudes, show sureness of line and masterly treatment of the body with unusual foreshortening and spatial contortions, demonstrated in *Nude with Raised Right Leg* (pl. 128). Once again one is reminded of works by Rodin. The strong inflection of the line describes the contour of the body, and its volume is emphasized through delicate modeling in gouache and strong accents of red in the face, shoes, and stockings. That year also saw the end of Schiele's relationship with Wally, since Edith, after their marriage, did not want Wally to continue as her husband's model. This event found its pictorial response in one of the artist's most important paintings of that year: *Death and Maiden (Man and Girl)* (fig. 13). The composition, conceptually, relates to *Cardinal and Nun* (pl. 75), especially since the two figures depicted are, in fact, Schiele and Wally. The mood, however, is completely different. While *Cardinal and Nun* was about passion and carnal love, *Death and Maiden* is about the anxiety of separation: the woman

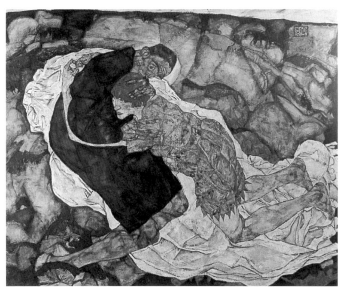

13. Egon Schiele. *Death and Maiden (Man and Girl)*. 1915. Oil on canvas, 59 x 70 7/8" (150 x 180 cm). Österreichische Galerie, Vienna

grabs the skeleton-like figure, while both of them float against a white drapery and a desolate mountainous landscape. Within the context of Viennese art, the painting shows affinities with Oskar Kokoschka's *The Bride of the Wind* (fig. 14), in which the two lovers float within the eye of a storm. Yet, while Kokoschka's subjects are expressive only through compositional form, Schiele's grieving figures convey the universal feeling of hopelessness and distress. Schiele's emotional complexity is by far more disturbing.

Death and Maiden is Schiele's "memento mori" to his relationship with Wally, but it resounds also in more universal terms as a comment on humanity. Stylistically the painting is interesting in terms of the juxtaposition of decorative and plain surfaces and, particularly, in terms of its spatial organization. The figures seem to float while at the same time they kneel on the cloth spread on the ground. The compositional organization shows a great similarity to another allegorical work of that year, *Transfiguration* (also known as *Levitation*)[43] (fig. 15), in which the two skeleton-like protagonists float against the rough, desolate cityscape. Both works mark a

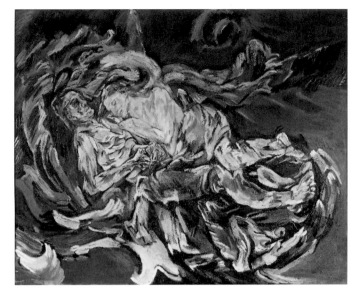

14. Oskar Kokoschka. *The Bride of the Wind*. 1914. Oil on canvas, 71 1/4″ x 7′3″ (181 x 221 cm). Öffentliche Kunstsammlung Basel, Kunstmuseum

momentary end to Schiele's interest in painting allegorical compositions. The change of circumstance occasioned by the war meant that Schiele now concentrated on painting war prisoners or simply portraits, while the lack of a proper studio made it impossible to execute complex, large-size works. Schiele will later take up the thread of allegorical compositions in 1917 with such works as *The Family*.

Following his marriage, Schiele found a new model, his wife Edith; later, his sister-in-law Adele, with whom he reportedly had an affair, sat for him occasionally. He made numerous portraits of Edith, seated or standing, wearing a striped dress or simply undressed, and depicted in erotic poses. Schiele's style changed too. It became more naturalistic. In the erotic drawings, a certain new element of tenderness appeared, possibly derived from an intimate knowledge of the sitter's body and the artist's emotional involvement with it. These drawings were devoid of the erotic aggressiveness present in the earlier depictions of the sexually experienced Wally or of other models or later of his sister-in-law, Adele. This new mood is well expressed in the watercolor *Reclining Woman Exposing Herself*

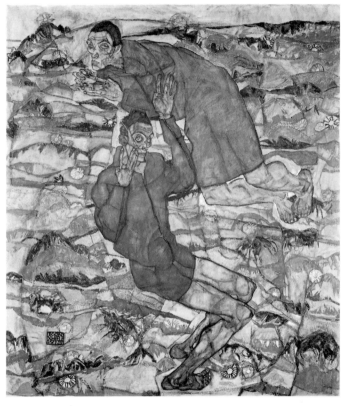

15. Egon Schiele. *Transfiguration (The Blind II)*. 1915. Oil on canvas, 78 3/4 x 67 3/4″ (200 x 172 cm). The Leopold Collection, Vienna

(pl. 133). The portraits of Edith clothed convey the same rather passive personality that can be perceived in photographs of her taken around the time (fig. 16). By all accounts Edith was profoundly unhappy with Schiele's military assignment, particularly to Mühling, where he was to guard Russian prisoners of war while she had little to do but wait for him at a nearby hotel, where she was living. That air of sadness and boredom is movingly captured in her portraits.

Schiele's paintings at this time remained fairly conventional, and his main creative energy was concentrated in his drawings, which cover a large spectrum of topics. The new ones are portraits of

Russian prisoners of war, such as that shown in plate 135. Here, a fragmentary figure with cut-off extremities reappears, yet this time the artist renders it in his late, naturalistic style. Another work, *One-Year-Volunteer Private* (pl. 137), also depicted in a naturalistic manner, makes masterful use of the white background of the paper to suggest the volume of the figure. The modeling of the face juxtaposes blues and reds in a manner similar to the works of 1913–14. Yet the presentation of the figure is straightforward, without theatricality or pantomime.

Views of Krumau constitute a large group of drawings from the early part of 1915, probably reminiscences of the artist's sojourn there the previous autumn. In 1916 he again returned to depictions of Krumau as well as to those of his studio in Mühling (pl. 136). They are executed in rapid and precise strokes of a pen or pencil, occasionally enhanced with watercolor. A certain anthropomorphic quality pervades them, and they convey a feeling of nostalgia. In formal terms they are striking in their perspectival presentation, either frontal or from above, and in their naturalistic detail. Witness Schiele's *Writing Table at the Mühling Prisoner-of-War Camp* (pl. 136). Here the fine, thin line, only occasionally highlighted by touches of watercolor, renders every object palpable and points toward such 1917 works as *Packing Room* (pl. 139) and *Supply Depot, Brixlegg Branch* (pl. 140), executed when he was already back in Vienna.

There was somewhat of a hiatus in Schiele's output in the years 1915–16 owing to his military service, but the following year brought a new creative vitality with figural works and land-scapes, executed in oil, and a broad variety of

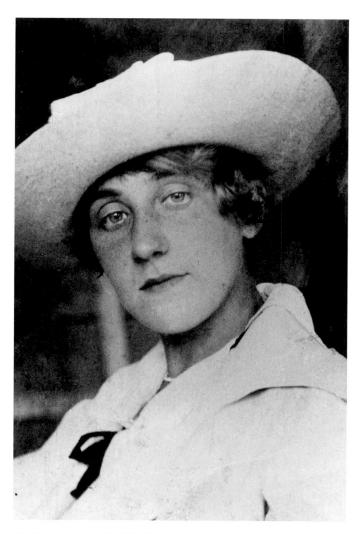

16. Photograph of Edith Schiele, c. 1917

subjects–female portraits and figure studies, depictions of women with children and children by themselves, male portraits, self-portraits, couples, as well as landscapes and still lifes–in drawing and watercolors. The canvases of 1917 become more painterly and show more obviously modeled textures, but they retain their former linear structure. Sometimes more vibrant impasto and a brighter palette are introduced, in particular in the depictions of nudes. Many of them are placed against a background of ocher and yellow. These colors Schiele reportedly associated with passion; see, for example, *Reclining Woman* (pl. 142).[44] One may wonder, however, whether this rich ocher background is not a reminder of the golden backgrounds in Klimt's paintings done in the early years of the century against which

the artist places this explicit, sexually inviting nude. A more lyrical and harmonious note enters the depictions of landscapes, which highlight lusher foliage rather than desolate trees and frequently even glow in the bright light of sunset.

In the male portraits, which consist primarily of seated figures in armchairs, such as the *Portrait of Dr. Hugo Koller* (Österreichische Galerie, Vienna), the artist indicates an interest in three-dimensionality, which is conveyed through the placement of the figure at an angle against a complex interior filled with books. The nudes, however, seem to remain set against neutral backgrounds, especially evident in the drawings. There is essentially no change in style in these nudes. The figures are rendered in the same naturalistic manner as they were a few years earlier; yet, they seem more mature and are described with greater economy of line, which is nonetheless thicker and more decisive. The colors that reveal the volumes of the figures do not change from preceding years. In fact, the palette, if anything, is more subdued, as witnessed in *Kneeling Girl Propped on Her Elbows* (pl. 143). This type of drawing coincides with another kind, also previously explored, namely, the thin unshaded line overlaid or supplemented by a spiral one, as in *Woman in Undergarments Leaning on Her Arms* (pl. 141). In choosing the poses of his models, Schiele draws on the repertoire he had used often in the past. Among the drawings executed in 1917, many were actually commissions from friends and, increasingly, from outside sources. These commissions, in fact, began to provide a substantial source of income for the artist. For some patrons he made several preparatory sketches, of which the most compre-

hensive group, a set of ten, depicts Franz Martin Haberditzl. As in the past, the face and hands of the sitter become the focal points of expression.

Improvement in Schiele's financial situation was echoed in his professional standing, and he now had an abundance of studio materials and the possibility of a choice of models. It was at that time that his wife's sister, Adele, posed for many drawings. It is sometimes difficult to distinguish which sister was the model, despite a fairly naturalistic manner of rendering. In reality, Adele had much darker hair and was more audacious in her poses than Edith, who was blonder, more reserved, and had more delicate features. The depictions of Edith show more tenderness, which is particularly evident in her final portrait of 1918, executed the day before her death.

During the period 1917–18 Schiele's drawing style, although not markedly changed, came to rely increasingly on contour line and tone. This contour line, simple and quick, captures the subject's essence. In drawings that emphasize volume, the delineation of that volume becomes stronger, due to the use of charcoal, a medium that offers a great capacity for textural experimentation and allows greater sensuality of expression. Simultaneously, there is an opposite tendency in his oils. They now become more painterly, although since many paintings remained unfinished at the time of the artist's death, it is difficult to evaluate what his further progress would have been.

A striking feature of the works of 1916–18 is their freedom of execution. They excel in the "continuous drawing" method; the figure is conveyed through contour drawing rather than through light and shadow. See, for example, *Head*

of the Dead Klimt (pl. 144). The manner is very personal, the distortions sometimes bizarre, as are the proportions and poses, which often defy the laws of gravity. They add character to the model rather than offer conventional beauty and, as a result, convey a special expressive quality. In the last two years of his life, Schiele once again attempted some allegorical compositions, most of which remained essentially unfinished. In these paintings–for example, *Two Crouching Women* (pl. 147) and *Three Standing Women* (pl. 149)–the style is looser, the colors brighter, and the figures and their faces unresolved. The drawings of these years, as already mentioned, are much more successful.

The year 1918 brought Schiele long-awaited success. Following the death of Klimt in February, he was recognized as the leading living Austrian artist (Kokoschka was then residing in Dresden). This reputation was confirmed by Schiele's one-man exhibition at the Vienna Secession in March, which sold out entirely. With a change in status came long-expected commissions. Schiele's new financial success enabled him to rent a larger studio; he hoped to establish an art school in the old one. But the ravages of war, with its shortages of fuel and food, were plaguing Vienna and profoundly affecting the population.

On October 28, after a short illness, Schiele's six months pregnant wife succumbed to the raging epidemic of Spanish flu. Schiele himself died in the same epidemic on October 31 at the age of twenty-eight. The last drawing of his wife, *Edith Schiele on Her Deathbed* (pl. 152), executed on the day before her death, shows him once again as an exceptional draftsman; the face is rendered naturalistically, with a thin, economical line, while the hair, drawn with assured swirling strokes, frames the delicate, sad, and suffering face. It is the last work by the artist, highly compassionate and dramatically moving.

Although Schiele's career was very short–essentially fewer than ten years, 1910–1918–his œuvre shows great variety, dynamism, and superb richness of accomplishment. His was an art of individuality and creative originality, focused on communicating the depth of human emotions and the force of human experience. His remarkable evolution from an emotionally and physically isolated and tormented adolescent in search of identity and artistic self to a fully mature artist whose images fascinate, trouble, and shock but are always informed by extraordinary creative energy transforms his art from the deeply personal to the universal. The radicality of his art and his rebellion against the traditional attitudes toward such taboos as sex and sexuality make his art relevant to and appreciated by today's young artists, art connoisseurs, and the public at large.

Notes

[1] Robert Musil, *The Man Without Qualities*, vol. 3, chap. 33 (London: Secker & Warburg, 1960).

[2] An in-depth discussion of the historical background of the period under consideration can be found in Allan Janik and Stephen Toulmin, *Wittgenstein's Vienna* (Chicago: Ivan R. Dee, 1966) and in Carl E. Schorske, *Fin-de-Siècle Vienna: Politics and Culture* (New York: Alfred A. Knopf, 1980).

[3] The biographical details are only referred to in this essay when necessary for the understanding of the artist's creative development. An extensive biography can be found at the end of this book.

[4] Albert Elsen, "Drawing and a New Sexual Intimacy: Rodin and Schiele," in Patrick Werkner, ed., *Egon Schiele: Art, Sexuality, and Viennese Modernism* (Palo Alto, California: The Society for the Promotion of Science and Scholarship, 1994), p. 8.

[5] Toulouse-Lautrec's work was exhibited at the Miethke Gallery in 1909 and van Gogh's at the 1909 *Internationale Kunstschau*. Hodler, Munch, and Minne were included in a number of Secessionist exhibitions. The latter was also shown at the Miethke Gallery and the 1909 *Kunstschau*. See Alessandra Comini, *Egon Schiele's Portraits* (Berkeley: University of California Press, 1974), pp. 35–38 and 53.

[6] Minne's work, viewed as that of an "authentic Gothic sculptor," was introduced to Vienna in the 1900 Secessionist exhibition with, among others, his masterpiece the *Fountain of Five Boys* (1898).

[7] For specific details, see biography.

[8] Rudolf Leopold, "'Art Cannot Be Modern; Art is Eternal,'" in Klaus Albrecht Schröder and Harald Szeemann, eds., *Egon Schiele and His Contemporaries* (Munich: Prestel Verlag, 1989), p. 46.

[9] At the first *Kunstschau* in 1908, Austrian and German artists participated with arts and crafts associations in a large-scale exhibition held at a temporary exhibition hall. The 1909 *Kunstschau* was international in scope and introduced Austrian artists to foreign influences.

[10] Danielle Knafo, *Egon Schiele: A Self in Creation* (Cranbury, N.J.: Associated University Presses, 1993), p. 60.

[11] Reportedly, upon their first meeting, Schiele asked, "Do I have talent?" Klimt looked through his portfolio and responded, "Talent? Yes! Much too much!" See Comini, 1974, p. 21.

[12] For details on this phase of Schiele's creative life, see Comini, 1974, pp. 47 and 50.

[13] An interesting discussion of the grimace is found in Klaus Albrecht Schröder, *Egon Schiele: Eros and Passion* (Munich: Prestel Verlag, 1995), pp. 64–66.

[14] In her catalogue raisonné of Schiele's oeuvre, Jane Kallir describes in great detail his use of the aqueous medium. See Jane Kallir, *Egon Schiele: The Complete Works* (New York: Harry N. Abrams, 1990), pp. 291 and 391.

[15] These models included Schiele's friends, Max Oppenheimer, Erwin van Osen, and Karl Zakovsek. See Kallir, p. 391.

[16] Kallir, p. 129 (citing Alessandra Comini, *Schiele in Prison* [Greenwich, Conn.: New York Graphic Society, 1973], p. 59), reprints the following entry from Schiele's prison diary: "Have adults forgotten how corrupted, that is, incited and aroused by the sex impulse, they themselves were as children? Have they forgotten how the frightful passion burned and tortured them while they were still children? I have not forgotten, for I suffered terribly under it." A slightly different translation appears in Comini, 1974, p. 14.

[17] Knafo mentions the coexistence of "innocence and lasciviousness" in Schiele's drawings of children and links it to Freud's theories of infantile sexuality, which were considered scandalous by his contemporaries, just as Schiele's art would be judged immoral in 1912. See Knafo, p. 105; also Kallir, p. 129.

[18] Any young girl aged fourteen and over was "eligible" for sex, according to the Austrian law of the period. See Werkner, "The Child-Woman and Hysteria," in Werkner, ed., *Egon Schiele: Art, Sexuality, and Viennese Modernism*, p. 67.

[19] Werkner, pp. 60–69, discusses Loos's theory equating ornament with feminine sensuality (and denouncing both). Loos, a major patron of Kokoschka, in whose work the adolescent model also frequently appeared, married a succession of younger women; even his unadorned architecture was seen by some critics as analogous to his preference for the physical type of the child-woman. Werkner associates this widespread trend in Viennese artistic circles with a basic fear of women. He cites the poet Peter Altenberg, the satirist Karl Kraus, and the

psychoanalyst Fritz Wittels as examples of those among Loos's acquaintances who shared the same views. Peter Haiko also examines Loos's double distaste for ornament and mature female sexuality, the latter seen as affiliated with the forces of nature and irrationality and thus beyond the control of man ("The 'Obscene' in Viennese Architecture," in Werkner, ed., *Egon Schiele: Art, Sexuality, and Viennese Modernism*, pp. 90–95).

20 "Proper" women were not supposed to enjoy sex, resulting in men's frequent visits to prostitutes and the common occurrence of contracting venereal diseases (witness the syphilis-related death of Schiele's father). For extensive discussion of this subject, see Janik and Toulmin, chap. 3, pp. 70–80.

21 Schröder, 1995, pp. 64–66, extensively discusses Lavater's and Bleuler's publications and their aesthetic appeal for Schiele. He also mentions other publications on the subject of hysteria; see pp. 83–86.

22 La Salpêtrière, a mental institution in Paris, still exists today.

23 Werkner, p. 72.

24 For a detailed discussion of these issues, see Werkner, pp. 71–72.

25 This technique is described in detail by Kallir p. 433.

26 Comini, 1974, p. 43.

27 Werkner, p. 73.

28 Knafo, p. 71.

29 Knafo, pp. 81–82, also interprets the frontality of these self-portraits as a means of overcoming crisis and finding the self through direct confrontation.

30 Knafo, pp. 87–91, discusses the many interpretations, for Schiele, of the double self-image: as the forging of a separate identity from his father; as a narcissistic image of self-love with homoerotic overtones; as the creation of a second self to counteract feelings of loneliness and loss of self; and, ultimately, as a means of establishing his immortality.

31 Comini, 1974, p. 97.

32 For example, in northern Germany around the turn of the century, a small artists' colony called Worpswede was founded by Fritz Mackensen with the aim of expressing emotion through simplified, coloristic images of nature. Among these so-called nature lyricists, the best known is Paula Modersohn-Becker. Emil Nolde, another highly individualistic descendant of the German Romanticists, was briefly affiliated with the artistic settlement in Dachau similarly devoted to communion between the self and the surrounding landscape. About a decade earlier, in 1886 and 1888, in France, Gauguin had traveled to Pont-Aven, an already established artistic colony, seeking to immerse himself in the peasant community and the natural environment. Modersohn-Becker's decorative, emotionally evocative landscapes find inspiration in the brilliant color and symbolism of Gauguin's paintings of these years.

33 Elsen, pp. 13–14.

34 Comini, 1974, pp. 156–57.

35 Kallir p. 308. Schiele was initially charged with kidnapping, rape, and immorality. Kallir, pp. 127–40, enumerates the events leading up to imprisonment and the court proceedings. She also discusses Schiele's prison diary and the watercolors and drawings he executed while in prison. Schiele's arrest was precipitated by an adolescent girl, who apparently ran away from home and sought refuge in his studio. After a few days, with Wally ever-present, the girl was taken home by her father. Eventually, the charges were dismissed, except for that of corrupting minors, which was based on drawings displayed on the walls of his studio, one of which was considered to be too explicitly erotic. This drawing, confiscated by the police, was burned by the judge during Schiele's trial.

36 Comini, 1974, p. 106.

37 Kallir, p. 520.

38 In a November 21, 1966, letter to Comini, which the latter kindly shared with this author, Beer described this dress and her sittings for Schiele and Klimt.

39 For biographical details, consult the biography.

40 Comini, 1974, pp. 135–36, provides a lively account of Schiele's courtship of the Harms' sisters.

41 Another, more complete, version of this painting is in the Österreichische Galerie in Vienna.

42 Kallir, p. 546, bases this assumption on Schiele's mid-June entry into the army.

43 Alternate titles for this work include *The Blind II, Saint, Soaring,* and *The Blind Man* (see Rudolf Leopold, *Egon Schiele: Paintings, Watercolours, Drawings* [London: Phaidon, 1973], cat. no. 265 and pl. 185).

44 Comini, 1974, pp. 171 and 245 note 53, cites personal interviews with the artist's sisters, sister-in-law, and Erich Lederer, who imparted this information to her.

Introduction

Rudolf Leopold

For my wife, Elisabeth

TANNENWALD.

JCH KEHRE EIN IN DEN ROTSCHWARZEN
DOM DES DICHTEN TANNENWALDES/
DER OHNE LARMEN LEBT VND
MIMISCH SICH ANSCHAVT,
DIE AVGENSTAMME DIE DICHT
SICH GREIFEN VND DIE SICHTBARE
NASSE LVFT AVSATMEN. ——
WIE WOHL ! —— ALLES IST
LEBEND TOT.

Prose poem by Schiele
from 1910

In addition to his work as an artist, the young Schiele also produced a considerable number of poems. In most instances he then transformed these writings into visual art, carefully lettered graphic statements like the two reproduced here.[1] The closing words of his "Fir Forest" ("Tannenwald")–"Everything is dead in life" ("Alles ist lebend tot")–have a deeply felt resonance, given his subsequent career. To him death was a constant presence, part of being alive–like Eros. Schiele also wrote at this time of his "passion to experience all there is." And unquestionably he did experience–and *create*–with passion.

In the poem "A Self-Portrait" ("Ein Selbstbild"), conventional syntax has been almost wholly abandoned; the words and phrases are like molten fragments thrust up into consciousness under great pressure from below. Schiele was as much an Expressionist in his writing as in his art.[2]

In his work from 1910 Schiele managed to break free of the prevailing Viennese style and invent his own Expressionism–a term first applied to art only in 1911. But, in fact, Schiele explored such a wide variety of styles that he cannot properly be identified with any particular movement or school. In his remarks at the opening of the Schiele exhibition at the Albertina in 1990, Konrad Oberhuber rightly noted that it is no exaggeration to say that Schiele occupied a place as unique in the art of his time as that of Michelangelo in the Renaissance.

In his earliest years, especially, Schiele suffered from a lack of understanding of his art in Vienna, but even then he was fully aware of his own importance. In September 1911, he wrote to Dr. Oskar Reichel: "I have it in me to record … to want to explore, to invent, to discover, with all the means at my disposal, which already threaten to ignite and consume themselves … and to shed light on the darkest eternities of our little world … So I am constantly creating more, seemingly endless new works out of myself … I am so rich that I must give myself away." At the beginning of the year, Schiele had sent this same Viennese collector a

picture "from my very newest series"–either *Deliriums*
(L 170) or *Prophets* (L 171)–one that then continued
with the *Poet* (pl. 45), the *Self-Seer II* (pl. 46), the
Wall and House in a Hilly Landscape with Fence
(pl. 49), and *Vision and Fate* (L 175). In his letter
accompanying the painting, he wrote: "In time you
will find it absolutely convincing, once you begin to
look not simply at it but into it. This is the picture
about which G. Klimt remarked that he would be
happy to have such visions. It is *definitely,* just now,
the finest work painted in Vienna."

From our own vantage point it is clear that Schiele
was altogether correct in his high opinion of himself.
There are only a few works by Klimt from this time
that can compare with his. In terms of genuine
artistry–and that includes the conquest of new
territory–his only serious competitors among the
Viennese painters of the day were Klimt and Kokoschka,
and at that time Kokoschka was living in Berlin.

Both Kokoschka and Schiele saw Gustav Klimt as
the most important stylistic force in Viennese painting
at the time. Yet it was not so much Klimt the painter
as Klimt the champion of the new who encouraged
them to find their own artistic style. It is important to
note that later even Klimt found inspiration in Schiele.
The pose of Schiele's 1909 *Danae* (L 130) appears to have influenced his
Leda (Dobai 202) from 1916/17. In addition, Schiele's extremely sensitive
Autumn Tree in a Gust of Wind (pl. 80), from 1912, obviously had an effect
on Klimt's *Landscape with Apple Tree II* (Dobai 195), painted four years
later. The monk-like bridegroom in Klimt's unfinished painting *The Bride*
(Dobai 222), from 1917/18, is essentially the figure of the dying monk,
reversed, from Schiele's *Agony* (L 218), from 1912. One has only to look at
the combination of the one shoulder hunched, the other one dropped, and
the angled head. Schiele had exploited such elements in his compositions
from the beginning.

With this brief excursus on Klimt's indebtedness to Schiele, I certainly
do not mean to detract from Schiele's far greater indebtedness to the

Prose poem by Schiele from 1910

older painter. In his search for his own style Schiele borrowed from both Klimt and Kokoschka, the former from the previous generation, the latter a mere four years older. Both of the younger artists were inspired by the clean contours of Klimt's *Beethoven Frieze*. Kokoschka was also fascinated by Mycenaean art, and in some instances incorporated direct borrowings from it in his work (see text for pl. 15). It must also be noted that Kokoschka borrowed from Schiele; his nude studies of a Savoyard boy from 1912 have the decisive outlines typical of Schiele's nudes from 1910, and his *Self-Portrait with Brush* (Winkler/Erling 112) and the preliminary drawing for it–both from 1914–in which the head is shown in half profile with the eyes looking in the opposite direction, are obviously patterned after some of Schiele's compositions, notably his 1912 painting *Self-Portrait with Chinese Lanterns* (pl. 77). All in all, however, reciprocal borrowings between the two most important Austrian Expressionists were neither frequent nor of particular significance.

Like every great artist, Schiele was rooted in a definite tradition. He never denied his indebtedness to Viennese Secessionism in general or Klimt in particular, despite his commitment to "New Art." He nevertheless transformed everything he received from that tradition into something uniquely his own. Its importance in his early development seems insignificant compared to the contributions he himself made to the art of his time.

Like Klimt, he had a gift for creating compositions of such formal perfection that one cannot imagine them otherwise. But unlike the older painter, whose approach was primarily decorative, Schiele's works reveal a greater concern for structure. The differences between the two artists are apparent in other aspects as well. Whereas Klimt sought to create excitement in his images by combining unlike elements, juxtaposing abstract and ornamental "painted mosaics," for example, with highly realistic portraits, Schiele achieved it with his carefully calculated arrangements alone. The intellectual content in Klimt's figural compositions is presented in greatly embellished ceremonial allegories and symbols, few of which strike us today as convincing and meaningful. Klimt's obstinate nature and love of sensual excess were simply inadequate for the representation of anything more profound or tragic. This is perfectly apparent if one compares his *Mother and Children* (also called *The Emigrants;* Dobai 163), painted in 1909/10, with Schiele's *Dead*

Mother I (pl. 41), also from 1910. Schiele was more successful at plumbing such depths because he identified with his subject matter.

Unprettified depictions of the darker side of human existence were naturally foreign to the highly decorative *Jugendstil*, certainly to its Viennese variant. The Expressionists Kokoschka and Schiele were the first to incorporate the tragic and ugly into their work as a way of evoking stronger emotions; one might even say that they invented the use of ugliness as an element of pictorial composition and introduced its potential to the art of our century. The images they created in their determination to express the depths of experience are as compelling and valid today as they were then. The current widespread interest in the two artists and frequently lavish praise accorded them are proof that our present-day tastes in art are in agreement with those of the Expressionist avant-garde of the early part of the century.

Only after careful study of his entire œuvre and stylistic analysis of all of its essential details can one determine Schiele's place in the art of his time. In numerous ways he is very different from other Expressionists, such as those of the group known as *Die Brücke*. To appreciate his individuality and achievement it is necessary to see them in the light of Viennese painting and its chief representatives. He is radically different from the young Kokoschka, for example; his approach clearly emphasized structure, whereas Kokoschka's was more improvisational, more painterly. Kokoschka concentrated mainly on the portrait, whereas Schiele created any number of expressive landscapes whose artistic quality is in no way inferior to that of his figural compositions. Kokoschka was to develop in his painting an almost Baroque flamboyance; in the depths of his being, Schiele, a dreamer and a realist, remained more attuned to the Gothic.

There are a number of features common to both, of course, and these are what set Viennese Expressionism apart from similar movements elsewhere. In his early years, his most crucial period in this regard, Schiele, like Kokoschka, preferred unusual subjects, and he painted them in somber, subtly nuanced tones that have little to do with the often deliberately garish colors of the German Expressionists. The Expressionism of the two Viennese painters–and of those who followed in their footsteps–favored psychological penetration. Their revealing portraits and moody landscapes reflect an intuitive, questioning dialogue

with their chosen subject matter. The early Expressionists in Germany, by contrast, tended to favor violence and provocation, presenting them in highly exaggerated colors and crude contours. (The large patches of color in the earliest works of the painters of *Die Brücke* clearly reveal the influence of French Fauvism.)

Unlike the artists of *Die Brücke,* Kokoschka and Schiele based their work on an art style whose leading masters were Gustav Klimt, Ferdinand Hodler, and Edvard Munch. (In his draftsmanship, Schiele was also influenced in many respects by Toulouse-Lautrec.) The two were indebted to Klimt and Hodler in questions of form, but in their subject matter they borrowed from Munch. Schiele cannot but have been intrigued by the novel way in which Munch interpreted human drives without obtrusive symbolism, by his predeliction for the dark side of life, his recurring images of loneliness, sorrow, despair, and death. His own depictions of such subjects are nevertheless quite unlike those of the Norwegian master. That he belonged to a different generation is already apparent in his unique concept of the erotic. In Schiele there is nothing reminiscent of Munch's themes of the "battle of the sexes" or the menace of his "demon woman."

The two artists were very different psychologically, of course, but they also lived in very different worlds. Turn-of-the-century Vienna was by no means the society that was portrayed by Ibsen and Strindberg and that shaped Munch's thinking and emotional life to the end. The decadence that was Vienna in the years around 1900 and afterward was excitable and impulsive, sex-driven and obsessed with death. It gave us Hugo von Hofmannsthal and Arthur Schnitzler, Otto Weininger and Sigmund Freud. In this Vienna at the turn of the century, life was not simply a matter of flamboyant fashions and superficial pleasures. Despite all the aestheticism and tolerance–the latter considered a Viennese specialty–there was a yearning for fundamentals, for essential correlations, for a certain something hidden beneath the pretty surfaces and behind the imposing facades. The pompous self-confidence of the late nineteenth century in Vienna is overshadowed in art and in literature by the thought of its impending end. This is true in the work of Anton Romako, for example, which was later to be of importance for the young Kokoschka. Its dissolution into tragicomic meaninglessness, into an orgy of sinister decay and grotesque absurdity, is the subject of Alfred Kubin's 1907 novel *The Other Side*, or of the *Tubutsch* story by Albert Ehrenstein, which

Kokoschka would illustrate four years later. Life appeared to be a "sickness unto death." Revelation in the midst of decay and the fascination of the process of dying were subjects that occupied Georg Trakl all his life; a study of the parallels between his poetry and the art of Schiele would be well worthwhile.

Very early in the work of the young Schiele, one comes to expect his rigorous rejection of the non-committal and superficial. Instead, one sees him struggling to express the deepest human emotions. His paintings speak of the torment of the loner, the distress of the seeker beset by visions, the pain and despair of the sick, and the sorrow of the hopeless. Schiele manages to elevate subjective emotion to the level of universal truth. For him autumn functions as a symbol of all that is fleeting in human existence. Even inanimate nature is filled with spirit. In his figural compositions, his landscapes with trees or houses, and even his cityscapes, the actual forms are replaced by his own highly idiosyncratic perceptions of them; his moods and feelings are transformed into visionary symbols of human experience that speak directly to the receptive viewer. Schiele managed to invest even the most ordinary objects with new meaning. Expressionism was more concerned with actual human experience than any other artistic trend in our century–and of its proponents virtually no one was so obsessively focused on it as the young Schiele. For that reason he devoted as much attention to his own feelings as he did to his mission as an artist. He turned his own suffering into images of men with a calling, men who see what others do not, who create what others cannot.

Schiele was an Expressionist, but it is a mistake to let oneself get caught up in the confessional, animistic, visionary, and ecstatic aspects of his work and in so doing to lose sight of his extreme preoccupation with form. It is also a mistake–one committed often enough–to dismiss Schiele's formal solutions as somehow merely decorative. To be sure, his very earliest works reflect *Jugendstil* preoccupation with superficial effects, but he soon succeeded in completely subordinating that interest to his own purposes. He did not cut himself off from his origins in *jugendstil* as thoughtlessly as did others who arrived at Expressionism by way of similar paths. It is precisely his seamless transformation of *Jugendstil*–specifically its Viennese version–into Expressionism that makes Schiele so important in art history.

Otto Benesch, who learned to appreciate the artist's work at his father's knee, called Schiele one of the "most gifted draftsmen of all time." And he was right: the first medium Schiele perfected, and the one in which he first demonstrated his artistry, even mastery, was a line distinctively his own. At the same time he developed an astonishing ability to emphasize with line what was important and ignore what was not. Few have managed to communicate so vividly not only forms but emotions with line alone–often only with outlines–as did Schiele. His superb draftsmanship alone sets him apart from other Expressionists. None of them commanded such subtlety of line: from incisive to caressing, from tensile to delicate, demure, nervous, scribbled, extended, interrupted, or suddenly veering off in a new direction. His repertoire was so comprehensive that he might have done without color altogether and no one would have missed it.

Nevertheless, Schiele was also an important colorist, a painter who by no means simply filled in the spaces between his lines and exploited colors for their ability to evoke emotional responses. Their latter function was essential to him, to be sure, but it is also important to notice how Schiele used color to help give structure to his compositions. In his paintings and watercolors the drawing usually functions as a sensitive framework into which colors are introduced in such a way as to be of equal importance. It is the combination of the two that communicates such varied human emotions and states of mind. A brief ten years elapsed between Schiele's first public appearance, when he took part in an exhibition of local artists in the monastery at Klosterneuburg, and his triumph in the spring exhibition of the Viennese Secession in 1918, six months before his death–time enough for him to prove himself a pathbreaking master of Expressionism, and not only the Viennese permutation of that movement.

But those who interpret Schiele solely in terms of his importance for Expressionism–great as it is–fail to appreciate other features of this highly complex artist. In 1916, earlier than many of the other Expressionist pioneers, Schiele turned away from the programmatic concerns of that movement and adopted a new, much more realistic style, but one often suffused with mannerism. Early in 1918, however, he began to develop yet another approach in his paintings, one at first having more to do with form–in *Family* (L 289) and *Two Crouching Women* (pl. 147)–and only

later with painting itself–*Three Standing Women* (pl. 149) and *Lovers III* (L 299). These compositions have virtually nothing to do with Expressionism. Their figures are more three-dimensional, and presented in a more painterly manner.

Five years after Picasso and Braque's pioneering invention, Schiele introduced geometry into his work and began to think "cubistically," and even then his Cubism was very different from theirs. But with this new concern for the depiction of three-dimensional volumes in space he was years ahead of Picasso–even though his early death prevented him from completing a number of the paintings that prove it.

These references to his later development are not meant to detract from Schiele's stature as an Expressionist. On the contrary, I am convinced that, with the exception of this new breakthrough in his painting on the eve of his death, his greatest work was produced in the years between 1910 and 1915. Even then he resisted committing himself to a specific approach and thereby limiting his options. He was mercurial; one sees him deciding on one style one day and on another one the next, and this is what makes the study of his artistic development so fascinating. His art is anything but predictable; it is organic, open to all possibilities. His commitment was not to any particular group but to art itself. Hence the inscription on one of his watercolors: "Art cannot be modern; art is eternal."

[1] In the sixth line of "Ein Selbstbild" (see p. 33), Schiele mistakenly wrote "Wegen" instead of "Wägen," but the "Gäbe" instead of "Gebe" in the eleventh line was apparently intentional, designed to link it syntactically to the following word, "Dämone." It is interesting that in both words, as everywhere else in this poem and in the 'Tannenwald" (see p. 32), Schiele placed the umlaut between the legs of the "A" rather than above it, apparently because he felt that this made for greater graphic interest.

[2] Otto Breicha is probably correct in his insistence that with these poems Schiele, doubly gifted like Kokoschka, Gütersloh, and Kubin, anticipated Expressionist writing in Austria (see *Finale und Auftakt*, written with Gerhard Fritsch, Salzburg, 1964).

Plates and Catalogue

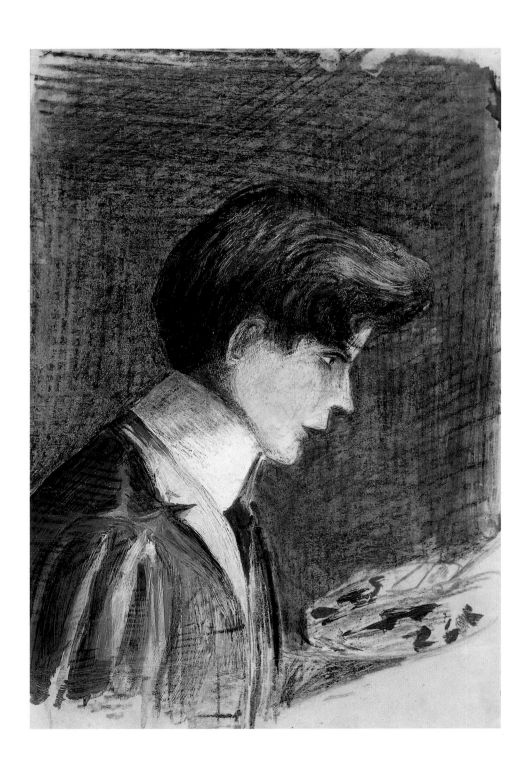

1 *Self-Portrait with Palette*
 (Selbstbildnis mit Palette)
 1905

This is one of the artist's earliest self-portraits. The young Schiele presented it to his school chum Eduard Weber on December 22, 1905, along with a verse he wrote into his friend's album.

Although there is still much of the schoolboy in this work, it also reveals the first signs of Schiele's inborn talent for composition. How many other fifteen-year-olds would have left the space below the palette empty, separating it with a heavy—that is to say deliberate—diagonal line from the painted area above? With this line the young Schiele produced an interesting variation on another diagonal that leads from the shoulder across the collar.

In addition to its formal interest, the self-portrait already displays a lively and highly individual sense of color.

Gouache, pencil, and black crayon on cardboard, 9 3/4 x 6 1/2" (24.9 x 16.4 cm)
Signed on the back: "Egon Schiele"
Leopold Museum Inv. 470

Provenance:
Eduard Weber, Tulln;
Rudolf Leopold, Vienna.

Literature:
Malafarina 1982, no. D1, not illus.;
L 1; K 1.

Exhibitions:
Tokyo 1986; Zurich 1988; Tokyo 1991; Tübingen 1995.

NOTES TO THE CATALOGUE

German titles appear in parentheses following the English titles. Those in quotation marks are Schiele's own.

The letters "K" and "L," followed by numbers, refer, respectively, to the catalogue raisonné by Jane Kallir, *Egon Schiele: The Complete Works,* and to Rudolf Leopold, *Egon Schiele: Gemälde, Aquarelle, Zeichnungen,* both of which are listed in full in the Bibliography.

Dobai, cited in relation to works by Klimt, refers to the publication by Fritz Novotny and Johannes Dobai, *Gustav Klimt, with a Catalogue Raisonné of His Paintings,* New York, 1968.

2 *Portrait of a Young Girl*
 (Mädchenbildnis)
 1906

Black crayon and charcoal
on paper, 15 1/2 x 11 7/8"
(39.4 x 30 cm)
Signed and dated center right:
"Schiele 06"
Leopold Museum Inv. 1465

Provenance:
Melanie Schuster, Vienna;
Rudolf Leopold, Vienna.

Literature:
K 11.

Exhibitions:
Tokyo 1991; Tübingen 1995.

Family tradition has it that this is the portrait of a Bohemian servant girl.
 The rendering of the head, especially, demonstrates how successful
Schiele had become at academic drawing.

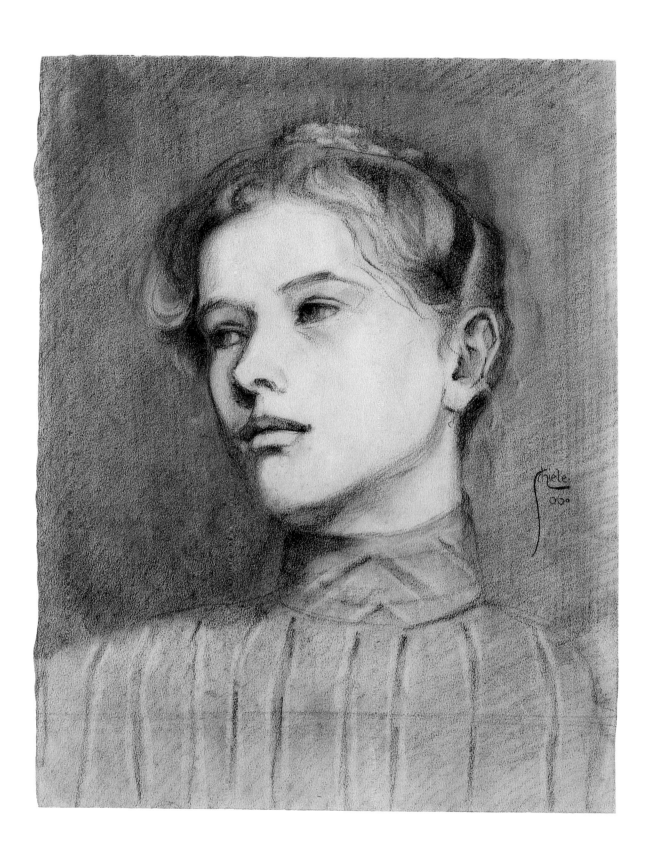

3 *Portrait of Marie Schiele with Fur Collar*
(Bildnis Marie Schiele mit Pelzkragen)
1907

Pencil, watercolor,
and gouache on paper,
12 5/8 x 8 3/4″ (32 x 22.3 cm)
Signed and dated upper left:
"Schiele. Egon. 07."
Leopold Museum Inv. 2309

Provenance:
Melanie Schuster, Vienna;
Norbert Gradisch, Vienna;
Norbert Gradisch, Jr., Vienna;
Sotheby's, London (auction), 1988;
Rudolf Leopold, Vienna.

Literature:
Nebehay 1979, fig. 8; Malafarina
1982, no. D7; L 28; K 10.

Exhibitions:
London 1975; Innsbruck 1977;
Vienna 1979; Tulln 1980;
Kirchheim unter Teck 1982;
Edinburgh 1983; Tokyo 1991;
Tübingen 1995.

In this very finished work it is obvious that the seventeen-year-old artist has learned from the Vienna Secessionists. When presenting a figure from the side they always favored a strict profile view. Yet the young Schiele tried to soften the profile somewhat and add life to this portrait of his mother by showing both ends of the fur collar of the jacket, developing a sense of depth in the area of the upper lip, the forehead, and the eyebrows, and having his subject look to the side.

The placement of this portrait on the page is already masterful.

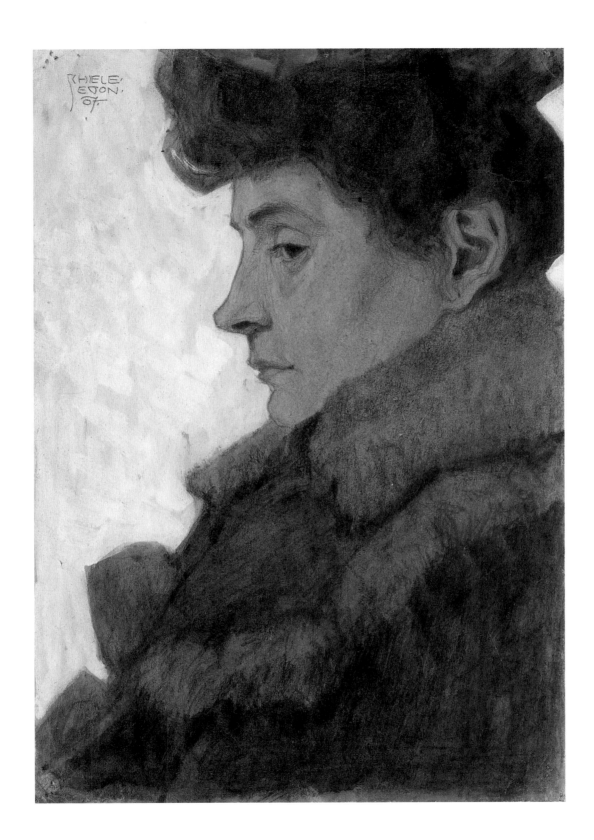

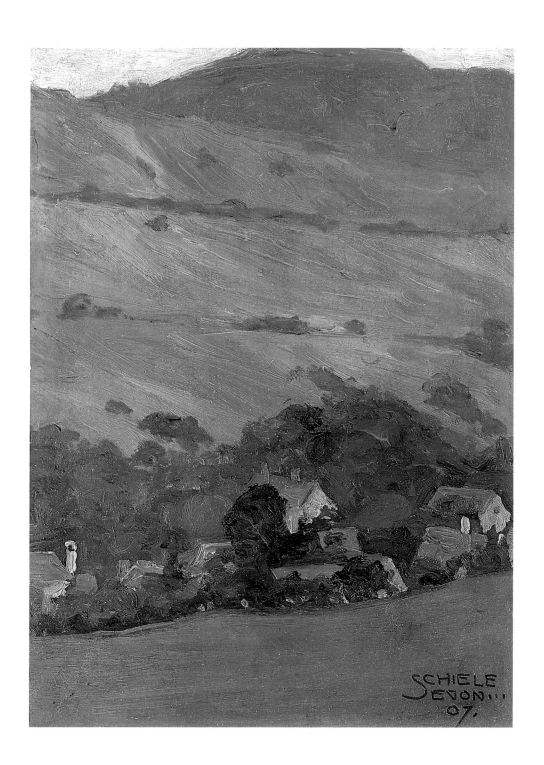

4 *Houses at the Foot of a Hill*
 (Häuser vor Bergabhang)
 1907

This view across a meadow shows houses and autumnal trees in a
hollow, with sloping fields and meadows behind and a mountain at the
very top.

For all its seeming naturalism, Schiele's subject has been composed
with great care. One notes how the angle of the gently undulating
boundary at the bottom of the foreground meadow opposes that of the
two shrub-lined paths on the opposite slope. That rise seems to be an
appropriate distance away, but it also appears to lift vertically, as though it
were a separate plane, while the mountain above has been cut
off by the top edge of the picture. Both of these features are wholly
consistent with the compositional style of the Secessionists.

Oil on cardboard mounted
on wood, 10 3/8 x 7 7/8"
(26.5 x 20 cm)
Signed and dated lower right:
"EGON SCHIELE ... 07."
Leopold Museum Inv. 471

Provenance:
Neue Galerie, Vienna;
Serge S. Sabarsky, New York;
Rudolf Leopold, Vienna.

Literature:
Malafarina 1982, no. 52; L 60;
K 65.

Exhibitions:
Tokyo 1986; Charleroi 1987; Zurich
1988; Tokyo 1991; Tübingen 1995;
Tokyo 1997.

5 *Swampy Woods in Autumn*
 (Herbstlicher Auwald)
 1907

Oil and pencil on cardboard,
9 7/8 x 7" (25 x 17.8 cm)
Signed and dated lower right:
"Schiele 07."
Leopold Museum Inv. 472

Provenance:
Estate of Egon Schiele, Vienna;
Melanie Schuster, Vienna;
Rudolf Leopold, Vienna.

Literature:
Malafarina 1982, no. 66, not illus.;
L 74; K 86.

Exhibitions:
Tokyo 1991; Tübingen 1995.

A breath of autumnal melancholy pervades this study from nature. Although some of its colors were inspired by *Jugendstil,* their overall harmony is highly individual. The consistent light-colored background adds life to the picture, providing relief from the somewhat somber tonality.

In his oil paintings from the summer of 1907, Schiele could not resist using a pencil, a somewhat dilettantish technique, and for that reason they are problematic. Yet, in this painting the two mediums are combined in a highly original way. The pencil drawing is essentially graphic; at the same time, however, one cannot fail to note the *chiaroscuro* that results from the combination of lighter colors and pencil strokes, an altogether painterly effect. Moreover, Schiele's pencil work is energetic but still rather cautious as he exploits the soft graphite for the purpose of shading. He executed the preliminary drawing in pencil, then painted, and finally drew again in the wet pigment.

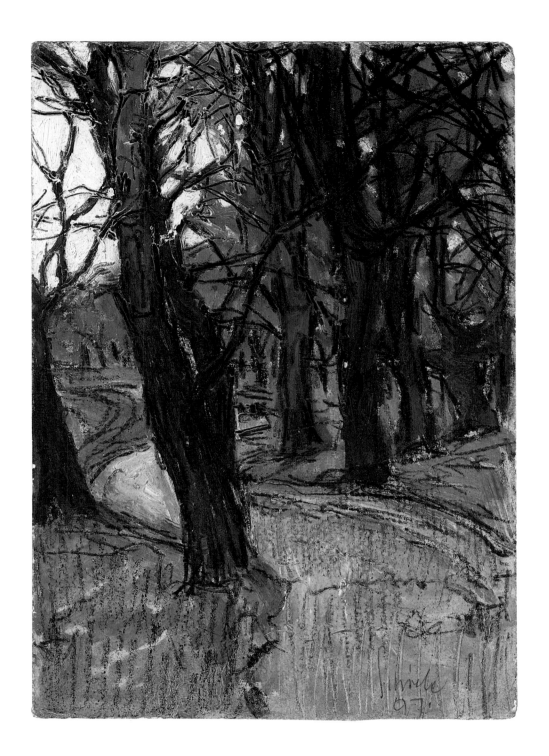

6 *Bare Trees, Houses, and a Shrine (Klosterneuburg)*
 (Kahle Bäume, Häuser und Bildstock [Klosterneuburg])
 1908

Oil and pencil on cardboard,
6 1/8 x 10 1/8" (15.5 x 25.5 cm)
Not signed, not dated
Leopold Museum Inv. 473

Provenance:
Marie Schiele, Vienna;
Alfred Sachs, Vienna;
Elfriede Flögel, Sauerbrunn
(Burgenland);
Rudolf Leopold, Vienna.

Literature:
Malafarina 1982, no. 67; L 75;
K 87.

Exhibitions:
Munich 1975; Tokyo 1986;
Charleroi 1987; Zurich 1988; Tokyo
1991; Tübingen 1995; Tokyo 1997.

Schiele was seventeen at the time he created this painting. I found it especially interesting to search for the subject that had inspired his composition. Unfortunately, it was not easy to find, for none of these Klosterneuburg houses are still standing. There is only a wayside shrine with an iron hand protruding from the top section, and Schiele did not even include the hand in his painting. Luckily, a photograph of a painting from about 1910 by Franz Horst (1862–1950) enabled me to identify the spot where Schiele stood.

Horst's painting presents a more conventional view, with the shrine roughly in the center of the picture. Schiele, by contrast, placed it on the far right, and moved it up so close to the viewer that it is cut off by the top and bottom edges. And, unlike Horst, Schiele omitted the iron hand, as it would have had no meaning in his picture. In this, as in every other way, Schiele appears to have forced his own sense of composition on the reality before him.

With the unusual twilight colors of this cluster of houses, the contrasting light sky, and the vehement strokes of dark graphite in the still-wet pigment, the young Schiele managed to evoke a distinct mood.

7 Houses on the Courthouse Square in Klosterneuburg
(Häuser des Klosterneuburger Rathausplatzes)
1908

Oil on cardboard, 7 3/8 x 8 5/8"
(18.6 x 22 cm)
Not signed, not dated
Leopold Museum Inv. 4140

Provenance:
Leopold Popper, Vienna;
Dorotheum, Vienna (auction), 1955;
Adolph D. Klarmann, Philadelphia;
Dorotheum, Vienna (auction), 1973;
Christie's, London (auction), 1978;
Dorotheum, Vienna (auction), 1984;
Rudolf Leopold, Vienna.

Literature:
Malafarina 1982, no. 102; L 101;
K 127.

Exhibition:
Tübingen 1995.

These buildings, unlike those in the previous picture, can still be identified, even though some of their facades have been altered and the painter simplified them considerably. In the previous composition of houses and a wayside shrine, Schiele first sketched the essential elements in pencil, but here he was content to define them with a wide brush.

The colors echo those of the Vienna Secessionists at this time even more obviously than the ones in the painting shown in plate 6. Schiele left glimpses of the orange underpainting in various areas to make the colors more interesting and add life to the overall effect. Typical of the Secessionists is the contrast created between the green of the chestnut tree, rendered in a few simple strokes, and the light pinkish-blue sky.

8 *Nude Boy Lying on a Patterned Coverlet*
(Nackter Knabe, auf gemusterter Decke liegend)
1908

Gold metallic paint, gouache,
pencil, and ink on paper,
9 3/8 x 12 3/8" (23.8 x 31.5 cm)
Signed and dated upper right:
"Schiele Egon 08" (also with the
monogram "S" above and to the
left of the signature, and to the
right of it the still-visible
letters "SCH")
Leopold Museum Inv. 1466

Provenance:
Rudolf Staechelin, Basel;
Rudolf Leopold, Vienna.

Literature:
Malafarina 1982, no. 118; L 121;
K 106.

Exhibitions:
Vienna 1919; Basel 1956; Lucerne
1974; Tokyo 1991; Tübingen 1995;
Tokyo 1997.

Here Schiele has fully adopted *Jugendstil,* not only its characteristic ornamentation on the fabric but also its fondness for ink and gold-bronze pigment. For the background he used this color unmixed, creating a vivid contrast to the dark coverlet below and the delicate green of the boy's hair.

More important for the development of his own signature style is Schiele's rendering of the body. With the exception of a few faint traces of green, the color of the paper itself was left untouched. It is the outline of the body that becomes important, with a distinct angularity developed at the knees and elbows. By the end of 1908 (see pl. 10), this angular outline style would be fully perfected.

9 *Nude Boy Bending Forward, Seen from the Back*
 (Rückenansicht eines vorgebeugten Jünglingsaktes)
 1908

Schiele softened the symmetry of this composition by varying the position of the arms, by letting the upper body bend slightly to the right, and by adding the almost comical touch of the face with an open eye glimpsed between the arm and the body.

This drawing is a major accomplishment in every way. In it Schiele not only put academic drawing behind him, but he also noticeably distanced himself from Klimt. There is no denying that such drawings are still clearly indebted to Klimt's drawing style in his studies for the *Beethoven Frieze*; Schiele also places extraordinary emphasis on outlines, relying on them to capture the essentials. But Schiele's curving outlines frequently end with an unexpected angularity. They are stronger, often retraced; they do not merely hint at the body forms, as in Klimt, but rather reveal their very structure. In this way Schiele broke through to a style of his own. The extremely spare internal drawing, consisting of but a few lines and some subtle shading, serves to suggest the three-dimensionality of the body but at the same time helps to emphasize its anatomical structure.

Black crayon on paper,
17 5/8 x 11 5/8" (44.6 x 29.7 cm)
Signed and dated lower right:
"Schiele 08"
Leopold Museum Inv. 1414

Provenance:
Carl Mayländer, Vienna;
Etelka Hofmann, Vienna;
Rudolf Leopold, Vienna.

Literature:
Leopold 1972, pl. 14; Wilson 1980, pl. 6; Marchetti 1984, p. 218; K 208.

Exhibitions:
London 1964; Vienna 1984; Venice 1984; Tokyo 1986; Tokyo 1991; Tübingen 1995.

10 *Stylized Flowers in Front of a Decorative Background*
 (Stilisierte Blumen vor dekorativem Hintergrund)
 1908

Oil and silver and gold metallic
paint on canvas, 25 7/8 x 25 7/8"
(65.5 x 65.5 cm)
Signed and dated lower right:
"Schiele. Egon 1908"
Leopold Museum Inv. 474

Provenance:
Dorotheum, Vienna (auction);
Max Morgenstern, Vienna;
Robert Morton, Preston, England;
Rudolf Leopold, Vienna.

Literature
Malafarina 1982, no. 122; L 127;
K 146.

Exhibitions:
Vienna 1928; Zurich 1988; Tokyo
1991; Tobu, Japan, 1994; Tübingen
1995; Tokyo 1997.

In this painting the gold background, unlike the one shown in plate 8, has been patterned. With its alternating brushstrokes, it almost appears to be hammered bronze. The juxtaposition of contrasting shades of gold further enriches the composition.

It would be difficult to imagine a greater contrast to this background than the plant Schiele places in front of it, its leaves in utterly unnatural shades of violet and its decoratively shaped blossoms a yellow-orange. What is most striking, however, is the way Schiele structured the outlines of these leaves; in many respects these outline forms, created in late 1908, already anticipate the ones of the great nudes on canvas that he would execute in 1910.

11 *Seated Black-Haired Man*
 (Sitzender schwarzhaariger Mann)
 1909

This work is a beautiful example of the fluid, secure drawing of the nineteen-year-old Schiele, in a style wholly divorced from academicism. One marvels not only at the outline of the body but also at the form of the hand resting on the right shoulder.

Schiele deliberately painted the flesh tones an almost uniform reddish-brown, contrasting it with the solid black of the head, rendered in ink.

Watercolor, ink, and pencil on paper, 12 3/8 x 12 3/8" (31.4 x 31.5 cm)
Signed and dated lower right: "SCHIELE EGON 09."
Leopold Museum Inv. 1385

Provenance:
Karl Hayd, Linz;
Rudolf Leopold, Vienna.

Literature:
Hertlein 1967, p. 37; K 326.

Exhibitions:
Tokyo 1991; Tübingen 1995.

12 *Young Girl Sitting in a Flowery Meadow*
 (Auf einer Blumenwiese hockendes Mädchen)
 1910

Watercolor and ink on paper,
11 x 7 1/4″ (28 x 18.4 cm)
Initialed and dated upper right:
"S.10."
Leopold Museum Inv. 1463

Provenance:
Jan Wahl; Gertrude Stein Gallery,
New York; Gertrude Fogler;
Sotheby Parke Bernet, New York
(auction), 1978; Rudolf Leopold,
Vienna.

Literature:
Leopold 1972, p. 82; K 721.

Exhibitions:
Tokyo 1991; Tübingen 1995.

Kokoschka's *Pietà,* a color lithograph used as the poster for the summer theater of the *Internationale Kunstschau* in Vienna in 1909 (see illustration below), greatly influenced this work by Schiele, who was four years younger than Kokoschka. In contrast to the almost amorphous figure of the dead Christ in Kokoschka's lithograph, however, the pose of Schiele's figure, the arrangement of the girl's head, arms, and body, already anticipate Schiele's own sense of anatomical structure.

Schiele wrote the word "March" on the back of his picture. According to Otto Benesch, the work may have been a design for spring in a proposed cycle of the seasons.

Oskar Kokoschka. Poster for the summer theater of the *Internationale Kunstschau,* Vienna, 1909

13 *Self-Portrait Modeling the Fashion Design for a White Suit (Selbstbildnis im weissen Modeanzug)*
1910

Gouache, watercolor, and pencil on paper, 17 7/8 x 12 3/8"
(45.3 x 31.3 cm)
Not signed, not dated
Leopold Museum Inv. 1462

Provenance:
Carl Mayländer, Vienna;
Etelka Hofmann, Vienna;
Rudolf Leopold, Vienna.

Literature:
Leopold 1972, p. 496f.; K 728.

Exhibitions:
Vienna, Albertina 1948; Tokyo
1991; Tübingen 1995.

A number of sketches and a total of seven finished fashion drawings are known. In three instances, this one among them, it is certain that Schiele served as his own model.

The designs were intended for the Wiener Werkstätte, but the famous crafts studio did not use them, as it found fashions for women more marketable. Nevertheless, Schiele had several of the suits made for himself. In addition to their utility as designs, these drawings were fully realized works of art with carefully considered proportions. Note in this example the arrangement of the buttons, the treatment of the lapels and jacket pockets, and the touches of black to contrast with the predominating white. Note also the deliberate use of the same unshaded orange-ocher for the flesh tones of the face and hands.

There is something grotesque about all of these designs, and it was clearly intentional. Otto Benesch considered this one, in which Schiele models a white suit and a panama hat, the most successful of the series.

14 Seated Female Nude with Raised Arms
(Sitzender weiblicher Akt mit erhobenen Armen)
1910

This drawing is a seemingly spontaneous arrangement of head, hands, and body, but with the line of the chin omitted so as not to detract from the diagonals of the forearms. Schiele's talent for omitting the nonessential and emphasizing what was important is already unmistakably apparent in this drawing. The lids of the closed eye are two simple arcs touching in the center, the upper one echoing the curve of the brow. That line is continued, in turn, by the lines at the base of the hand. Everything is in some way related to everything else.

Whereas Schiele's earlier works were intended to be mainly decorative, we now see him focusing on structure. The outlines of the arms and torso clearly reflect this concern more than they do the anatomical realities. Note the continuation of the line of the right breast and the auxiliary line leading to the right elbow. This articulation of the form has nothing to do with the rendering of this particular body; it is strictly a matter of artistic structure.

One cannot help but note similarities with the great nudes on canvas from this same year (L 140, 141, 143, 144, and 145) and the corresponding works on paper.

Black crayon on paper,
16 1/2 x 9 1/2″ (42 x 24.3 cm)
Initialed lower right: "S"
Leopold Museum Inv. 1461

Provenance:
Graphische Sammlung Albertina,
Vienna; Rudolf Leopold, Vienna.

Literature:
Leopold 1972, p. 88f.; L 32; K 514.

Exhibitions:
Tokyo 1991; Tübingen 1995.

15 *Kneeling Male Nude (Self-Portrait)*
(Kniender Männerakt [Selbstdarstellung])
1910

Watercolor, gouache, and black
crayon on paper, 24 3/4 x
17 5/8" (62.7 x 44.5 cm)
Initialed and dated lower left:
"S.10."
Leopold Museum Inv. 1380

Provenance:
Max Wagner, Vienna;
Max Wagner, Jr., Vienna, later
London; Galerie St. Etienne,
New York; Ronald Gilbert,
New York; Ronald Lauder,
New York; Serge S. Sabarsky,
New York; Rudolf Leopold, Vienna.

Literature:
Leopold 1972, pl. 33; Stefano 1992;
K 692.

Exhibitions:
Vienna, Albertina 1948; New York,
Galerie St. Etienne 1965;
Darmstadt 1967; Zurich 1988;
Tokyo 1991; Tübingen 1995.

In his title vignette for *Die träumenden Knaben* (see illustration below),
Kokoschka was "strongly influenced by Mycenaean works of art."[1]
Kokoschka's emaciated figures not only reflect those in the depiction of a
siege on a Mycenaean funnel-shaped silver rhyton, but he also borrowed
the second woman on the tower, complete with the position of her arms,
for the central figure in his composition.

That figure, in turn, was clearly what inspired Schiele to create the
self-portrait reproduced here. However, he made a number of important
changes: the lower part of the kneeling leg is allowed to point to the back,
the gestures and the position of the head have been rethought, and the
rather casual outline of the original has given way to one that is emphatic
and controlled. (The less successful right hand is the only form Schiele
reworked before producing the painted version, L 140.) The compositional
correspondences between the various parts of the body are even more
evident in the painting. In that work it is also obvious that Schiele
succumbed to a degree of formalism.

In the *Seated Male Nude (Self-Portrait)* (pl. 17), the artist would soon
achieve a perfect blending of gesture, structure, and expressiveness.

[1] Jaroslav Leshko, "The Influence of the Mycenaean Discoveries on Modern Art," reprinted in
part in *Mitteilungen der Österreichischen Galerie* 13, no. 57 (1969).

Oskar Kokoschka. Title vignette
for the series of color lithographs
Die träumenden Knaben, 1908

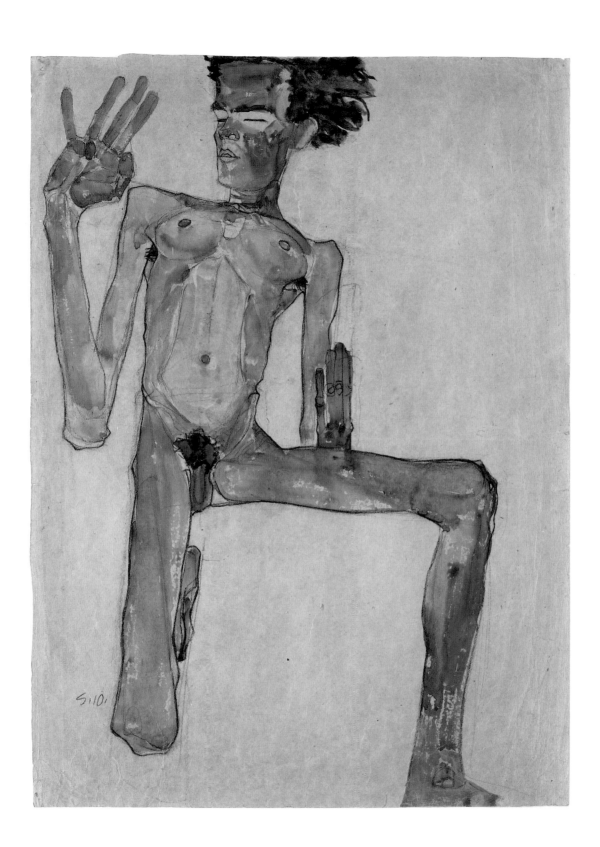

16 Composition with Three Male Nudes
 (Komposition dreier Männerakte)
 1910

Ink and pencil on paper,
7 3/8 x 8 1/8″ (18.7 x 20.5 cm)
Not signed, not dated
Leopold Museum Inv. 1459

Provenance:
Dorotheum, Vienna (auction), 1987;
Rudolf Leopold, Vienna.

Literature:
K 723.

Exhibition:
Tokyo 1991.

This design was doubtless created in connection with the superb *Seated Male Nude (Self-Portrait)* painted on canvas (pl. 17). Schiele not only succeeded in making each of these figures interesting in itself, but he also combined them in such a way as to produce an effective composition.

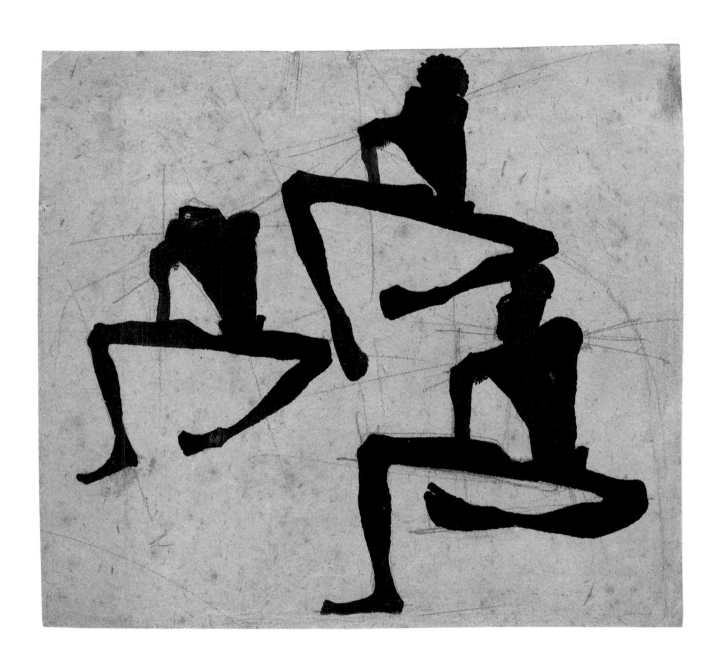

Oil and gouache on canvas,
60 x 59 1/8″ (152.5 x 150 cm)
Not signed, not dated
Leopold Museum Inv. 465

Provenance:
Carl Reininghaus, Graz;
Friedl Aigner, Vienna;
Dorotheum, Vienna (auction), 1954;
Rudolf Leopold, Vienna.

Literature:
Mitsch 1974, p. 6; Comini 1974,
fig. 59; Wilson 1980; Malafarina
1982, no. 147; Werkner 1986;
Berger 1988; Werkner 1994;
L 145; K 172.

Exhibitions:
Vienna, Hagenbund 1932; Vienna
1961; Munich 1964; London 1964;
New York, Guggenheim Museum
1965; London 1971; Bregenz 1971;
Munich 1975; Hamburg 1981;
Edinburgh 1983; Rome 1984;
Vienna 1985; Tokyo 1986;
Charleroi 1987; Zurich 1988; Tokyo
1991; Tübingen 1995; Tokyo 1997.

Of the four great 1910 nudes on canvas–for the male ones Schiele served as his own model–the seated one reproduced here and the standing male version (L 144) were probably the last to be painted. Their angular, pointed outlines are still startling, but are clearly derived from a style he had developed in earlier works such as the *Plum Tree with Fuchsias* (L 138). The projections and hollows in the outline of the nude reproduced here seem to reflect the essential structure of the figure much more logically, creating striking breaks in the dynamic interplay of straight and curving lines. They are not merely ends in themselves, as they would come to be often enough in the years 1917 and 1918; rather, they are abstractions derived from the body's actual contours deliberately employed for their formal effect. The division of the body's surface into sharply defined areas in no way detracts from the overall structure. In many respects the figure has the quality of a woodcut.

The composition is exquisitely balanced. The splayed legs branch off from a columnar torso stretching up at an angle to the right. For balance, the head inclines in the opposite direction. To insure the integrity of the figure and guarantee its pictorial autonomy, its feet and any indication of the support on which it rests were simply omitted.

The flesh tones seem unnatural; they consist mainly of lighter and darker values of a greenish-yellow set off by the orange of the rib cage and the reddish-brown of the legs. These are in turn contrasted against the deep blue-black of the hair and various accents in red: the eye, the nipples, the navel, the genitals. The lighter yellowish tone of the trunk is bracketed by deeper shades above and below. The colors are all essentially sallow, and together with the angular projecting bone structure they suggest emaciation and weakness, but at the same time they reveal the essential structure of the figure. Here and there one becomes aware of a white aureole, but the lighter background as a whole is what gives the darker figure its vividness. Although Schiele frequently did not predetermine the sizes of the empty sections of his compositions, it is obvious in this case–as in the three other nudes on canvas and the portraits from this same year–that he placed the self-contained figure onto the white surface with great care. Its varying distances from the edges appear to have been calculated precisely, and the negative forms between the face and the right shoulder and between the hair and the left arm are of considerable interest in themselves.

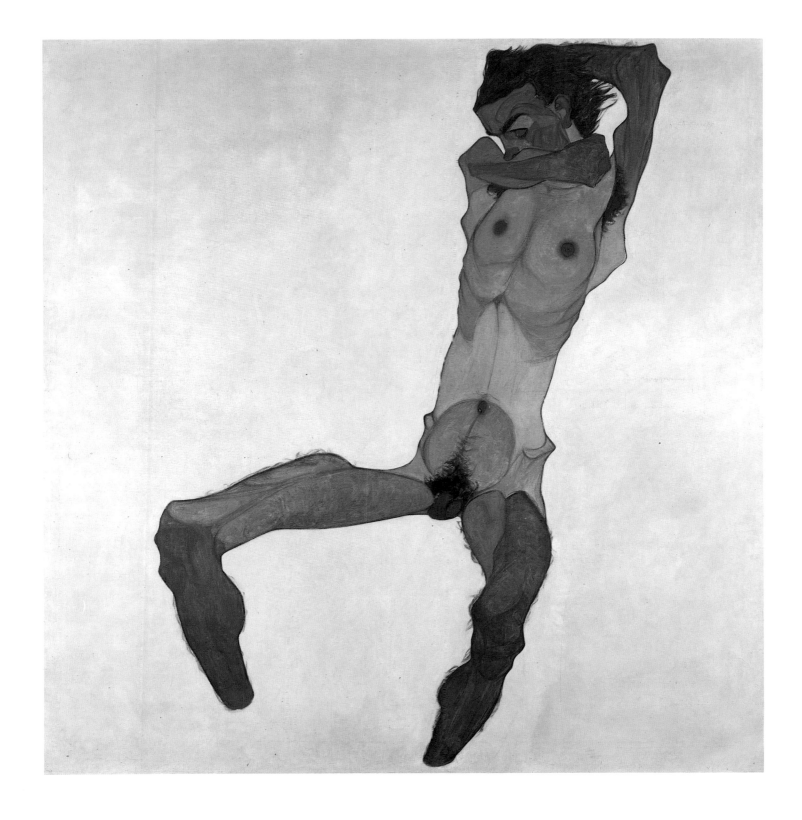

Schiele never surpassed this figure in terms of composition and drama; all that he gained from here on was a richer sense of color. Form and expression have become as one.

18 *Reclining Nude Girl*
 (Liegendes nacktes Mädchen)
 1910

The artist's signature would lead one to believe that this work dates from 1908. However, the flow of the outlines and the internal drawing clearly show it to have been executed in 1910. Moreover, it was only in that year that Schiele began to produce works as sexually provocative as this one.

His mistaken dating is by no means an indication that he wished to be thought more precocious than he really was, as did Ernst Ludwig Kirchner or Oskar Kokoschka, for example. It was simply a matter of poor memory. He could just as easily have erred in the opposite direction. He later inscribed the picture he did of the writing desk in his studio in 1914 (L 253) with the date "1916."

Schiele frequently signed and dated his sketches, even his paintings, long after he had finished them, and his memory was unreliable. As noted above, the style of this drawing makes it clear that it can only have been done in 1910. When he finally signed it, Schiele apparently tried to recall what sort of signature he had used in 1908. He therefore inverted his name but failed to pattern his letters after his earlier style; these are the ones he routinely used in 1910.

Pencil on paper, 17 3/4 x 12 5/8"
(45.1 x 31.9 cm)
Signed and (incorrectly) dated
lower right: "SCHIELE EGON 08"
Leopold Museum Inv. 1384

Provenance:
Rudolf Staechelin'sche
Familienstiftung, Basel;
Rudolf Leopold, Vienna.

Literature:
K 548.

Exhibitions:
Tokyo 1991; Tübingen 1995.

74

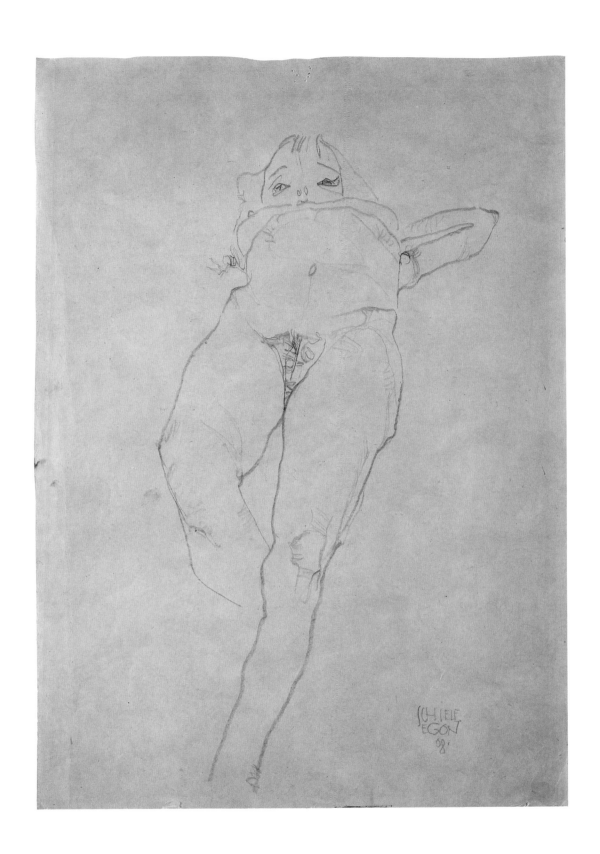

19 *Three Nude Girls*
 (Drei nackte Mädchen)
 1910

Watercolor, gouache, and indelible pencil on paper, 6 1/8 x 11 3/4"
(41 x 29.8 cm)
Not signed, not dated
Verso: *Nude Female with Raised Arms.* 1910. Black crayon and gouache on paper. Initialed and dated right: "S. 10."
Leopold Museum Inv. 2316

Provenance:
Galerie Kornfeld & Klipstein, Bern; Rudolf Leopold, Vienna.

Literature:
Leopold 1972, pl. 29; K 511.

Exhibitions:
Tokyo 1991; Tübingen 1995.

These three nudes were probably executed in the first half of 1910. The one in profile in the center, especially, is clearly indebted to the group "The Longing for Happiness" from Klimt's *Beethoven Frieze.* Despite numerous parallels, however, the differences are obvious. With his disciplined line, Klimt managed to give the outline of his emaciated nude the elegance of *Jugendstil.* Not so Schiele: the pose of his nude is more nervous and hectic; his outline runs out to sharp points; the body's length is exaggerated.

It is also interesting to see how Schiele attempted to layer his figures in space, even though the overall concept is two-dimensional. To that end he placed one figure atop another and rendered them in progressively darker colors from left to right. The one on the right is also executed on a considerably smaller scale.

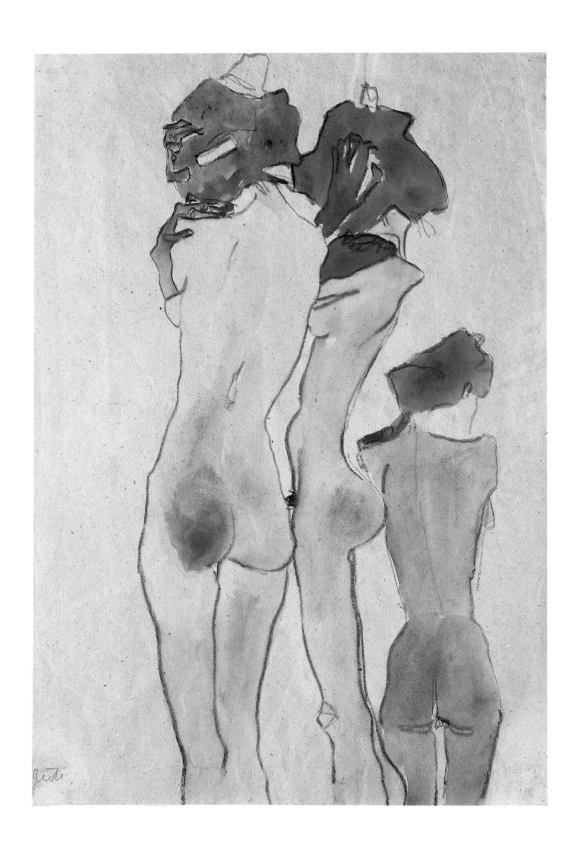

20 *Sick Girl, Seated*
 (Sitzendes krankes Mädchen)
 1910

Pencil, watercolor,
and gouache on paper,
17 3/4 x 12 3/8" (45 x 31.3 cm)
Not signed, not dated
Leopold Museum Inv. 1454

Provenance:
Rudolf Staechelin'sche
Familienstiftung, Basel;
Rudolf Leopold, Vienna.

Literature:
K 427.

Exhibitions:
Vienna 1919; Vienna, Albertina
1968; Lucerne 1974; Tokyo 1991;
Tübingen 1995.

With the simplest of means–the hands and knees pressed together and especially the sad expression of the dark eyes in a bilious face–Schiele here captured the unmistakable look of illness.

The pale tint of the girl's genitals, to be sure, has much to do with Schiele's fixation with that part of the anatomy. Even so, with this faint touch of color, he created a formal balance in the drawing between two color-emphasized poles–the face with its eyes and the abdomen with the genitals–and contrasted the one with the other.

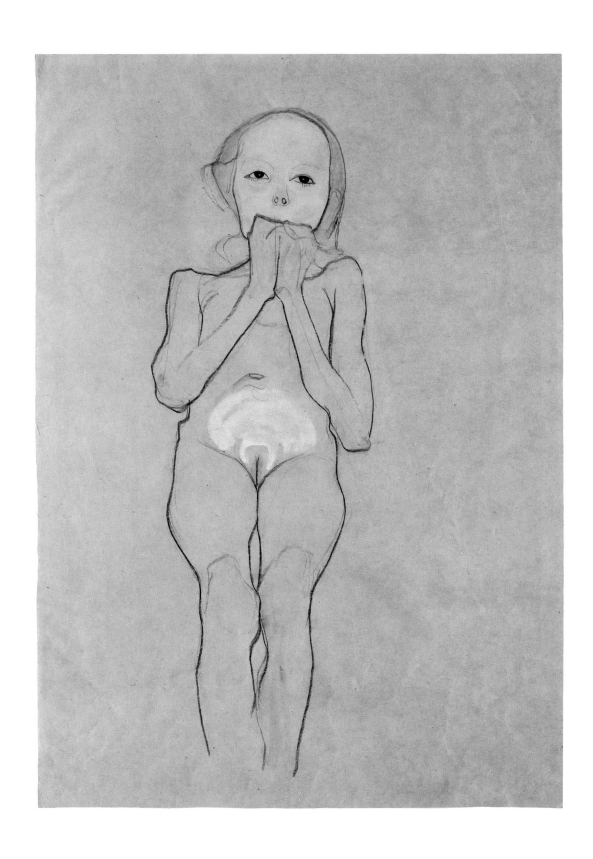

21　*Pregnant Woman in Red*
　　(Schwangere in Rot)
　　1910

Watercolor and black crayon
on paper, 17 1/8 x 12 1/4″
(43.4 x 31 cm)
Initialed and dated lower right:
"S.10."
Leopold Museum Inv. 2349

Provenance:
Estate of Egon Schiele, Vienna;
Melanie Schuster, Vienna;
Rudolf Leopold, Vienna.

Literature:
K 528.

Exhibition:
Tübingen 1995.

Here Schiele painted most of the flesh a harsh red, thereby heightening the expressiveness of the figure with its black outlines and setting it off against the background color of the paper. The woman's mask-like, raised face appears to have been only an afterthought. Far more important is the shape of her body–the hefty thighs and the swollen belly as round as an apple.

Although the right half of the drawing with the woman's distended body, thigh, and arm is altogether believable, the left half is less convincing. Here Schiele provided an outline only for the upper part of the arm, then filled in the rest with his brush to match the other arm.

He deliberately left the bottom half of the sheet blank, placing his monogram and the date at the very bottom so as to indicate that the pregnant woman was lying on an elevated surface–probably an examination table, for Schiele drew a series of pregnant women and newborn infants (see pls. 22, 23, and 24) at the gynecological clinic in which his friend–and a collector–Dr. Erwin von Graff worked. In all of these drawings the artist left out the table or chair supporting the figure so as to guarantee its autonomy as an artistic image.

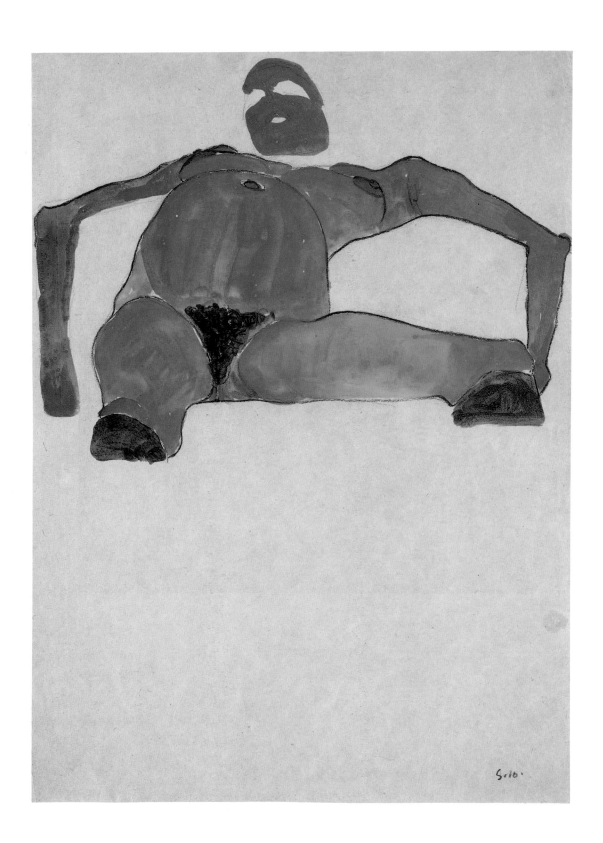

22 *Pregnant Woman with Green Belly*
 (Schwangere mit grünem Bauch)
 1910

Black crayon and watercolor
on paper, 17 3/4 x 12 1/4″
(45.1 x 31.1 cm)
Initialed and dated lower right:
"S.10."
Leopold Museum Inv. 2340

Provenance:
Gustav Epstein;
Hauswedell & Nolte,
Hamburg (auction), 1980;
Rudolf Leopold, Vienna.

Literature:
K 540.

Exhibition:
Tübingen 1995.

Here Schiele painted the woman's belly a pale green, surrounding it with thighs, an arm, and an upper body in more realistic reddish-brown tones. The face and hair are rendered in an even stronger reddish-brown, heightened by the red of the lips and the swollen eyelids. In contrast to the *Pregnant Woman in Red* (pl. 21), the face is executed in detail, and the woman's gaze is altogether moving.

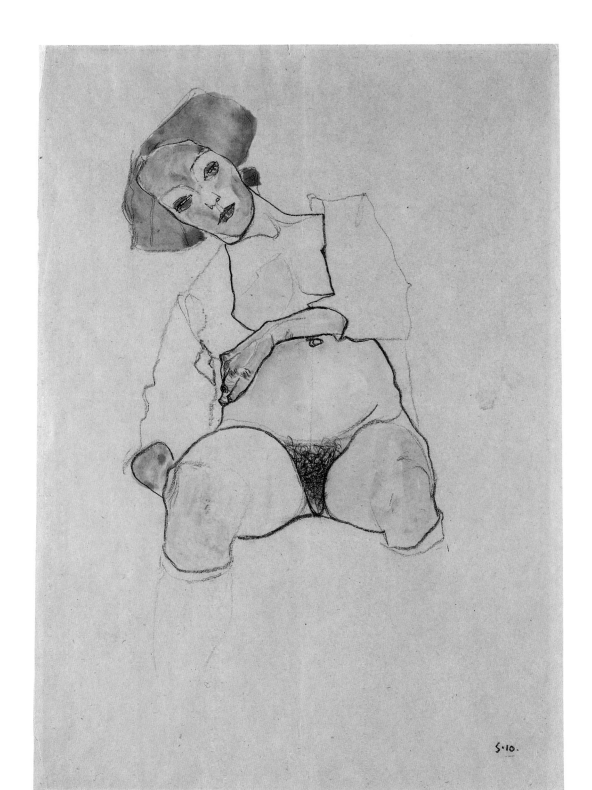

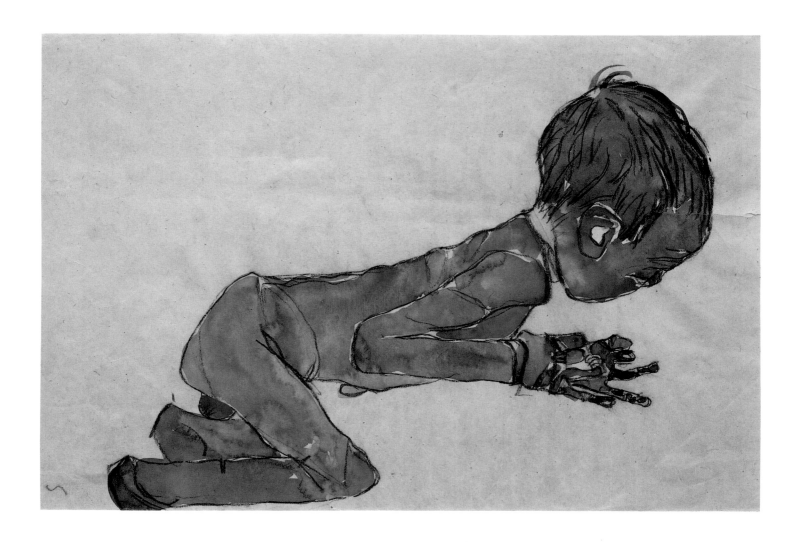

23　*Newborn with Bent Knees*
　　(Neugeborenes mit angezogenen Knien)
　　1910

Watercolor, black crayon, and
gouache on paper,
11 3/8 x 16 7/8″ (29 x 43 cm)
Initialed lower left: "S" (see text)
Leopold Museum Inv. 1410

Provenance:
Estate of Egon Schiele, Vienna;
Melanie Schuster, Vienna;
Rudolf Leopold, Vienna.

Literature:
Leopold 1972, pl. 37; K 387.

Exhibitions:
Vienna 1919; Innsbruck 1963;
Tokyo 1991; Tübingen 1995.

In the drawing and the colors of this work, Schiele masterfully captured the helplessness of a newborn infant. Although we see the face only in profile, we sense that the child is crying. Schiele exaggerated the reds and blues of the baby's skin, just as he exaggerated the deformation of its buttocks so soon after delivery. Needless to say, he was quick to utilize their flatness for its formal effect.

The placement of Schiele's monogram would suggest that the drawing was originally done in a vertical format, but that contradicts its character. He signed it in this way because the Vienna Secessionists favored either square or vertical formats. He too did most of his works in a vertical format, but up to the time of his death he habitually signed, retroactively, even his horizontal works as though they had been turned the other way.

84

24 *Newborn Holding His Hands in Front of His Face*
(Neugeborenes, die Hände vor das Gesicht haltend)
1910

Like the previous example, Schiele here convincingly captured the helplessness of a newborn infant.

Watercolor and black crayon
on paper, 12 5/8 x 17 5/8″
(31.9 x 44.9 cm)
Initialed upper right: "S" (see text
for pl. 23)
Leopold Museum Inv. 1404

Provenance:
Rudolf Staechelin'sche
Familienstiftung, Basel;
Rudolf Leopold, Vienna.

Literature:
Koschatzky 1968, pl. 3; K 384.

Exhibitions:
Vienna 1919; Vienna, Albertina
1968; Lucerne 1974; Tokyo 1991;
Tübingen 1995.

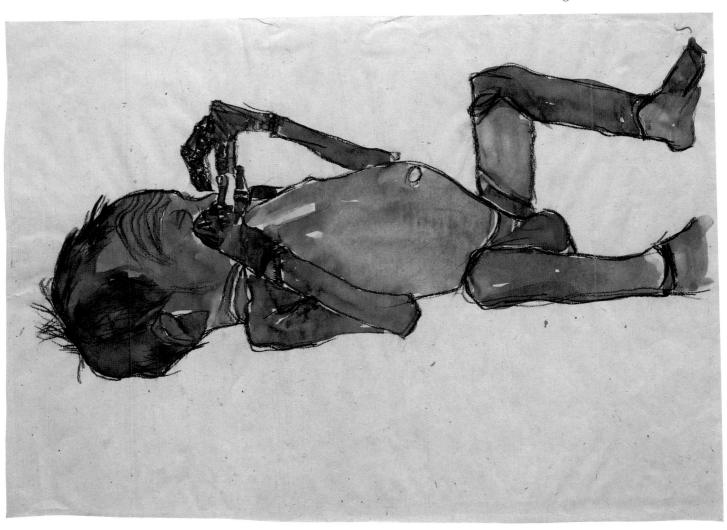

25 Nude Male Torso
(Männlicher Akttorso)
1910

Gouache, watercolor,
and black crayon on paper,
17 5/8 x 11" (44.8 x 27.9 cm)
Signed and dated lower right:
"EGON SCHIELE 1910."
Initialed lower left: "S"
Leopold Museum Inv. 1452

Provenance:
Estate of Egon Schiele, Vienna;
Melanie Schuster, Vienna;
Rudolf Leopold, Vienna.

Literature:
Leopold 1972, pl. 38; K 675.

Exhibitions:
Des Moines 1971; Tokyo 1991;
Tübingen 1995.

This rather miserable figure has a deeply curved spine and pendulous buttocks. Schiele managed to heighten the sense of the grotesque with the fingers hanging down into the drawing from the top. The work has not been cropped; this is the way Schiele meant it to be.

Every part of the figure corresponds to every other part. The buttocks, for example, relate to the pointed right knee, and that knee, in turn, is reflected in the angle of the heel below. The outline above the left kneecap has been scooped out to match the convex contour of the right calf. The resulting negative space is echoed by the one above the right knee.

One is struck not only by the countless correspondences of line but also by the wealth of colors, each blending into the next and none confined to a specific area. A lilac-red passes through intermediary shades into the dark blue of the thigh, against which Schiele set off the genitals so that they virtually glow. Not only is this impressive in terms of painting; it also emphasizes, like the luxurious pubic hair, the sexual element.

With the blue of the right thigh, Schiele managed to separate the leg in space from both the genitals and the left thigh with color alone, a separation already suggested by the placement of the feet and the foreshortening of the right calf. Yet he made the right foot the same size as the left–perhaps even a little larger, owing to its central position and its importance in the overall composition–and in so doing caused the figure to seem somehow two-dimensional, with equally important elements more suggestive of a design.

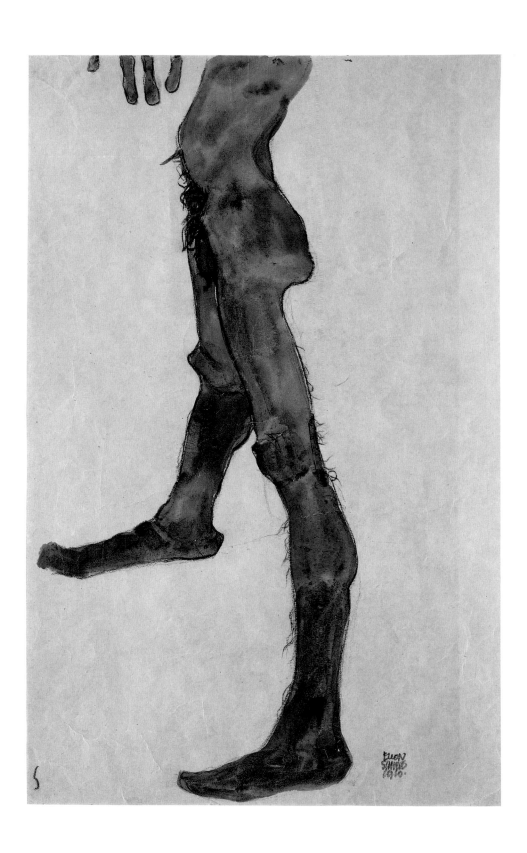

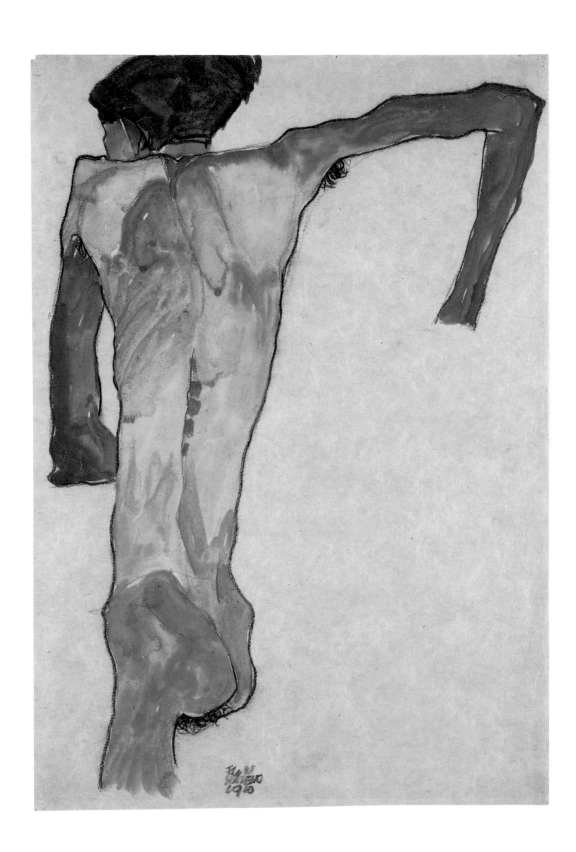

26 *Nude Leaning on His Elbow, Seen from the Back*
 (Sich aufstützender Rückenakt)
 1910

The pictorial form is clearly defined. All of the elements are cross-referenced and reciprocally determinative. For this reason the right hand is simply omitted, for it would have created an accent Schiele did not want.

One is struck by the amount of color in the torso and especially the arms. For all their autonomy and exaggeration, these yellowish-greens and oranges and even the red are juxtaposed with extraordinary success. The work properly calls to mind the Fauves in France, although Otto Benesch insists that Schiele had no knowledge of them at this time.

The colors may be improvised and the body unnaturally emaciated, even deformed; however, specific observations are perfectly believable—even the extremely hunched shoulder. This is precisely the way a skinny man's shoulder blade lifts when he leans on his elbow.

Gouache, watercolor,
and black crayon on paper,
17 5/8 x 11 7/8" (44.7 x 30.2 cm)
Signed and dated bottom center:
"EGON SCHIELE 1910"
Leopold Museum Inv. 1451

Provenance:
Estate of Egon Schiele, Vienna;
Melanie Schuster, Vienna;
Rudolf Leopold, Vienna.

Literature:
Leopold 1972, pl. 41; K 648.

Exhibitions:
Tokyo 1991; Tübingen 1995.

27 *Kneeling Girl in Orange-Red Dress*
 (Kniendes Mädchen in orangerotem Kleid)
 1910

Gouache, watercolor,
and black crayon on paper,
17 5/8 x 12 1/4" (44.6 x 31 cm)
Initialed lower left: "S"
Leopold Museum Inv. 1453

Provenance:
Estate of Egon Schiele, Vienna;
Melanie Schuster, Vienna;
Rudolf Leopold, Vienna.

Literature:
Leopold 1972, pl. 40; K 476.

Exhibitions:
Tokyo 1991; Tübingen 1995.

Schiele's younger sister Gertrude was the model for this drawing. The artist rendered her dress, stockings, and shoes in various shades of red, from orange to a bluish-red–even adding a few touches of green. The folds of the sleeve are almost crystalline in structure. It is also important to notice the hand, which has been executed in an extremely painterly manner. A line leading from it to the hem of the girl's skirt traces Schiele's interest in the composition of the work.

Although the figure has been positioned on the surface with great care, one must not overlook its subtle three-dimensionality. This is no longer the sort of two-dimensional figure created by *Jugendstil* artists.

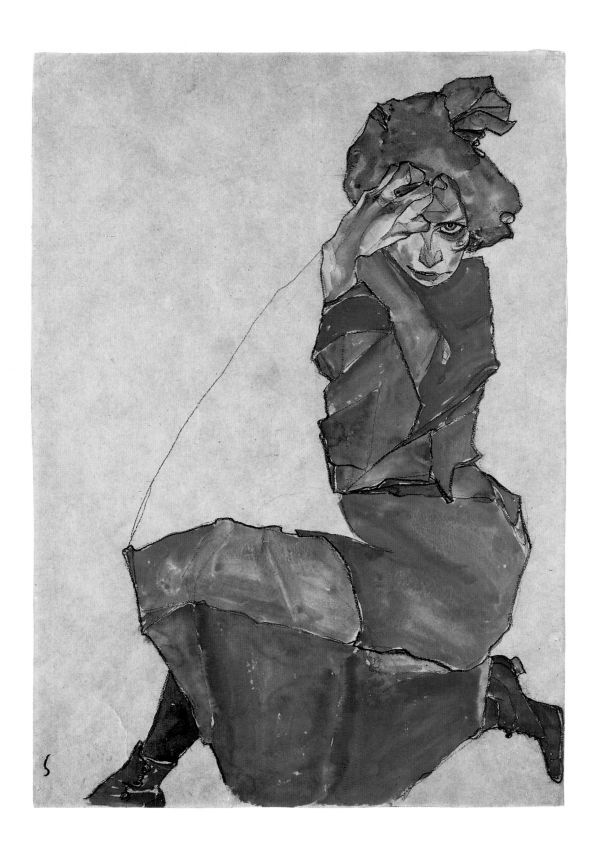

28 *Osen with Crossed Arms*
 (Osen mit überkreuzten Armen)
 1910

Black crayon, watercolor,
and gouache on paper,
17 1/2 x 12 1/8″ (44.4 x 30.8 cm)
Initialed and dated lower right:
"S.10."
Leopold Museum Inv. 2347

Provenance:
Estate of Egon Schiele, Vienna;
Melanie Schuster, Vienna;
Rudolf Leopold, Vienna.

Literature:
Leopold 1972, pl. 35; Comini 1974,
fig. 54; Mitsch 1974, fig. 15; Wilson
1980, pl. 13; Whitford 1981, fig. 49;
Patka 1986, fig. 45; Werkner 1986,
fig. 70; Whitford 1987, p. 72;
K 598.

Exhibitions:
London 1964; Vienna, Albertina
1968; Tübingen 1995.

Schiele's painter friend Erwin Dominik Osen modeled for him on a number of occasions in 1910. This particular nude of him verges on the grotesque. The emaciated body is elongated, and the angular arms look like sections of some kind of pipe, as though Schiele were taking to the extreme the style of many works by the sculptor George Minne. The hands are abnormally large, the head appears to be separated from the torso. In terms of form, however, the line of the jaw where it touches the arm at an acute angle is carefully continued in the upper outline of the left forearm and is precisely opposed by that of the right forearm. The tilt of the head is repeated in the angle of the right hand and especially the extremely long torso. These angles are balanced by the opposing movement of the relatively small buttocks.

Although the depiction is essentially scurrilous, in its formal construction nothing has been overlooked. Schiele's mastery of drawing is already evident in his wonderful outlines.

29 *Osen with Fingertips Touching*
 (Osen mit aneinandergelegten Fingerspitzen)
 1910

This nude's columnar trunk, intersected by the hands forming a single horizontal line, seems to continue upward through the neck and head, the hair forming a sort of capital at the top. The tilted axis of the whole construction, relieved somewhat by the angled lines of the forearms, gives the composition a certain tension and restlessness. However, the almost level line of the hands holds it in check.

The detail in the drawing of the face and hands is impressive. They—and the navel—are the only areas to which Schiele added color, but this time in harmonious tones and not the exaggerated ones of the previous nude.

Black crayon, watercolor,
and gouache on paper,
15 1/8 x 11 7/8" (38.3 x 30 cm)
Signed and dated lower right:
"EGON SCHIELE 1910."
Inscribed by the artist upper left:
"MIME VAN OSEN"
Leopold Museum Inv. 2348

Provenance:
Rudolf Leopold, Vienna.

Literature:
Leopold 1972, pl. 35; Mitsch 1974, fig. 17; K 600.

Exhibition:
Tübingen 1995.

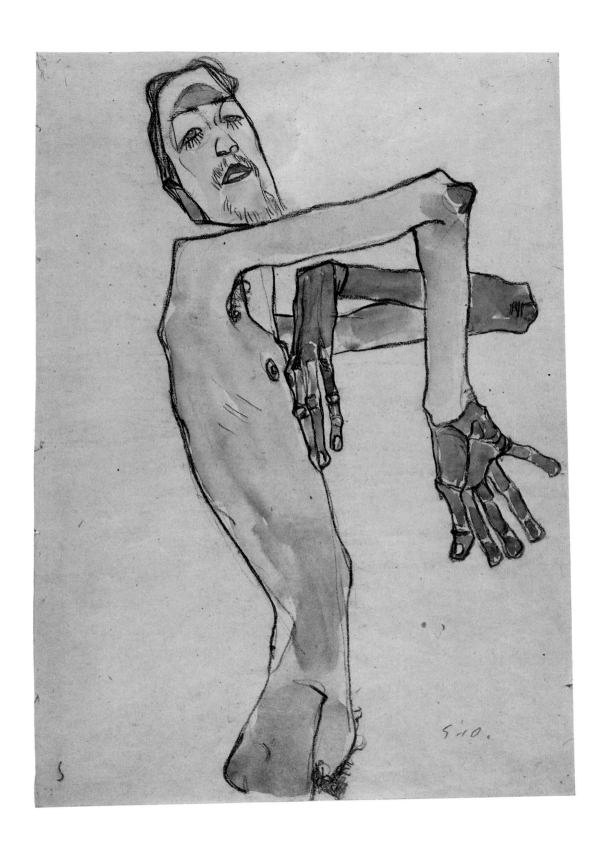

28 *Osen with Crossed Arms.* 1910

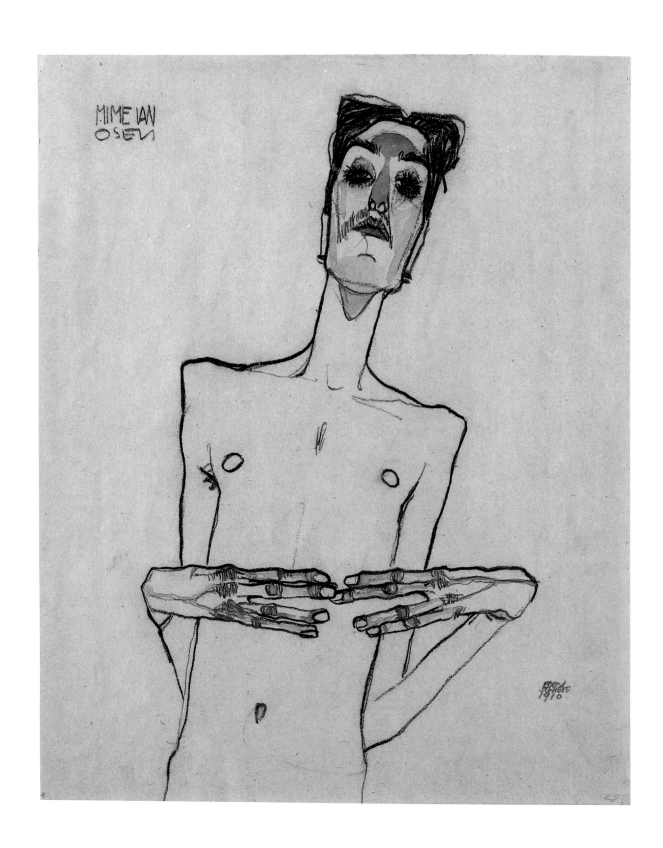

29 *Osen with Fingertips Touching.* 1910

30 *Kneeling Female Nude*
 (Hockender weiblicher Akt)
 1910

Gouache, watercolor,
and black crayon on paper,
17 1/2 x 12 1/4″ (44.4 x 31 cm)
Initialed and dated center right:
"S.10."
Leopold Museum Inv. 1456

Provenance:
Marlborough Fine Art, London;
Rudolf Leopold, Vienna.

Literature:
Leopold 1972, pl. 46; Akademische
Druck- und Verlagsanstalt 1985,
pl. 1; K 556.

Exhibitions:
London 1964; Munich 1975;
Brussels 1981; Zurich 1988; Tokyo
1991; Tübingen 1995; Tokyo 1997.

This impressive presentation of a nude is composed of opposing movements, and its internal structure, though minimal, is clearly executed. Crucial to its success is the decisive outline with the many small angles along its course. It is interesting how the lines of the face are taken up and continued by those of the neck.

Schiele succeeded perfectly with the obviously risky combination of colors in the head, the orange of the face interrupted by traces of green and contrasting with the lilac-red and blue of the hair. The body is mainly a yellow-ocher with occasional green and yellowish tones. Contrast is provided by the red of the nipples, the small spot of red in the navel, and the black crayon lines of the pubic hair. The surrounding white aura sets off the figure from the yellowish tone of the paper.

In 1910 Schiele's favorite paper for drawing was ordinary buff-colored packing paper, on which he generally drew with a black crayon. Examples of it that have been exposed to light over the years have darkened somewhat.

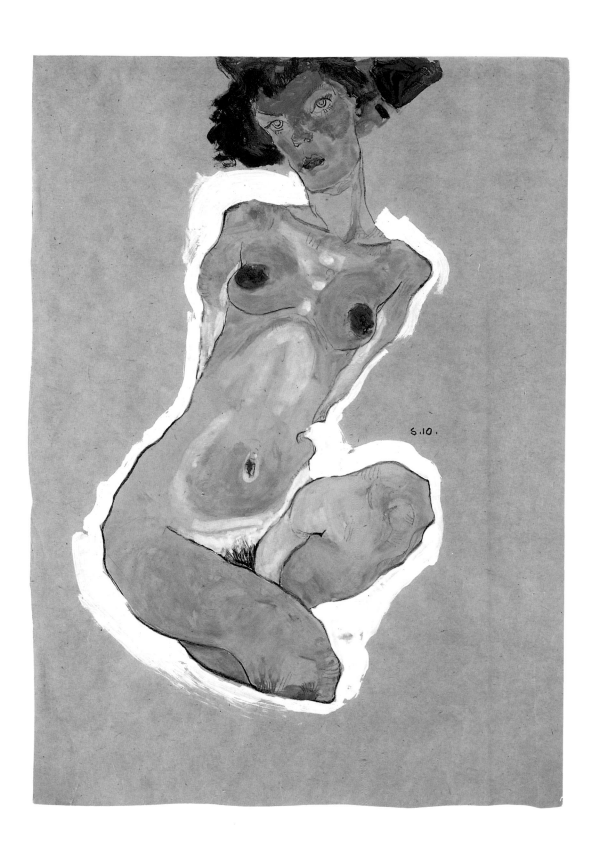

31 *Self-Portrait in Shirt*
 (Selbstbildnis in Hemd)
 1910

Black crayon, watercolor,
and gouache on paper,
17 3/4 x 12 3/8″ (45 x 31.5 cm)
Initialed and dated center left:
"S.10."
Additional initial lower left: "S"
Leopold Museum Inv. 2317

Provenance:
Stuttgarter Kunstkabinett
(auction), 1957;
Viktor Fogarassy, Graz;
Hans Dichand, Vienna;
Rudolf Leopold, Vienna.

Literature:
Comini 1974, pl. 33; Comini 1976,
fig. 9; Malafarina 1982, no. D13;
Marchetti 1984, fig. 233; K 682.

Exhibitions:
Lucerne 1974; Munich 1975; Tokyo
1986; Tokyo 1991; Tübingen 1995.

Only the figure is colored; the white shirt was simply left the color of the paper.

The last joints of the fingers of the left hand are not shown; however, the right hand is represented solely by the last two joints of the fingers and the fingernails. The lively outlines of these fingers are especially fascinating.

Here again all of the elements of the composition are interrelated; the hands refer to each other and together they anchor the whole.

The hair looks like tongues of flame. This time Schiele gave the same light reddish-brown to his eyes.

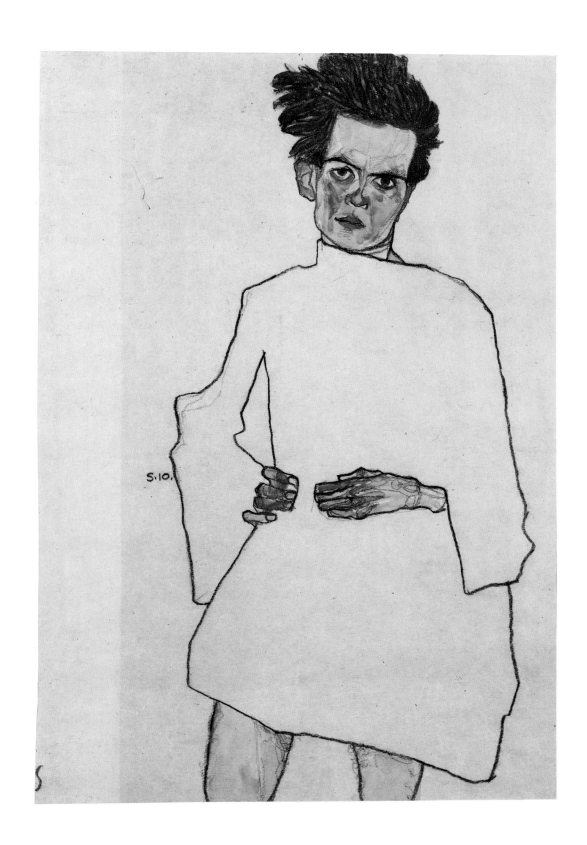

32 *Self-Portrait*
(Selbstbildnis)
1910

Gouache, watercolor,
and black crayon on paper,
17 1/2 x 12" (44.3 x 30.5 cm)
Initialed and dated lower right:
"S 10"
Leopold Museum Inv. 1458

Provenance:
Eduard Josef Wimmer-Wisgrill,
Vienna; Rudolf Leopold, Vienna.

Literature:
O. Benesch 1951, pl. 1; O. Benesch
1958 (2); Leopold 1972, pl. 44;
Wagner 1975, p. 32; Hofmann
1987, p. 30; Stefano 1992; K 694.

Exhibitions:
Vienna, Albertina 1948; Vienna,
Albertina 1968; Munich 1975;
Tokyo 1986; Zurich 1988; Tokyo
1991; Tübingen 1995.

This is perhaps Schiele's loveliest self-portrait in watercolor. A young man looks out at the world with large, questioning eyes. These eyes, the high forehead, and the full shock of hair are set apart from the lower part of the face. Even in terms of size, the eyes emphasize the predominance of the mind. The oversized head is carried by a delicate, still-adolescent body. The narrow-chested torso is only suggested, but the few lines are enough.

The sloping shoulders are barely indicated so that we are not distracted from the key elements in the composition. The large, colorful head is balanced by the equally colorful striped shirt-sleeve that has been deliberately separated from it by the uncolored body of the shirt. Of the right sleeve we see just a narrow triangle beyond the line of the chest.

One need only look at the impressive rendering of the hair or the modeling of the forehead and the temples to recognize that Schiele has by now become a masterful painter. The olive-gray of the forehead is set against the light red of the cheeks. Traces of blue help define the angle of the jaw. The bright red-orange ear stands out against the dark hair above it. These colors are unnatural, to be sure, but they have been applied in the proper relationships, so that the effect is altogether lifelike. Even though the flesh tones are vivid, it is the eyes, with their dramatic contrast between light and dark, that dominate the composition.

The work is a masterpiece in every respect, idiosyncratic and authoritative. Mature deliberation and intuition are evident in equal measure.

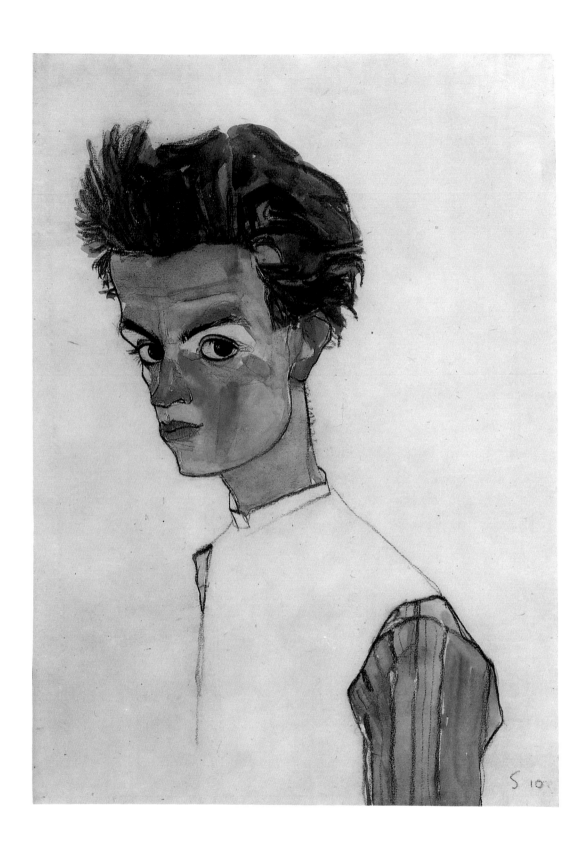

33 Nude Self-Portrait in Gray with Open Mouth
(Selbstakt in Grau mit offenem Mund)
1910

Gouache and black crayon
on paper, 17 5/8 x 12 3/8"
(44.8 x 31.5 cm)
Signed and dated lower right:
"SCHIELE 10."
Leopold Museum Inv. 1460

Provenance:
Estate of Egon Schiele, Vienna;
Gertrude Schiele-Peschka, Vienna;
Rudolf Leopold, Vienna.

Literature:
K 696.

Exhibitions:
Vienna, Albertina 1948; Vienna
1985; Tokyo 1991; Tübingen 1995.

One could hardly imagine a greater contrast between the face in the preceding self-portrait and the one in this one. The naked man looks like he is being crucified, and his face registers sheer horror. Everything is rendered in grim grays and black; only around the eyes is there a trace of yellow to heighten their expressiveness.

The arms are only suggested, so that the form remains self-contained. The composition is concentrated, the figure autonomous.

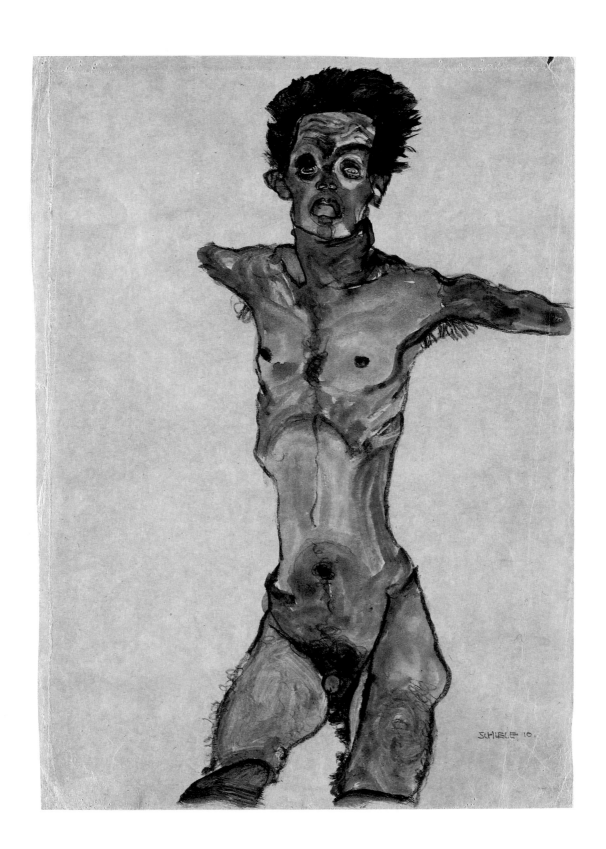

34 Seated Boy with Clasped Hands
(Sitzender Bub mit gefalteten Händen)
1910

Gouache, watercolor,
and black crayon on paper,
16 7/8 x 11 3/8" (43 x 29 cm)
Initialed and dated lower right:
"S.10."
Verso: *Portrait Head of Dr. Oskar
Reichel.* Black crayon on paper
Leopold Museum Inv. 1455

Provenance:
Etelka Hofmann, Vienna;
Carl Mayländer, Vienna;
Rudolf Leopold, Vienna.

Literature:
K 453.

Exhibitions:
London 1964; Tokyo 1991;
Tübingen 1995.

Once Schiele achieved his artistic independence, he began rendering the dark portions of the face–the nostrils and eye sockets–in light tones, contrary to the way they appear in reality. He followed this principle to the extreme in 1910 and 1911. It is especially apparent in the *Self-Portrait* (pl. 32), where even the area between the nose and the mouth is lighter in color. In the case of this seated boy, the folds of the jacket, which should have been darkest, are indicated by an absence of color in an unnatural but masterful inversion of reality.

Schiele painted the boy's head and hands in a simple scale of color from red to bluish-red, contrasting these with the dark tones of the jacket and knickers. To provide tonal uniformity he also added a bit of red to the black in some areas. The red in the face of this proletarian boy looking straight into the viewer's eyes is wonderfully expressive.

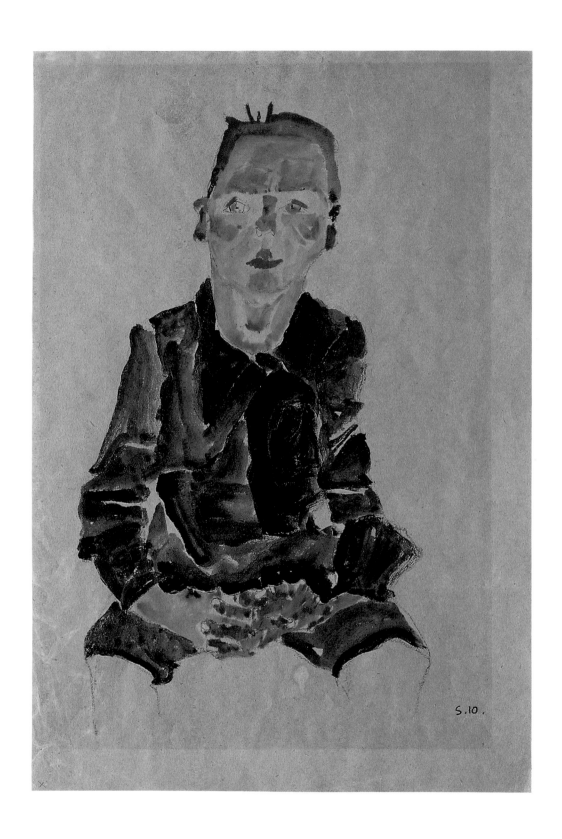

35 *Standing Boy with Hat*
(Stehender Junge mit Hut)
1910

Gouache, watercolor,
and pencil on paper,
17 1/2 x 12 3/8" (44.5 x 31.2 cm)
Initialed and dated center right:
"S.10."
Leopold Museum Inv. 1450

Provenance:
Koloman Moser, Vienna;
Sotheby's, London (auction), 1971;
Rudolf Leopold, Vienna.

Literature:
K 443.

Exhibitions:
Vienna 1919; Tokyo 1991;
Tübingen 1995.

To judge from his hat, this is a peasant boy, but he could also be a poor city child. There is no question but that he is poor; his hands are so calloused and worn that one would take them for those of a middle-aged laborer if one saw them by themselves. Schiele has movingly captured the boy's destitution, not only in the rendering of his clothing–knickers, jacket, and hat–but also in his unsteady pose and his piteous look.

Despite all of his expressiveness, Schiele never forgets questions of form. With the slight tilt of the head to the left, the slant of the figure is balanced on the page.

To obtain a graphic line, Schiele used a gouache mixed with varying amounts of water. Long and short brushstrokes and alternating open and heavily painted areas reveal the artist's mastery of painting in this period.

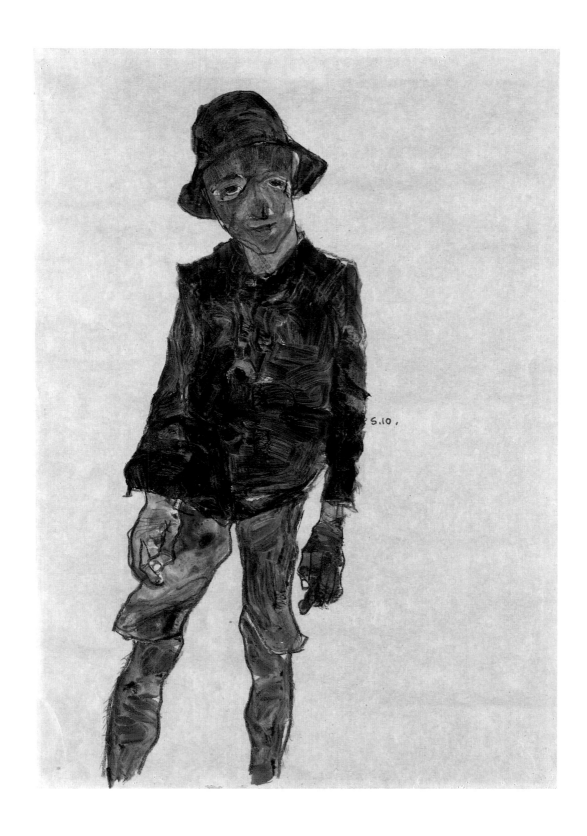

36 Red-Haired Girl with Spread Legs
(Rothaariges Mädchen mit gespreizten Beinen)
1910

Gouache, watercolor,
and pencil on paper,
17 3/8 x 12" (43.9 x 30.4 cm)
Initialed and dated above center
right: "S.10."
Leopold Museum Inv. 3664

Provenance:
Wolfgang Gurlitt, Munich;
Galleria Galatea, Turin;
Rudolf Leopold, Vienna.

Literature:
Leopold 1972, pl. 51; K 418.

Exhibition:
Tübingen 1995.

In a considerable portion of his work, Schiele shows himself to be obsessed with sex. This girl inspired him to make a number of erotic depictions,[1] of which the one reproduced here is perhaps the most successful. Inside the dark hem of her skirt, virtually framed by it, the lighter area is as though set on a stage, the reddish, and therefore very noticeable, genitals surrounded by white and yellowish underwear.

Equally striking, however, is the degree of calculation evident in this composition, its considerable formal balance. The narrow wedge of the skirt stretched between the knees, with its strong, nearly straight lines, anchors two triangles, one above and one below. The upper one consists of the sensitively painted gray-black blouse, the lower one of the angled legs. The feet provide a certain countermovement.

The colors in the work are especially delightful. Schiele juxtaposed the various shades from gray to black with those from orange to red–not to mention the touches of green in the skirt–and finally the white of the undergarments to the black and red. The face and hair appear precisely at the top of the figure's central axis, the exposed genitals at the bottom of it. In the one case the red is surrounded by a white aureole, in the other by the white of the underwear. The foreshortening of the face, although only lightly drawn, is masterful.

[1] See Galerie Kornfeld & Klipstein, Bern, sale 121, 1966, lot 970, and Galerie St. Etienne, New York, 1968, no. 32, illus. p. 79.

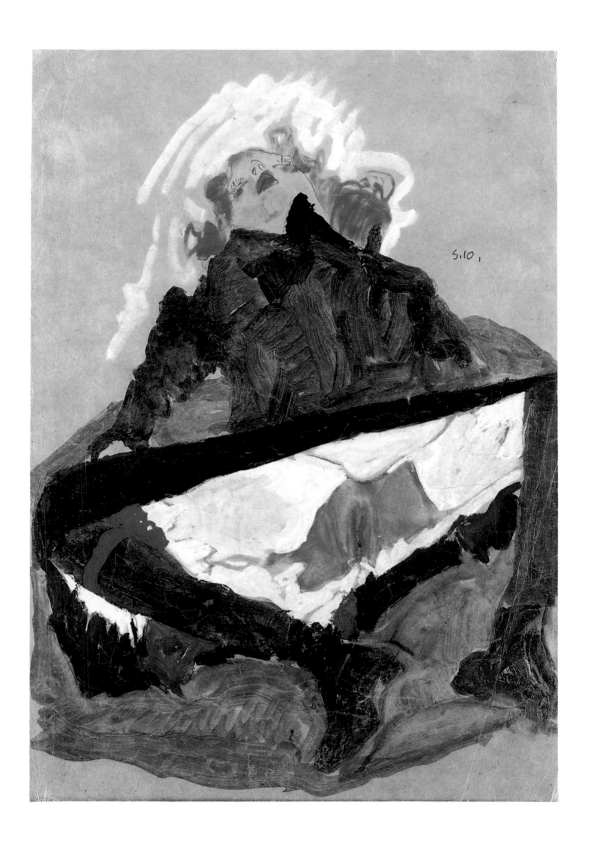

37 Self-Portrait in Black Robe
(Selbstbildnis in schwarzem Gewand)
1910

Gouache, watercolor,
and black crayon on paper,
17 3/4 x 12 1/8″ (45.1 x 30.9 cm)
Initialed and dated center right:
"S.10."
Leopold Museum Inv. 1447

Provenance:
Alfred Spitzer, Vienna;
Galerie St. Etienne, New York;
Rudolf Leopold, Vienna.

Literature:
Karpfen 1921; Karpfen 1923, p. 113;
Leopold 1972, pl. 52; K 699.

Exhibitions:
Vienna 1928; New York 1948; New
York 1957; Innsbruck 1963; Zurich
1988; Tokyo 1991; Tübingen 1995;
Tokyo 1997.

A man strange and mysterious, wearing black, fixes the viewer with a glassy and melancholy gaze. Schiele has here drawn and painted himself very differently from the way he did only a short time before. He is no longer a boyish young man (see pl. 32).

With the exception of the face, which has a pale yellow ground–part of the alienating effect of the portrait–the figure is painted in nothing but black and the many gradations of it made possible by diluting it with water. The right sleeve is solid black, the left one, by contrast, considerably lighter. The series of diagonal brushstrokes in a light gray next to it make it seem even less substantial. These brushstrokes serve to break the symmetry of the composition. At the same time, the nervous strokes–and the blottings surrounding the head–create a certain space for the figure. This is not a haphazard sketch; everything–even the retention of the dribble of black below the lapel–has been carefully weighed. The eye sockets have been left without color, as have the shirt collar and the hand. Here the light eye sockets, which in reality would have been darker, of course, do not seem a mere artistic trick as they often did earlier (see, for example, the *Kneeling Male Nude,* L 140), but rather accord with the spirit of the whole. The slight curve of the body and the predominantly gray tones with the brushstrokes still visible in the body of the coat give the figure a ghostly appearance.

The assured brushwork of this self-portrait represents one of Schiele's greatest achievements as a painter.

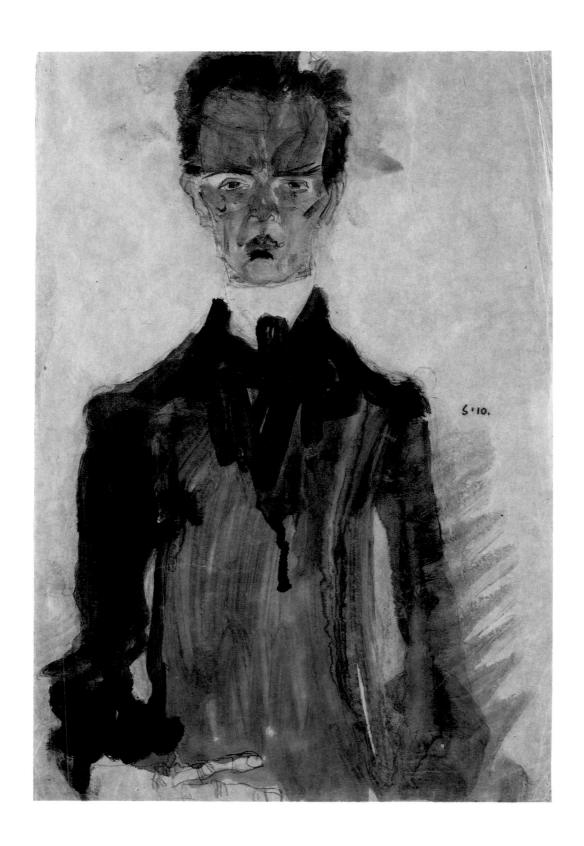

38 Nude Self-Portrait
(Selbstakt)
1910

Gouache and black crayon
on paper, 17 5/8 x 12 1/8″
(44.9 x 31.3 cm)
Initialed and dated center right:
"S.10."
Verso: *Woman with Bow in Her
Hair.* 1909. Pencil and crayon on
paper. Signed and dated lower
right: "SCHIELE EGON 09"
Leopold Museum Inv. 2320

Provenance:
Viktor Fogarassy, Graz;
Hans Dichand, Vienna;
Rudolf Leopold, Vienna.

Literature:
Comini 1974, fig. 75a; Mitsch 1974,
pl. 9; Comini 1976, pl. 10; Comini
1978, pl. 25; Nebehay 1979,
fig. 106; Nebehay 1980, fig. 68;
Malafarina 1982, no. D22; K 708.

Exhibitions:
Innsbruck 1973; Lucerne 1974;
Munich 1975; Zurich 1988;
Tübingen 1995.

This sheet alone, with works on both sides (see illustration below), shows what amazing progress Schiele made in a single year. At the beginning of 1910 he was still a talented *Jugendstil* artist working in traditional styles; by the end he had broken through to a completely independent Expressionism. The self-portrait reproduced here also shows an advance over previous works of this year. He no longer paints the parts of the body in wholly different colors, as he did in the nudes shown in plates 25 and 26; instead, he emphasizes the divisions important for the picture with almost graphic brushstrokes in a limited range of color.

Schiele's critics referred to works of his such as this as "rabbit pictures," as they found them to look like nothing so much as skinned rabbits in a butcher's display. When Schiele learned of this, he vowed to paint many more pictures of this kind. Today they could also serve as reminders of the concentration camps.

The anatomical exaggeration of this work is nevertheless balanced by the clear, calculated composition. It is fascinating how, in the formation of the torso, the rib cage with the arms–truncated so as not to distract from the form–relates to the pelvis, and how the column of the neck rises up out of the hollow behind the collarbones. The whole is crowned by a head painted in a *chiaroscuro* that is a masterful achievement.

The figure is set off from the buff tint of the packing paper by a white outline that registers its every contour. It too reflects the Expressionism toward which Schiele was heading. The resulting image is wholly his own, a moving, expressive cipher compounded of outline, color, and an exemplary composition.

Woman with Bow in Her Hair
(verso of pl. 38). 1909.
Pencil and crayon on paper

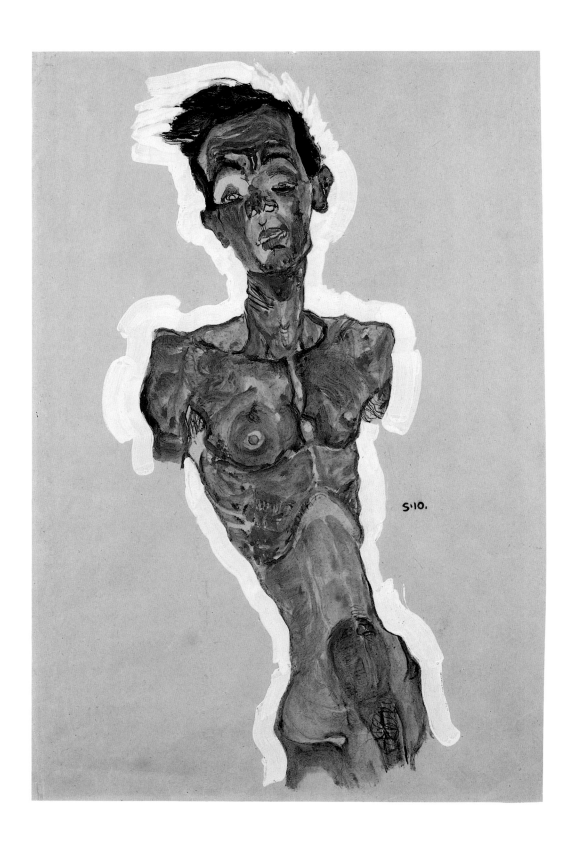

39 *Grimacing Self-Portrait*
(Selbstdarstellung mit verzerrtem Gesichtsausdruck)
1910

Gouache and black crayon
on paper, 17 7/8 x 12 1/8"
(45.3 x 30.7 cm)
Signed and dated lower right:
"SCHIELE 10."
Leopold Museum Inv. 2312

Provenance:
Alfred Spitzer, Vienna;
Viktor Fogarassy, Graz;
Galerie Würthle, Vienna;
Rudolf Leopold, Vienna.

Literature:
Comini 1974, pl. 34; Nebehay
1979, fig. 58; Nebehay 1980,
fig. 10; Wilson 1980, pl. 15;
Whitford 1981, fig. 57; Sotriffer
1982, p. 191; Kuchling 1982, p. 20;
Malafarina 1982, no. D14; Werkner
1986; K 705.

Exhibitions:
Vienna 1925; Bern 1956; New
York, Guggenheim Museum 1965;
Darmstadt 1967; London 1971;
Innsbruck 1973; Lucerne 1974;
Munich 1975; Vienna 1980; Zurich
1988; Tübingen 1995; Tokyo 1997.

Exaggeration is part of all of Schiele's self-portraits from 1910. Here the face is hideously contorted. Only isolated teeth are visible in the open mouth–although Schiele had perfectly fine teeth–the eyebrows are raised as high as possible, and the open shirt reveals his scrawny chest.

The deliberately unnatural coloring ranges from red to blue, and Schiele exploited that contrast in the jacket especially. There he also applied the color in a manner that clearly sets it apart from the flesh tones. The apparent contrast between this unnatural coloring and the exaggerated drawing is reconciled by a strong sense of composition, and the result is definitely something new.

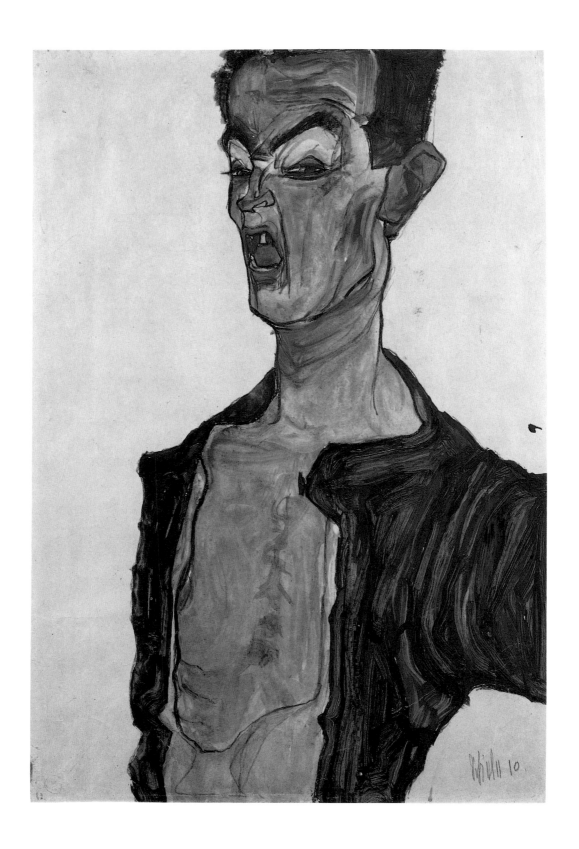

40 Girl with Tilted Head
(Mädchen mit geneigtem Kopf)
1910

Pencil on paper, 17 1/4 x 12 1/8"
(43.8 x 30.8 cm)
Initialed and dated lower right:
"S.10."
Leopold Museum Inv. 1449

Provenance:
Galerie Arnot, Vienna;
Peter Graubart, Vienna;
Alex Stone, New York;
Sotheby's, New York
(auction), 1986;
Rudolf Leopold, Vienna.

Literature:
K 586.

Exhibitions:
Tokyo 1991; Tübingen 1995.

It has not been noticed before, but Schiele used this drawing when painting the head of the *Dead Mother I* (pl. 41).

Presumably his sister Gerti posed for the drawing, tilting her head to the side and slightly to the back. As a result–in contrast to the face in the painting–the face is slightly foreshortened, especially the nose. However, the line of the neck and the face, the angle of the cheekbone, the way the hair falls to the left, and the shape of the lips are very like those of the dead mother. One must therefore assume that this pencil drawing was more than likely a study for the head in the painting.

Given Schiele's stylistic evolution, it is also clear that the drawing could only have been done in either November or December of 1910.

41 *Dead Mother I*
("*Tote Mutter*" *I*)
1910

Given its painterly style and the way color has been added as a means of heightening its graphic structure, this painting can only have been executed in either November or December of 1910.[1] The fine pencil drawing visible in the hands is characteristic of this period.

The three lighter and sharply defined areas–the mother's face and neck, her hand, and the child visible in her womb[2]–are aligned along a slightly tilted axis rising upward from the lower left. The infant's head and hands essentially follow this axis, whereas the mother's face and hand lie perpendicular to it. This contrast and the tilted alignment of these most important elements of the composition create a sense of movement that is then held in check by the rest of the painting. The overall effect is accordingly one of self-contained harmony.

The pale flesh tones of the mother's face and neck are abruptly cut off by the band of black beneath it. Above it, however, between the face and the brownish- and bluish-black of the background, there is a somewhat lighter section comprising her hair and a thin, wedge-shaped portion of her dress. The painting thus alternates sharp contrasts with more subtle ones.

The mother's hair, which falls on the left, could be a borrowing from the *Pietà* that Kokoschka produced for the summer theater of the *Internationale Kunstschau* in Vienna in 1909 (see illustration on p. 62),[3] but here its execution and the resulting effect are altogether different. Unlike Kokoschka, Schiele was concerned with subtler relationships, and he used this hair as a kind of crown for his composition.

Important inspiration for the tilted face cut off by a dark shape below came from Klimt's painting *Mother with Children* (Dobai 163; also known as *Widow, Mother,* or *Emigrant*), which was exhibited in Venice in 1910. But if one compares this detail of the head in the two paintings and their overall concept, it becomes apparent that Klimt failed to adequately express the deeper meaning of this particular subject, especially in terms of color. The woman's vivid flesh color seems inconsistent with her deeply sorrowing pose. And the children, presumably helpless and threatened, look much too winsome.

Not so in Schiele. The inherent tragedy is communicated in every part of the composition. The child is truly helpless; the mother's features are visibly distorted by grief. Her eyes have glazed over. The skin colors, the washed-out face and hand of the mother and the orange and yellow-red

Oil and pencil on wood,
12 5/8 x 10 1/8" (32 x 25.7 cm)
Initialed and dated upper right:
"S.10."
Leopold Museum Inv. 475

Provenance:
Arthur Roessler, Vienna;
Rudolf Leopold, Vienna.

Literature:
Roessler 1918, p. 58; Karpfen 1921, pl. 11; Roessler 1922; Schmidt 1956, pl. 16; Breicha and Fritsch 1964, p. 206; Comini 1974, pl. 69; Mitsch 1974, pl. 14; Vergo 1975, fig. 174; Wilson 1980; Marchetti 1984, p. 217; Werkner 1986; Hobhouse 1988, fig. 49; Stefano 1992; L 167; K 177.

Exhibitions:
Vienna 1912; Vienna 1925; Vienna 1928; Vienna, Neue Galerie 1948; Amsterdam 1956; Bern 1957; St. Gallen 1957; London 1960; Innsbruck 1963; London 1964; New York, Guggenheim Museum 1965; Salzburg 1968; Munich 1975; Venice 1984; Tokyo 1986; Zurich 1988; Tokyo 1991; Tübingen 1995; Tokyo 1997.

of the infant, clearly contrast death and life. The latter virtually glow in contrast to the surrounding blackness.

The black strokes encircling the section containing the infant are not meant to suggest folds of the mother's clothing, but rather the impenetrable barrier that traps the helpless creature: the corpse of its mother, who even in death continues to press her hand to her body as though to protect her infant.

The tragedy is genuine, and it is deeply affecting. The artistic image is wholly expressive of the subject matter. This painting, executed in the final months of 1910, is one of Schiele's most riveting creations.

[1] Compare, for example, the closely related first version of the *Self-Seer*–also executed in November/December 1910, to judge from a letter from the artist to Arthur Roessler (Wiener Stadtbibliothek, Inv. 180.640)–or the *Nude Self-Portrait, Grimacing* (Graphische Sammlung Albertina, Inv. 30.766). Regarding the latter, see Leopold 1972, p. 144.

In his chapter on Schiele's mother pictures, Arthur Roessler (1948; 1st ed. 1922) reports that the artist painted this picture on December 24, 1910, and gave it to him as a Christmas present that same evening. This is contradicted by a letter from the painter dated January 10, 1911, in which he begs Roessler to bring him the money for the *Dead Mother*. (Roessler had published that letter himself long before, in his *Briefe und Prosa von Egon Schiele,* Vienna, 1921, pp. 49–51.)

Moreover, Roessler relates (1948, pp. 22–24) that in 1911 Schiele brought him "five pictures painted in only four days on small wood panels," the pigments "still wet." These were *Self-Portrait* (1911, L 194), *Wally* (1912, L 212), *Bedroom in Neulengbach*, which the artist called *My Living Room* (1911, L 193), *Still Life* (1911, L 192), and *Tree in Early Spring*, actually the painting *Small Tree in Late Autumn* (1911, L 199). Yet some of these works were, in fact, executed months apart from each other; it is not true that Schiele painted them "in only four days." Accordingly, we need hardly take seriously Roessler's contention that the *Dead Mother* was painted "in a few hours" on December 24, 1910, after a night spent on the train, and that Schiele gave him the "still wet" picture that very evening.

The painting is small, to be sure, but it is executed with such care that it seems highly unlikely that Schiele could have produced it in such a short time. Moreover, the artist made at least one drawing in preparation for it (see pl. 40).

Most of Roessler's "recollections" are either contradicted by the known facts or are at least highly suspect. There is therefore no need to accept his assertion that this painting was executed in late December 1910–December 24 would have been impossible in any case. To judge from the changes in Schiele's style in that year, it seems more likely that he painted the work somewhat earlier, though admittedly sometime during the period November–December.

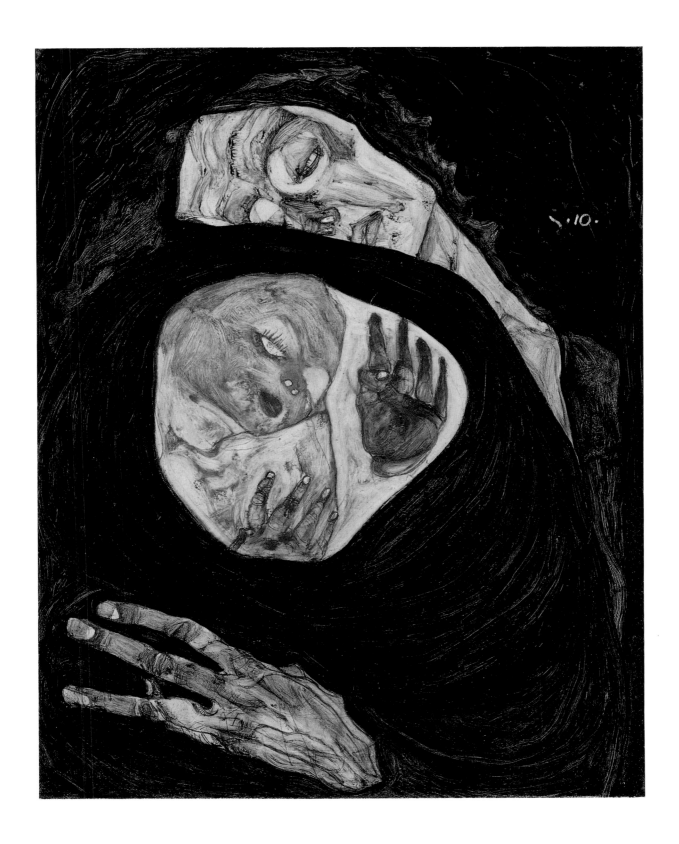

[2] It is difficult to determine whether or not Schiele was inspired in this work by Margaret Macdonald Mackintosh's plaster relief *Heart of the Rose,* from 1902 (*Charles Rennie Mackintosh: The Complete Furniture, Furniture Drawings & Interior Designs,* London, 1979, p. 119). The relief depicts two women, and in the belly of the one in the foreground there is a nearly circular opening like a rose, in the center of which lies a tiny naked infant.

It is not certain whether Schiele had either seen the relief or even heard of it. A copy, executed by Mackintosh, was in the music salon of Fritz Wärndorfer, one of the co-founders of the Wiener Werkstätte, but Wärndorfer was not a Schiele collector, nor was he acquainted with him.

Although he may have been inspired by the work of other artists–and was certain to have been by Klimt's *Mother with Children*–what Schiele brought to the subject matter and the composition is far more important, and that is what gives the work its power.

[3] The influence of Kokoschka's *Pietà* is much more apparent in Schiele's earlier *Young Girl Sitting in a Flowery Meadow* (pl. 12), which was meant to represent spring in a cycle of the seasons.

42 *Seated Nude Girl with Stockings and Shoes*
 (Sitzendes nacktes Mädchen mit Strümpfen und Schuhen)
 1910

The chair, the right arm, and the bottoms of the feet have been omitted for compositional reasons. We only realize that the girl is, in fact, sitting down from the notch in her right hip and thigh. Schiele achieved a degree of delicacy in this soft pencil drawing from late 1910 that he would never surpass.

The same girl, here posed innocently enough, also served as the model for some highly erotic images in late 1910 and early 1911. Some are simple drawings, others are colored with pigments that Schiele mixed, so as to produce more graphic structures, with Syndetikon, a common adhesive at the time made of carbohydrates and water glass.

Pencil on paper, 22 x 14 1/2"
(55.8 x 36.8 cm)
Initialed and dated lower right:
"S.10."
Leopold Museum Inv. 1390

Provenance:
Neue Galerie am Landesmuseum
Joanneum, Graz, Inv. no. 10806;
Rudolf Leopold, Vienna.

Literature:
Nebehay 1979, fig. 77; Nebehay 1980, fig. 99; Whitford 1981, fig. 60; K 576.

Exhibitions:
Darmstadt 1967; London 1971; Bregenz 1971; Munich 1975; Wörgl 1977; Brussels 1981; Vienna 1985; Zurich 1988; Tokyo 1991; Tübingen 1995; Tokyo 1997.

43 *Standing Girl with Hands Together (Gerti Schiele)*
 (Stehendes Mädchen mit aneinandergelegten Händen [Gerti Schiele])
 1910

This drawing, executed with a soft pencil, could only have been done at the end of 1910 or the beginning of 1911. The playful lines describing the hat and its fringed band–the delicate vertical lines to the right of the head–the rendering of the wisps of hair to the left of the neck, and finally the heavier outlines of the blouse would suggest a date of 1911.

The drawing of this head, especially, is lifelike and magical.

Pencil on paper,
22 x 14 5/8" (56 x 37.2 cm)
Not signed, not dated
Leopold Museum Inv. 1389

Provenance:
Neue Galerie am Landesmuseum
Joanneum, Graz, Inv. no. II/10.803;
Rudolf Leopold, Vienna.

Literature:
K 509.

Exhibitions:
Darmstadt 1967; Wörgl 1977; Tokyo 1991; Tübingen 1995.

42 *Seated Nude Girl with Stockings and Shoes.* 1910

43 *Standing Girl with Hands Together (Gerti Schiele).* 1910

44 *Draped Self-Portrait*
 (Selbstdarstellung mit Umhang)
 1911

Pencil on paper, 20 1/4 x 10 5/8"
(51.5 x 27.1 cm)
Not signed, not dated
Leopold Museum Inv. 1388

Provenance:
Gutekunst & Klipstein, Bern;
Christian M. Nebehay, Vienna;
Rudolf Leopold, Vienna.

Literature:
Leopold 1972, pl. 65; K 942.

Exhibitions:
Bern 1956; Innsbruck 1963; Zurich
1988; Tokyo 1991; Tübingen 1995.

Schiele would never have dreamed of producing a drawing like this, in which the lines of the drapery scarcely suggest fabric, let alone the figure underneath, before 1911. In this remarkable self-portrait the lines in question were meant primarily to produce a free, graphic structure. They are very well-defined, but at the same time differentiated with extreme care.

The suggestion of abstraction in this composition links it to the paintings *Poet* and *Self-Seer II* (pls. 45 and 46). The drawing of the face and the position of the hands also reveal a direct connection to those works.

Oil on canvas, 31 5/8 x 31 1/2"
(80.5 x 80 cm)
Initialed and dated upper left:
"S.11."
Leopold Museum Inv. 450

Provenance:
Arthur Stemmer, Vienna, later
London; Rudolf Leopold, Vienna.

Literature:
Gütersloh 1911; Leopold 1972,
pl. 66; Comini 1974, fig. 72; Mitsch
1974; Malafarina 1982, no. 164;
Marchetti 1984; Friesenbiller 1985;
Nebehay 1989; Stefano 1992;
L 172; K 192.

Exhibitions:
Munich, Neue Kunst Hans Goltz
1912; Vienna 1925; Berlin 1926;
Frankfurt 1926; Vienna 1928;
London 1964; New York,
Guggenheim Museum 1965;
Vienna, Österreichische Galerie
1968; Munich 1975; Venice 1984;
Tokyo 1986; Charleroi 1987; Zurich
1988; Tokyo 1991; Tübingen 1995.

Schiele's poet–obviously given his own features–is not at home in the world and seems virtually crushed by its weight. He is a troubled, melancholy ecstatic. This is nevertheless communicated in an image of great formal discipline. Only Schiele would have been capable of combining the two. The first hint of such a composition is the ink and watercolor drawing of a girl sitting in a meadow (pl. 12) from roughly a year before, but here all traces of *Jugendstil* have been abandoned.

The aureole that frequently surrounds the head in Klimt's portraits was included for purely decorative purposes; see, for example, Klimt's 1902 *Portrait of Emilie Flöge* (Dobai 126). In Schiele, however, the aureole above the head is an element of the compositional structure.

The dark garment covers all but a narrow strip of the figure's left shoulder, creating a shape that appears to be a long, thin neck (Schiele had already produced a similar effect in his portrait of the painter Karl Zakovsek, L 148). The left hand appears unnaturally thin as well. Its lack of a thumb is a Schiele trademark; he frequently either omits the thumb altogether or draws it bent at a sharp angle or turned into the palm of the hand.

The line below the head and the neck serves as a kind of upper border for the composition, one that is supported by the right hand and the column of the nude torso. The displacement of this support to the side is balanced by the right thigh, the lower part of which was deliberately painted in vivid colors so that it forms a counterpart to the face. The left hand, which crosses the other at a right angle, also has its specific importance within the composition, and the same can be said of the outer contour of the black garment, even though it is not very distinct against the only slightly lighter background.

The face was drawn with the brush, which again produced a wealth of formal correspondences in its details. If one compares this manner of drawing with the brush to that of van Gogh, one notes that in the latter the lines and dots inspired by Seurat are highly agitated, creating a swirl-like movement. Schiele, by contrast, produces a vivid yet carefully controlled complex of lines. It is ingenious how Schiele relates the slits of the eyes to the different curves of the eyebrows, extends these in turn into the lines of the nose, allows the upper lip to rise in two peaks toward the mismatched nostrils, has the rounded line of the lower lip mirror the upper line of the chin, and structures the latter as a triangle resting on the black garment.

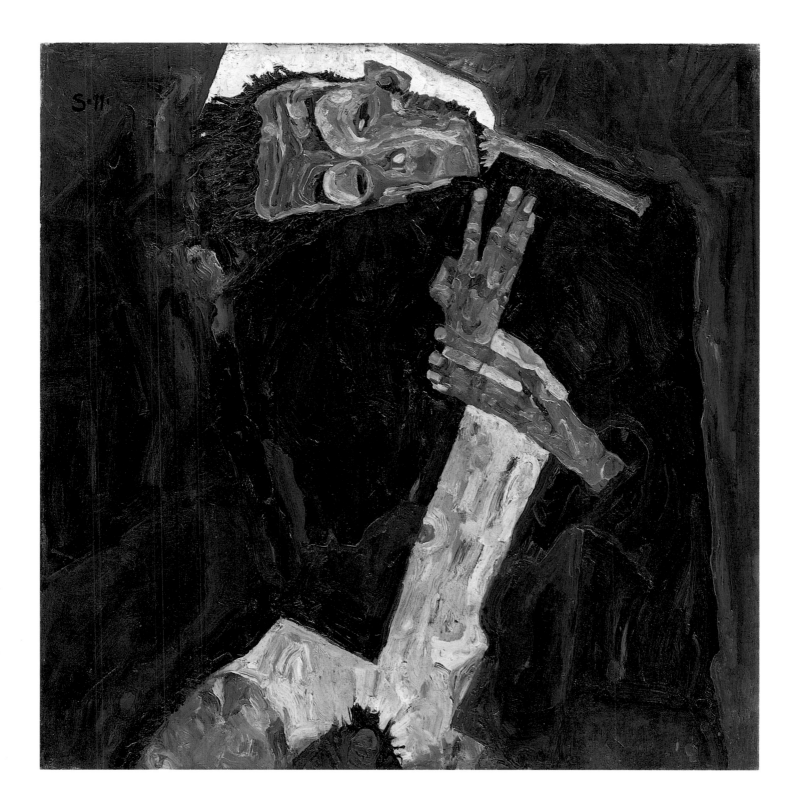

Schiele's self-exposure, both psychological and physical, goes so far as to include the glans of his penis, which he exploits for its bright red color. That spot of red, another at the navel, and a third at the ear become focal points, growing lighter toward the top. Ultimately, the formal qualities of the drawing and the colors, for all their expressiveness, are of equal importance. The dramatic contrast of light and darkness that Schiele selected for his composition is enriched by a multitude of bright but harmonious colors placed with great bravura.

46 *Self-Seer II*
 ("Selbstseher" II)
 1911

Appropriately, Schiele also referred to this painting as *Death and Man.*
The painter is sunk in meditation, his eyes closed. The red spots in the
center of the lids suggest the intensity of his inward gaze. He sees himself
and his approaching fate. His face appears a second time directly behind
him, but this one is deathly pale, the mouth open, the cheeks sunken. It is
the face of a corpse. The doppelgänger's bleached-out shroud billows up
behind the figure and to his right. The agitated brushstrokes of the
background and a mysterious eye-like object on the right heighten the
sense of the uncanny.

Any number of artists have portrayed themselves in the presence of
Death, the latter usually in the form of a skeleton–an image that the
twentieth century no longer finds frightening. Gustav Klimt even used the
skeleton decoratively, arming it with a small red cudgel in *Death and Life*
of 1915 (Dobai 183). Schiele was more up to date; even as early as 1911
the twenty-one-year-old managed to depict Death in a way one might
imagine it even today. That is why this painting is so disturbing.

Even with subject matter such as this Schiele maintained control,
refusing to abandon his picture to formlessness and chaos. His compo-
sition is highly calculated, its forms clearly defined. It is particularly
fascinating to see how he balances the strangely light area that backs his
figure's right side with a few brushstrokes in a very similar tone roughly
in the center of the opposite side. The painting is dominated by shades of
brown, which are everywhere enriched by traces of a cinnabar–red, a
muted green, and black.

In the drawing reproduced in plate 44, which is related both to this
painting and to the *Poet,* the arms also form a right angle. Here, however,
the situation is somewhat puzzling: the section of the forearm below this
intersection is the same color as the arm crossing it, a shade very similar
to that of the figure of Death. Given the position of the left arm (imagine it
somewhat elongated between the shoulder and elbow), it is possible that
this is the arm of Death. Yet both the spread fingers of the other
hand–the thumb, as so often, is bent sharply toward the palm–and their
somewhat darker color make it clear that it belongs to the living man. In
this period Schiele tended toward abstraction and frequently ignored
anatomical accuracy for the sake of a more effective composition. In this
instance it is unclear whether he simply wished to balance the pale face
of Death with a similar color in the bottom half of the painting, thereby

Oil on canvas, 31 5/8 x 31 1/2″
(80.5 x 80 cm)
Initialed and dated lower left:
"S.11."
Leopold Museum Inv. 451

Provenance:
Max Hevesi, Vienna;
Neue Galerie, Vienna;
Galerie St. Etienne, New York;
Rudolf Leopold, Vienna.

Literature:
Hofmann 1968, pl. 7; Leopold
1972, pl. 67; Mitsch 1974, fig. 36;
Comini 1974, fig. 87; *Mizue* 1977,
p. 33; Wilson 1980, pl. 43;
Whitford 1981, fig. 79; Malafarina
1982, no. 165; Dube 1983, p. 72;
Marchetti 1984, p. 227; Werkner
1986, fig. 80; Gordon 1987, fig. 29;
Nebehay 1989, fig. 21; Stefano
1992; L 173; K 193.

Exhibitions:
Vienna 1923; Vienna 1924; Vienna
1928; Zurich 1930; Bern 1937;
Paris 1939; New York 1948;
Amsterdam 1956; Bern 1957;
St. Gallen 1957; Innsbruck 1963;
Munich 1964; London 1964; New
York, Guggenheim Museum 1965;
London 1971; Munich 1975; Tokyo
1986; Charleroi 1987; Zurich 1988;
Tokyo 1991; Tübingen 1995.

solidifying the composition vertically as well as from side to side, or whether he intended to have the hand of the living figure clasped by the arm of Death. Inasmuch as this is Schiele, it is also perfectly possible that the ambiguity was intended.

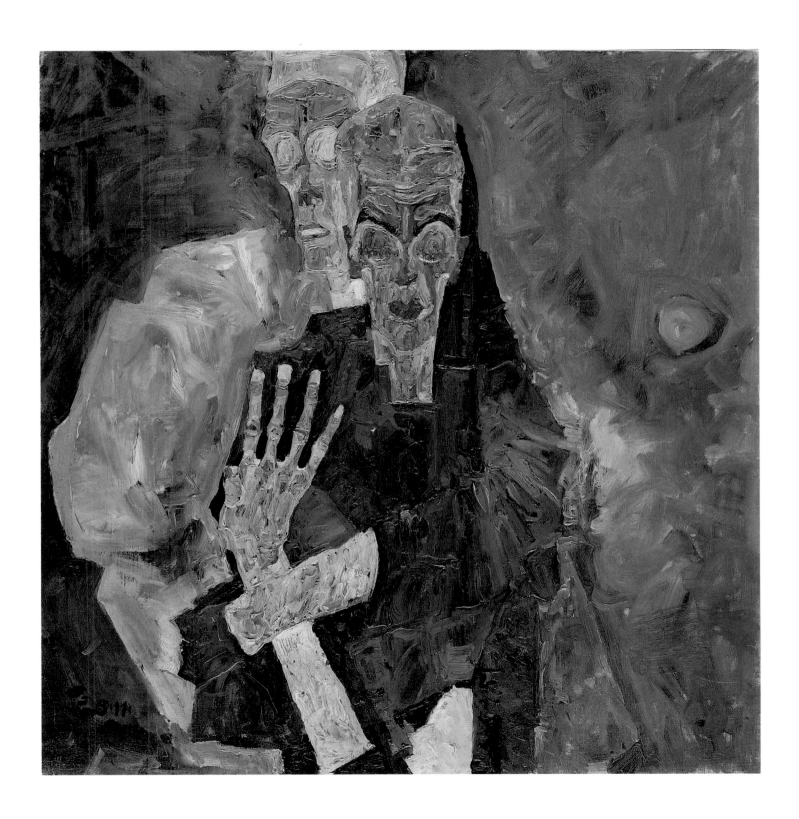

47 *Girl with Crossed Legs*
 (Mädchen mit übereinandergeschlagenen Beinen)
 1911

Gouache, watercolor,
and pencil on paper,
21 1/8 x 14 1/8″ (53.5 x 36 cm)
Initialed and dated upper right:
"E. S. 1911."
Leopold Museum Inv. 2342

Provenance:
Bey Behcet Özdoganci;
Rudolf Leopold, Vienna.

Literature:
Leopold 1972, pl. 69; K 828.

Exhibition:
Tübingen 1995.

A woman with a catlike face–in underwear and skirt–sits with one leg resting on the other. We therefore see her lace bloomers and a bit of her pubic hair, which Schiele has rendered in a dark red. Emphasis on the genitals–whether out of lust or compulsion or both–is a constant in Schiele.

The legs are so large because they are closer to the viewer and perspective demands that they be so; Schiele exploits the black of the stockings as a contrast to both the whiteness of the undergarments and the aureole surrounding the figure, important elements in his composition. The upper outline of the crossed leg forms a triangle with the hem of the skirt, one that is as though rotated to the left and backed by an irregular oval shape, possibly an armchair. Also, the axis of the upper body and head slants slightly to the left. It is only the opposing direction of the left leg and the bend in the outline of the background oval next to it that solidifies the composition.

The black of the stockings and the reddish-brown and blue of the inside of the skirt stand out against the delicate gray of the oval background. The hair repeats these tones and is rendered with a similarly fluid kind of painting. This is a very important feature, given Schiele's further development in 1911, whereas the sharper contrasts between the black, the red, and the white–the stockings and their garters, the undergarments, and the aureole surrounding the figure–are already familiar from works done in the last months of 1910.

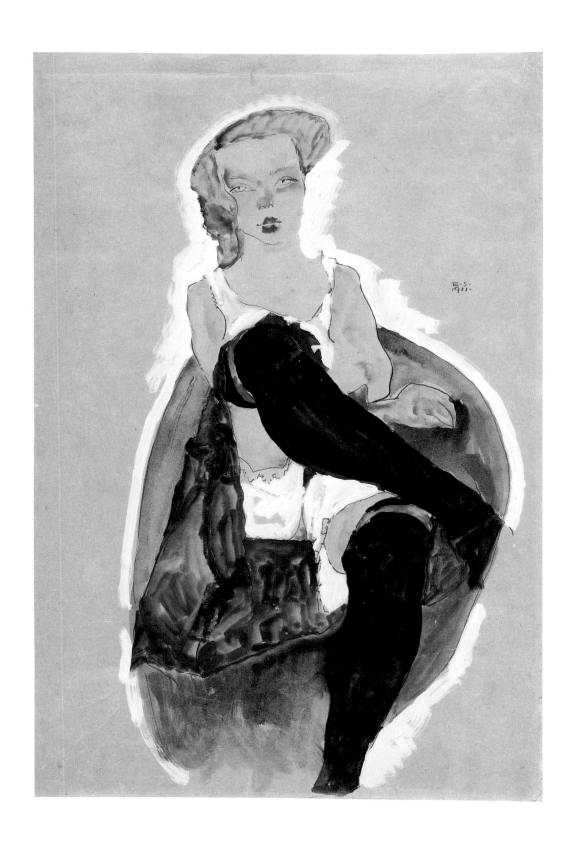

48 *Houses at the Foot of a Slope with Stations of the Kreuzberg Mountain (Krumau)*
 (Häuser vor Anhöhe mit Kreuzberg Wegstationen [Krumau])
 1911

Pencil on paper, 12 3/8 x 17 5/8"
(31.5 x 44.8 cm)
Signed and dated lower left:
"EGON SCHIELE 1911"
Leopold Museum Inv. 1412.

Provenance:
Rudolf Leopold, Vienna.

Literature:
K 984.

Exhibitions:
Vienna 1970; Tübingen 1995.

This scene is a slope of the Kreuzberg Mountain near Krumau. The foreground has been left empty deliberately, so that the houses do not appear too close. They stand out clearly against the stations of the Kreuzberg above and behind them. The traces of shading around them also help them to project forward in space.

Schiele was only concerned with the essentials of the motif, and despite its seemingly sketchy quality, the composition is self-contained. His drawing, with considerable pressure of a soft pencil, is masterful.

49 *Wall and House in a Hilly Landscape with Fence*
 (Mauer und Haus vor hügeligem Gelände mit Zaun)
 1911

Oil on canvas, 20 1/2 x 19 1/8"
(52 x 48.7 cm)
Initialed and dated upper left:
"ES 1911"
Leopold Museum Inv. 476

Provenance:
Alfred Spitzer, Vienna;
Franz Wotruba, Vienna;
Rudolf Leopold, Vienna.

Literature:
Malafarina 1982, no. 166; L 174;
K 208.

Exhibitions:
Vienna 1928; Brussels 1961;
London 1964; Vienna, Österrei-
chische Galerie 1968; Zurich 1988;
Tokyo 1991; Tübingen 1995; Tokyo
1997.

This picture was painted not long after the *Self-Seer II* (pl. 46), as is clear not only from its style of painting but also its colors. Here Schiele was even less concerned with reality, freely inventing whatever struck him as necessary.

This wall and house with a small tower, and especially the bit of crenellation on the right, may have been seen in Krumau, but they have been placed in a wholly different setting, a hilly landscape with a fence extending toward the back. In addition, the right side of the tower surely did not slant inward this way in reality. Schiele chose to paint it like this for formal reasons, opposing the slant with diagonal lines, including those of the fenceposts, running in the other direction. The composition seems to be much more abstract than that of the *Self-Seer II,* its painterly *chiaroscuro* more pronounced. Yet for all its abstraction, the somewhat mysterious scene makes a powerful impression. Schiele achieved much the same effect in a very different way in his *Autumn Tree in a Gust of Wind* (pl. 80).

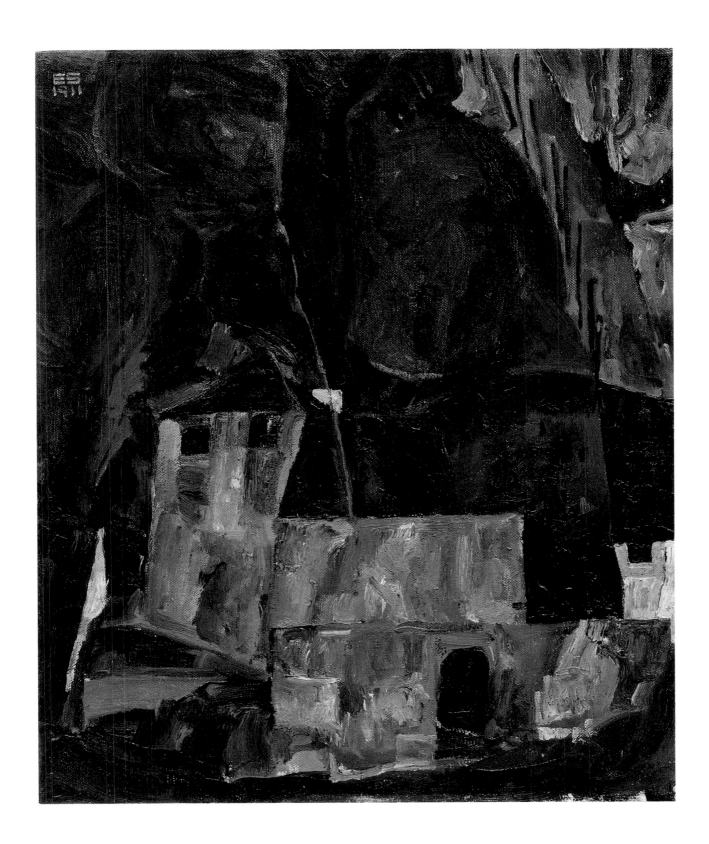

50 *Black-Haired Girl with Raised Skirt*
(Schwarzhaariges Mädchen mit hochgeschlagenem Rock)
1911

Gouache, watercolor,
and pencil on paper,
22 x 14 7/8" (55.9 x 37.8 cm)
Initialed and dated center right:
"E.S. 1911."
Leopold Museum Inv. 2307

Provenance:
Bey Behcet Özdoganci;
Rudolf Leopold, Vienna.

Literature:
Leopold 1972, pl. 71; Nebehay
1989; Stefano 1992; K 859.

Exhibitions:
Zurich 1988; Tokyo 1991;
Tübingen 1995.

Although certain details in this drawing are very similar to those in plate 47–note, for example, the way the corners of the mouth are formed–the watercolors have been applied in a very different manner. Schiele's breakthrough into a more painterly style is especially apparent in his rendering of the hair, the face, and the lifted skirt. The abundant hair is virtually monochrome, with only lighter and darker tones of a grayish brown-black, but painted with a remarkable degree of freedom that perfectly captures its texture. The pale face with delicately shaded red and gray around the eyes and on the cheeks and mouth forms a startling contrast. The dark skirt shimmers with color, even though its predominant tone is again a gray-black. The bottom edge of the larger section of it is tinted with a strong blue that recurs in a similar shade at the top of *Dead City III* (pl. 53), where it is also used to mark the boundary between light and dark.

The neutral-colored upper body, with its only minimally suggested structure, serves more to separate the head and torso than to connect them. It sets off the face, with its slightly open mouth, closed lids, and flowing black hair, from the lower body, framed by the dark skirt. The focal point of this lower portion is the woman's sex peeking out from her white underclothes. Shaped like a heart, it becomes virtually an object of adoration. For Schiele it clearly was.

In this drawing, Schiele transformed a girl's erotic fantasy into art, capturing it in a masterly display of painting.

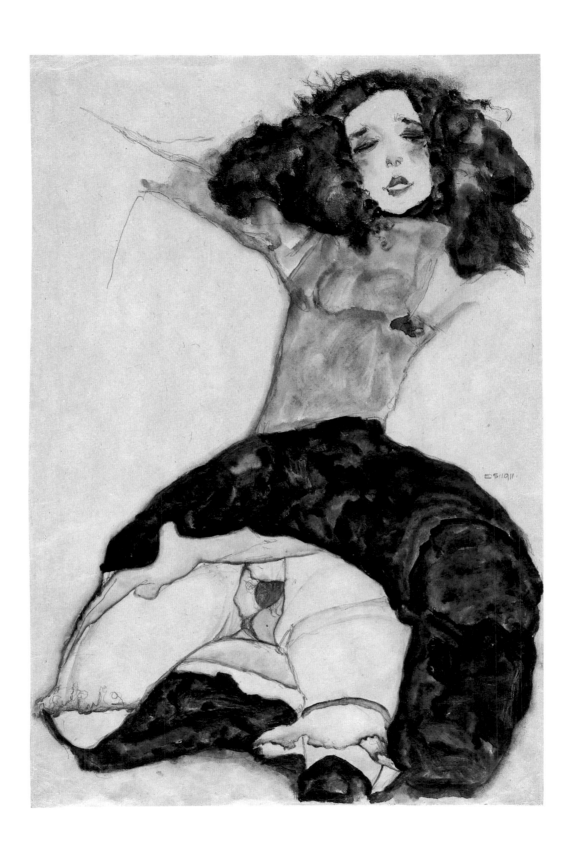

51 *Reclining Female Nude*
(Liegender Frauenakt)
1911

Pencil on paper, 12 1/8 x 17 5/8"
(30.8 x 44.8 cm)
Signed and dated lower left:
"EGON SCHIELE 1911"
Leopold Museum Inv. 1401

Provenance:
Hans Dichand, Vienna;
Rudolf Leopold, Vienna.

Literature:
Werkner 1994 (2); K 854.

Exhibitions:
Tokyo 1986; Tokyo 1991;
Tübingen 1995.

The drawing here displays a sensitivity similar to that of the painting in the *Black-Haired Girl with Raised Skirt* (pl. 50). The contours of the body and limbs are traced in long, unbroken lines, the outline of the hair only suggested with light hatching. The face, however, is set off by a heavy, shaded line, and the neck that connects it to the body is deliberately omitted. This allowed Schiele to both emphasize the face and juxtapose it to the genitals, also rendered with heavier shading. He used this method in numerous drawings of female nudes, but one also sees the same principle at work in wholly different contexts, for example, the painting *Autumn Tree in a Gust of Wind* (pl. 80).

The face and genitals become the focal points–both formally and psychologically. This face, with its narrowed eyes gazing to the side and slightly open mouth, is as expressive of the reclining woman's lasciviousness as is her uncommonly graphic sex. Was it she who was filled with desire or Schiele, the voyeuristic observer?

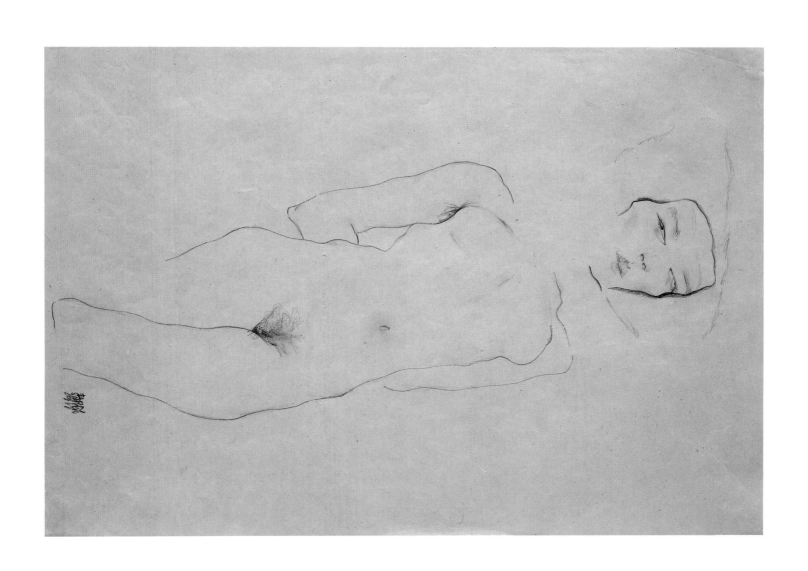

52 *Girl with Bared Torso*
(Mädchen mit entblösstem Unterleib)
1911

Gouache, watercolor,
and pencil on paper,
21 1/4 x 14" (54 x 35.6 cm)
Signed and dated bottom center:
"SCHIELE 1911."
Leopold Museum Inv. 2343

Provenance:
Bey Behcet Özdoganci;
Rudolf Leopold, Vienna.

Literature;
Leopold 1972, pl. 76; K 843.

Exhibition:
Tübingen 1995.

This image fills most of the surface of the sheet and therefore seems closer to the viewer. The girl is virtually offering herself: her eyes are half closed, her tongue shows suggestively in her slightly opened mouth. Her eyelids, cheeks, mouth, and genitals are highlighted with red.

The blouse is painted with great delicacy in rich colors. The same tones are repeated in much more delicate tints in the flesh and in darker, stronger shades in the stockings. The upper edge of the blouse is convex, whereas its lower edge is a double curve that is mirrored in the line of the top of the stockings. The blouse and the stockings, which serve to set off the exposed body between them, are thus related to each other by both line and color.

As so often in drawings of this period, Schiele left the face largely free of color (see, for example, pl. 50) so that it stands out as a light area surrounded by darker shades. It is set off by a sharp outline, part of which is only the edge of the adjacent color. For the sake of color harmony, the hair, which with its bold outline serves to crown the composition, is painted a violet-brown.

The soft, wavy contours of the body are similar in style to those in the drawings *Seated Girl with Raised Skirt* (pl. 58) and *Standing Female Nude with Arms Crossed Over Her Breast (Moa)* (pl. 60).

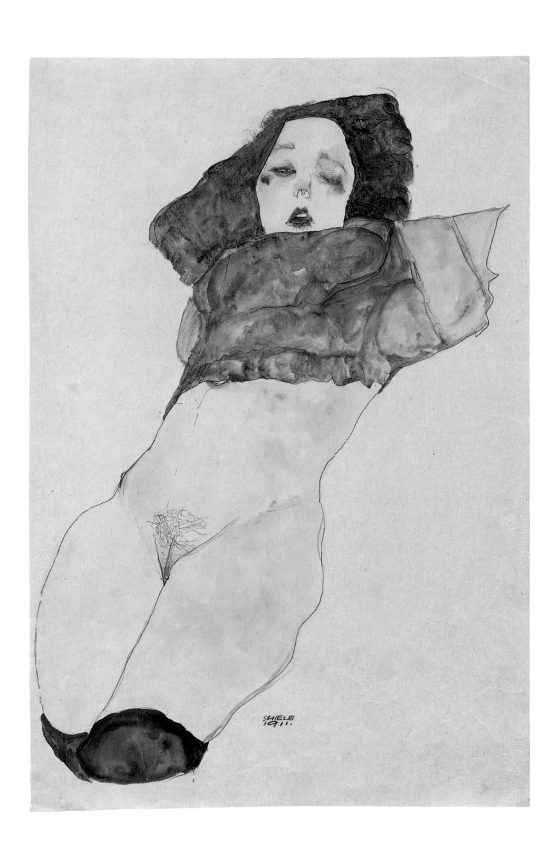

53 Dead City III ("Tote Stadt" III) 1911

Oil and gouache on wood,
14 5/8 x 11 3/4" (37.3 x 29.8 cm)
Signed and dated upper right:
"EGON SCHIELE 1911."
Leopold Museum Inv. 460

Provenance:
Arthur Roessler, Vienna;
Alfred Spitzer, Vienna;
Fritz Grünbaum, Vienna;
Gutekunst & Klipstein, Bern;
Galerie St. Etienne, New York;
Rudolf Leopold, Vienna.

Literature:
Karpfen 1921; Leopold 1972, pl. 72;
Mitsch 1974; Whitford 1981;
Malafarina 1982, no. 173; Werkner
1986; Nebehay 1989; L 182; K 213.

Exhibitions:
Vienna 1912; Vienna 1925; Vienna
1928; Bern 1956; Innsbruck 1963;
London 1964; New York,
Guggenheim Museum 1965;
Vienna, Österreichische Galerie
1968; Munich 1975; Venice 1984;
Tokyo 1986; Zurich 1988; Tokyo
1991; Tübingen 1995; Tokyo 1997.

Schiele had already painted this group of houses in Krumau in the fall of 1910 (L 157; see illustration below), and even then he had introduced changes into his motif. In 1911, as one of a series of small-format views of Krumau (L 177–80, 183), he reworked the same subject on a small wood panel. It was probably this cityscape that Schiele referred to in a letter to Arthur Roessler dating from roughly the end of August 1911, saying that he had as yet held it back, and believed that it "is the most solemn in color." In any case, the twenty-one-year-old Schiele created with this painting a striking, fantastic vision.

Here the block of houses appears to have been pulled forward somewhat and isolated more completely than it was in the first version from 1910. The blue-black river still flows beside the houses to the left. The sides of the block form two lines that diverge slightly as they extend upward. The houses are here seen from a higher angle so that the roofs are elongated and the front-facing facades are foreshortened. (For compositional reasons, one wall, the narrow, windowless one at the top, has been lengthened.) This steeper vantage point and the change in the row of windows in the facade on the left from a horizontal to a slight diagonal heighten the three-dimensional effect, especially of the houses in front. This is apparent even in details, such as the shed that projects forward from the house in the center.

The striking arrangement of light and dark areas in this 1911 painting results in a more self-contained composition. The colors, mainly dark, sonorous tonalities enlivened in areas with more intense values–note the greenish-blue that edges the light narrow wall at the top (see pl. 50) and the touch of carmine-pink to the right of it, next to which is a somewhat wider patch of grayish-blue–produce a rich pictorial uniformity. Light reflections shimmer off the roofs; some of them almost appear to be in motion.

First version of *Dead City*. 1910.
Watercolor, gouache,
and Syndetikon on paper

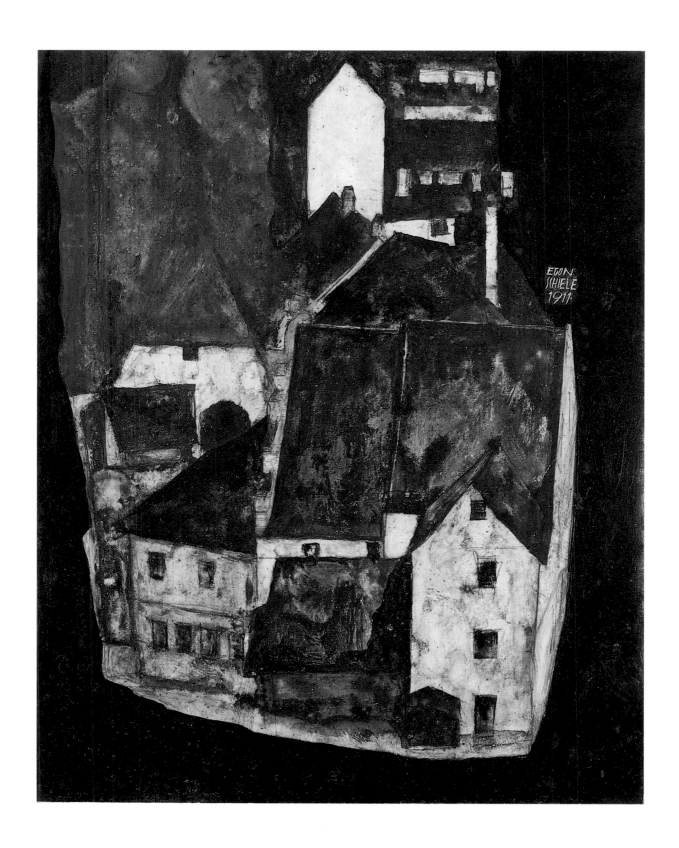

Gouache, watercolor,
and pencil on paper,
17 1/2 x 12″ (44.5 x 30.4 cm)
Signed and dated center right:
"EGON SCHIELE 1911"
Inscribed center left:
"ANTON PESCHKA!"
Leopold Museum Inv. 1381

Provenance:
Dorotheum, Vienna (auction), 1954;
Rudolf Leopold, Vienna.

Literature:
Leopold 1972, pl. 74; Akademische
Druck- und Verlagsanstalt 1985;
K 934.

Exhibitions:
Berlin 1960; Munich 1975; Tokyo
1986; Tübingen 1995.

In this painting the more intense blue, red-violet, and violet tones are achieved with thicker pigments. Schiele used them to create more graphic structures in those areas, contrasting them against the lighter shirt painted in watery colors with a tendency to run. The head, torso, and arms of this very painterly portrait are still quite recognizable as reflections of the reality before him, but in the areas rendered in black–the trousers–and in violet and various shades of blue, Schiele invented more freely. These colors are contrasted with the browns, ochers, and oranges of the hair and flesh tones.

The painting seems somehow restless owing to the great variety of colors and the different ways in which they have been applied, yet the face of his model, comfortably seated with his eyes closed, wears an expression of inner calm and manly earnestness.

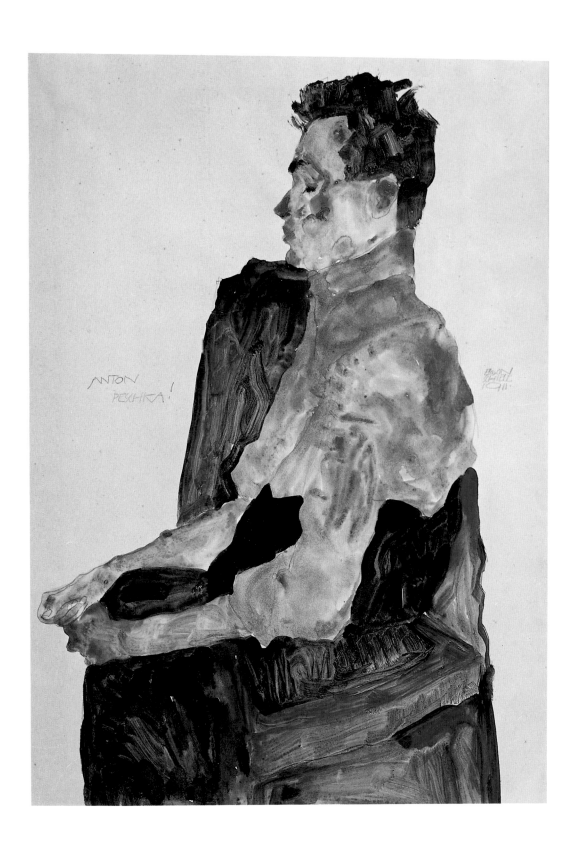

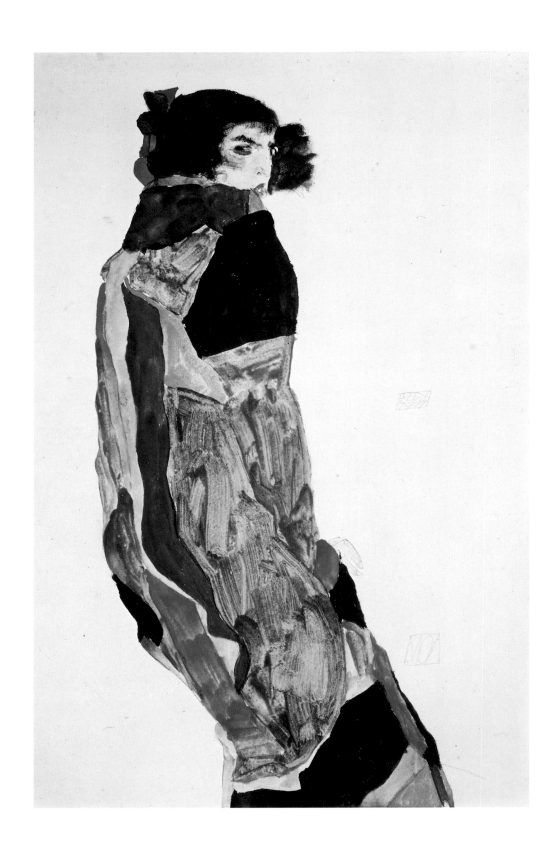

55 *Moa, the Dancer*
 (Moa, die Tänzerin)
 1911

This rendering of a dancer swathed in bright fabrics is noteworthy in that it demonstrates how far Schiele distanced himself from his early indebtedness to Klimt. Because this type of draped figure was a virtual trademark of the older painter, it is readily apparent how very differently Schiele has approached it. In Klimt's paintings, the areas of decorative fabric become stiff and architectural; Schiele treats them not as ends in themselves, pictures-within-pictures, as it were, but as flowing elements integrated into the diagonal pose. Their surfaces and bands of color seem to be in motion and therefore evoke a dancer's movements.

Just as Klimt frequently topped his ornamental drapery structures with a highly realistic face, Schiele has also rendered the face and hands in a more literal way, using a different style of drawing and painting from that employed for the drapery. The face is left almost entirely free of color and, because of the contrast with the black hair that frames it, seems even lighter than it is. The eyes are deep black and highly expressive. The lower lip and the nostrils are exaggerated so as to balance them.

The similarity to Klimt in this deliberate contrast between a realistic face and abstract, decorative drapery is only superficial. Schiele was by this time more concerned with the expressive potential of his art and had long since rejected the lovely illusions of his mentor.

Gouache, watercolor,
and pencil on paper,
18 7/8 x 12 3/8" (47.8 x 31.5 cm)
Signed and dated center right:
"EGON SCHIELE 1911."
Inscribed lower right: "MOA"
Leopold Museum Inv. 2310

Provenance:
Lea Bondy Jaray, Vienna,
later London;
Rudolf Leopold, Vienna.

Literature:
Leopold 1972, pl. 78; Nebehay
1989; Stefano 1992; K 906.

Exhibitions:
Amsterdam 1956; Salzburg 1968;
Zurich 1988; Tokyo 1991; Tübingen
1995; Tokyo 1997.

Oil on canvas, 37 3/4 x 35″
(95.8 x 89 cm)
Signed and dated lower right:
"EGON SCHIELE 1911."
Leopold Museum Inv. 527

Provenance:
Heinrich Benesch, Vienna;
Otto Benesch, Vienna;
Rudolf Leopold, Vienna.

Literature:
Malafarina 1982, no. 183;
L 191; K 216.

Exhibitions:
Vienna, Neue Galerie 1948;
Tübingen 1995.

In this bit of landscape surrounded by a fence, the fence is black, the landscape dark and autumnal. The sky, by contrast, is extremely light; in the thin spots, the black underpainting shows through, muted by a wash of white. That underpainting is visible undiluted in a black strip running down the right edge from the top to roughly the center. This strip is an important part of the composition; it serves as a wall and becomes a kind of foil, causing the fence to appear much smaller by contrast and therefore farther back.[1]

This strip also has another function in that it counters the overriding symmetry of the arrangement, centered on the light reddish-brown rectangle at the bottom, the small tree, the clothesline pole behind it, the shack at the edge of the hill, and the corner of the fence at the very back of the lot. This is one deviation from that symmetry; others are the unequal distances of the two sections of fence left and right, the corner in the fence, shifted slightly to the left, and the hill in the middle distance, which appears to be steeper on the left side. These are balanced by the opposing angle of the light reddish-brown area already mentioned and the more substantive fence on the left side. The interplay of these various elements adds a certain dynamism to an otherwise potentially static arrangement.

In this fall landscape in warm colors, the small tree has been stripped of most of its leaves and all but a single fruit. On the hill stands a windblown shack, with an even more rickety arbor structure in front of it. A black fence marks the boundaries; above it is a cold sky with crows. One can almost hear their cawing. In such a context the clothesline poles suggest the crosses in a cemetery.[2]

The sense of looking down on the scene from high above is heightened by the way the land beyond the hill lifts upward, coming to a point at the corner of the fence: a landscape seen as a cathedral. This high vantage point, from which all of the elements of the landscape have equal value, also occasions something fundamentally new. The old landscape conventions of foreground, middle distance, and background are no longer valid.[3]

With this picture Schiele also created a psychological statement: autumn's decay has become symbolic of life's impermanence.

[1] This strip was cropped in both of Otto Kallir's catalogues raisonnés (1930 and 1966). It was falsely assumed that Schiele had simply not finished painting at this edge. It is

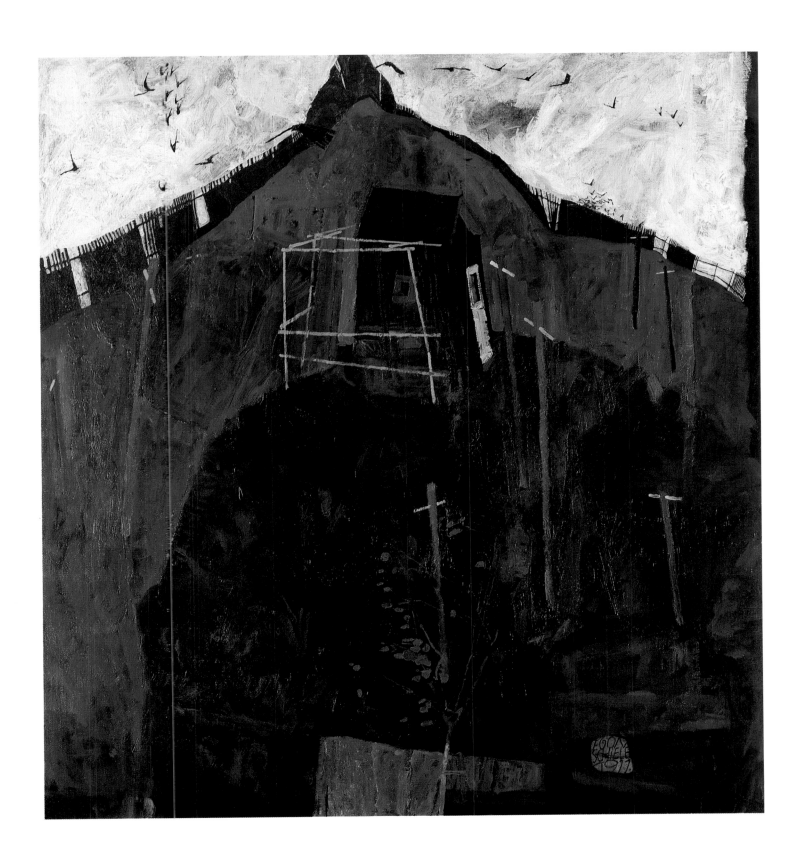

clear, however, that the artist left it unpainted quite deliberately, for he painted up to the edge below it. At the same time he also carefully reduced the irregular quadrangle of reddish-brown in the bottom center to a smaller size.

[2] This notion is also found in Hans Sedlmayr, *Verlust der Mitte* (Salzburg, 1948). However, it is mentioned in the context of a dismissive judgment based on a complete misunderstanding of the painting.

[3] By comparison, the point of view in Oskar Kokoschka's landscapes remained conventional from his earliest works to his late years–despite their novel colors and the thick pigments he employed in his pictures until 1924. He structured them with the familiar foreground, middle distance, and background that artists have used for centuries.

57 Semi-Nude (Self-Portrait)
(Halbakt [Selbstdarstellung])
1911

Gouache, watercolor,
and pencil on paper,
17 5/8 x 12 3/8" (44.7 x 31.3 cm)
Signed and dated lower right:
"EGON SCHIELE 1911."
Leopold Museum Inv. 1445

Provenance:
Stuttgarter Kunstkabinett
(auction), 1958;
Rudolf Leopold, Vienna.

Literature:
Leopold 1972, pl. 89; K 950.

Exhibitions:
Innsbruck 1963; Götzis 1965;
Vienna, Albertina 1968; Tokyo
1991; Tübingen 1995.

Schiele here presents himself as either despairing or dying.

The agitated contour lines–both those drawn with a pencil and the ones painted with a brush in black–are similar to those of the painting *Pregnant Woman and Death* (L 198), but this composition, filled with tension, appears to have been executed in a single sitting. The detail of the wavy furrows across the forehead–here traced with pencil, there with a brush–shows the great similarity in style between the two works.

Schiele painted the face in the same values as those used for the exposed portion of the body. Oddly, he even used the same colors for the cloth that wraps the body from the waist down. The color alone ensures the continuity of this tilted figure from top to bottom.

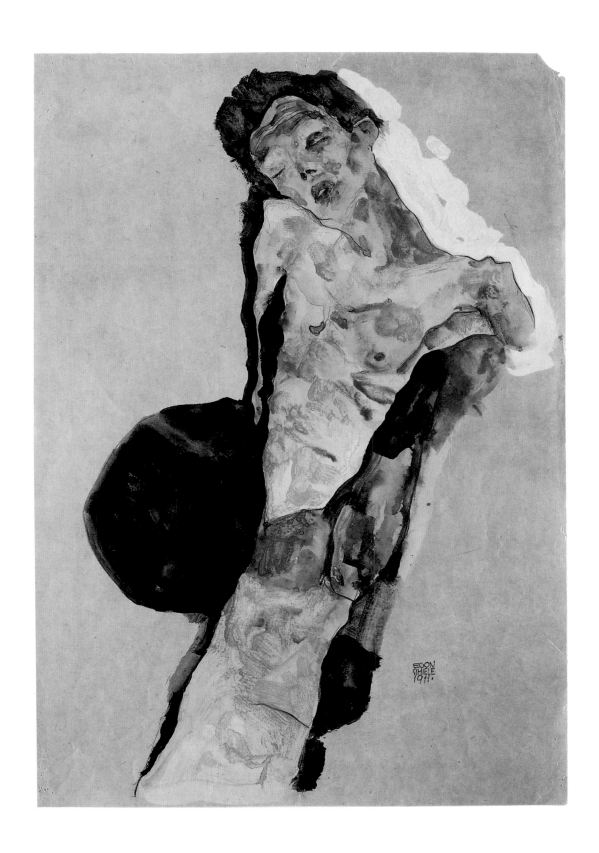

58 *Seated Girl with Raised Skirt*
(Sitzendes Mädchen mit hochgeschlagenem Rock)
1911

Pencil on paper, 18 3/4 x 12 1/4"
(47.5 x 31 cm)
Signed and dated center right:
"EGON SCHIELE 1911."
Leopold Museum Inv. 1443

Provenance:
Estate of Egon Schiele, Vienna;
Melanie Schuster, Vienna;
Rudolf Leopold, Vienna.

Literature:
Leopold 1972, pl. 75; K 921.

Exhibitions:
Tokyo 1991; Tübingen 1995.

The drawings reproduced here and in plate 59 expose their subjects in more than just a physical sense. They are erotic depictions without any of the trappings of pornography. The young girl's rather limited physical charms and her forlorn expression seem to be related. They certainly are in terms of composition. In both works the face and the genitals are emphasized and rendered in greater detail than the rest of the figure, so that they stand as focal points at the top and bottom of the picture.

In some areas the lines are deliberately interrupted. We see the almost melodious waves in them that characterize Schiele's drawing during this period. In the self-portrait, shorter lines of shading next to the delicate outlines cause the rib cage, pelvis, and hand to lift forward in space. The arm, by contrast, is relegated to the background.

Schiele's facial expression in the self-portrait is ambiguous, rather more arrogant than forlorn. Yet the rendering of the nose and mouth is very similar in both drawings; the artist's lips and those of the girl are virtually identical.

Both drawings were made with the very hard pencil that Schiele favored at this time.

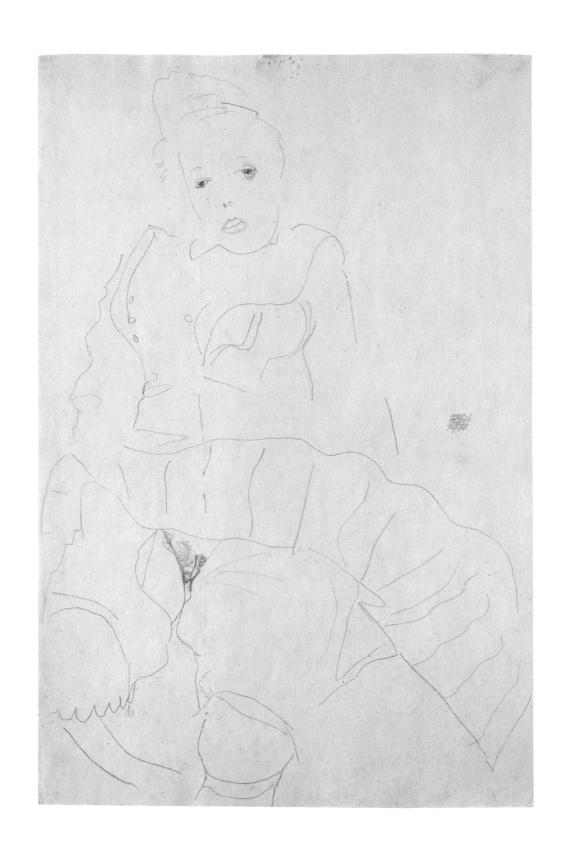

59 *Nude Self-Portrait, with Hand on Genitals*
 (Selbstakt, Hand am Genitale)
 1911

Pencil on paper, 18 3/4 x 12 1/8"
(47.7 x 30.8 cm)
Signed and dated center right:
"EGON SCHIELE 1911."
Leopold Museum Inv. 2380

Provenance:
Estate of Egon Schiele, Vienna;
Melanie Schuster, Vienna;
Rudolf Leopold, Vienna.

Literature:
Leopold 1972, pl, 75; K 949.

Exhibition:
Tübingen 1995.

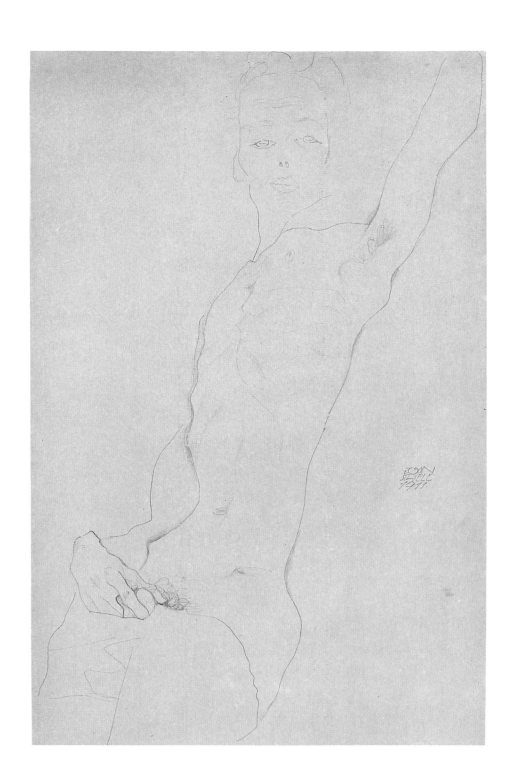

60 *Standing Female Nude with Arms Crossed Over Her Breast (Moa)*
(Stehender weiblicher Akt mit über der Brust verschränkten Armen [Moa])
1911

Pencil on paper, 18 7/8 x 12 5/8"
(47.9 x 32.1 cm)
Signed and dated center right:
"EGON SCHIELE 1911."
Leopold Museum Inv. 1446

Provenance:
Otto Schönthal, Vienna;
Otto Schönthal, Jr., Vienna;
Rudolf Leopold, Vienna.

Literature:
Leopold 1972, pl. 77; K 909.

Exhibitions:
Tokyo 1991; Tübingen 1995.

This is a nude drawing of Moa, the dancer we have already seen in plate 55. Here Schiele elongated still further her already very slender body. It narrows to an extremely small waist, then widens again in the pelvis so that the two sections are vividly contrasted. The graphic focal point in the bottom half of the picture is the pubic hair, in the top half the shading above the eye–not, as in most other drawings, the eyes themselves.

The lines, as is typical of Schiele's drawings in this period, are almost like music: note how the single line traces the body's contour down from the left shoulder at a diagonal, changes direction at the waist, follows around the hips and buttocks, and finally resumes its original direction. The contours, with their pleasing succession of larger and smaller waves, seem to obey abstract pictorial laws, yet they leave no doubt about the shapes of the various parts of the body.

A number of formal parallels are visible between these lines and the major divisions of the body. Note, for example, the similar angles describing the two elbows, also the way the indentation at the waist on her left side is repeated on the right elbow. It was precisely for the sake of this parallel that the right arm was drawn so very long. The resulting difference in height of the two elbows also enhances the illusion that we are seeing the figure from below and gives it a distinct three-dimensionality. The lower body, seen from above, projects the same sense of three dimensions, in no small part because of the perspective rendering of the pubic hair. An imaginary diagonal joins the right and left elbow, an opposing diagonal the right hip and the curve of the left buttock; together they suggest the twist of the figure in space.

What makes the figure resemble a piece of sculpture, finally, is the great sensitivity of Schiele's line, even though it is only an outline drawn on a two-dimensional surface.

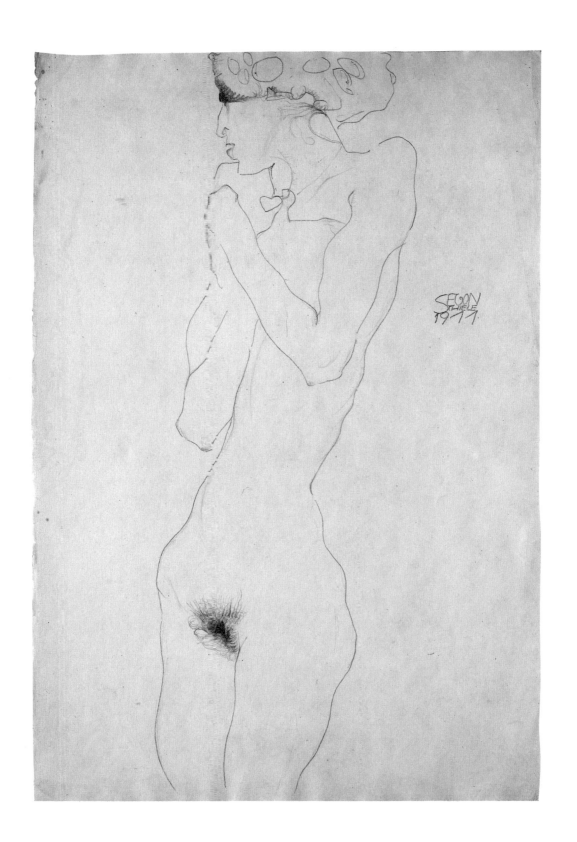

61 Small Tree in Late Autumn
(Kleiner Baum im Spätherbst)
1911

Oil on wood, 16 1/2 x 13 1/8"
(42 x 33.5 cm)
Signed and dated lower right:
"EGON SCHIELE 1911."
Leopold Museum Inv. 459

Provenance:
Arthur Roessler, Vienna;
Richard Lanyi, Vienna;
Neue Galerie, Vienna;
Galerie St. Etienne, New York;
Rudolf Leopold, Vienna.

Literature:
Leopold 1959, p. 20; Leopold 1972,
pl. 90; Malafarina 1982, no. 191;
Werkner 1986; L 199; K 222.

Exhibitions:
Vienna 1928; Zurich 1930; Vienna,
Neue Galerie 1932; Vienna 1933;
New York 1941; New York 1948;
New York 1953; Innsbruck 1963;
Salzburg 1968; Munich 1975;
Tokyo 1986; Zurich 1988; Tokyo
1991; Tobu 1994; Tübingen 1995;
Tokyo 1997.

The consistent curve of the hill mirrors the shape of the crowning branches of the tree, which are painted in similar tones. At the same time, nothing could be a greater contrast to the imperturbable solidity of the hilltop than the tree's frail, windblown silhouette.

Because the lower part of its trunk has been limed, the top of the tree and the center section with its bluish trunk and one large limb cantilevered out to the right seem cut off from the ground and are therefore juxtaposed to it. In terms of color, the olive and reddish-brown of the dead grass contrasts with the blue tones of the center section of the tree. A bright, pearl-gray sky serves as the backdrop for the hopeless struggle of this defenseless tree. It is being whipped by the wind, as one can see from the moving clouds. The trunk of the tree is hideously twisted, its natural growth having already been checked in two places. In the upper one the trunk has thickened, forming something like a head from which the thin branches reach upward like wildly gesticulating arms. The branch that extends out to the right below this can be seen as a leg, the limed trunk the other leg.

The tree has become a symbol of man's fate; there is virtually nothing to compare with its anthropomorphism in the Expressionism of the time. It almost seems that the poor tree is dancing. Essentially, however, the image is a dramatic symbol of man's isolation and vulnerability in the face of hostile forces; the dance is a dance of death.

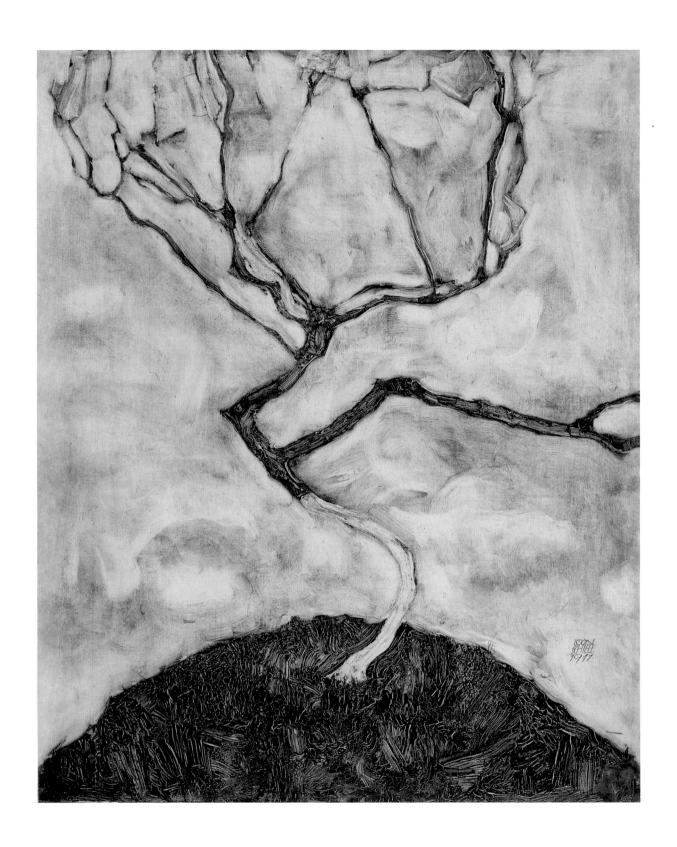

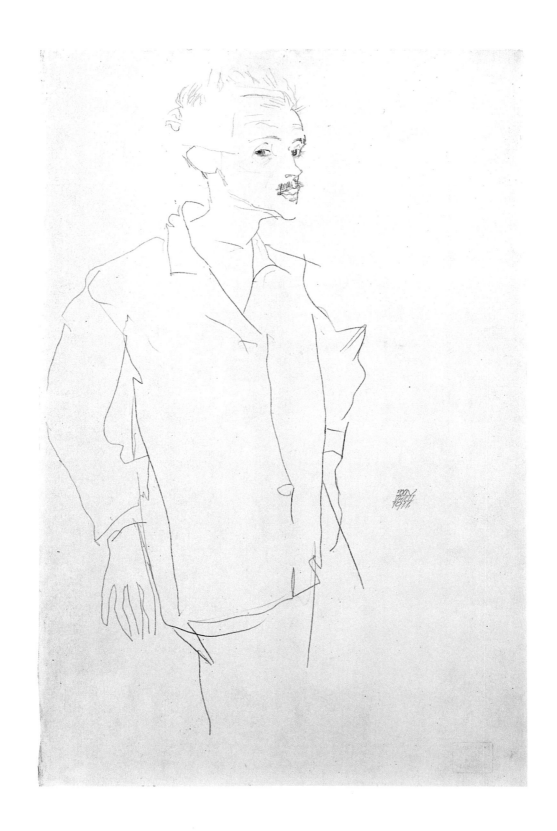

62 *Self-Portrait with Moustache*
 (Selbstbildnis mit Schnurrbart)
 1911

Here Schiele drew himself wearing an open shirt and standing relaxed in front of a mirror. A number of details, like the hand and the ear, are only sketched in. The artist has concentrated mainly on his face, which is full of life. He naturally included the moustache he wore at this time (see pl. 64).

Pencil on paper, 19 x 12 1/2"
(48.2 x 31.7 cm)
Signed and dated center right:
"EGON SCHIELE 1911."
Leopold Museum Inv. 1448

Provenance:
Viktor Fogarassy, Graz;
Hans Dichand, Vienna;
Rudolf Leopold, Vienna.

Literature:
K 960.

Exhibitions:
Lucerne 1974; Tokyo 1986; Tokyo 1991; Tübingen 1995.

63 *Nude Self-Portrait* (study for the Sema portfolio)
(*Selbstakt* [Studie zur Sema-Mappe])
1912

Ink on paper, 18 3/8 x 11 7/8"
(46.8 x 30 cm)
Signed and dated lower right:
"EGON SCHIELE 1912."
Leopold Museum Inv. 1440

Provenance:
Viktor Fogarassy, Graz;
Hans Dichand, Vienna;
Rudolf Leopolf, Vienna.

Literature:
Comini 1974; Mitsch 1974;
Malafarina 1982, no. D46;
Marchetti 1984; K 1160.

Exhibitions:
Innsbruck 1973; Lucerne 1974;
Munich 1975; Brussels 1981;
Venice 1984; Tokyo 1986; Tokyo
1991; Tübingen 1995.

This is one of the artist's studies for the lithographed self-portrait he contributed to the Sema portfolio, which was published in Munich by Delphin Verlag in April 1912. A letter dated January 23, 1912, suggests that he had already finished these studies. The presence of the moustache also helps to date the work to the first weeks of 1912 (see pl. 62).

Schiele first drew this figure in black ink, then added washes to it with great verve, in places adding still more drawing in the wet ink with the tip of the brush handle.

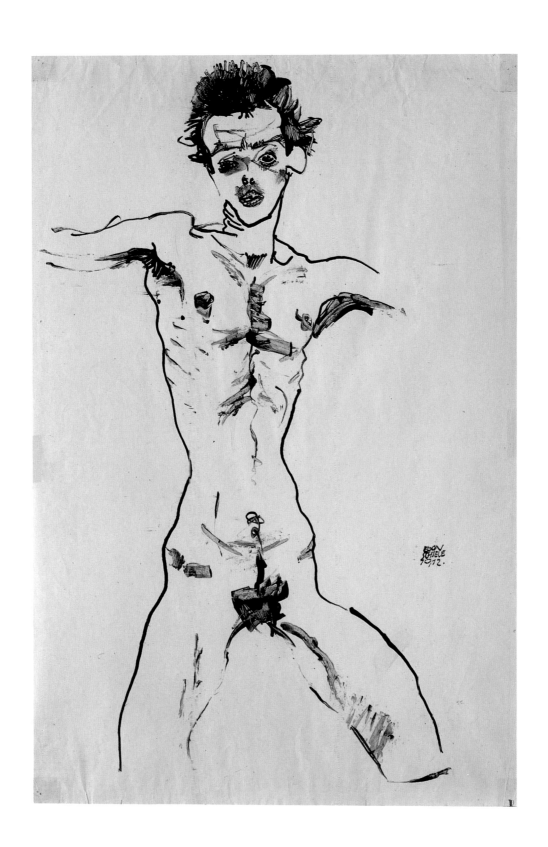

64 *Self-Portrait with Lowered Head*
(Selbstbildnis mit gesenktem Kopf)
1912

Oil on wood, 16 5/8 x 13 1/4″
(42.2 x 33.7 cm)
Signed and dated lower right:
"EGON SCHIELE 1912"
Leopold Museum Inv. 462

Provenance:
Johannes Scheider, Vienna;
Rudolf Leopold, Vienna.

Literature:
Leopold 1972, pl. 91; Malafarina
1982, no. 208, not illus.; Nebehay
1989; Stefano 1992; L 202; K 228.

Exhibitions:
Zurich 1988; Tokyo 1991; Tübingen
1995; Tokyo 1997.

This man seems grotesque, mysterious, and miserable all at the same time. The head bends forward, the eyes gazing up through his eyebrows. The whites of the eyes are therefore like crescent moons, glowing brightly against the dark skin tone of his face. The skull is powerful, but the cheeks are sunken. A neat moustache sits above the blue-red lips.

It would appear that Schiele painted himself with the light behind him. In any case what interested him was the contrast between the dark forms of the face, the bare chest, and the hand, and the white of the background and the only slightly shaded drape. The sharp angle between the head and the right shoulder mirrors the one formed by the spread fingers–only one of many formal parallels in this highly impressive composition. Schiele's painterly sensibility is just as apparent in his signature application of pigment as it is in his juxtaposition of the various tonal values.

The self-portrait study for the double figure of the *Hermits* (pl. 65), reproduced below, was done a short time after this painting. Schiele wore a moustache only from the late fall of 1911 to the first weeks of 1912, and he conscientiously recorded it in his depictions of himself (see pl. 62). He used this same pose in the later study and in the larger composition of the *Hermits,* where the hand with spread fingers is placed on his right hip.

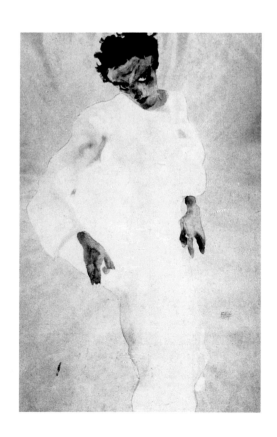

Self-Portrait in White Cowl
(study for the self-portrait in *Hermits*;
pl. 65). 1912. Pencil, watercolor, and gouache on paper

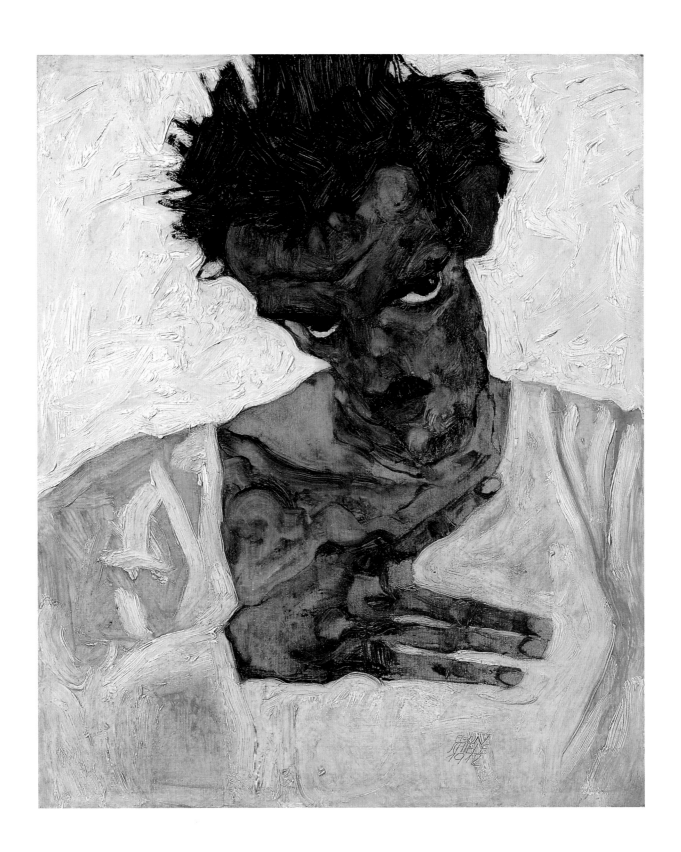

Oil on canvas, 71 1/4 x 71 1/4"
(181 x 181 cm)
Signed and dated three times
lower left: "EGON SCHIELE 1912"
Leopold Museum Inv. 466

Provenance:
Estate of Egon Schiele, Vienna;
Arthur Stemmer, Vienna, later
London; Rudolf Leopold, Vienna.

Literature:
Braun 1912; Karpfen 1921; Schmidt
1956; Dobai 1968/69; *Mizue* 1969;
Leopold 1972, pl. 92; Mitsch 1974;
Comini 1974; Sailer 1975; *Mizue*
1977; Whitford 1981; Malafarina
1982, no. 209; Nebehay 1989;
Stefano 1992; L 203; K 229.

Exhibitions:
Vienna 1912; Munich, Neue Kunst
Hans Goltz 1912; Amsterdam 1917;
Vienna 1925; Frankfurt 1926; Berlin
1926; Prague 1928; Vienna 1928;
Amsterdam 1956; Bern 1957;
St. Gallen 1957; London 1964; New
York, Guggenheim Museum 1965;
Vienna, Österreichische Galerie
1968; Munich 1975; Zurich 1988;
Tokyo 1991; Tübingen 1995; Tokyo
1997.

In this painting Schiele merged two lifesize figures into a double image. The cloak that envelops them could have been borrowed from Klimt, but Schiele dipped it in black, and instead of the lavish ornaments of *Jugendstil* he limited himself to only discreet abstract designs at the shoulders.

The faces are clearly those of Schiele and Klimt, but these citations, as in the "architectural portraits" of his cityscapes, are not intended to be taken literally. In a long letter he wrote about the painting to Carl Reininghaus, Schiele makes no mention of the fact that in it he had portrayed himself and Klimt: "I admit that you are right for once: in the large painting one cannot properly see exactly how the two are standing … the indistinctness of the figures, which are perceived as folded together … the bodies of men tired of life, suicides, but bodies of men of feeling. Think of the two bodies as a cloud of dust like the earth that wants to rise up and is forced to break apart and lose its power. In a picture that is not intended to have this meaning, one would surely want to see the poses of the figures emphasized, but it was not the intention here." Schiele's attempt to defend his picture to one of his collectors was unsuccessful; he never managed to sell the work. The grandeur of his creation, its unique combination of monumental, almost abstract forms and highly dramatic expressiveness, was not appreciated. The deliberate contrast between these dark, silhouetted figures and the light background is only superficially related to that of Schiele's portrait figures from 1910.

Here the background has become part of the painterly process, which is much more immediate. Essential to the composition is the diagonal center axis of the large, dark, almost abstract robed figure rising up from right to left. The two heads incline even further in the same direction. This movement is opposed by the hill in the background, the white line that rises up from the flower, and the foot, which is obviously juxtaposed to Schiele's face. The wonderful contours of the "cloak" were not easily achieved–Schiele changed and reworked them in various ways–but they appear to be so natural that one accepts them as the product of a single inspiration. The hands of the younger "hermit," exquisite in their drawing and coloring, stand out against the blackness of the cloak.

The left hand clutches a portfolio that is scarcely visible against the dark cloak. With it Schiele wished to suggest only that he was carrying with him a collection of his drawings. But he is no longer showing any of

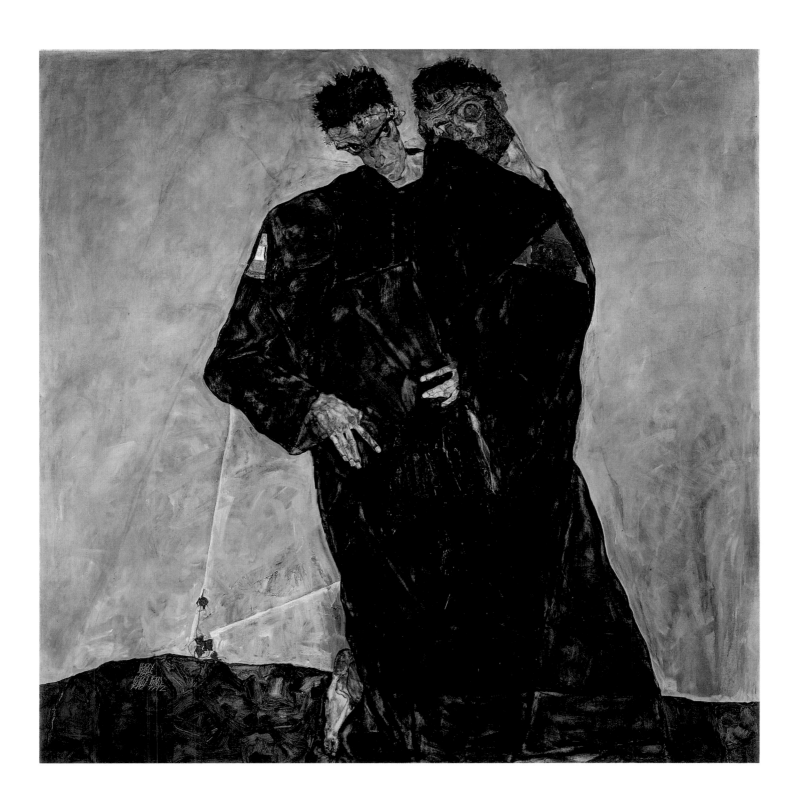

them, as he does in a drawing from 1909 (Albertina Inv. 31.392). Also, he no longer has Klimt pore over them like a priest reading his missal. This time Klimt, the other "hermit," has his eyes closed. Is he asleep or dreaming? He wears a wreath of autumn fruit around his brow, as though he had already enjoyed the harvest. The sensual, full lips in Schiele's face are in marked contrast to the sunken cheeks, the furrowed, angular brow, the crown of withered thistle blossoms, and the painfully wide-open eyes. A single rosebush pushes up from the ground to the left of the double figure, its blooms fading, their stems wilted.

These living figures have been infected with a "sickness unto death." Every element of the painting is calculated to express a wholly tragic world view. Both the idea and its execution are filled with passion. Schiele was by no means exaggerating when, in that same letter to Reininghaus, he wrote that the painting "was created from nothing but the most heartfelt emotion."

66 Reclining Nude with Stockings
(Liegende Nackte mit Strümpfen)
1912

Pencil on paper, 12 1/2 x 18 7/8"
(31.7 x 48 cm)
Signed and dated upper right:
"EGON SCHIELE 1912"
Leopold Museum Inv. 1402

Provenance:
Bayer Gallery, New York;
Sotheby Parke Bernet, New York
(auction), 1979;
Rudolf Leopold, Vienna.

Literature:
K 1019.

Exhibitions:
New York 1960; Tokyo 1991;
Tübingen 1995.

The virtual lyricism that infuses the contours of Schiele's drawings beginning in the second half of 1911 is here further heightened, even somewhat exaggerated, in the case of the depiction of the left leg. There is only a suggestion of the top of the stocking there and also of the cloth on which the nude is reclining.

In some areas the outlines are emphasized by delicate smaller lines placed next to them that create a three-dimensional effect. In 1913 Schiele routinely added such shading to his drawings (see, for example, pl. 90 and the figure that accompanies pl. 91).

The flowing hair is rendered in much more delicate lines than those used to describe the body.

Oil on wood, 16 3/4 x 13 3/8″
(42.5 x 34 cm)
Signed and dated lower right:
"EGON SCHIELE 1912."
Leopold Museum Inv. 461

Provenance:
Heinrich Benesch, Vienna;
Otto Benesch, Vienna;
Rudolf Leopold, Vienna.

Literature:
O. Benesch 1958 (1); Comini 1973;
Comini 1974; Malafarina 1982, no.
207; L 201; K 224.

Exhibitions:
Vienna 1925; Vienna 1927; Vienna,
Neue Galerie 1948; Vienna 1985;
Tokyo 1986; Zurich 1988; Tokyo
1991; Tübingen 1995; Tokyo 1997.

This woman's face is the picture of sadness. Her cheeks are sunken,[1] her nose is extremely narrow, her skin pale, her eyes large and dark, welling with tears. The sallowness of the face seems even more extreme in contrast to the red of the mouth and the black of the eyes, the clothing, the hair, and the kerchief. The upper edge of this head covering is asymmetrical, oddly flattened on the left. Behind it we see part of a man's face. That face and a thin triangle of reddish-ocher behind it complete the curve begun by the kerchief and hair on the right. Schiele is suggesting that the woman has this man–himself, in fact, an artist touched by madness–on her mind. It is he who is the cause of her sorrow. There is no longer anything beautiful in the world, not even the red rose,[2] which has wilted, in front of a cold patch of chrome-yellow. The effect of the striped ribbon to the right of the head is very different; its colors glow mysteriously.

The model for this woman's head[3] was Schiele's companion, Wally Neuzil. To be sure, Wally was blond and blue-eyed, but there is no question but that this is she. When the colors of a given composition or subject matter required it, as here, Schiele simply gave her dark hair and eyes (see, for example, K 1196).

Schiele doubtless patterned the man's head after himself. It is interesting to note his awareness that his companion mourned him, the brilliant but disturbed artist.

This small painting is one of Schiele's most expressive works and is virtually without parallel in his œuvre.

[1] This impression is enhanced by the way the black kerchief partially obscures the right cheek.

[2] Strangely enough, Alessandra Comini (1974, p. 106) calls this wilted bloom a sunflower, even though it is red and one can recognize its rose-like sepals.

[3] It is more than likely that Schiele based this woman's face on the colored drawing (K 1118) reproduced on page 174. The face in the drawing, with its teary eyes, was much more probably the pattern for this painting and not, as Jane Kallir suggests, for the *Portrait of Wally* (pl. 78). It is true that Schiele borrowed the lace collar and shoulder contours of the drawing for that portrait, considerably altering them, of course, but that face was based on the one in his watercolor drawing *Wally Kneeling in a Gray Dress* (pl. 74). In no other drawing from this year does one find a woman's face with such large, tear-filled eyes–in the painting they do not focus, which only adds to the impression of sorrow. The shapes of the lips and eyebrows also match those of the woman in the painting in their essential details.

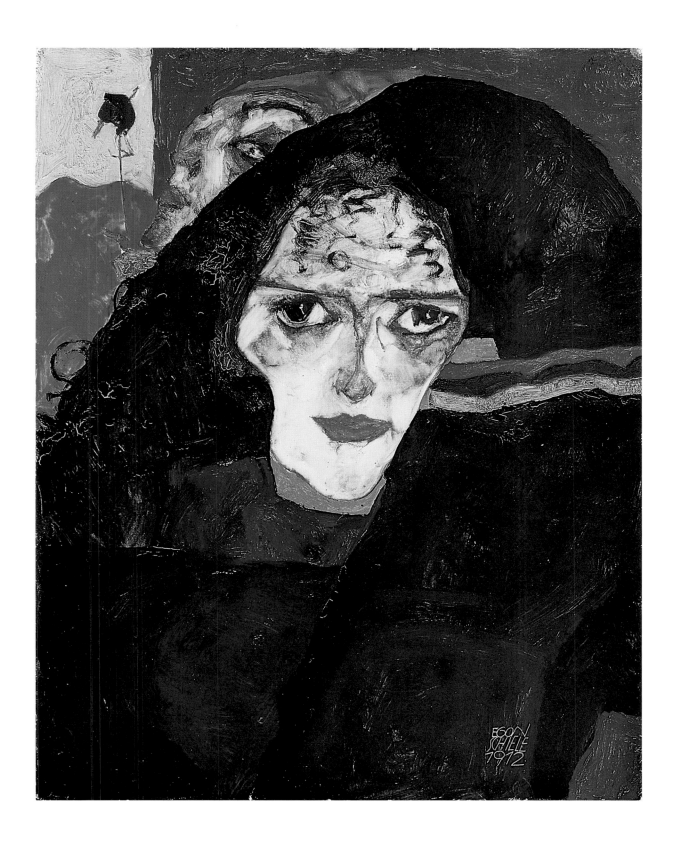

Wally with Necklace. 1912. Pencil, watercolor, and gouache on paper

Comini writes (1974, pp. 105–06) that after Schiele was released from prison, he transformed the "idyllic" portraits of himself and Wally that he had painted at the beginning of 1912 (pls. 77 and 78) into a record of his anguish in a new painting, namely, the *Mourning Woman.* Then, feeling that he had been unjustly treated by society, he tried to take revenge by attacking one of its main institutions, the Church. That is why he painted the scandalous *Cardinal and Nun* (pl. 75). Considering that he was a subject of Emperor Franz Josef and that only a short time before he had been imprisoned and charged with immoral behavior, it was a bold move. In his painting of the nun and the cardinal, Schiele quite plainly depicted a sexual act.

Careful stylistic analysis unquestionably reveals that the *Mourning Woman* was executed *before* the so-called idyllic portraits and also before the *Cardinal and Nun.* Most important, Schiele painted all of these pictures *before* he was sent to prison. Accordingly, neither the *Mourning Woman* nor the *Cardinal and Nun* can be thought of as a reaction to that event.

Study of the Schiele letters in the Albertina indicates that for months after his imprisonment, Schiele painted no pictures at all, both for psychological and financial reasons. He managed to begin painting again only in December 1912, and the first works from that time were by no means the *Mourning Woman* and the *Cardinal and Nun,* but rather a pair of paintings based on motifs from Krumau: *Twilight City* and *The Small City II* (pl. 81).

68 *Embrace*
(Umarmung)
1912

Gouache, watercolor,
and pencil on paper,
12 5/8 x 18 1/2" (32 x 47.1 cm)
Signed and dated lower left:
"EGON SCHIELE 1912."
Leopold Museum Inv. 2376

Provenance:
Heinrich Benesch, Vienna;
Klipstein & Kornfeld, Bern
(auction), 1960;
Rudolf Leopold, Vienna.

Literature:
Leopold 1972, pl. 93; K 1147.

Exhibition:
Tübingen 1995.

Schiele gave these two intertwined figures a common outline, simply ending the woman's thigh with a curving line and leaving the man's leg undefined.

Within this overall form the man's body is darker, the woman's lighter–the only aspect of the drawing that has anything to do with convention. But within the man's skin tone the colors are vivid, ranging from bright blue to brick red. Within the preestablished contours of the limbs, the painting is quite free. The way its colors run together and its wavy outlines link this work from the beginning of 1912 to typical ones from 1911.

The man's dark hair forms the center of this dynamic composition. Otto Benesch relates that his father, who owned this drawing, told him that Schiele here showed himself with one of his models.

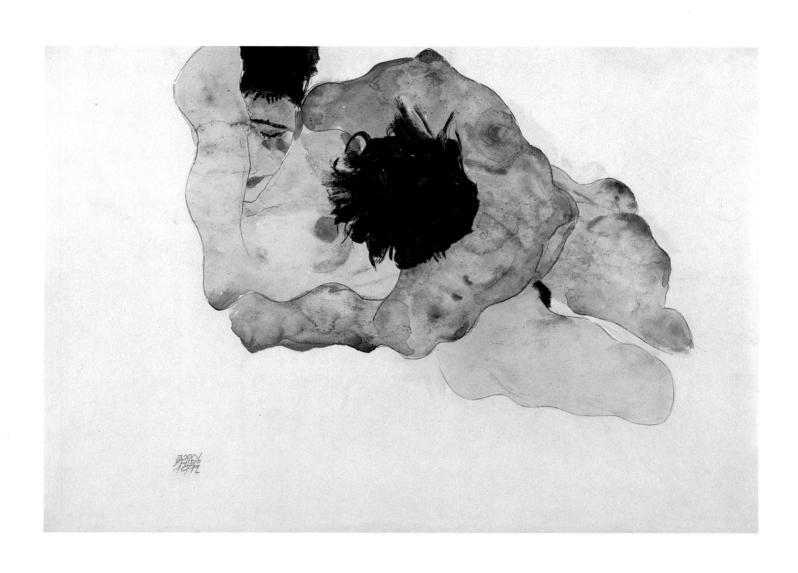

69 *Woman with Child on Her Arm (Frau mit Kind am Arm)* 1912

Pencil on paper, 18 1/2 x 12 1/4″
(47 x 31 cm)
Signed and dated lower left:
"EGON SCHIELE 1912."
Leopold Museum Inv. 1439

Provenance:
Estate of Egon Schiele, Vienna;
Melanie Schuster, Vienna;
Christie's, London (auction), 1984;
Rudolf Leopold, Vienna.

Literature:
Leopold 1972, pl. 95; K 987.

Exhibitions:
New York 1983; Tokyo 1991;
Tübingen 1995.

This drawing, like the painting in plate 70, depicts a woman and child, but the two works could not be more different in spirit. Here the child seems anything but frightened; in fact, it appears apathetic, perhaps even retarded, because of the way the mouth hangs open. The woman, by contrast–perhaps the child's mother, perhaps not–seems full of life. Her expressive eyes dominate not only her face but also the drawing as a whole.

With very few lines Schiele convincingly captured the way the child perches on the woman's lap and their different facial expressions.

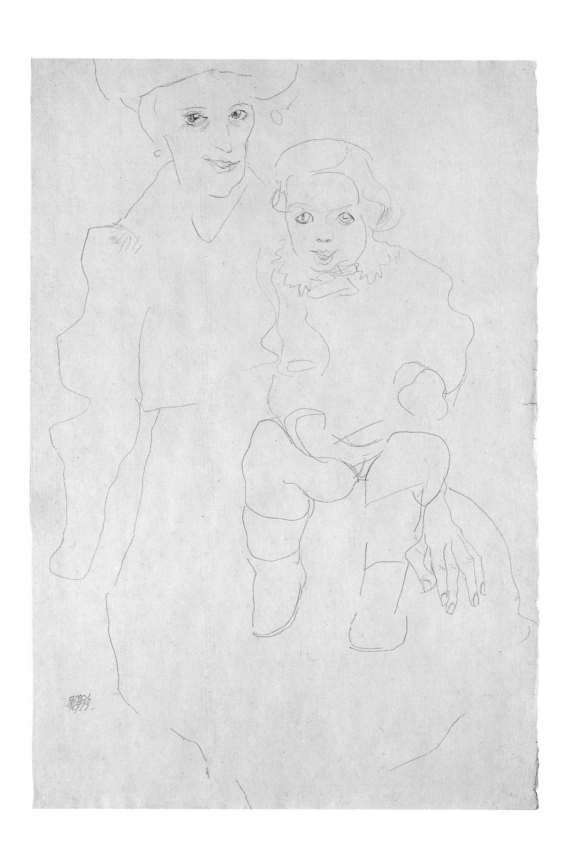

70 *Mother and Child*
 (Mutter und Kind)
 1912

Oil on wood, 14 3/8 x 11 1/2"
(36.5 x 29.2 cm)
Signed and dated lower right:
"EGON SCHIELE 1912"
Leopold Museum Inv. 652

Provenance:
Emil Toepfer, Vienna;
Neue Galerie, Vienna;
Paul Clairmont, Zurich;
Rudolf Leopold, Vienna.

Literature:
Leopold 1972, pl. 94; Malafarina
1982, no. 213; L 205; K 225.

Exhibitions:
Cologne 1912; Vienna 1923; Vienna
1928; Zurich 1930; Innsbruck 1963;
London 1964; New York,
Guggenheim Museum 1965;
Vienna, Österreichische Galerie
1968; Edinburgh 1983; Rome 1984;
Tokyo 1986; Tokyo 1991; Tübingen
1995; Yokahama 1997.

The composition of this painting resembles that of an icon, but here there is none of the hieratic solemnity of such works. Two faces and two hands stand out against a dark, highly agitated background. The child seems to be staring out with horror at a hostile world, one to which the mother has resigned herself. Her eyes and mouth are closed, her cheeks sunken. The two heads are pressed against each other and connected by a common white collar. Their bodies are as though hidden in shadow, the child's only suggested by the way the mother's hand has been placed protectively around its right shoulder.

The vivid colors of the faces and hands resemble those of the watercolor in plate 68, but are much more expressive. In some areas Schiele clearly painted with his fingers, leaving prints in the wet pigment. The mother's head is surrounded by a deep, glowing blue.

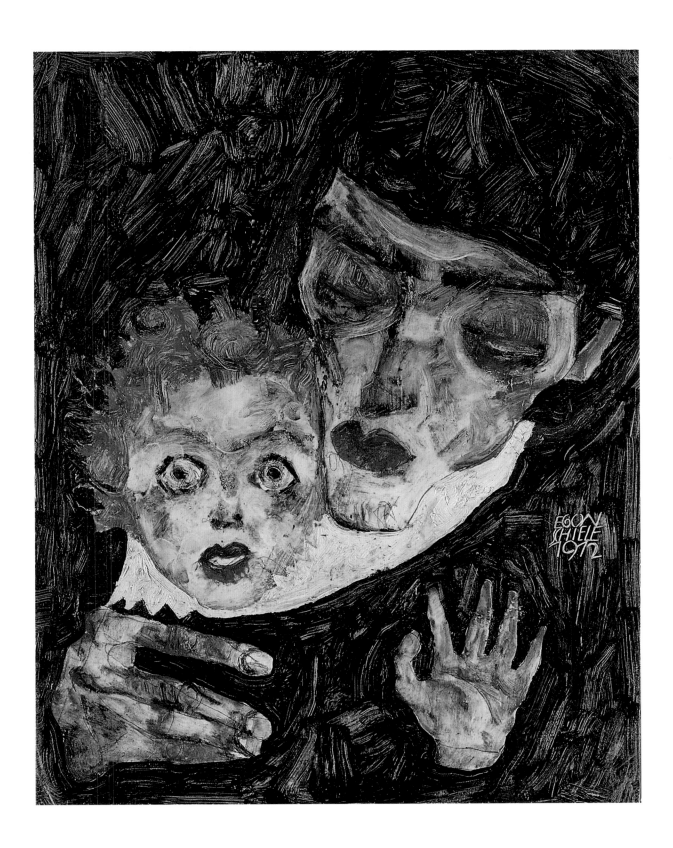

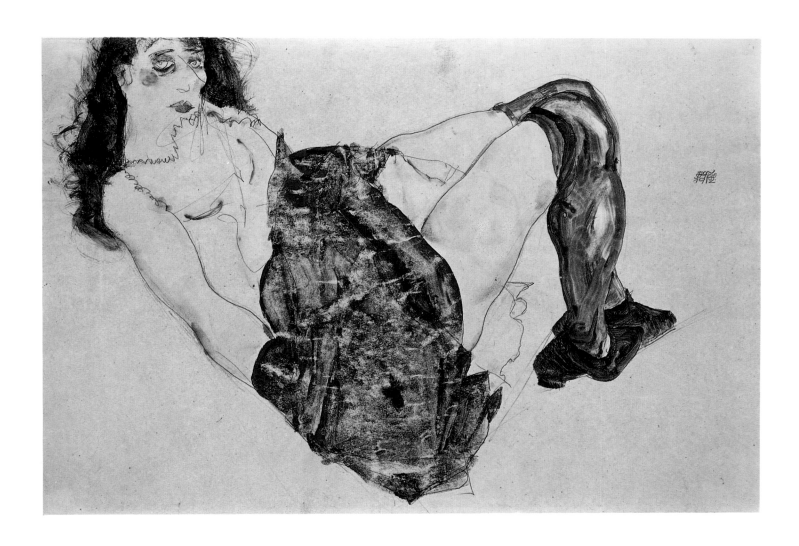

71 *Black-Haired Woman with Blue Drape Around Her Hips*
(Schwarzhaarige mit blauem Tuch über den Hüften)
1912

This model must have been leaning against something, for she could scarcely have maintained such a pose for long without support. By omitting that support, Schiele was able to emphasize the angle formed by the woman's torso and thighs. The composition is anchored at the sides by the dark, flowing hair and the stockings and shoes. The latter are painted in the same color, so that they appear to be a single form. To stabilize that form, the heel of the right shoe has been unnaturally elongated to the back so that it provides with the toe of the left shoe a symmetrical base for the two legs.

Gouache, watercolor,
and pencil on paper,
12 3/8 x 18 7/8" (31.5 x 48 cm)
Signed and dated upper right:
"EGON SCHIELE 1912"
Leopold Museum Inv. 1403

Provenance:
Wolfgang Gurlitt, Munich;
Marlborough Gallery, London;
Rudolf Leopold, Vienna.

Literature:
Leopold 1972, pl. 98; K 1100.

Exhibitions:
Vienna, Albertina 1948; Linz 1949;
Salzburg 1950; Munich 1957;
Heidelberg 1962; Turin 1963;
London 1964; Munich 1975; Tokyo
1991; Tübingen 1995.

72 Self-Portrait with Hunched and Bared Shoulder
(Selbstbildnis mit hochgezogener nackter Schulter)
1912

Oil on wood, 16 5/8 x 13 3/8″
(42.2 x 33.9 cm)
Signed and dated lower right:
"EGON SCHIELE 1912."
Leopold Museum Inv. 653

Provenance:
Wolfgang Gurlitt, Munich;
Rudolf Leopold, Vienna.

Literature:
Leopold 1972, pl. 96; Malafarina
1982, no. 215; L 209; K 227.

Exhibitions:
Linz 1949; Salzburg 1950;
Amsterdam 1956; Bern 1957;
St. Gallen 1957; London 1960;
Salzburg 1968; Munich 1975;
Tokyo 1986; Tokyo 1991;
Tübingen 1995; Tokyo 1997.

The face is filled with horror: the mouth hangs half open, the eyes are wide. Panic has been channeled into painting, the agitation evident even in the way the pigments were applied. In some areas Schiele used a brush, in others his fingertips. With the tip of the brush handle he scratched the "scar" on his forehead.

The skin color–ocher, red-brown, and red–resembles that of someone who has been badly burned. The line of the jaw is traced with a suggestion of blue–a delightful contrast. The almost white background and the only slightly darker drape set off the silhouette of the head, neck, and right shoulder. The left shoulder is covered, so as not to detract from the diagonal sweep of the opposite shoulder and head, the major elements.

The bare shoulder is turned directly toward the viewer. It appears as though it has been thrust up from the bottom edge of the painting. By contrast, the head and hair are cut off by the top and right edges. The sense of being pressed into a corner–a universal human feeling, in this case autobiographical–is thus literally reflected even in the arrangement of the composition.

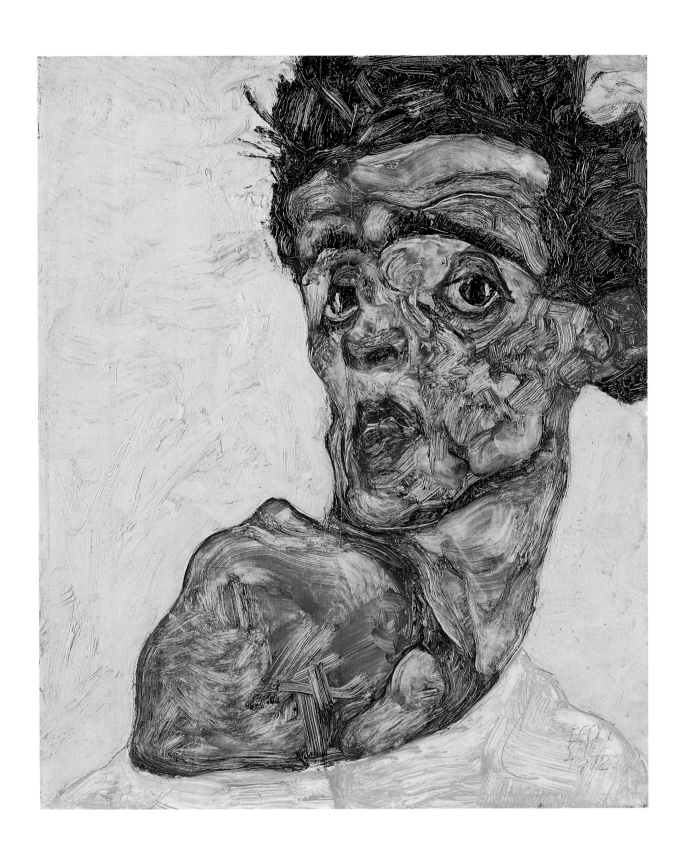

73 *Nude Self-Portrait, Crouching*
(Aktselbstbildnis, hockend)
1912

Pencil on paper, 19 5/8 x 11 3/8"
(50 x 29 cm)
Signed and dated lower left:
"EGON SCHIELE 1912."
Leopold Museum Inv. 1444

Provenance:
Estate of Egon Schiele, Vienna;
Melanie Schuster, Vienna;
Rudolf Leopold, Vienna.

Literature:
Leopold 1972, pl. 97; K 1165.

Exhibitions:
Tokyo 1991; Tübingen 1995.

The artist here drew himself crouched in a highly contorted pose. His upper body, head, and left arm twist in one direction, his buttocks and legs in the other.

The lowered head with its expressive face is rendered in greater detail. The furrowed brow, the few curly lines that describe the hair, and even the waviness of the body contours in some areas are reminiscent of drawings Schiele had done the previous year. Most of the undulations in the outlines have been suppressed, to be sure; all in all his drawing has become more realistic. The contours are drawn with verve. Schiele's mastery is amply demonstrated in the bravura rendering of the foreshortened right foot.

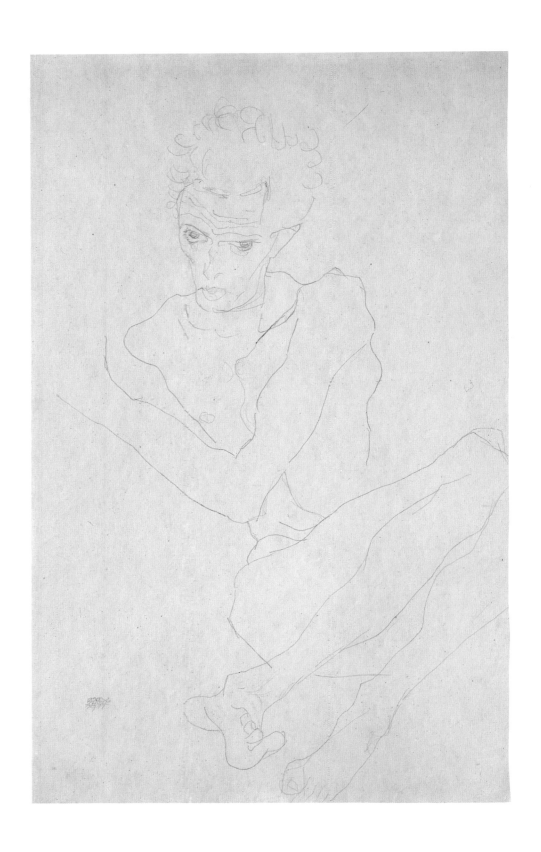

74 *Wally Kneeling in a Gray Dress*
(Kniende Wally mit grauem Kleid)
1912

In this lively watercolor study of Schiele's favorite model in this period, Wally Neuzil, he juxtaposed the reddish flesh tone to the gray-black of her dress. The folds of the fabric are wonderfully rendered, so that it appears that light is falling on them from above.

It seems odd, but this study of a female model clearly served Schiele as a pattern for the figure of the cardinal in his painting *Cardinal and Nun* (pl. 75), even though the head is here turned and resting on the right shoulder. This head was also used for the painting *Portrait of Wally* (pl. 78).

Perhaps even more remarkable is the fact that the face of the nun bears an astonishing similarity to the one in the *Self-Portrait with Hunched and Bared Shoulder* (pl. 72). The position of the dark eyes is the same, as are the wavy form of the bridge of the nose and the placement of the nostrils. Unlike some painters of the second half of the nineteenth century–Michael von Munkaçsy, for example–who frequently searched among hundreds of subjects for a suitable type for a painting, Schiele utilized whatever was at hand, even regardless of gender, reworking whatever he borrowed from his studies in such a way as to make it altogether convincing.

Gouache, watercolor,
and pencil on paper,
18 1/8 x 12 3/8″ (46 x 31.2 cm)
Signed and dated lower left:
"EGON SCHIELE 1912."
Leopold Museum Inv. 2350

Provenance:
Rudolf Leopold, Vienna.

Literature:
Leopold 1972, pl. 100; K 1125.

Exhibition:
Tübingen 1995.

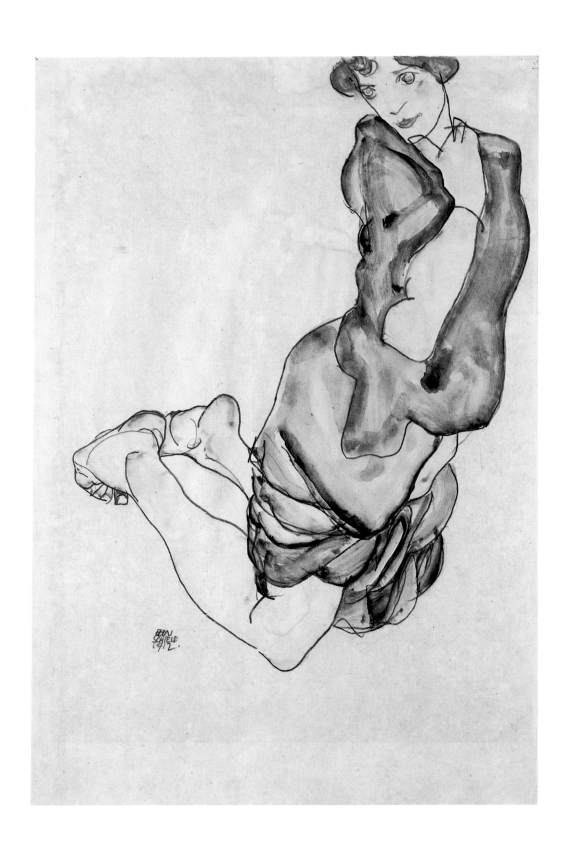

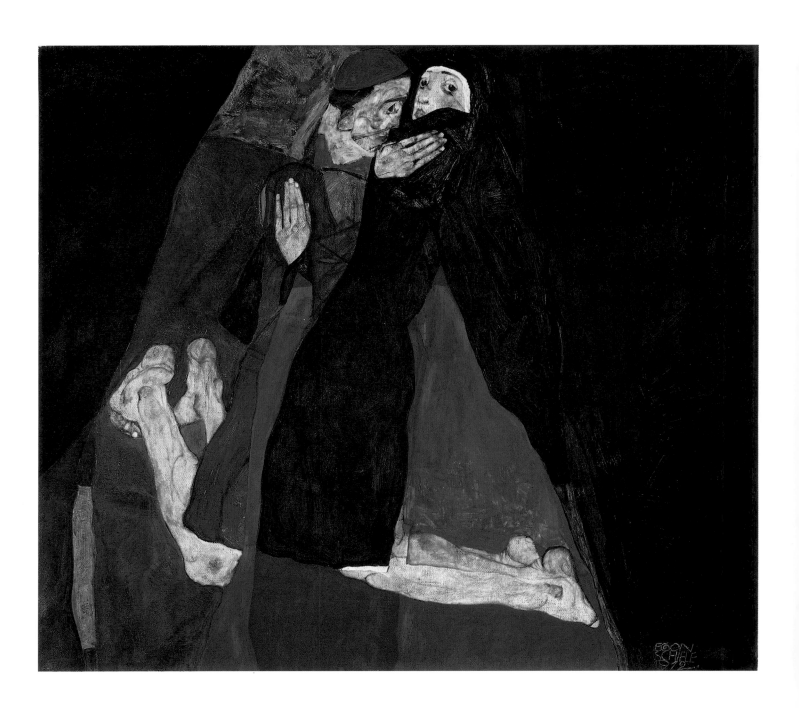

75 Cardinal and Nun (Embrace)
(Kardinal und Nonne ["Liebkosung"])
1912

The shocking subject matter is fixed within a strict formal arrangement, and the expressiveness of the work is inseparable from its magnificent structure. The dominating triangle shape, with its base at the bottom edge of the painting, incorporates three smaller triangles.

Red, black, and the contrasting light flesh tones of the two bodies predominate. The red shows the richest variety of shading. In those areas where it achieves a bright cinnabar, it takes on an uncommonly exciting radiance. Perhaps the only other painter in our century to paint a red as expressive as this was Chaim Soutine. Unlike him, however, and without sacrificing any of its intensity, Schiele presents the color in shapes that are highly controlled.

Another triumph is the rendering of the cardinal's feet. They were drawn with great precision, yet they are incredibly expressive. The figure is braced so firmly on these feet and the knees that it can press forward against the nun, who draws back slightly from the pressure.

Particular importance was given to the poses of the two hands; both are captured in the gesture of prayer, a reflection of the pair's vocation. His palm is reverently placed against her body, hers against his. Schiele referred to this picture–not without sarcasm–as *Embrace*. The nakedness and coarseness of the two pairs of legs are deliberately set off against the nun's habit and the cardinal's robe, as though Schiele wished to suggest that carnal desire cannot be suppressed, but rather breaks through all of our denials and prohibitions. The nun, her eyes wide, looks terrified. The cardinal's expression is more ambiguous. With his face, his red cap, and his strangely curved neck, Schiele more than likely meant to suggest the male organ. One is justified in this assumption by the fact that Gustav Klimt explained to his friends–Schiele being one of them–that in the neck of the man in his painting *The Kiss* (see p. 13), he had meant to evoke not only the potency of the figure but also the back of the penis.

Unquestionably, Schiele's *Cardinal and Nun* is a paraphrase of Klimt's *The Kiss*, but it was only the subject matter of the latter that inspired Schiele's response. He completely reworked the motif, both in terms of content and form. The import of Klimt's painting–he also spoke of this–namely, that a girl who gives in to a kiss is already at the edge of the abyss, is no longer especially apparent in Schiele's. In his work the abyss yawns for both figures. The nun, to be sure, is in greater danger than the

Oil on canvas, 27 1/2 x 31 5/8" (70 x 80.5 cm)
Signed and dated lower right: "EGON SCHIELE 1912"
Leopold Museum Inv. 455

Provenance:
Heinrich Rieger, Vienna;
Heinrich Rieger, Jr., London;
Österreichische Galerie, Vienna;
Rudolf Leopold, Vienna.

Literature:
Dobai 1968/69; Leopold 1972, pl. 101; Mitsch 1974; Comini 1974; Wilson 1980; Whitford 1981; Malafarina 1982, no. 216; Gordon 1987; Nebehay 1989; Stefano 1992; L 210; K 232.

Exhibitions:
Munich, Neue Kunst Hans Goltz 1912; Munich 1913; Berlin 1914; Vienna 1925; Vienna 1928; Zurich 1930; Paris 1937; Venice 1948; Vienna, Neue Galerie 1948; London 1964; New York, Guggenheim Museum 1965; Vienna, Österreichische Galerie 1968; Munich 1975; Zurich 1988; Tokyo 1991; Tübingen 1995; Tokyo 1997.

cardinal owing to her position, but her legs are firmly braced; the strip of grass to the right of them falls much more steeply than in Klimt's painting, mirroring the opposing angle of the ground to the left. Schiele transformed Klimt's flower-filled meadow into bare earth interrupted only by strips of grass that are fixed elements in the pictorial structure, the man's static calm and the woman's nestling against him into an exciting forward thrust and counterthrust. A paradisiacal idyll, with tender submission on the part of the female, has become a picture of terrifying compulsion: *Jugendstil* has been transformed into Expressionism.

76　Nude with Blue Stockings Bending Forward
(Nach vorn gebeugter Akt mit blauen Strümpfen)
1912

Gouache, watercolor,
and pencil on paper,
14 3/4 x 11 3/8" (37.5 x 28.9 cm)
Signed and dated lower left:
"EGON SCHIELE 1912."
Leopold Museum Inv. 1441

Provenance:
Franz Hauer, Vienna;
Leopold Hauer, Vienna;
Rudolf Leopold, Vienna.

Literature:
Leopold 1972, pl. 102; Marchetti 1984; K 1088.

Exhibitions:
Florence 1964; Munich 1975; Tokyo 1986; Zurich 1988; Tokyo 1991; Tübingen 1995; Tokyo 1997.

Schiele brilliantly met the challenge of this picture, the foreshortening of a nude figure seen at an angle from above. The woman's body is described with sensitive contours and at the same time the picture is given a clear structure. For the latter the curving line of the spine is all-important.

The touches of color along the outlines, the shading lines next to them in some areas, and the delicate painting in the interior of the figure give it a definite three-dimensionality.

The overall coloring is as vivid as that of the oil paintings created at this same time, for example, the *Calvary* (L 215) or the *Portrait of Wally* (pl. 78).

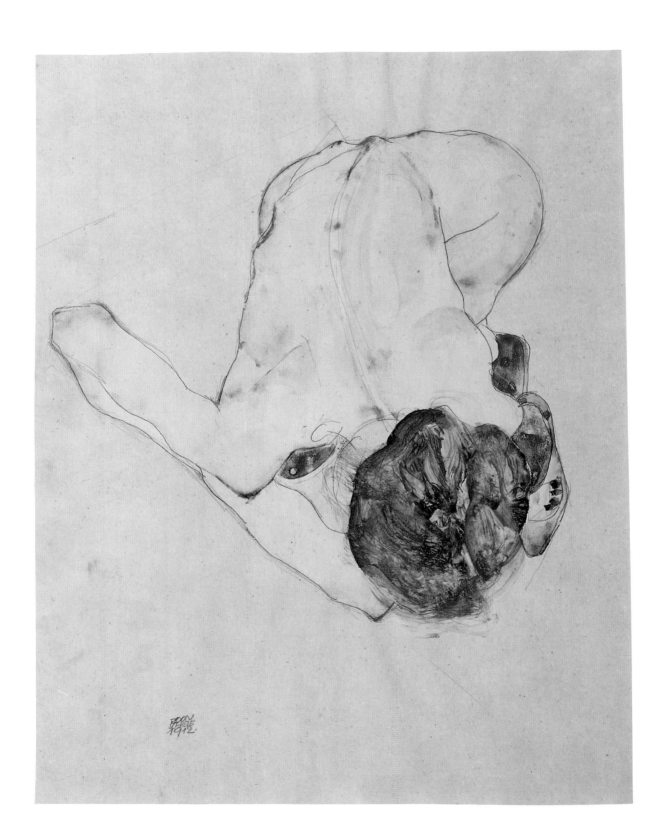

Self-Portrait with Chinese Lanterns
(Selbstbildnis mit Judenkirschen)
1912

Oil and gouache on wood,
12 5/8 x 15 5/8″ (32.2 x 39.8 cm)
Signed and dated lower right:
"EGON SCHIELE 1912"
Leopold Museum Inv. 454

Provenance:
Heinrich Mayer, Vienna;
Johann and Joseph Parzer, Vienna;
Rudolf Leopold, Vienna.

Literature:
Roessler 1928 (1); Roessler 1929;
Leopold 1972, pl. 103; Comini
1974; Malafarina 1982, no. 217;
Werkner 1986; Nebehay 1989;
L 211; K 233.

Exhibitions:
Vienna 1925; Vienna 1928;
Salzburg 1957; Stuttgart 1957;
Düsseldorf 1959; London 1960;
Innsbruck 1963; Vienna, Österrei-
chische Galerie 1968; Munich 1975;
Tokyo 1986; Zurich 1988; Tokyo
1991; Tobu 1994; Tübingen 1995;
Tokyo 1997.

This is one of Schiele's most popular self-portraits.

The complex interrelationships between the pictorial elements–one shoulder dropped, the other hunched, the head inclined to the side, the Chinese lanterns and their curving stems and dried leaves–are magnificently controlled. The hair and the torso are deliberately cut off by the edges of the painting and are thus juxtaposed.

The head is supported by a slender, slightly curved neck. The fragility this suggests is continued in the way the head turns in one direction, the eyes gaze in another, and in the expression of pain on the face. Note the odd, wine-red pupils and the moss-green of the irises. All of this is totally convincing–in contrast, for example, to the theatricality of Oskar Kokoschka's lithographed self-portrait with brush from 1914.

Schiele's sensitive drawing is apparent in numerous details. For example, the line of the left shoulder is continued by that of the right side of the jaw, which, after it angles upward, parallels the outline of the neck. His painting is equally deft; the placement of the colors in the face and neck is masterful–another reason why this self-portrait is so appealing.

Schiele here portrayed himself exactly as he was: a hypersensitive man and an artist.

78 *Portrait of Wally*
 (Bildnis Wally)
 1912

Schiele painted this portrait of his companion as a counterpart to his *Self-Portrait with Chinese Lanterns* (pl. 77).

The arms rest next to the slender body.[1] The head is tilted forward, the eyes overlarge. Yet the radiant gaze has something melancholy about it. Again Schiele used physical details to express meaning, depicting psychic need convincingly.

The strictly balanced composition utilizes in part geometric shapes: the right cheek virtually forms the base of a half-circle that begins with the chin, extends around the left cheek, and is then only suggested as it passes through the hair. As an echo of this is the slightly curved stem of the plant, the upper part of which corresponds to the outline of the hair just across from it. Similarly, but more markedly than in the self-portrait, behind the head a light gray shape is set off from the otherwise white background, its outline in careful compositional matching with the picture as a whole.

The color harmony is extraordinary: orange, ocher, and blue; white, light gray, and black; and red and green produce an impressive consonance.

Oil on wood, 12 7/8 x 15 5/8″
(32.7 x 39.8 cm)
Signed and dated lower left:
"EGON SCHIELE 1912"
Leopold Museum Inv. 453

Provenance:
Emil Toepfer, Vienna; Richard Lanyi, Vienna; Lea Bondi Jaray, Vienna, later London; Heinrich Rieger, Vienna; Heinrich Rieger, Jr., London; Österreichische Galerie, Vienna; Rudolf Leopold, Vienna.

Literature:
Roessler 1928 (2); Leopold 1972, pl. 104; Comini 1974; Malafarina 1982, no. 218; Nebehay 1989; Stefano 1992; L 212; K 234.

Exhibitions:
Vienna 1925; Vienna 1928; Salzburg 1957; Stuttgart 1957; Düsseldorf 1959; Innsbruck 1963; Vienna, Österreichische Galerie 1968; Munich 1975; Tokyo 1986; Zurich 1988; Tokyo 1991; Tübingen 1995; Tokyo 1997.

[1] Schiele adopted the contours of the shoulders and arms and the lace collar from a colored drawing of Wally (K 1118; see illustration, p. 174)–reworking them, of course–but not the face. The face is based on the one in *Wally Kneeling in a Gray Dress* (pl. 74); there it is still somewhat sketchlike, to be sure, but in all of the essential elements the two are very similar.

Just as he frequently combined a number of single motifs in his cityscapes, Schiele did not hesitate to base a figure in one of his paintings on two or more drawings–sometimes of different models (see pl. 142).

The face in the drawing from which Schiele borrowed the arms and the lace collar is the one that he transformed into the *Mourning Woman* (pl. 67).

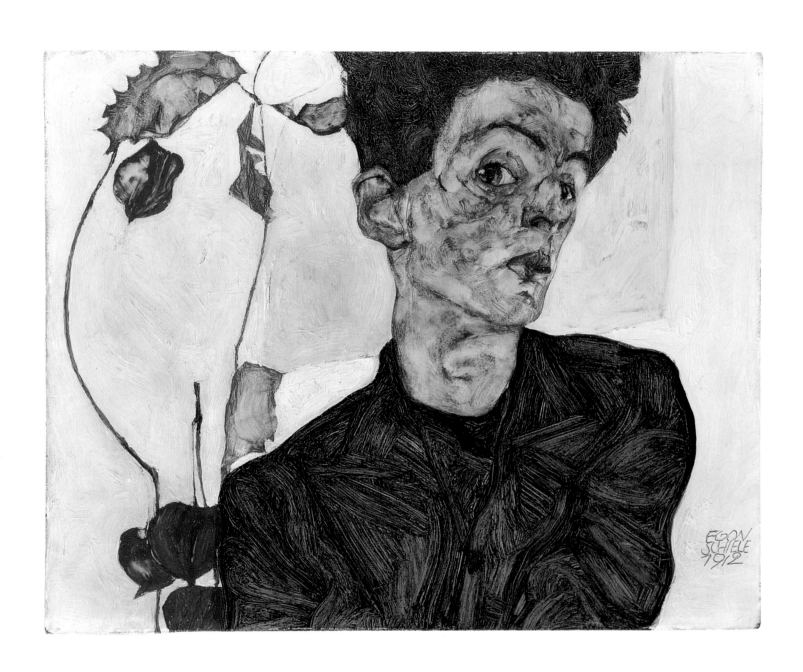

77 *Self-Portrait with Chinese Lanterns.* 1912

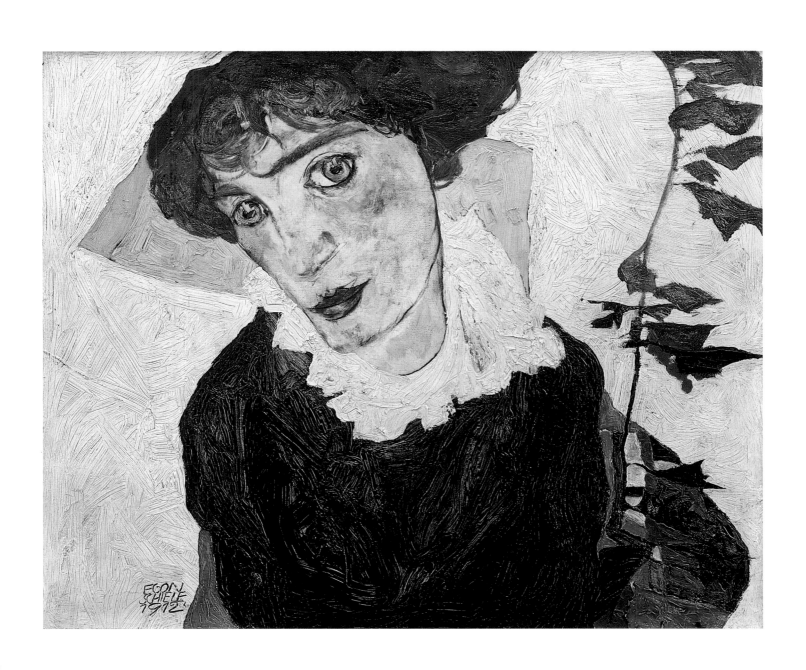

78 *Portrait of Wally.* 1912

79 *Deuring Castle*
(Deuring-Schlösschen)
1912

Gouache, watercolor,
and pencil on paper,
12 3/8 x 18 7/8″ (31.5 x 48 cm)
Signed and dated left center:
"EGON SCHIELE 1912."
Leopold Museum Inv. 2373

Provenance:
Friedrich Lehmann, Vienna;
Viktor Fogarassy, Graz;
Hans Dichand, Vienna;
Rudolf Leopold, Vienna.

Literature:
Koschatzky 1968; Leopold 1972,
p. 648; Comini 1976; Marchetti
1984; Nebehay 1989; K 1216.

Exhibitions:
Vienna, Albertina 1948; New York,
Guggenheim Museum 1965;
Darmstadt 1967; Vienna, Albertina
1968; Bregenz 1971; Innsbruck
1973; Lucerne 1974; Munich 1975;
Brussels 1981; Venice 1984;
Tübingen 1995.

This small castle stands above the city of Bregenz. Schiele painted it in August 1912, from the square in front of the parish church of St. Gallus. The tower on the left, with an octagonal top story, was added onto the essentially medieval complex in the second half of the seventeenth century.

Schiele contrasted the castle's ocher walls and reddish roofs with basically cooler colors dominated by a light blue-green and an ultramarine. He applied these vivid colors describing the dense foliage that surrounds the castle almost in the manner of an Action painter.

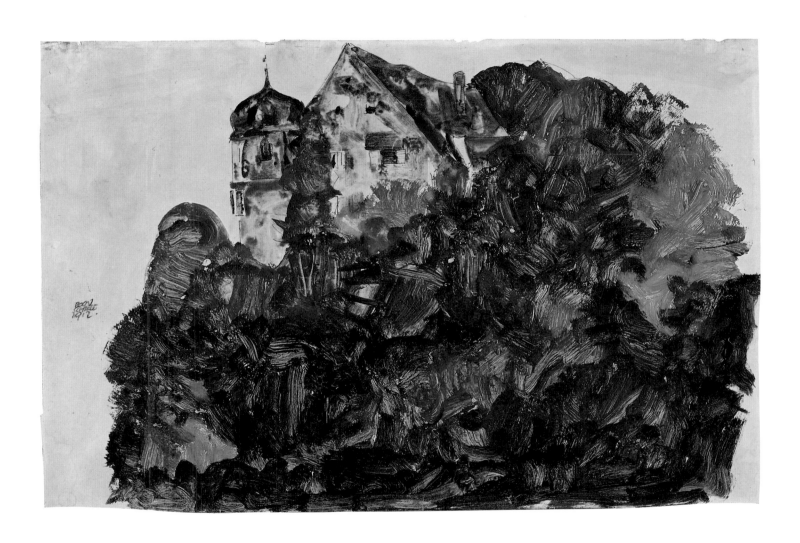

80 *Autumn Tree in a Gust of Wind*
 (Herbstbaum in bewegter Luft)
 1912

Oil on canvas, 31 1/2 x 31 5/8"
(80 x 80.5 cm)
Signed and dated right center:
"EGON SCHIELE 1912."
Leopold Museum Inv. 449

Provenance:
Estate of Egon Schiele, Vienna;
Magda Mautner-Markhof, Vienna;
Grasmayer family, Salzburg;
Rudolf Leopold, Vienna.

Literature:
Schmidt 1956; Sotriffer 1963;
Breicha and Fritsch 1964; Köller
1965; Mitsch 1974; Whitford 1981;
Malafarina 1982, no. 227;
Friesenbiller 1985; Nebehay 1989;
Stefano 1992; Werkner 1994 (1);
L 221; K 239.

Exhibitions:
Vienna 1912; Amsterdam 1956;
Bern 1957; St. Gallen 1957;
Düsseldorf 1959; Cologne 1962;
Innsbruck 1963; Munich 1964;
London 1964; New York,
Guggenheim Museum 1965;
Vienna, Österreichische Galerie
1968; Munich 1975; Venice 1984;
Vienna 1985; Tokyo 1986; Zurich
1988; Tokyo 1991; Tobu 1994;
Tübingen 1995; Tokyo 1997.

At first glance, many people see this painting as an abstraction. This is because the background clouds and the connection between the tree's branches and the ground are not immediately perceived. Schiele deliberately left the limed trunk a lighter color so as to isolate the branches from the strip of ground at the bottom and the distant range of hills for the sake of contrast between light and dark and the play of colors. The separation is even more complete than that in the painting in plate 61. In their isolation, the forms of the branches are also dramatically juxtaposed to those of the earth below.

The longer one studies this painting, the more realistic it seems. The different shapes of the branches reflect different responses to life. The wind bends the topmost ones like whips and causes the thinner ones that branch off from the one rising nearly straight up in the upper left to flutter like flags. Others have become crippled in their tedious struggle, and those in the lower right have apparently given up, as they hang down exhausted. The bluish-black of the chain of hills above the light reddish-ocher field sets it off and relegates it to the far distance.

Never before–or after–did Schiele paint a sky with such sensitivity, such a nuanced array of tonalities. The lightest areas are like halos surrounding the tree's last leaves. Areas like these frequently appear in stormy skies in early winter, and country people call them "snow lights," recognizing that they signal the approach of a blizzard. Yet they, too, like so much else in the picture, are not rendered realistically. In this landscape Schiele managed to capture altogether convincingly the raw energy of a storm in late autumn. With this tree, totally exposed and threatened, he also created a symbol of human existence.

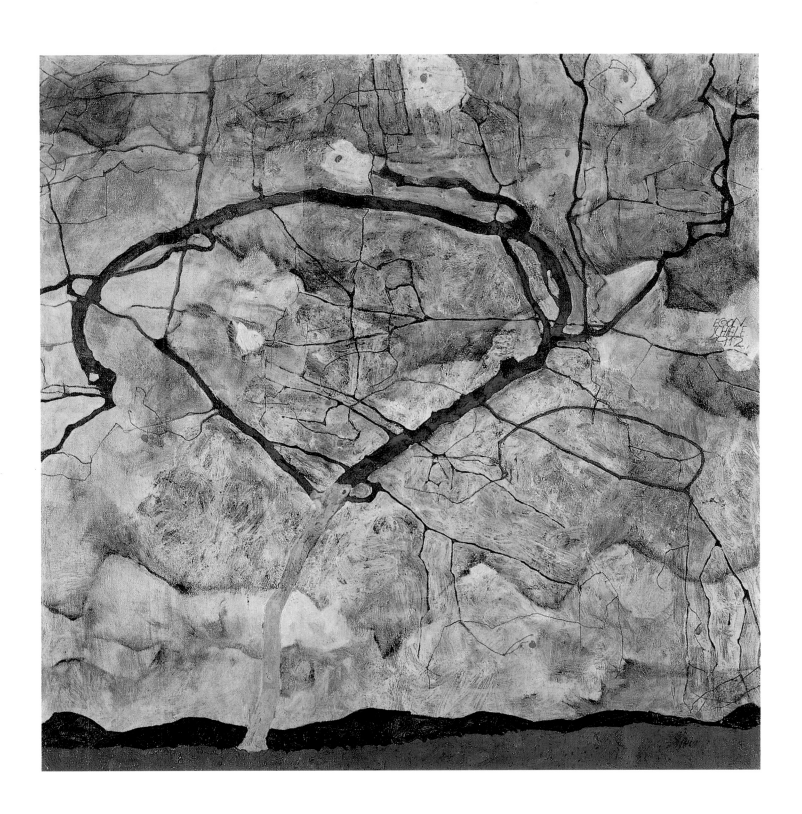

81 *The Small City II* (also *Small City III*)
(*"Die kleine Stadt" II* [also *"Kleine Stadt" III*])
1912/13

Oil on canvas, 35 1/4 x 35 5/8″
(89.5 x 90.5 cm)
Signed and dated right center:
"EGON SCHIELE 1913"
Inscribed by the artist on the
stretcher: "Die kleine Stadt"
Leopold Museum Inv. 482

Provenance:
Estate of Egon Schiele, Vienna;
Hubert Jung, Vienna;
Galerie Würthle, Vienna;
Viktor Fogarassy, Graz;
Hans Dichand, Vienna;
Rudolf Leopold, Vienna.

Literature:
Köller 1965; Comini 1976; Nebehay
1977; Schmied 1979; Nebehay
1979; Nebehay 1980; Whitford
1981; Malafarina 1982, no. 245 and
pl. XXI; Werkner 1986; Nebehay
1989; Fournier 1992; L 227; K 261.

Exhibitions:
Budapest 1913; Stuttgart 1957;
Vienna 1964; London 1964; New
York, Guggenheim Museum 1965;
Vienna, Österreichische Galerie
1968; Munich 1975; Tokyo 1979;
Vienna 1980; Rome 1984; Vienna
1985; Charleroi 1987; Zurich 1988;
Tokyo 1991; Tübingen 1995; Tokyo
1997.

Schiele sat in prison from April 13 to May 7, 1912, and once he was released it took him a long time before he was able to begin painting again. Not only was he shaken by the experience, but he also lacked a proper studio and probably the money with which to secure the necessary materials. For the first two paintings he undertook, he had to use canvas that had been stitched together from two smaller scraps. On November 16 he wrote to Arthur Roessler that "with the most primitive of materials" he had "almost finished a few paintings." From their style and the fact that they are both painted on canvases that have been patched together, it would appear that this painting and the *Twilight City* (L 226) were among the ones he wrote about to Roessler and to Carl Reininghaus in a letter of December 20, 1912. They were surely painted either in late 1912 or early 1913. In his letter to Reininghaus, he mentions having painted cityscapes. Since Schiele frequently only signed and dated his paintings long after they had actually been completed, the date of 1913 on this one is not necessarily accurate.

It is a sign of Schiele's mental state at this time that neither this painting nor the *Twilight City* was inspired by fresh impressions. Unlike any of his other cityscapes from these years, they were pieced together from sketches of Krumau motifs that lay at hand and from invented structures.

There is no single location in Krumau from which even those buildings that can be identified appear as they do here. The one that is most recognizable is the Jodokus Church, upstream with its wall facing the Moldau and its adjacent structures in the center at the top. But even here the facade has been painted red–which it is not–and the facades of the houses to the left of it have been twisted so that they continue upward at an angle rather than facing the same way. The buildings to the right of the church, and especially the crenellated wall beyond them, have been changed considerably. For all of these changes, whether in color, shape, or orientation, the church and the structures on either side of it are the only part of the city that Schiele left in something like its actual configuration.

The large building just to the right of center, with two tall white chimneys, is clearly the Jesuit seminary, even though it too has been reworked, most obviously by the addition of three dormer windows. In reality, however, it is elevated, and nowhere can you look down on its roof like this and the side facing Obere Gasse. The crenellated wall below

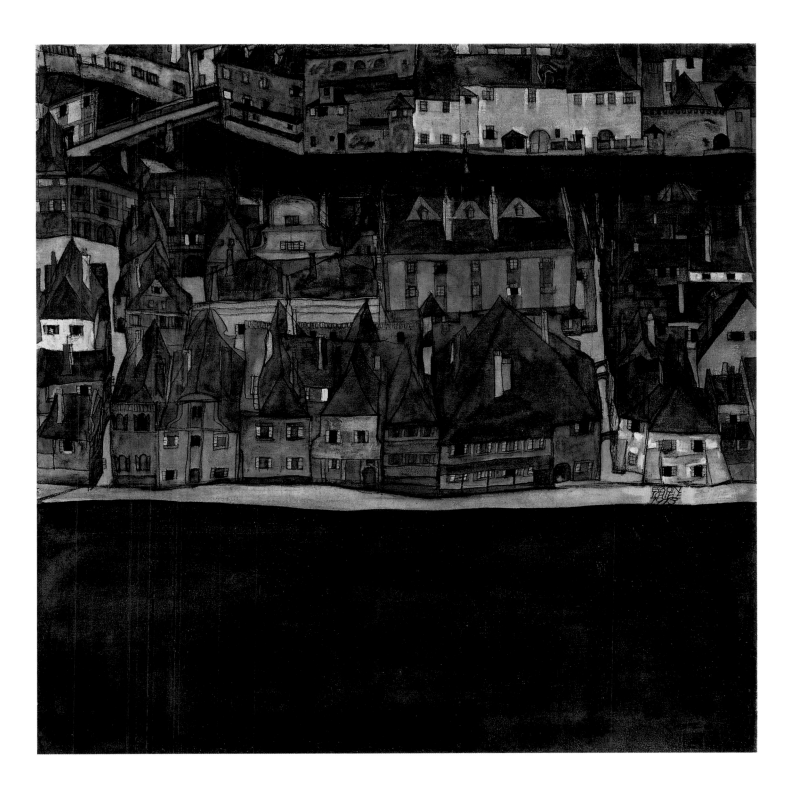

it and to the left may be a reminiscence of the facade of Krumau's City Hall. In use since roughly 1650, it is made up of four Gothic houses, but in Schiele's painting there appear to be only three. And, in fact, the City Hall building faces in a different direction in relation to the Bader Bridge, visible in the upper left, which connects the old town with the new. It is also in a different part of town, one that could not have been seen from this viewpoint. Even farther removed from this area is the building to the right of what may be City Hall and seemingly unconnected to it. In my inventory of Schiele's motifs (Leopold 1972, p. 649f.), I have catalogued these and many other alterations the painter made to Krumau's actual topography.

Fascinating as it may be to pin down these individual motifs, what is more important is that by altering them and combining them with structures of his own invention, Schiele managed to create a highly evocative image of a city drenched in time. The roofs are gray-black, the facades more colorful. A black river winds between them. At the top of the picture the stream is narrower, at the bottom it has widened and shows shifting reflections. The roofs of the many buildings are tall and steep, almost like hats, and many of the windows below them look like eyes. It is as though we were looking at as many faces.

The lovely colors of the facades of the houses and the blackness of the river–both freely invented by Schiele–complement each other. The result is a harmonious whole.

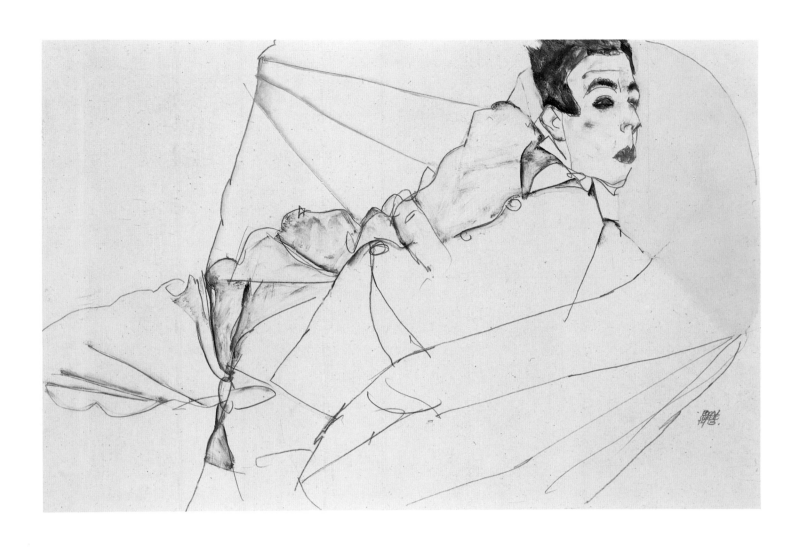

82 *Reclining Boy (Erich Lederer).* 1913

82 *Reclining Boy (Erich Lederer)*
 (Liegender Knabe [Erich Lederer])
 1913

Pencil, gouache, and
watercolor on paper,
12 1/2 x 19" (31.8 x 48.1 cm)
Signed and dated lower right:
"EGON SCHIELE 1913."
Leopold Museum Inv. 1408

Provenance:
Rudolf Leopold, Vienna.

Literature:
Leopold 1972, pl. 113; K 1224.

Exhibitions:
Munich 1975; Tokyo 1986; Tokyo
1991; Tübingen 1995; Tokyo 1997.

The boy is lying in an upholstered chair, his head resting against the back.
One is struck by the drastic turning of his head, which, seen from above,
looks extremely odd against the flat yellow behind it.

To judge from Schiele's stylistic evolution, this drawing, with its highly
charged but sensitive lines, must date from the beginning of 1913. The
subject matter confirms such an assumption. The rigid lines of the
drawing and the application of painting to only a part of it reveal a
definite step in the direction of abstraction. Schiele painted only the back
of the yellow chair, and as a result one does not at first recognize it for
what it is. Its right arm would also be puzzling–unlike the left one, which
is clearly connected to the back–if the lines describing it, angled up from
the body, were not traced in the same telltale yellow-ocher.

The light-colored face stands out in three dimensions against the
deliberate flatness of the chair. The strongly contrasting dark hair and
eyes, and even more the softly painted shadows, are also typical of
Schiele's work from early 1913.

83 Reclining Girl with Ocher Cloth
(Liegendes Mädchen mit ockerfarbenem Tuch)
1913

Schiele here combined light and dark areas, some thickly painted and some virtually untouched, into a successful statement. The parts of the body delicately modeled in watercolor stand out against the strong ocher of the drapery. The wavy outlines and the nuanced color in the stockings situate the drawing in the first months of 1913. New is the way in which the composition is divided into clearly defined sections: the ocher cloth, the nude parts of the body, and the dark stockings and hair, which bracket the figure on either side. The simplified drawing of the fingers is also something that Schiele would not have produced before 1913. Graphically, the placement of these two hands is a delight.

Gouache, watercolor, and pencil on paper, 12 3/8 x 19" (31.5 x 48 cm) Signed and dated lower right: "EGON SCHIELE 1913." Leopold Museum Inv. 1392

Provenance: Bey Behcet Özdoganci; Rudolf Leopold, Vienna.

Literature: Leopold 1972, pl. 116; K 1250.

Exhibitions: Vienna, Albertina 1948; Salzburg 1968; Tokyo 1991; Tübingen 1995.

84 Reclining Female with Spread Legs
(Liegende mit gespreizten Beinen)
1913

The pose of this provocative nude, with her frivolous gaze and legs spread wide, is very different from that of the model in the previous example. Because of the extreme foreshortening of the face, the figure seems to consist almost solely of legs and a head that is framed by spiral locks of hair. The latter were drawn with greater pressure on the pencil and therefore stand out against the face.

Pencil on paper, 12 1/2 x 19" (31.8 x 48 cm) Signed and dated lower right: "EGON SCHIELE." Leopold Museum Inv. 1411

Provenance: Estate of Egon Schiele, Vienna; Melanie Schuster, Vienna; Rudolf Leopold, Vienna.

Literature: Leopold 1972, pl. 117; K 1251.

Exhibitions: Tokyo 1991; Tübingen 1995.

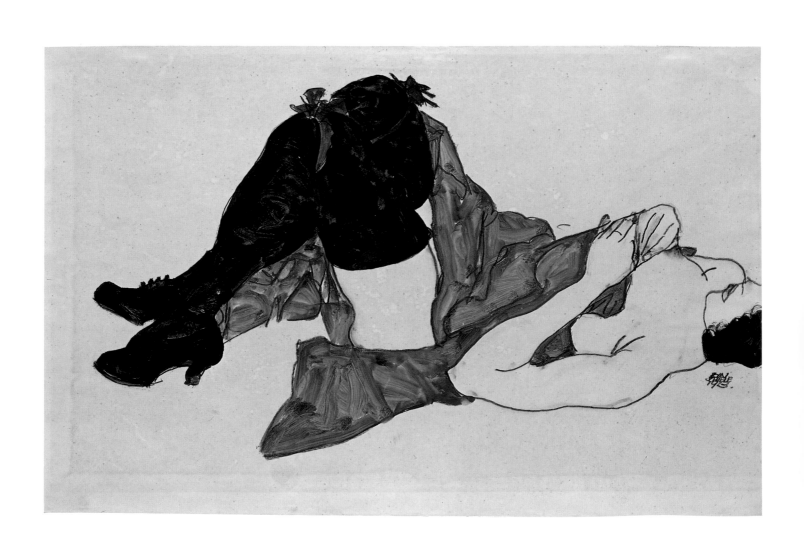

83 *Reclining Girl with Ocher Cloth.* 1913

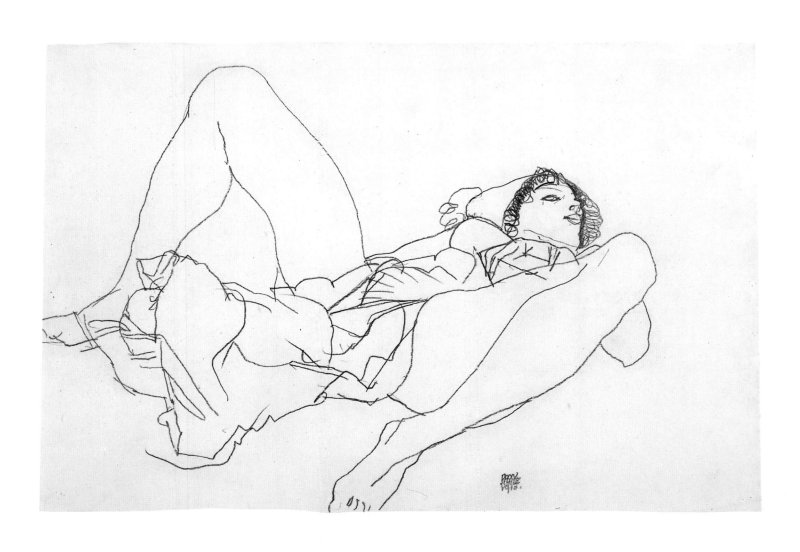

84 *Reclining Female with Spread Legs.* 1913

85 *Mother and Daughter*
(Mutter und Tochter)
1913

Gouache, watercolor,
and pencil on paper,
18 7/8 x 12 5/8" (47.9 x 31.9 cm)
Signed and dated lower right:
"EGON SCHIELE 1913."
Leopold Museum Inv. 1436

Provenance:
August and Serena Lederer,
Vienna; Erich Lederer, Geneva;
Rudolf Leopold, Vienna.

Literature:
Leopold 1972, pl. 129; Marchetti
1984; Akademische Druck- und
Verlagsanstalt 1985; K 1298.

Exhibitions:
Amsterdam 1956; St. Gallen 1957;
Innsbruck 1963; Munich 1975;
Brussels 1981; Venice 1984; Zurich
1988; Tokyo 1991; Tübingen 1995.

This is a tense but extraordinarily self-contained composition. The dominant diagonal axis of the elongated girl's body is balanced by the vertical braid and the roughly opposite diagonal described by the mother's forearm and the upper part of the girl's right arm. The tilt of the mother's face, the girl's face, and the outside contour of the left hip and thigh also help to stabilize the composition.

The drawing of the girl's body, with its shoulder sloping to the right and the braid hanging down her back, is particularly impressive. Her skin color, enlivened by delicate tones of red and gray, is set off against the scarlet-red of the mother's dress. The hair of both women–in contrast to the following plate–is an identical blond.

86 *The Mother and the Daughter*
 ("Die Mutter und die Tochter")
 1913

This composition is more static than the one shown in the previous plate. Here the axis of the girl's body is vertical, as is her braid. The mother's red dress forms a steep pyramid interrupted by the backward tilt of the girl's head on the one side and on the other by the scissor-like conjunction of the two women's arms. Schiele's interest in geometric shapes is apparent not only in the larger forms–the pyramid already mentioned–and in the details: the sharp, straight lines and the many convex and concave curves.

The intentionally somewhat rigid composition has been colored with extreme sensitivity. Note the blond hair of the mother, the darker hair of the daughter with its black shadows, the blue veiling the tips of the mother's fingers between them, the very sensitively textured red in the dress, and–as a definite contrast to it–the gray and black of the fabric that acts as a foil for the girl's body. The sharper and softer red tones of the mother's face are combined with the black of the lids and brows, the ocher-blond with the blue, in a particularly delicate manner.

In addition to creating these lovely combinations of color and form, Schiele presented in this work a touching image of the awkwardness and immaturity of the body of a very tall young girl.

Gouache, watercolor, and pencil on paper, 18 1/2 x 12 5/8" (47 x 32 cm)
Signed and dated lower right: "EGON SCHIELE 1913."
Inscribed lower right: "DIE MUTTER UND DIE TOCHTER"
Leopold Museum Inv. 2356

Provenance:
August and Serena Lederer, Vienna; Wolfgang Gurlitt, Munich; Rudolf Leopold, Vienna.

Literature:
Leopold 1972, pl. 130; K 1297.

Exhibitions:
Linz 1949; Salzburg 1957; Munich 1957; St. Gallen 1957; Munich 1964; Tübingen 1995; Tokyo 1997.

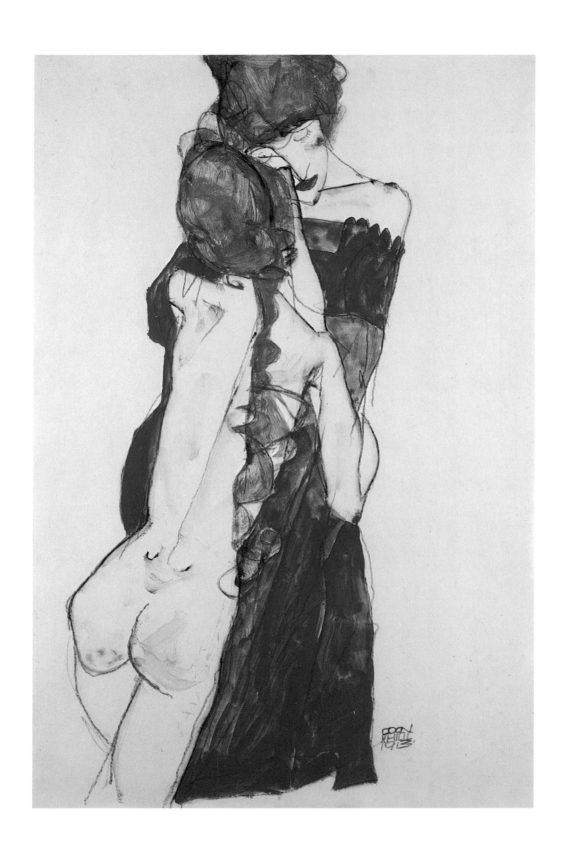

85 *Mother and Daughter.* 1913

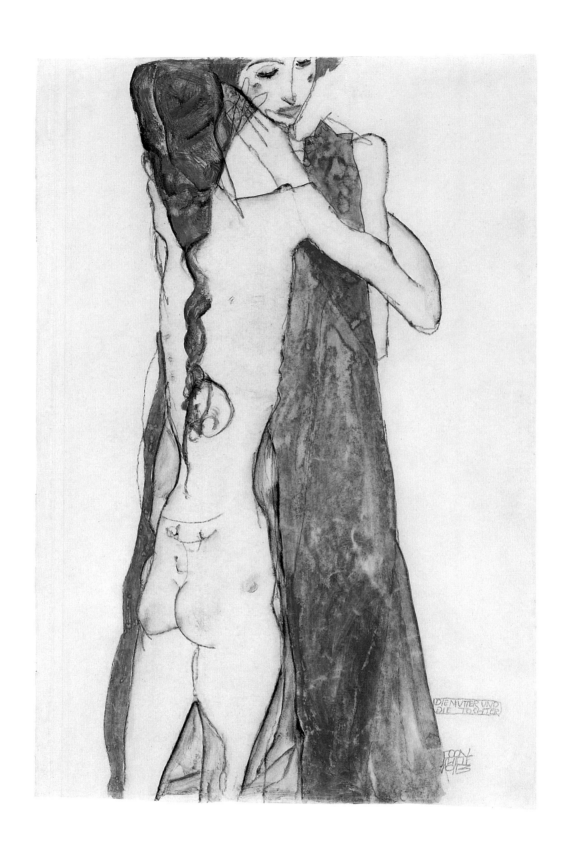

86 *The Mother and the Daughter.* 1913

87 *Standing Female Torso with Olive-Green Shirt*
(Stehender weiblicher Torso mit olivgrünem Hemd)
1913

Pencil, watercolor, and
gouache on paper,
18 7/8 x 12 5/8" (47.8 x 32 cm)
Signed and dated lower right:
"EGON SCHIELE 1913."
Leopold Museum Inv. 2353

Provenance:
Bey Behcet Özdoganci;
Rudolf Leopold, Vienna.

Literature:
Leopold 1972, pl. 121; K 1392.

Exhibition:
Tübingen 1995.

In 1913 Schiele executed a whole series of drawings of nude female torsos, both alone and in groups. They most often show only the legs and lower body–and occasionally the entire body but no head (see pls. 89, 90, and the illustration on p. 223). The torso reproduced here is probably the most beautiful of the lot, and in formal respects the most perfect–a completely self-contained composition. There is no trace of form for form's sake. The girl assumes her eccentric pose in a perfectly natural way.

The right leg dominates the composition in that it is placed at an angle and set forward in space. This is also underscored by its coloring. Longer for reasons of perspective, it is even further elongated by the way the foot continues in the same direction. If one extends the axis of the leg upward, it strikes the pointed section of the shirt just above the navel. A combination of various elements is required to balance such a long diagonal: the turning of the left foot to the side in the opposite direction, the angle of the left leg, and especially the diagonal lines of the left pelvis and right arm, which parallel each other.

The girl's nudity is emphasized by the presence of the contrasting olive-colored shirt, only sparingly painted, with brick-red along the outlines, strokes of gray, and blue-black, so that it seems very thin. Although this delicate combination of colors is striking, it is the drawing that predominates. This sets the work apart from those of 1912, in which painting and drawing were equally balanced, and certainly from those of 1911, when painting was often the most important element.

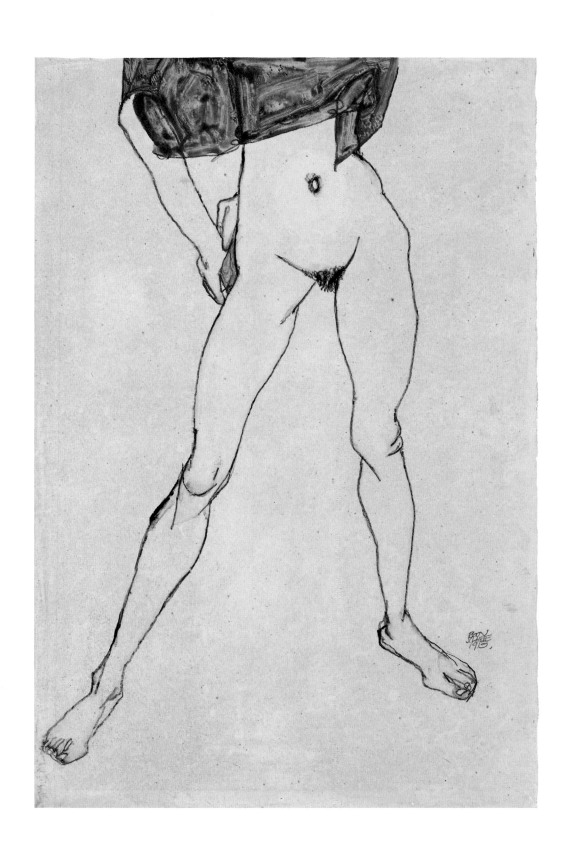

Kneeling Girl
 (Kniende)
 1913

Pencil, watercolor, and
gouache on paper,
18 5/8 x 12 5/8" (47.4 x 32 cm)
Signed and dated lower right:
"EGON SCHIELE 1913."
Leopold Museum Inv. 1438

Provenance:
Bey Behcet Özdoganci;
Rudolf Leopold, Vienna.

Literature:
Leopold 1972, pl. 123; K 1285.

Exhibitions:
Tokyo 1991; Tübingen 1995.

This kneeling girl appears to have been caught in motion. Her expression and the extreme tilt of her head–cut off as it is by the top edge–give the impression that she is afraid of bumping against something above her.

One can see from the outline of the mattress on which the girl is kneeling how carefully it was incorporated into the composition. Props such as this are rare in Schiele's work. His figures are usually shown standing, sitting, lying, or kneeling without the slightest indication of their surroundings. Here he provided a base for this fragile, angular figure so as to underscore the sense of dynamic movement. The pillow between her legs, painted bright red, helps to explain the position of the right calf and foot extended away from us.

Especially notable are the short fanned lines suggestive of ribs. Although anatomically incorrect, they are justified in the context of the composition and are thus perfectly acceptable.

All of the elements in the arrangement are cross-referenced, but in an inconspicuous way, so that one's first impression is that of a living, moving figure.

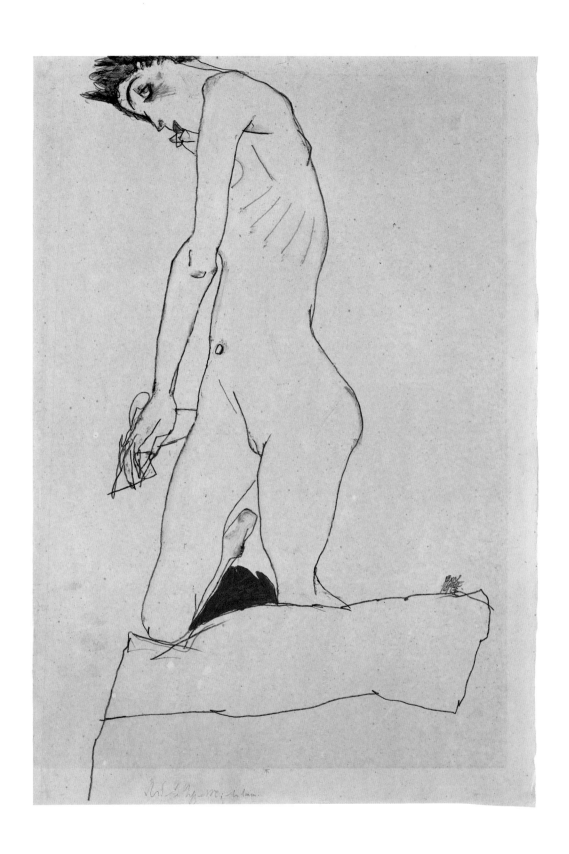

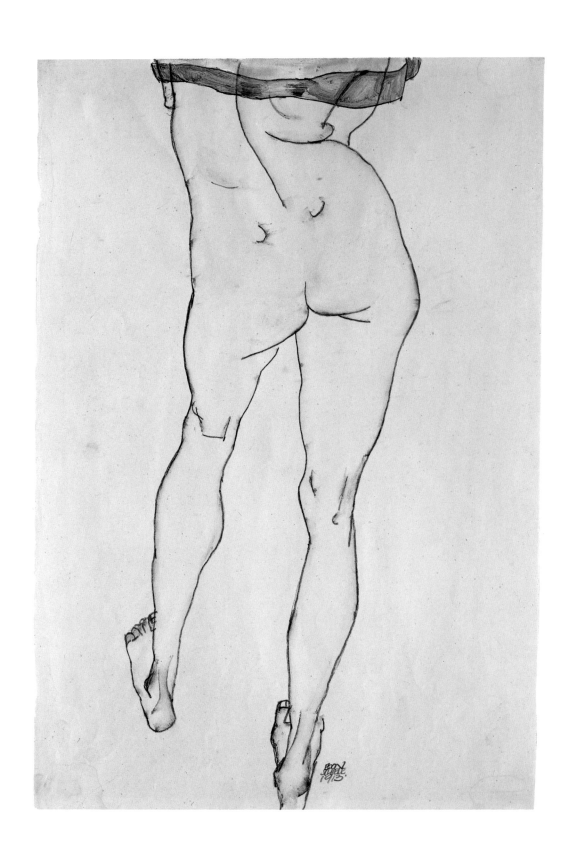

89 *Female Torso Seen from the Back*
 (Rückenansicht eines weiblichen Torsos)
 1913

This study is related to the back views that are preserved as fragments of the picture *Conversion II* (1913; L 237 and 238). The strong contours of this nude torso are highlighted and made more lifelike with subtle coloring. Schiele rendered the left Achilles tendon with his brush, without preliminary drawing–a notable exception from his normal practice.

Pencil and gouache on paper,
18 7/8 x 12 5/8" (47.8 x 32 cm)
Signed and dated bottom center:
"EGON SCHIELE 1913."
Leopold Museum Inv. 1437

Provenance:
Viktor Fogarassy, Graz;
Hans Dichand, Vienna;
Rudolf Leopold, Vienna.

Literature:
Comini 1976; Malafarina 1982,
no. D58; K 1373.

Exhibitions:
New York, Guggenheim Museum
1965; Darmstadt 1967; Bregenz
1971; Innsbruck 1973; Munich
1975; Tokyo 1991; Tübingen 1995.

90 *Red Blouse*
 ("Rote Bluse")
 1913

Gouache, watercolor,
and pencil on paper,
19 x 12 5/8″ (48.2 x 31.9 cm)
Signed and dated lower right:
"EGON SCHIELE 1913."
Inscribed lower right:
"ROTE BLUSE"
Leopold Museum Inv. 1433

Provenance:
Fritz Grünbaum, Vienna; Heirs of
Fritz Grünbaum, The Netherlands;
Galerie Kornfeld, Bern (auction),
1981; Rudolf Leopold, Vienna.

Literature:
K 1394.

Exhibitions:
Bern 1956; Bern 1957; St. Gallen
1957; Vienna, Albertina 1968;
Zurich 1973; Tokyo 1986; Tokyo
1991; Tübingen 1995.

Schiele here produced an exciting contrast between the flat, brilliant scarlet of the blouse and the fully three-dimensional body. He depicts only a torso, but formally it strikes one as "complete," a self-contained composition.

The open blouse serves to frame the naked body. Shading here and there along the outlines of the legs and arms lifts them off the paper and places them in space (see the standing torso in the drawing on p. 223).

Just as the shoulder and head are cut off at the top, the left foot is cut off at the bottom. Thanks to this formal juxtaposition, one does not perceive their absence as a deficiency. Nor does one register the highly casual rendering of the hands, for they serve as key elements in the composition. The right hand appears at the apex of a roughly triangular shape only interrupted by the naked body, its curved base formed by the left arm and sleeve. The spread legs form another triangle, the point of which is represented by the pubes, which are executed in three dimensions in contrast to the flat surface of the blouse. It was not only for formal reasons that Schiele made this part of the body the center of his composition.

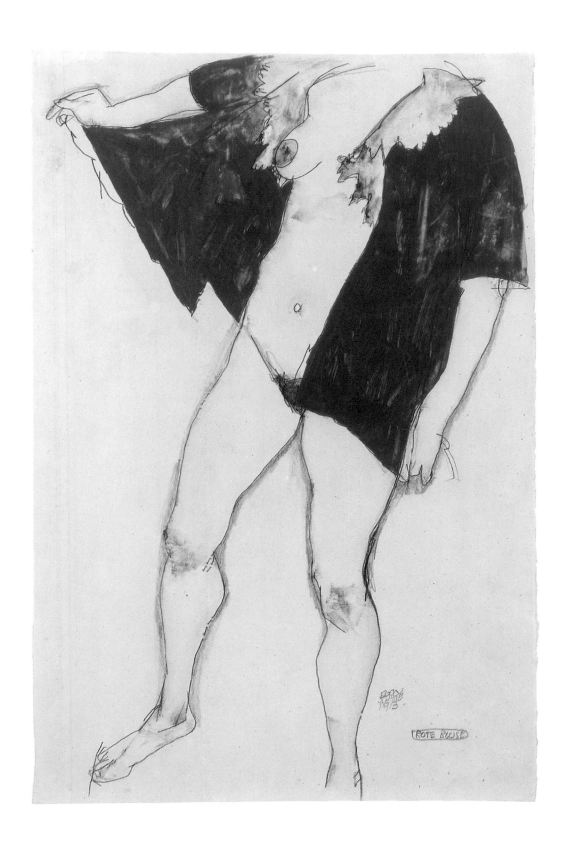

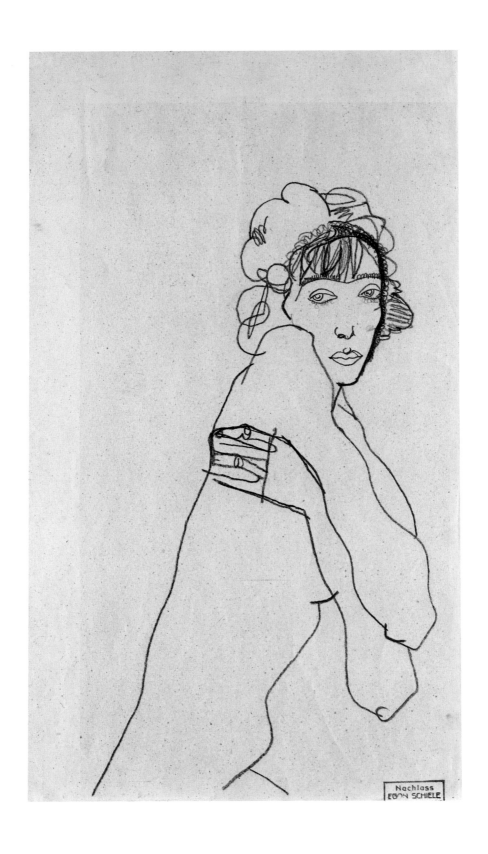

91 *Nude Girl with Crossed Arms*
(Nackte mit überkreuzten Armen)
1913

The body of this nude girl and her crossed arms–highly intriguing in terms of drawing–form a triangular shape. A tendency toward geometrical forms is also quite apparent in the rendering of the eyebrows and in other details. The girl's face almost appears to be hiding behind the raised shoulder, an indication that she is somewhat shy. There is also a hint of wariness in her rather melancholy expression.

In the standing nude torso on the back of this sheet (see illustration below), the right leg, bent sharply at the knee, forms a large triangle with the left one, which extends the line of the body downward. The top line of the right thigh approximately continues the inner line of the left forearm. The latter, in turn, is related to the point at which the right arm disappears behind the body. It was for the sake of that reference that the left arm was deliberately deformed.

As is frequently the case in drawings from this period, the outlines are shaded, so that the figure becomes an actual body in space. This drawing adds another spatial effect; the foreshortening of the lower part of the right leg places it well to the back, and the execution of the only partially visible right foot is delightful.

Pencil on paper, 18 3/8 x 10 3/8 (46.5 x 26.3 cm)
Estate stamp lower right.
Verso: *Standing Torso with Right Leg Bent.* 1913. Pencil on paper.
Signed and dated lower right: "EGON SCHIELE 1913"
Leopold Museum Inv. 1442

Provenance:
Estate of Egon Schiele, Vienna;
Melanie Schuster, Vienna;
Rudolf Leopold, Vienna.

Literature:
Breicha and Fritsch 1964; Leopo 1972, p. 276; Johnston 1980, p. 269; K 1337.

Exhibitions:
Berlin 1960; Innsbruck 1963; Tokyo 1991; Tübingen 1995.

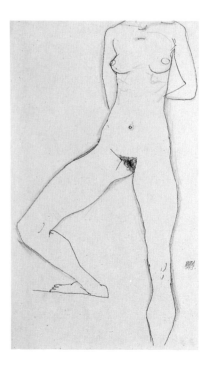

Standing Torso with Right Leg Bent (verso of pl. 91). 1913. Pencil on paper

223

92 *Old Roof*
(Alter Giebel)
1913

Gouache, watercolor,
and pencil on paper,
12 3/4 x 19 3/8″ (32.3 x 49 cm)
Signed and dated lower right:
"EGON SCHIELE 1913."
Leopold Museum Inv. 1413

Provenance:
Otto Benesch, Vienna;
Eva Benesch, Vienna;
Serge S. Sabarsky, New York;
Rudolf Leopold, Vienna.

Literature:
O. Benesch 1951; K 1473.

Exhibitions:
Vienna, Albertina 1948; Zurich
1988; Tokyo 1991; Tübingen 1995.

Schiele first explored this old structure with its crumbling masonry and derelict roof in an earlier pencil drawing from 1913 (K 1474), made during his summer vacation in Carinthia. In that work he included its ground floor as well. In this version it was omitted; a carefully executed painting of this subject only suggests the ground floor with narrow strips of olive and orange across the bottom.

The warm-colored masonry is surrounded by blackish tones, here and there mixed with blue. At the bottom of its opening there are touches of brick-red so intense that one might almost take them to be the flames of an open fire. The soaring roof makes one think of a chapel.

Schiele produced a number of studies of buildings in pencil and gouache on paper, but this is surely the most impressive of them. Otto Benesch reproduced it in his 1951 Schiele portfolio. It even surpasses the very beautiful study of old houses on the Flössberg in Krumau (Albertina, Inv. 31.158), which I reproduced elsewhere (Leopold 1972, pl. 161). Both works once belonged to Otto Benesch.

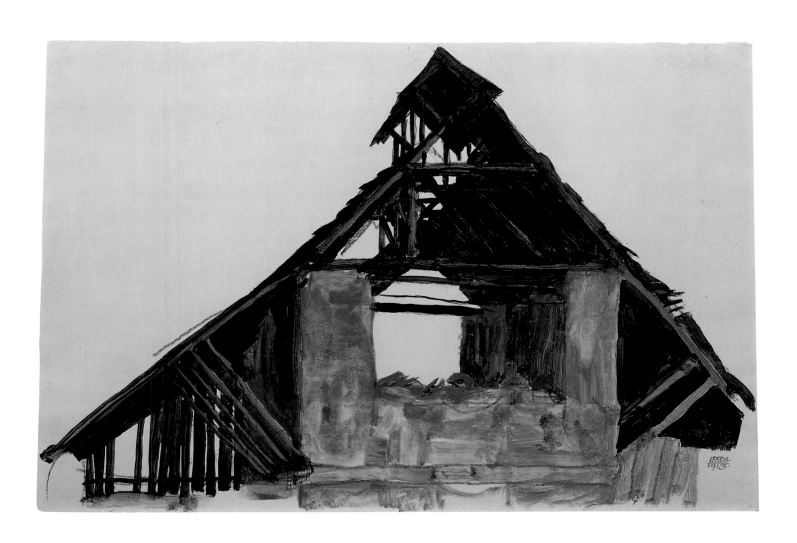

93 *Girl (Seated with Yellow Cloth)*
 ("Mädchen" [Sitzende mit gelbem Tuch])
 1913

Watercolor, gouache, and
pencil on paper,
12 3/8 x 18 3/4" (31.2 x 47.6 cm)
Signed and dated lower right:
"EGON SCHIELE 1913."
Inscribed lower right: "MÄDCHEN"
Leopold Museum Inv. 2381

Provenance:
Galerie Kornfeld, Bern (auction),
1956; Rudolf Leopold, Vienna.

Literature:
Leopold 1972, pl. 131;
Marchetti 1984, p. 225; K 1278.

Exhibitions:
Bern 1957; St. Gallen 1957; Berlin
1960; Innsbruck 1963; Munich
1975; Venice 1984; Tübingen 1995.

The basic symmetry created by the upper body and the legs extending out from it at roughly right angles is enlivened by the tilt of the head to the side and especially by the differently proportioned thighs, which form a common axis sloping down toward the right. The sharp downward movement of the left leg below the knee also introduces a certain imbalance. Since the outline of the left thigh as it was first drawn from life failed to provide the important axis just mentioned, Schiele altered it. He also changed the position of the head, but–as in all such cases of which I am aware–made no attempt to erase the original lines.

The angle of the right knee does not correspond to that of the left one, which has been deformed into a point, as it serves as a counterbalance to the straight outside line of the left calf. The projecting angles become important elements in the two-dimensional design, but at the same time they reflect the figure's extension in space. This drawing is an early and very typical example of how Schiele chose to restructure the body so as to produce geometric forms, much as the French Cubists were doing, though in a very different manner. Unlike them, he preserved its natural appearance.

The skin tone is essentially that of the paper itself, to which hints of brick-red and gray-black have been added. Despite these delicate touches of painting, it is the graphic element that dominates the work. The more heavily painted areas of the cloth and hair are firmly anchored in the overall structure.

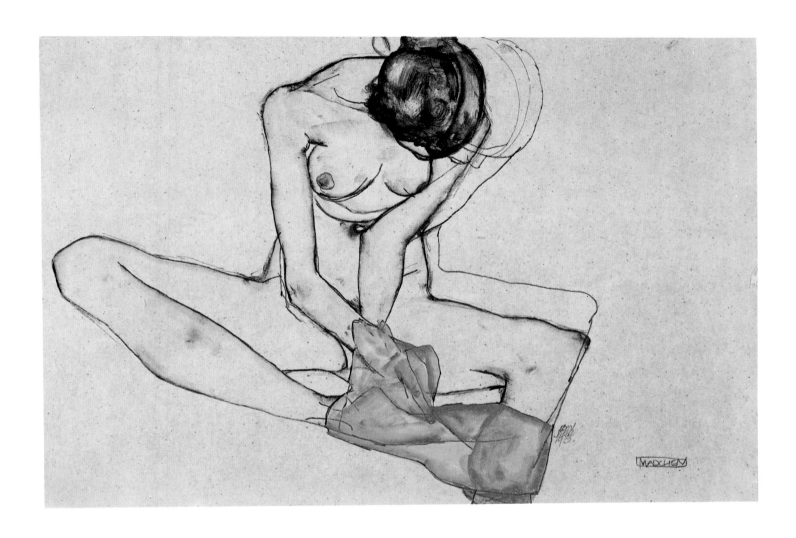

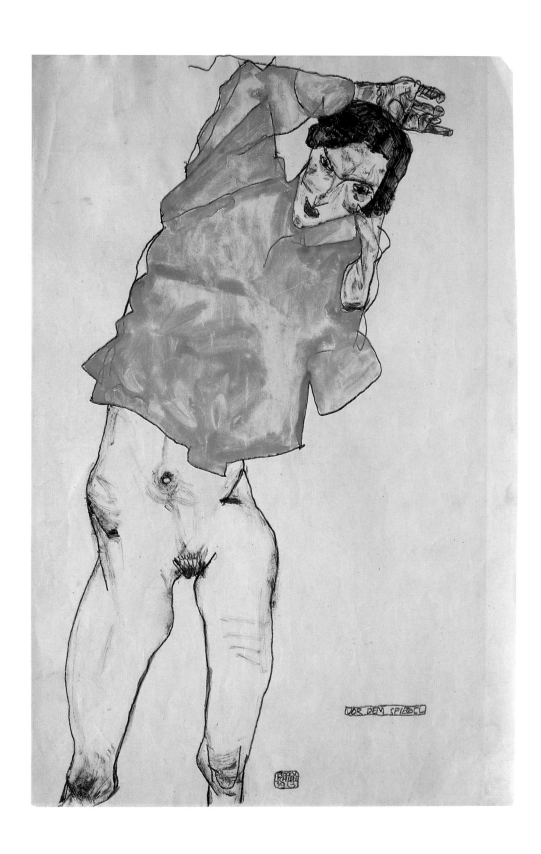

94 *In Front of the Mirror*
("Vor dem Spiegel")
1913

Schiele rarely painted such a luminous green as the one used for this woman's shirt. It contrasts sharply with the body, with its accents of intense color, and serves to accentuate its nakedness. The ugliness of the woman's face, her sex, and her deformed thigh and knee are balanced by the beautiful colors and expressive lines of the highly satisfying composition. This is a fine example of Schiele's habit of depicting the ugliness of a body unflinchingly, even exaggerating it.

The tilt to the right of the upper body, the head, and the hands introduces a distinct imbalance to the arrangement, but it is just checked by the opposing tilt of the pelvis. This "just" was Schiele's intent, and it is what makes the work so lively and impressive.

Gouache, watercolor,
and pencil on paper,
19 x 12 1/8″ (48.3 x 30.9 cm)
Signed and dated bottom center:
"EGON SCHIELE 1913"
Inscribed lower right:
"VOR DEM SPIEGEL"
Leopold Museum Inv. 1435

Provenance:
Rudolf Leopold, Vienna.

Literature:
Leopold 1972, pl. 132; K 1362.

Exhibitions:
Berlin 1960; Tokyo 1991; Tübingen 1995.

95 The Dancer
("Der Tänzer")
1913

Gouache, watercolor, and pencil
on paper, 18 7/8 x 12 5/8"
(47.8 x 31.9 cm)
Signed and dated lower right:
"EGON SCHIELE 1913"
Inscribed lower right:
"DER TÄNZER"
Verso: *Sketch of a Female Nude*
Leopold Museum Inv. 1434

Provenance:
Estate of Egon Schiele, Vienna;
Melanie Schuster, Vienna;
Rudolf Leopold, Vienna.

Literature:
Breicha and Fritsch 1964; Leopold
1972, pl. 133; K 1414.

Exhibitions:
Vienna 1928; Vienna, Albertina
1948; Linz 1949; Vienna, Albertina
1968; Des Moines 1971; Munich
1975; Brussels 1981; Zurich 1988;
Tokyo 1991; Tübingen 1995.

The arms of this strange, dancing figure are caught in hectic, angular, rhythmic movement. The rest of the composition underscores his complete abandon. The firm pencil lines appear to have been laid down in a trance, sharp contours alternating with descriptive scribbling. Zigzags and lines crossing each other are common. The painting is equally expressive: even less concerned with reality, it reflects both the dancer's excitement and that of the painter.

Most of the work is done in bright colors. Here there are only touches of the biting blue-green that is so prominent in most drawings from this period. Red, ocher, blue, and brown predominate, applied in either simple dots or drawn-out strokes of the brush. The leftward extension of the right forearm and that of the head behind the hunched left shoulder do not completely counter the essential instability of the tilted figure. This is, of course, deliberate, and it helps to express the excitement of this man utterly absorbed in his dancing.

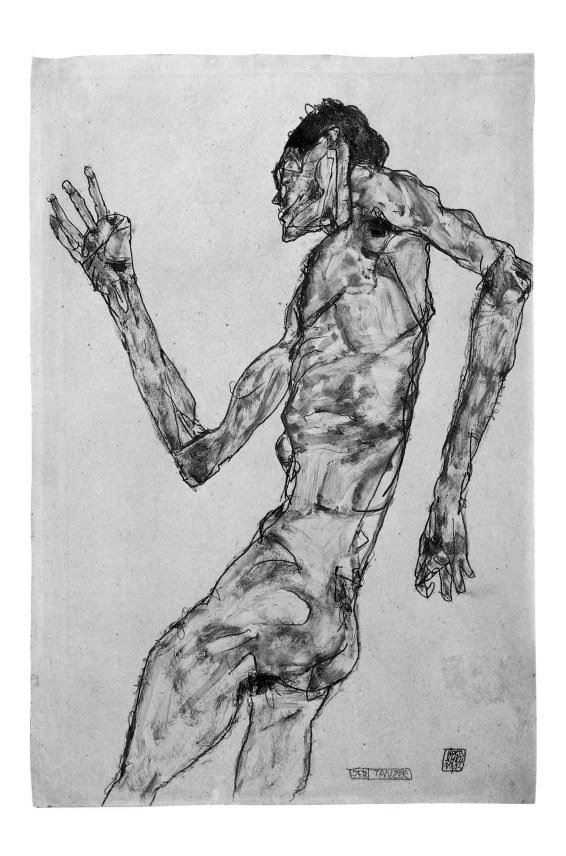

96 *Self-Portrait as Saint* (study for *Encounter*)
(Selbstbildnis als Heiliger)
1913

Oil, gouache, and black crayon
on paper, 9 1/8 x 9 3/8″
(23 x 23.7 cm)
Not signed, not dated
Leopold Museum Inv. 2325

Provenance:
Sotheby's, London (auction), 1986;
Rudolf Leopold, Vienna.

Literature:
K 1446.

Exhibitions:
Tübingen 1995; Tokyo 1997.

Schiele here presents himself as a monk in a reddish-blue habit. His head faces left–unlike the head in the painting *Encounter* (L 243). In the painting it is not the monk who wears a halo, as he does here, but rather the saint behind him. Even so, there is no question but that this work was produced in association with the painting.

Schiele executed the drawing with a black crayon, then painted the various sections with almost uniform oil colors. Only in the head did he add accents in red to the basic brownish tones and also violet, most noticeably in the left eye. The result is a satisfying color harmony.

The forms of the face have been greatly simplified–the ear, for example, is rendered as a simple triangle. Even so, there is a tremendous expression of sadness in this work.

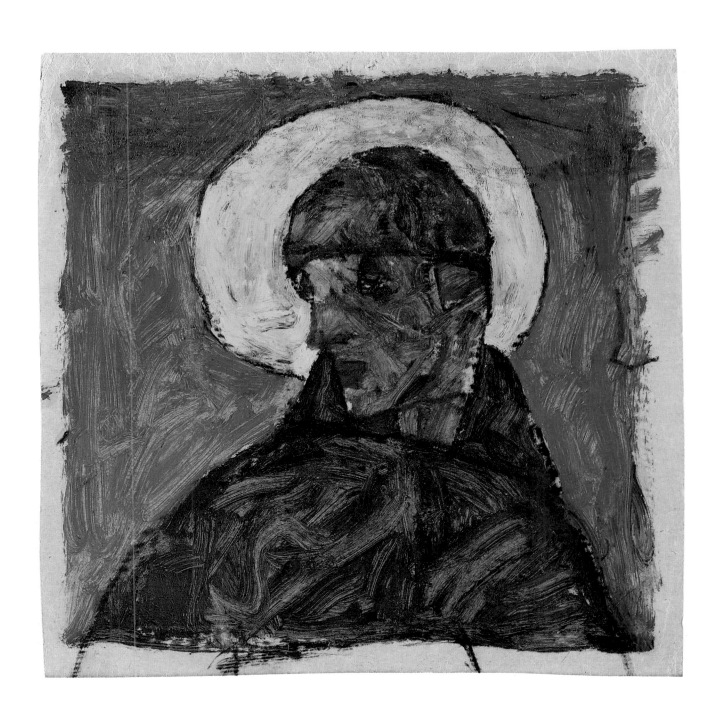

Preacher (Nude Self-Portrait with Blue-Green Shirt)
("Prediger" [Selbstakt mit blaugrünem Hemd])
1913

Gouache, watercolor, and
pencil on paper, 18 5/8 x 12 1/4″
(47.2 x 31.1 cm)
Signed and dated bottom center:
"EGON SCHIELE 1913"
Inscribed lower right: "PREDIGER"
Leopold Museum Inv. 2365

Provenance:
Wolfgang Gurlitt, Vienna;
Galleria Galatea, Turin;
Rudolf Leopold, Vienna.

Literature:
Reisner 1960; Leopold 1972,
pl. 134; Marchetti 1984;
Friesenbiller 1985; Nebehay 1989;
K 1441.

Exhibitions:
Vienna 1919; Salzburg 1950;
Munich 1957; Recklinghausen
1959; Heidelberg 1962; Turin 1963;
Tübingen 1995.

Schiele's presentation of himself in this drawing is rather strange, even scurrilous. His head bends forward from the body at nearly a right angle, parallel to the extended right forearm. (For the sake of the formal relationships in the composition, the forearm was deliberately drawn much lower than anatomical reality would allow.) He gazes downward fixedly, apparently at his genitals, which are emphasized by a touch of red. Do the gaze and the extended hand have something to do with the word *"Prediger"* (preacher), which was subsequently inscribed on the drawing? Erich Lederer recalls that Schiele generally gave very little thought to the inscriptions that commonly appear on his drawings from 1913, inventing them only after the works had been completed. Some of them are perfectly appropriate, but others seem somewhat arbitrary.

The excessive weight of the head and arm stretching toward the left is partially balanced by the forward angle of the right thigh, the similar angle of the left forearm, and the billowing of the shirt to the back. To relate the extended head and arm to each other, Schiele bent the right hand upward slightly so that its axis converges with that of the head. This also serves to close off the composition to the left. The light skin color with accents in red is contrasted to the darker blue-green of the shirt.

The distinctly geometric tendency of the drawing is apparent in the many lines that appear to be arcs of circles in the body and the neck as well as in the contours and details of the face, especially the odd pair of angles on the cheek–the one on the left intersected by a vertical line–and the interesting rendering of the eye area.

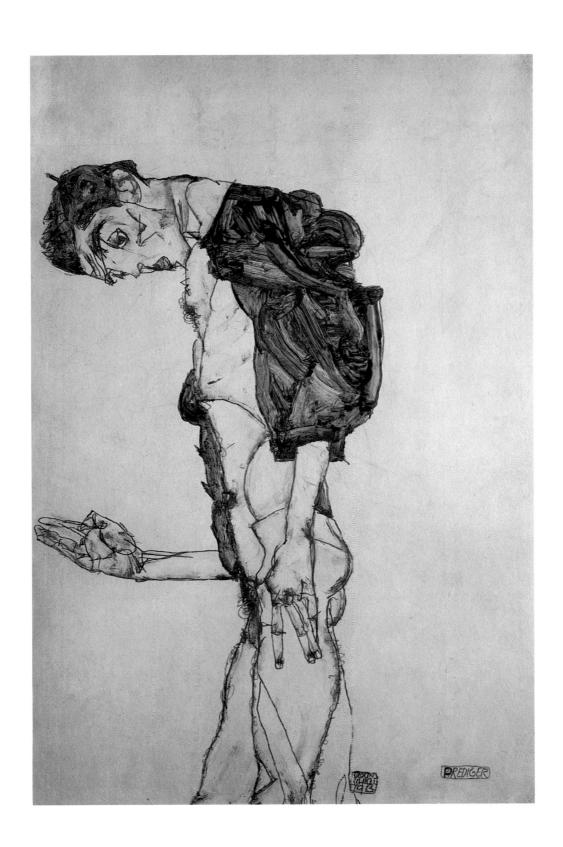

98 *Reclining Female in Undergarments, Resting on Her Elbows*
(Liegende in Unterwäsche, sich aufstützend)
1913

Pencil on paper, 11 5/8 x 17 7/8"
(29.5 x 45.5 cm)
Signed and dated lower right:
"EGON SCHIELE 1913"
Leopold Museum Inv. 1407

Provenance:
Estate of Egon Schiele, Vienna;
Melanie Schuster, Vienna;
Rudolf Leopold, Vienna.

Literature:
K 1365.

Exhibitions:
Salzburg 1968; Tokyo 1991;
Tübingen 1995.

The arrangement of this composition is nearly symmetrical: two larger shapes are separated by the slender waist. The upper body, head, arm, and hand balance the bulk of the buttocks and upper thigh.

Much more interesting, however, are the strong lines of this drawing. In some areas shorter lines branch off from them or they cross, suggesting nothing so much as stitching. Lines like these are mainly found in Schiele's 1914 drawings, and some as late as 1915; compare, for example, the drawing in plate 110, dated 1914.

Schiele generally did not date his drawings immediately. He would inscribe a number of them at a time, relying on his memory, which often failed him (see, for example, the work in pl. 18). This drawing may well be a case in point. It was done with a soft pencil on paper placed on top of a somewhat rough drawing board, so that the lines have an unusual texture to them. When he added his signature and date, presumably some time later, the paper was given a smooth backing. It is altogether possible that he dated the work to the wrong year, and that it was actually done in 1914.

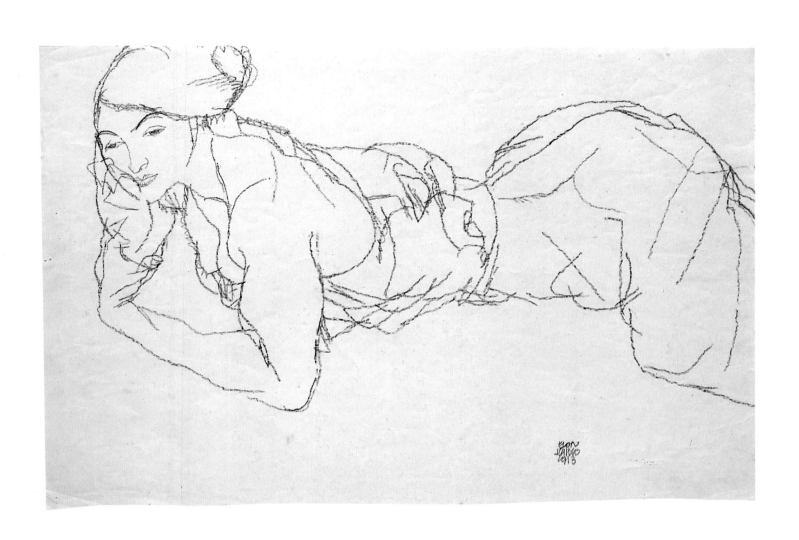

99 *Krumau on the Moldau
(Krumau an der Moldau)*
1913/14

Oil on canvas,
39 1/8 x 47 1/2"
(99.5 x 120.5 cm)
Signed and dated lower right:
"EGON SCHIELE 1914"
Leopold Museum Inv. 655

Provenance:
Friedrich and Maria Hora, Vienna;
Rudolf Leopold, Vienna.

Literature:
Malafarina 1982, no. 267; Marchetti
1984, p. 232; Friesenbiller 1985,
p. 23; Nebehay 1989, fig. 103;
L 244; K 278.

Exhibitions:
Vienna, Neue Galerie 1948;
Innsbruck 1963; London 1964;
New York, Guggenheim Museum
1965; Vienna, Österreichische
Galerie 1968; Munich 1975; Venice
1984; Zurich 1988; Tokyo 1991;
Tübingen 1995; Tokyo 1997.

When Schiele sketched these Krumau houses extending from the Moldau to the City Hall square, he was looking down on them from the top of a tower. He then distributed their roofs and facades, separated by narrow alleyways, across the surface of his painting. Although the composition of the work reflects a great concern for two-dimensional design, the houses retain their spatial integrity. The picture is therefore a very typical and pleasing example of the new manner of composition apparent in Schiele's work beginning in 1913.

The facades of the row of houses in the foreground are actually perfectly aligned, but Schiele has set each one slightly behind the next until they reach the street. The building on the right is pulled forward and painted a yellowish tone to match the color of the one on the far left. The essential boundaries of the composition are set by these two houses and the back wall of the City Hall facade at the top, which is painted a similar yellowish color. These three buildings mark the angles of an isosceles triangle. Across the very top, to close off the composition, Schiele added a strip of green that has nothing to do with the actual scene. The bottom presents broader stripes extending across the whole canvas. The deep black one along the bottom edge represents the Moldau.

Above this solid base of buildings, the houses with their white, orange, violet, gray, and red facades below dark roofs take on a life of their own. Two narrow alleys slice through them. The facades of the smaller cluster on the right side of the street are highly varied and presented with extreme foreshortening. These structures are more brightly colored; with the exception of the one at the top end, even their roofs are lighter in tone. By contrast, the quarter bounded by the two vertical streets, with its dark roofs and highly varied facades, seems more blocklike and massive.

Many of the facades have only two windows that look like eyes. The ones in the horizontal violet strip of wall appear to be leering at us from under the large hat of the roof. Just above that roof is the back wall of the City Hall building. Schiele structured its varied gables with great sensitivity. The high walls and warped roofs, the small windows, and the lively, freely invented colors convey the image of a sleepy town forgotten by history. This painting is perhaps the only cityscape by Schiele in which there is no trace of pessimism, of the tragedy of old age. All we sense is a gentle melancholy.

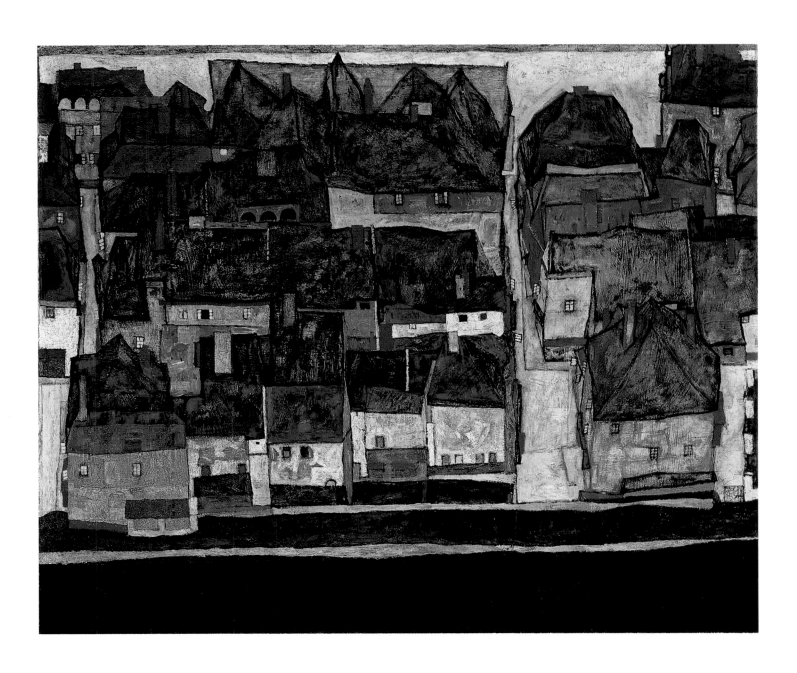

100 *Couple in Dancers' Pose*
(Paar in tänzerischer Pose)
1914

Pencil on paper, 18 x 11 1/8″
(45.6 x 28.1 cm)
Signed and dated lower right:
"EGON SCHIELE 1914"
Leopold Museum Inv. 2364

Provenance:
Estate of Egon Schiele, Vienna;
Melanie Schuster, Vienna;
Rudolf Leopold, Vienna.

Literature:
Leopold 1972, pl. 145; K 1670.

Exhibitions:
Berlin 1960; Tübingen 1995.

These two figures, pressed together, appear to be dancing. The woman, seen from the back and wearing a hat, stands in front, while the man behind her faces forward. His brow is captured with one continuous line. His jaw, chin, and lips are also perfectly rendered in shorthand by a single line that twice changes direction but is never interrupted. The nose is also only a simple acute angle. These and other details are typical examples of Schiele's concentration in his drawing on the graphic essentials.

Much more important for this drawing is the arrangement of the two figures, its unusually dynamic construction. The woman's back and right leg form the main axis, while her neck, head, and left leg bend in the opposite direction. Her body dominates the composition. The man's figure is only secondary, his limbs serving as harmonious variations on hers. The contour of his left side and thigh provides a fascinating counterpoint to the line of her body just to the left of it. The round outline of his wrist echoes the sharp curve of her raised left shoulder.

Incisive lines–like some of the ones here–are occasionally found in Schiele's drawings beginning in the second half of 1912.

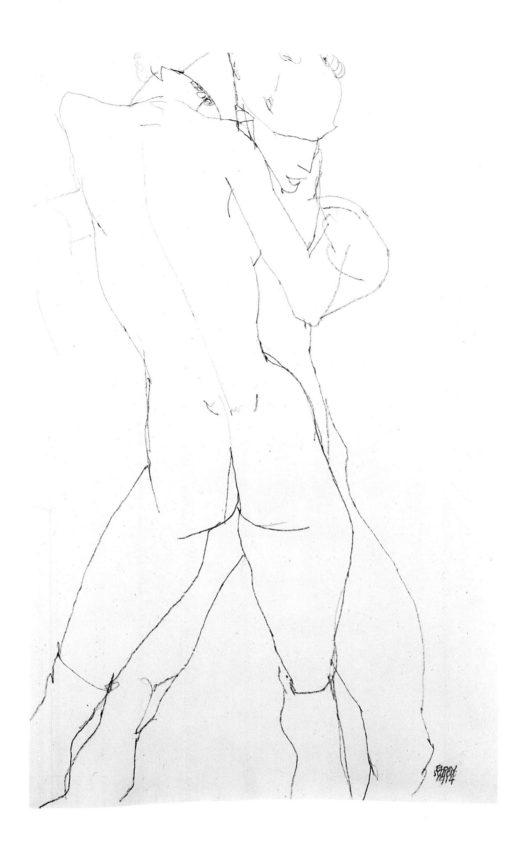

101 *Crouching Woman with Green Kerchief*
(Kauernde mit grünem Kopftuch)
1914

Gouache and pencil on paper,
18 1/8 x 12 1/4" (47 x 31 cm)
Not signed, not dated
Leopold Museum Inv. 1431

Provenance:
Wolfgang Gurlitt, Munich;
Galleria Galatea, Turin;
Rudolf Leopold, Vienna.

Literature:
Reisner 1960, fig. 5; Leopold 1972,
pl. 142; K 1500.

Exhibitions:
Recklinghausen 1959; Tokyo 1991;
Tübingen 1995.

Schiele used this same model a number of times in the first half of 1914. Here her upper body, right shoulder, and head are bent forward. Her nakedness is set off and emphasized by the stockinged calves and the lighter and darker fabrics. Her spread legs and the curving cloth over her head call to mind a yawning bivalve exposing its light-colored insides. Her nipples, painted like the navel in a bright orange, protrude between her arms. There is something animal-like in her gaze. A bit of pubic hair is visible at the point where her right arm crosses her left thigh.

Schiele masterfully exploited the overlapping and perspective foreshortening that resulted from his looking down at the figure from above. His fondness for geometric shapes is particularly apparent in the distinctly triangular face and in the many lines that could be parts of circles or ellipses. The curly lines accompanying many of the contours help to define the position in space of the various parts of the body. The kerchief, painted in contrast to the face and hair as an essentially flat form, has a similar function.

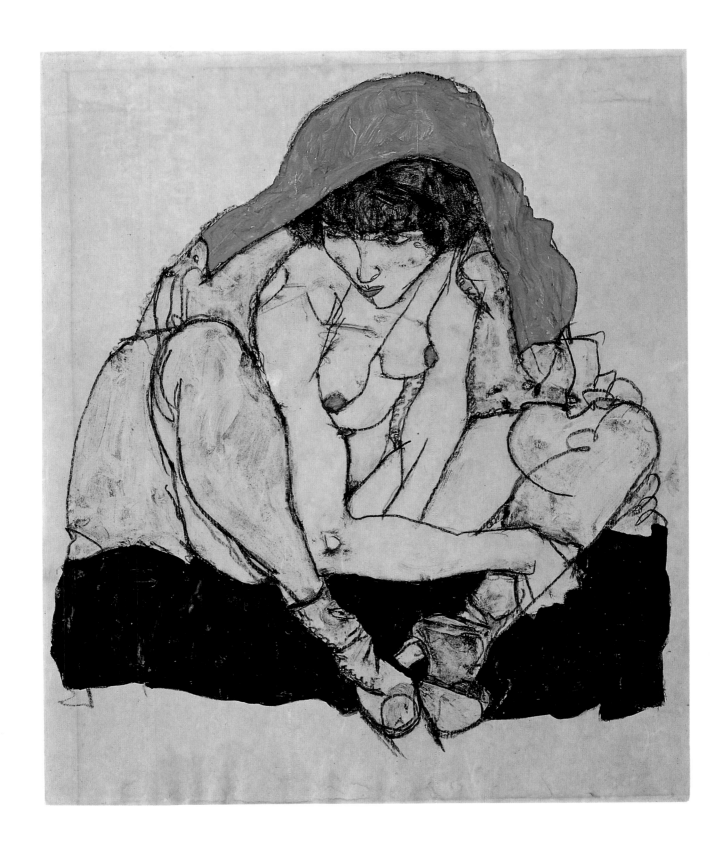

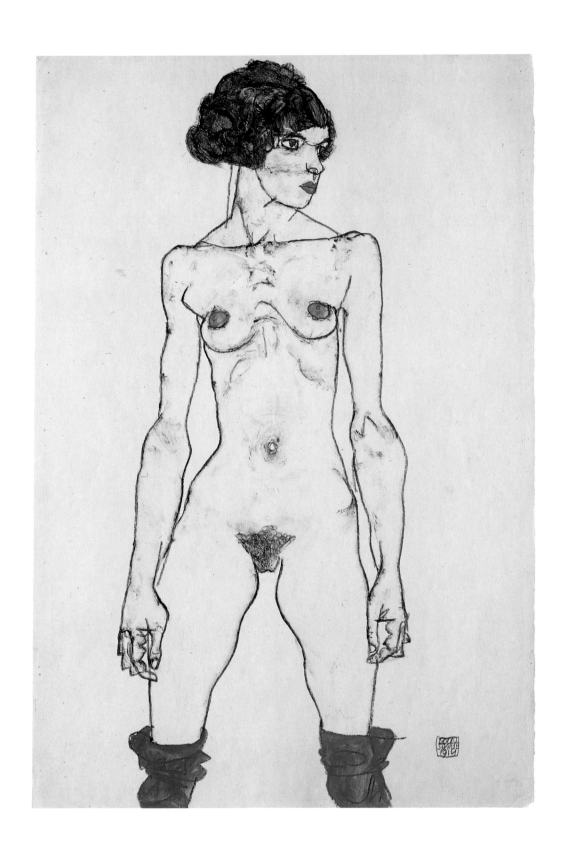

102 *Standing Nude Girl with Stockings*
 (Stehendes nacktes Mädchen mit Strümpfen)
 1914

The wiry hardness of these lines is made even more pronounced by the coloring. The drawing reveals a definite similarity in style to that of the *Blind Mother* (pl. 104). Note, for example, how that neck area is described as a triangle.

The same interest in geometric forms is also apparent in the construction of the body. It is seen essentially from the front, the legs far apart. Its symmetry is slightly relieved by the twist of the head to the side and a slight turning of the upper body in the opposite direction To accentuate this change of direction, Schiele emphasized the collarbones, which are clearly visible beneath the skin, with added color. Imaginary lines drawn through the hands and the breasts would roughly parallel their slight deviation from the horizontal. The breasts have been treated as a major element in the composition. The nipples, lips, and stockings are painted in the same bright orange, which adds stability to the whole. The painting of the rest of the skin, by contrast, is extremely delicate.

Pencil, watercolor, and gouache on paper, 19 x 12 3/4" (48.3 x 32.2 cm)
Signed and dated lower right: "EGON SCHIELE 1914"
Leopold Museum Inv. 1429

Provenance:
Galerie Kornfeld, Bern (auction), 1955; Schmid, Vienna; Rudolf Leopold, Vienna.

Literature:
Leopold 1972, pl. 146; K 1488.

Exhibitions:
Innsbruck 1963; Des Moines 1971; Munich 1975; Tokyo 1991; Tübingen 1995.

103 *Crouching Woman* (study for *Blind Mother,* pl. 104)
(Hockende Frau)
1914

Pencil on paper, 18 1/4 x 10"
(46.4 x 25.5 cm)
Signed and dated lower right:
"EGON SCHIELE 1914"
Verso: *Seated Man with Loincloth*
(presumably a self-portrait). 1914.
Pencil on paper.
Not signed, not dated
Leopold Museum Inv. 1432

Provenance:
Estate of Egon Schiele, Vienna;
Gertrude Peschka, Vienna;
Rudolf Leopold, Vienna.

Literature:
Leopold 1972, pl. 148; K 1511.

Exhibitions:
Tokyo 1991; Tübingen 1995.

This interesting drawing is related both to the *Blind Mother* (pl. 104) and to the engraving *Mourners,* produced some months later.

Schiele was inspired in this motif by Auguste Rodin's bronze *Crouching Woman* (1882; Neue Pinakothek, Munich), which depicts a woman crouched in an almost identical pose with her right hand resting on her left ankle.

With the outlines of the body, arms, and legs, Schiele recorded the essentials of the pose and the formal correspondences between the various parts of the figure. The only areas worked out more fully are the feet and the head, both of which are rendered in a highly geometric manner. The basic shape of the face is a triangle, with a semicircle above it for the skull. The lines of the eyes, the nose, and the right cheek appear to be sections of ellipses. Hatching and spiral lines, some tighter, some more open, describe the hair. The toes and the spaces between them are also represented by tiny geometric shapes, while the kneecap is indicated by a larger semicircle.

Small rows of lines like the ones perpendicular to some of the longer lines in the feet and either abutting or intersecting them are found in many drawings executed after this time (see especially pl. 110). Schiele relied on them to indicate spatial values.

The verso of this sheet depicts a study of a narrow-chested man wearing a loincloth (see illustration below).

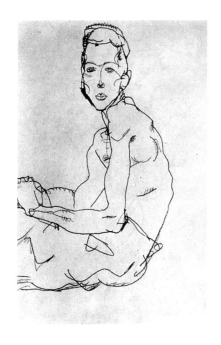

Seated Man with Loincloth
(verso of pl. 103). 1914. Pencil on paper

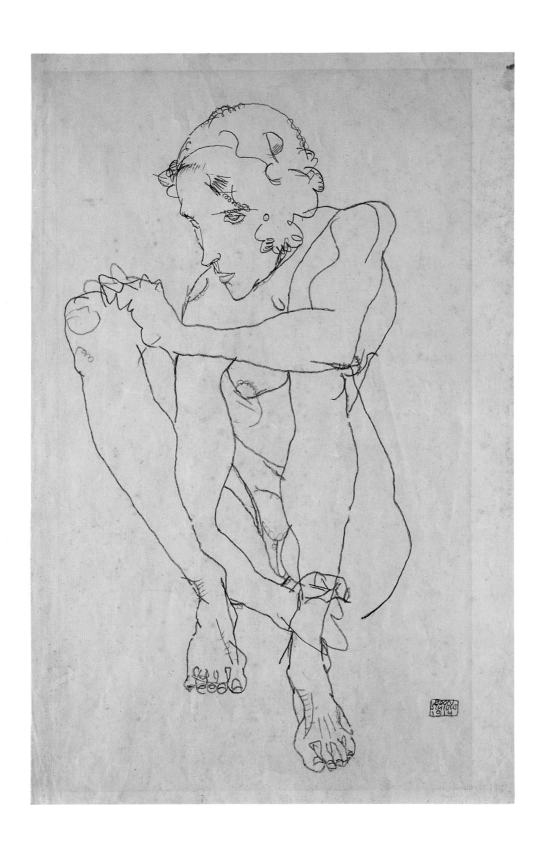

104 Blind Mother ("Blinde Mutter") 1914

Oil on canvas, 39 x 47 1/4"
(99 x 120 cm)
Signed and dated lower right:
"EGON SCHIELE 1914"
Leopold Museum Inv. 483

Provenance:
Adolf Neufeld, Vienna;
Neue Galerie, Vienna;
Wolfgang Gurlitt, Munich;
Rudolf Leopold, Vienna.

Literature:
Hofmann 1968; O. Kallir 1970;
Mitsch 1974; Whitford 1981;
Malafarina 1982, no. 270;
Marchetti 1984; Clair 1986;
L 247; K 272.

Exhibitions:
Munich 1914; Vienna 1914; Vienna
1920; Vienna 1923; Vienna 1928;
Zurich 1930; Amsterdam 1956;
Bern 1957; St. Gallen 1957;
Düsseldorf 1959; Innsbruck 1963;
London 1964; New York,
Guggenheim Museum 1965;
Vienna, Österreichische Galerie
1968; Rome 1984; Vienna 1985;
Tokyo 1986; Zurich 1988; Tokyo
1991; Tübingen 1995; Tokyo 1997.

A woman is nursing two infants, crouched in what appears to be an extremely uncomfortable position, her upper body bent sharply to the right between her widespread legs. It would be difficult to assume such a pose, and one would think it hardly an ideal one in which to cradle and nurse two babies. Yet the complex, highly angular figure in the center of this composition is an uncommonly compelling, self-contained image, a powerful commentary on the hopeless situation of a mother who is blind. Her pose and the lifeless emptiness of her eyes are altogether pitiful. The figure—most notably the raised left shoulder—was inspired by a sculpture by Rodin (see pl. 103). Schiele has the shoulder loom up from between the legs like a mountain peak, becoming the highest lighter area in the whole composition. To emphasize this, he deliberately toned down the crown of the woman's head, which is nearly bald, like the heads of the infants; its form is related to those of the bent knees.

For compositional reasons, the rendering of this body is very taut. Everything that is soft and feminine in Rodin's nude, such as the delightful swelling at the nape of the neck, has disappeared. A straight line runs up from the neck to the left shoulder. If one were to extend this line and that of the right shoulder, they would be seen to form a triangle, with its base the slightly curving line of the collarbones. The smaller triangle of the face, a sharp angle describing the right cheek and left jaw, juts down into this form. Above the face rests the semicircle of the skull—one of many instances of an alternation between angled shapes and portions of circles or ellipses.

Despite the considerable importance of geometry, there is still no sense of excessive formalism, for both the composition as a whole and all of its details are filled with dramatic intensity. The grouping of the mother and infants is closed off by the pillars of the legs, the towering left shoulder, and the arm extended in the opposite direction at the bottom. The woman's weight pulls toward the left. Her instability and the resulting tension are precisely balanced by the child on the right and the shape of the peasant crib behind her on the left. This area to the left of the figural grouping is divided into a number of different shapes, whereas the one to the right of it is left in an amorphous darkness. The different treatment of these sections compensates for the slight shift of the figural grouping to the right of center. In contrast to the darkness on the right, the left leg and upper part of the cradle are clearly defined. Together with the bit of cloth extending across the bottom at the right, the end of the cradle and the

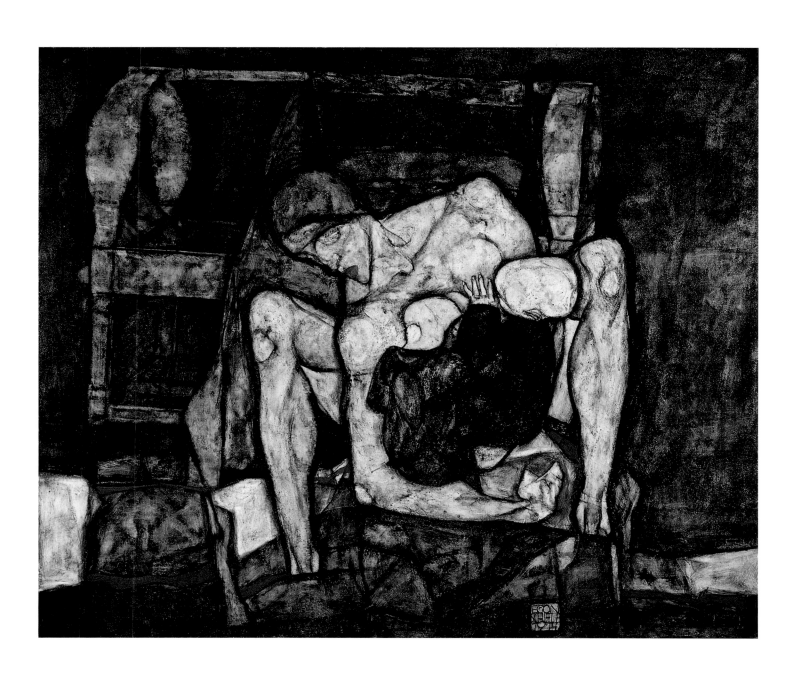

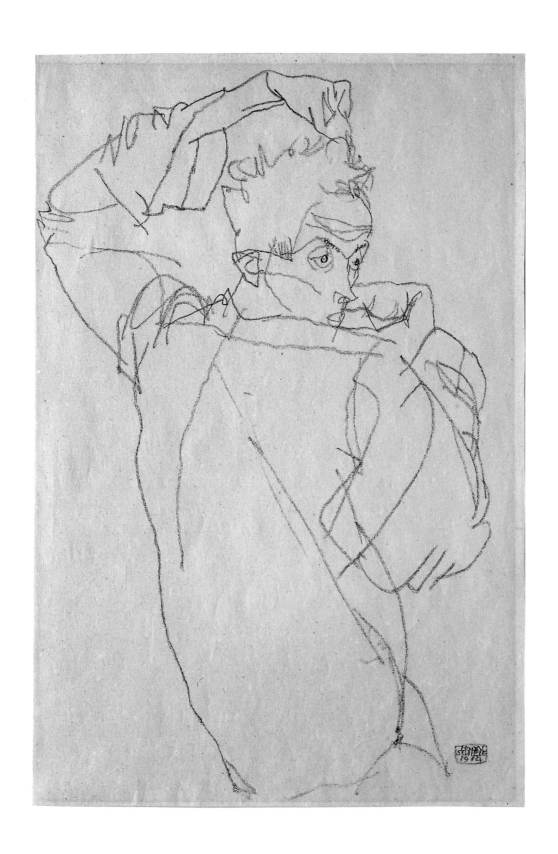

left leg create a fascinating downward movement reminiscent of a waterfall that drops from cliff to cliff, then finally reaches the bottom and calmly proceeds on its way.

In addition to a slightly brighter green, the red accents in this strip of cloth are the only strong colors in the painting. Everywhere else the dominant tones are more muted, though they produce a definite *chiaroscuro.* Some of these tones are cooler, some warmer. The mysterious background and the equally warm shades of the cradle, with darker shading applied to a yellowish ground–these surfaces have the reassuring texture of old parchment–contrast dramatically with the ice-cold skin tone of the mother and the heads of the infants. This, too, serves to point up her tragedy. Light and dark areas overlap, as do cold and warm ones, and all are skillfully intermeshed. All of the elements in the picture are clearly identified with regard to both texture and volume, so that the structure of the whole seems more logical and believable than that of any of Schiele's other paintings, whether earlier or later.

105 *Self-Portrait in Dramatic Pose*
(Selbstbildnis in Pose)
1914

This figure is standing at an angle in space, seemingly engaged in a twisting movement. Its momentary situation is masterfully captured with only the fewest of lines. With its sharp turning to the right, the head appears to continue the torsion of the body. The positions of the arms and hands evoke pantomime.

The freely flowing, sensitive lines enhance the impression of motion. Even though they are laid down quite casually, the tendency toward geometry is obvious. It is particularly apparent in some of the details of the face. The ear, for example, takes the form of a triangle, the line of the left brow intersects with the right one at the top of the nose, then continues downward in a sweeping curve to its tip. The bent hand next to the face forms a right angle, the one above the head has a triangular shape. The zigzags and rows of parallel strokes added to the main contours of the shirt translate its folds into the freest of graphic forms.

Pencil on paper, 18 7/8 x 12 1/8"
(47.7 x 31 cm)
Signed and dated lower right:
"EGON SCHIELE 1914"
Leopold Museum Inv. 1430

Provenance:
Estate of Egon Schiele, Vienna;
Melanie Schuster, Vienna;
Rudolf Leopold, Vienna.

Literature:
Breicha and Fritsch 1964;
Weiermair 1968; Leopold 1972,
pl. 153; K 1660.

Exhibitions:
Amsterdam 1956; Munich 1975;
Tokyo 1991; Tübingen 1995.

*Crouching Nude Girl
(Kauernder Mädchenakt)
1914*

Gouache and pencil on paper,
12 3/8 x 19″ (31.4 x 48.3 cm)
Signed and dated lower right:
"EGON SCHIELE 1914"
Verso: *Self-Portrait (Head)*. 1914.
Pencil on paper.
Not signed, not dated
Leopold Museum Inv. 1398

Provenance:
Kornfeld & Klipstein, Bern;
Rudolf Leopold, Vienna.

Literature:
Leopold 1972, pl. 155;
K 1608.

Exhibitions:
Bern 1964; Vienna, Albertina 1968;
Munich 1975; Zurich 1988; Tokyo
1991; Tübingen 1995.

This woman has bent her upper body well down between her spread knees, locking her arms over her legs and placing the soles of her feet together. The artist has exploited her pose–the way the body, arms, and legs seem interwoven–to produce an unusually self-contained, three-dimensional figure. One hardly notices various deviations from anatomical accuracy, as they are perfectly justified within the composition. The left arm, for example, is unnaturally elongated and the elbow crosses beyond the foot's silhouette, forming a counterpart to the right knee peeking up behind the head–itself a fiction, for it could scarcely have been seen in a pose such as this. That knee is crucial to the composition, for it continues the contours of the right arm and the left thigh.

The figure's contour lines are emphasized by the coloring. While they serve to define the thigh, they also roughly divide the shape formed by the thigh and trunk in half. Thus the curve of the lower back echoes the lower line of the thigh. That line, in turn, mirrors the outline of the adjacent calf. The long curve of the back is also juxtaposed to the left elbow, which is farther away. One could compile a whole catalogue of such correspondences. The consistent coloring–unnatural though it is–contributes considerably to the integrity of this figure.

Self-Portrait (Head) (verso of pl. 106).
1914. Pencil on paper

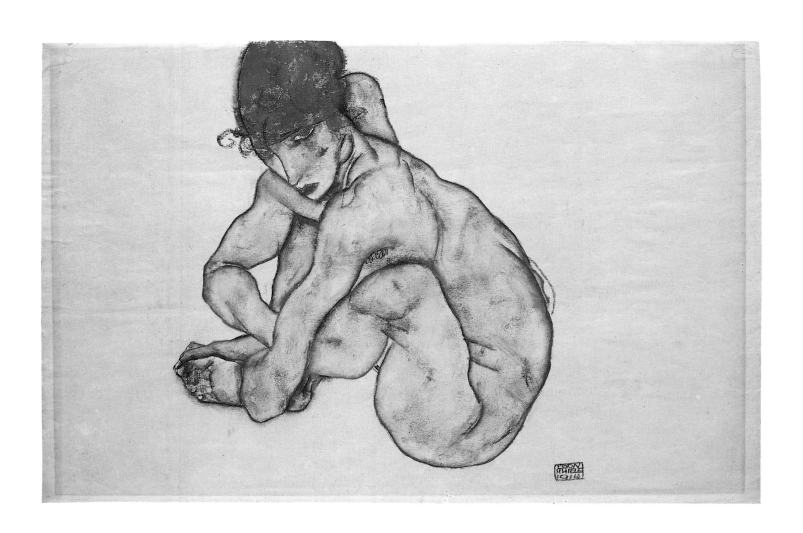

107 *Reclining Woman with Raised Right Leg*
(Liegende mit erhobenem rechtem Bein)
1914

Pencil on paper, 12 5/8 x 19 1/8″
(32 x 48.4 cm)
Not signed, not dated
Verso: *Mother and Child.*
Pencil on paper.
Leopold Museum Inv. 1395

Provenance:
Kornfeld & Klipstein, Bern;
Galerie Kornfeld, Bern
(auction), 1987;
Rudolf Leopold, Vienna.

Literature:
K 1579.

Exhibitions:
Tokyo 1991; Tübingen 1995.

The model has here assumed a pose she could not have sustained for long. Accordingly, Schiele worked more swiftly than usual, as is perfectly obvious from countless details in this powerful drawing.

In addition to producing a highly successful composition, the artist may have wished to tell us something more. By placing the model's hand on her genitals and having her gaze in that direction, he suggests that she is masturbating.

Even in this rapid and highly spirited drawing, the use of geometric shapes, such as the triangle for the woman's face, is unmistakable.

Self-Portrait with Closed Eyes
(Selbstdarstellung mit geschlossenen Augen)
1914

Gouache, watercolor, and
pencil on paper, 19 1/8 x 12 3/8″
(48.5 x 31.5 cm)
Signed and dated lower right:
"EGON SCHIELE 1914"
Leopold Museum Inv. 2315

Provenance:
Heinrich Stinnes;
Gutekunst & Klipstein, Bern
(auction), 1938;
Zdenko Bruck;
Galerie Kornfeld,
Bern (auction), 1980;
Rudolf Leopold, Vienna.

Literature:
K 1655.

Exhibitions:
Brussels 1981; Tokyo 1986; Tokyo
1991; Tübingen 1995.

This remarkable figure, dressed in only a green shirt, clasps his hands in front of his chest, tilting his head back slightly with his eyes closed: another of Schiele's visions of himself.

As a reflection of his concern for geometry, the bridge of the nose has been shifted so much to the right that it now divides the face precisely in half. The lips and chin, by contrast, are too far to the left. The lips are wholly without color, which becomes more noticeable because of the strong color that emphasizes the symmetrical eyebrows above them. Together with the closed eyes and spidery hands, they produce a strange impression. It is as though Schiele meant to present himself as a penitent, or perhaps he is caught up in a mystical trance.

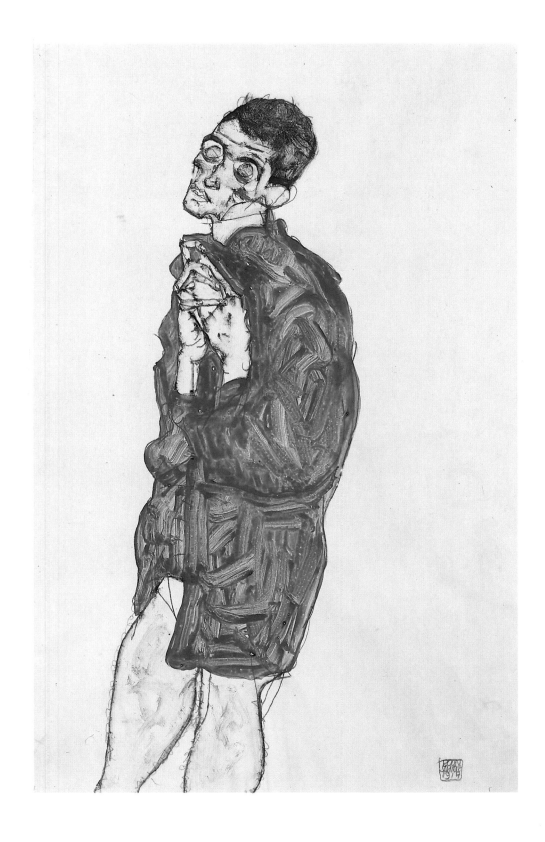

109 *Two Girls Embracing (Seen from the Back)*
(Sich umarmende Mädchen [Rückenansicht])
1914

Gouache and black crayon
on paper, 19 1/8 x 10 3/8"
(48.5 x 26.7 cm)
Signed and dated lower right:
"EGON SCHIELE 1914"
Leopold Museum Inv. 1426

Provenance:
Gutekunst & Klipstein, Bern;
Galerie St. Etienne, New York;
Otto Schönthal, Vienna;
Rudolf Leopold, Vienna.

Literature:
Malafarina 1982, no. D73; K 1606.

Exhibitions:
Bern 1956; New York 1959; Boston
1960; Berkeley 1963; New York,
Galerie St. Etienne 1965; New York
1968; Brussels 1981; Tokyo 1991;
Tübingen 1995.

These two nude girls have their arms around each other. Although Schiele had one of them place her left thigh between the other one's legs, where a bit of pubic hair is visible, and although the "clothes" around the legs at the bottom suggest that the last veils have fallen, there may be no particular subtext to any of this. If there is any message, it is that even when constructing such a purely formal composition Schiele could not refrain from including a suggestion of sexuality.

The faceless figures placed next to each other in a purely ornamental manner make it obvious that they were of no particular interest to the artist. The heads are almost brutally cut off by the edge of the sheet, just like the fabric at the bottom. These two more intensely colored areas serve to close off the composition above and below. What is essential is what falls between them: the almost identical bodies and their intertwined limbs.

By this time in Schiele's work the outlines were no longer required to describe the complex structure of a figure by themselves. Internal drawing and painting have become more important. Schiele chose to suggest the flesh tones with an unnatural dark brown, in some places shading it with a bit of black. This helps to unify the composition. To describe the internal structures, he applied the same color with a dry brush. Color contrast is provided by occasional smudges of blue-green and completely unnatural accents in red and blue. All of these serve to call attention to the structural arrangement of this brilliant composition.

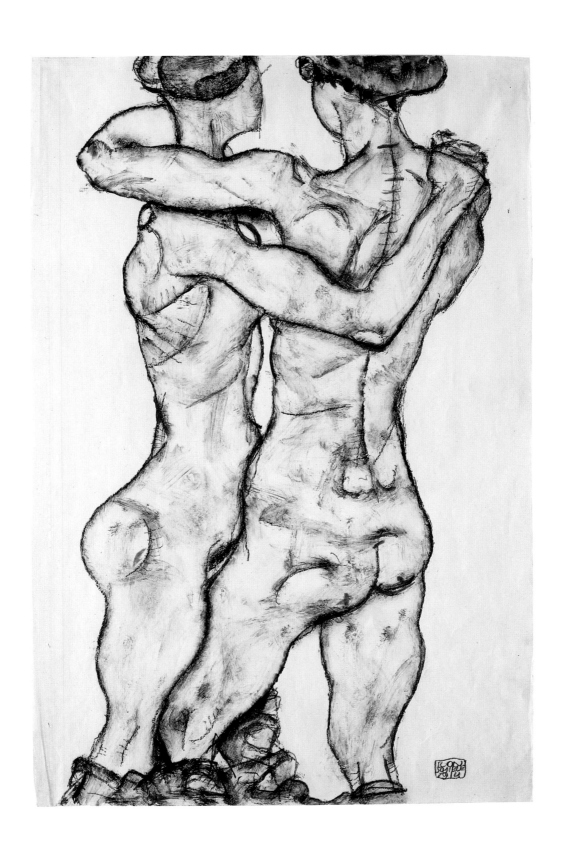

110 *Reclining Woman with Raised Chemise*
(Liegende mit hochgeschobenem Hemd)
1914

Pencil on paper, 12 1/2 x 18 7/8"
(31.8 x 48.1 cm)
Signed and dated lower left:
"EGON SCHIELE 1914"
Leopold Museum Inv. 1409

Provenance:
Galerie Kornfeld, Bern;
Rudolf Leopold, Vienna.

Literature:
Leopold 1972, pl. 157; K 1550.

Exhibitions:
Tokyo 1991; Tübingen 1995.

This nude is lying down, but the signature was placed in such a way as to suggest that the drawing was done in vertical format (see pl. 23). Many of the lines of the drawing are bordered or intersected by rows of perpendicular hatching, which had begun to appear already in the second half of 1913. Here, in one of the loveliest examples of this technique, they are especially numerous. Much like the smudges and short strokes of color in Schiele's watercolors of the same period, these pencil shadings lend volume to the various forms and serve to fix them in space. That function is especially apparent along the center line of the torso and in the folds of the fabric.

The head and face have been greatly simplified to reflect geometric shapes: they are described with only a simple oval outline, a few curving lines for the hair, two semicircles tracing the lines of the brows and the sides of the nose, and finally a short angled line for the tip of the nose. The eyes are missing altogether, but the other lines in the face are so accurate that their absence is not disturbing in the least. (In these years Schiele often suggested eyes with only tiny circles of the pupils–see, for example, pls. 126 and 128.) The artist's fondness for geometry is even apparent in the mons veneris, where short curving lines alternate with tiny rows of spirals. These bring into focus the graphic area on the left side of the composition, both as subject and form. Its counterpart on the right side is the chemise, with its brilliantly executed, highly three-dimensional folds.

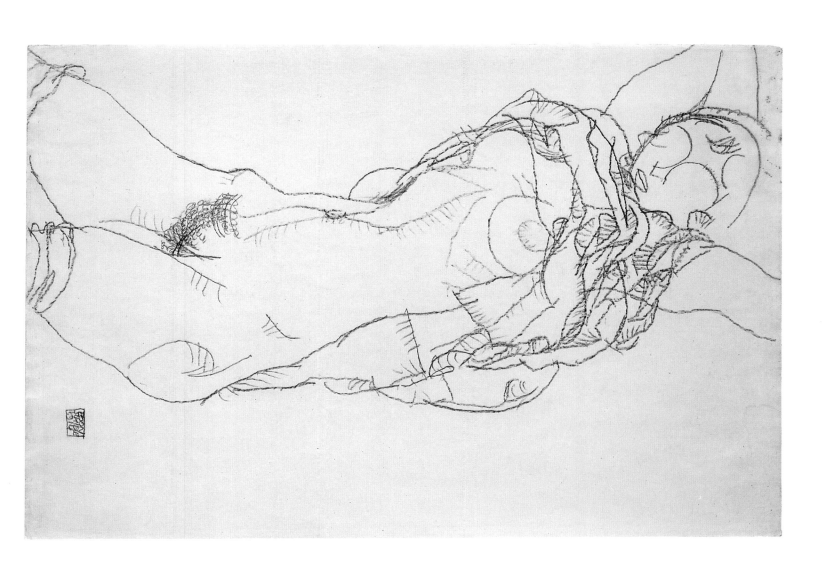

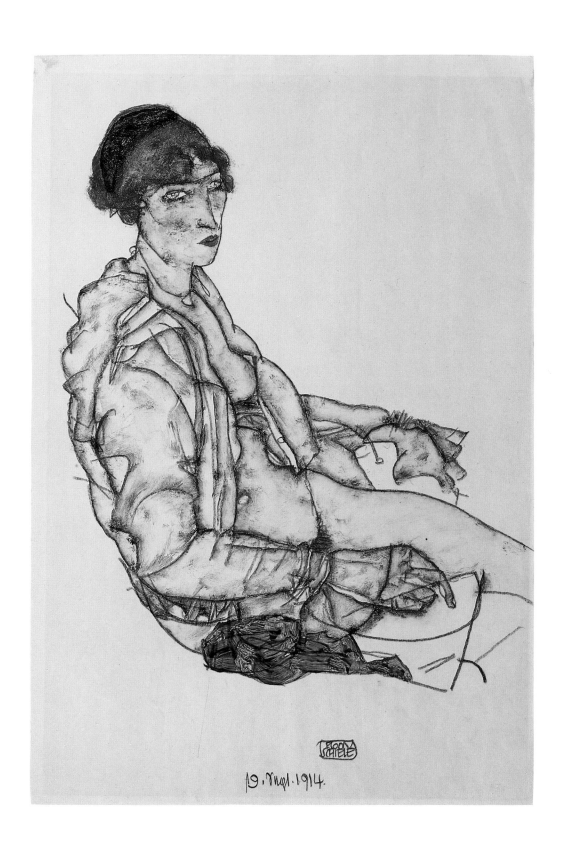

111 *Seated Woman with Blue Headband
(Sitzende mit blauem Haarband)*
1914

This is an outstanding example of Schiele's ability to combine precise drawing with equally explicit coloring. His geometric bent is clearly apparent in many of the details, both in the outlines as well as in the internal structures. In the jacket, especially, these forms are emphasized by the coloring, which is most intense next to the lines.

The combination of cool blue-green and blue also underscores the constructive quality of the drawing. Schiele allows this combination of tones to dominate over the browns and scattered reddish tones of the flesh, the ashen brown of the hair, and the brick-red mouth.

Gouache and pencil on paper,
19 x 12 5/8" (48.2 x 32 cm)
Signed and dated bottom center:
"EGON SCHIELE 19. Sept. 1914."
Leopold Museum Inv. 1425

Provenance:
Rudolf Leopold, Vienna.

Literature:
Leopold 1972, pl. 165;
Nebehay 1989; K 1594.

Exhibitions:
Zurich 1988; Tokyo 1991; Tübingen 1995.

*Landscape with Fields
(Felderlandschaft)*
1914

Pencil on paper, 12 5/8 x 19 1/8"
(32 x 48.5 cm)
Signed and dated lower right:
"EGON SCHIELE 1914"
Leopold Museum Inv. 1396

Provenance:
Estate of Egon Schiele, Vienna;
Melanie Schuster, Vienna;
Rudolf Leopold, Vienna.

Literature:
Leopold 1972, pl. 164; K 1679.

Exhibitions:
Tokyo 1991; Tübingen 1995.

Except for a small section in the lower left, Schiele left the foreground empty, concentrating on the distant fields stretching across a long, low hill. At first glance, the sizes and shapes of these fields seem haphazard, but, in fact, they were carefully calculated to create a satisfying composition. The perspective vanishing point lies slightly left of center. Accordingly, the angles of the fields sloping up from the bottom of the hill on either side create a certain symmetry. The long narrow ones extending downward from the upper left are roughly matched on the right by smaller ones that descend at a steeper angle and by a large patch of dense shading. Absolute symmetry would have seemed unnatural. Between these two groupings of parallel plots are a few wider ones of irregular shape, and several with curving upper borders. The overall effect is wonderfully varied, thanks to the alternating long and short lines, the changing direction and varying densities of the rows of shading, and the spiral scribbles here and there. Using great imagination, Schiele captured the charming randomness of these irregular fields with purely graphic means.

All of these various elements are subordinate to the larger form of the hill, which extends across the entire sheet, without either beginning or end. The space above it is easily read as sky. The slight horizontal curve of the ridge set against it and the unbroken pattern of fields and meadows suggest something of the world's vastness.

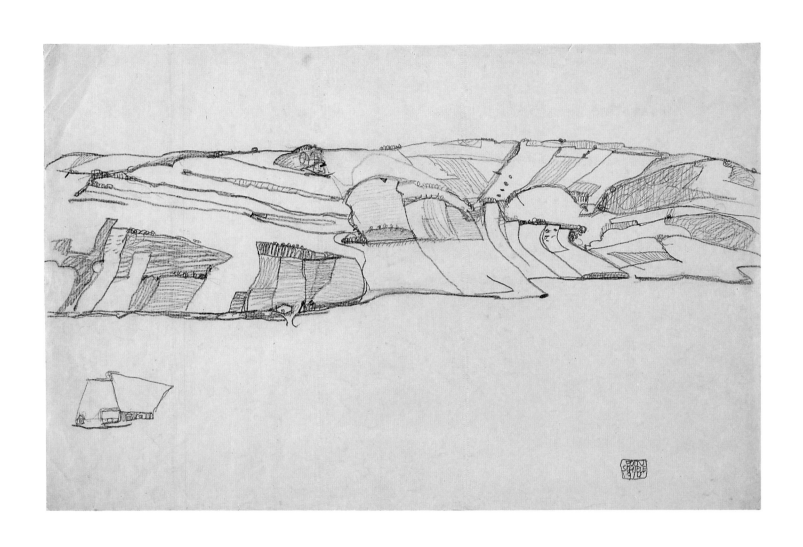

113 *Seated Nude with Red Garter, Seen from the Back*
 (Sitzender Rückenakt mit rotem Strumpfband)
 1914

Gouache and pencil on paper,
17 1/2 x 11 7/8" (44.3 x 30.2 cm)
Signed and dated lower right:
"EGON SCHIELE 1914"
Verso: *Sketch for the Portrait of*
Friederike Maria Beer (L 256).
Pencil on paper.
Leopold Museum Inv. 2338

Provenance:
Bey Behcet Özdoganci;
Rudolf Leopold, Vienna.

Literature:
Leopold 1972, pl. 166;
K 1614.

Exhibitions:
St. Gallen 1957;
Vienna, Albertina 1968;
Tübingen 1995.

The flesh of this seated figure is rendered with various shades of brown and touches of blue-green and brick-red. With these Schiele not only captured the tone of her skin but identified the volumes and functions of the various parts of her body with uncommon success. It is this free and loose way of painting that makes the drawing so fascinating. By minimizing her sexuality in this back view, Schiele was able to concentrate on the rhythmic sequence set up by her knees, her shoulders, and her head.

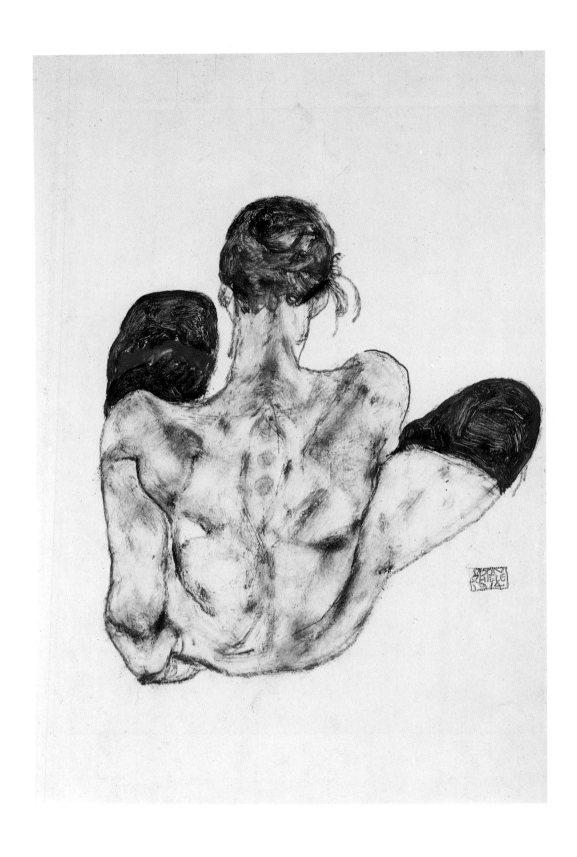

114 *Row of Houses (Krumau)*
(Häuserzeile [Krumau])
1914

Pencil on paper, 11 5/8 x 18 3/8″
(29.5 x 46.5 cm)
Signed and dated lower right:
"EGON SCHIELE 1914"
Collector's stamp lower left
Leopold Museum Inv. 1393

Provenance:
Heinrich Böhler, Vienna, later
Lugano; Mabel Böhler, Lugano;
Rudolf Leopold, Vienna.

Literature:
Leopold 1972, pl. 656; K 1692.

Exhibitions:
Berlin 1960; London 1964; Götzis
1965; Salzburg 1968; Vienna 1970;
Tokyo 1991; Tübingen 1995.

Schiele found this row of houses in a suburb of Krumau called Flössberg. Some of the structures have since disappeared, and the rest have been substantially altered. It was only with the help of an old photograph that I managed to determine that they were, in fact, from Krumau.

Schiele captured the basic forms of these houses with great sensitivity (see text for pl. 115).

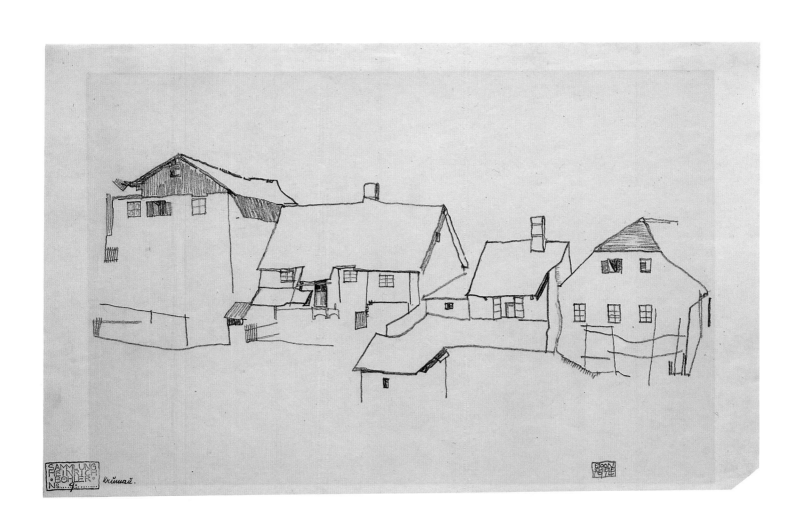

115 *Quarter in Krumau* (preliminary drawing for *The Row of Houses I*)
(Krumauer Stadtviertel)
1914

Pencil on paper, 17 1/4 x 12 5/8"
(43.7 x 31.9 cm)
Signed and dated lower right:
"EGON SCHIELE 1914"
Leopold Museum Inv. 2308

Provenance:
Rudolf Leopold, Vienna.

Literature:
Leopold 1972, pl. 160; K 1696.

Exhibitions:
Amsterdam 1956; St. Gallen 1957;
Vienna 1970; Zurich 1988; Tokyo
1991; Tübingen 1995; Tokyo 1997.

It is easy to pick out this complex of Krumau houses, built on a curve, from the many others one looks down upon from the Schlossberg. To emphasize the curve, Schiele left out a number of other structures or only included suggestions of them. These fragmentary suggestions, such as the roof outlines and one facade in extreme foreshortening in the foreground, have an important function. They effectively enhance the sense of looking down from a height and give some indication of how far away the main cluster of houses actually is.

The sweeping line of houses flows upward and back into the depth of the picture space. With its many angled lines facing the river, the formal emphasis turns toward the left, which Schiele corrected by placing the bridge and houses on the other side. In addition, the line formed by the structures and turning to the right from the tall double house helps to anchor the thrust of the curve to the left.

The lines describing these roofs and walls appear to be quite straightforward, but they are, in fact, drawn with great sensitivity, varied not only in their shapes but also in their intensity. This alone adequately captures the three-dimensional forms of the structures, even though Schiele's masterful manipulation of perspective also comes into play. The sense of space would have been enhanced had he applied more shading, but that would have compromised the wonderful effect of pure line. The few patches of shading he did use serve merely as accents in this superb drawing.

The letters visible here and there on the walls of the houses are color notes for the large paintings of such a curving row of houses that Schiele was planning. The first two of these, *The Row of Houses I* (L 258) and *The Town Crescent* (L 260), were executed in 1915, the third and last, *Town's End* (L 284), at the end of 1917 or the beginning of 1918.

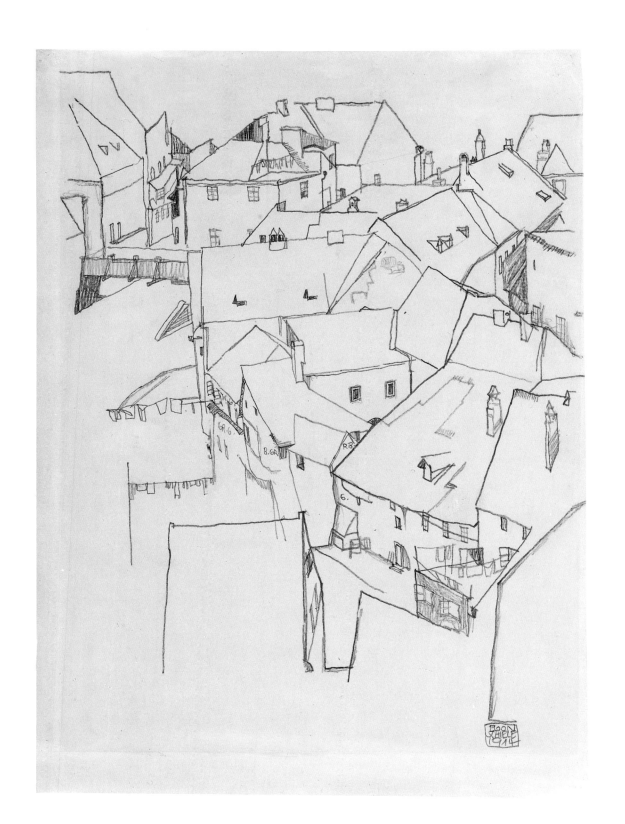

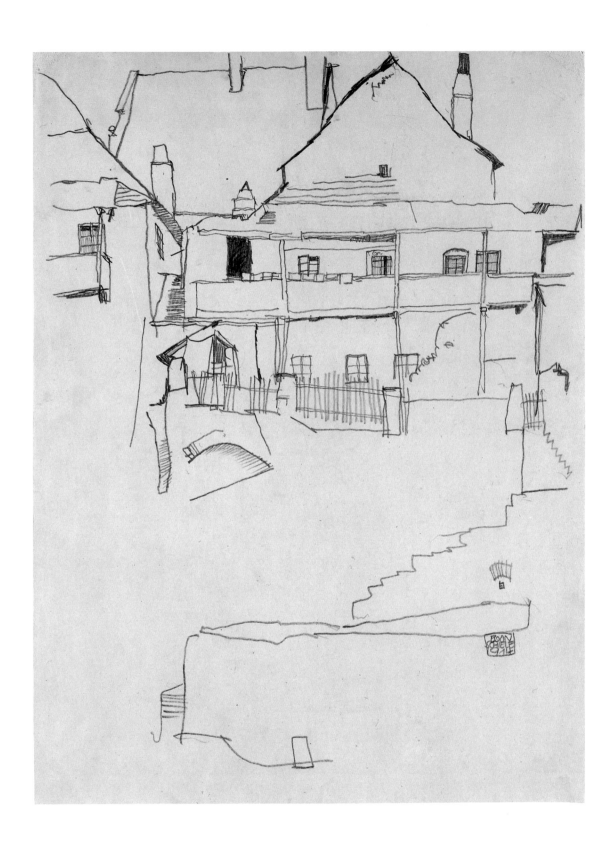

116 Study for *House with Shingled Roof*
(Studie zum *"Haus mit Schindeldach"*)
1914

Schiele's motif in this drawing was a house that one can still see in Krumau at 30, Rooseveltova ulice (formerly Adalbert-Stiftergasse). It is squeezed in between other structures, as both a preliminary sketch for the painting *House with Shingled Roof* (L 262; reproduced in Leopold 1972, p. 658) and this detailed drawing clearly indicate. In the painting, Schiele omitted the structures beside and behind the house and placed it in an imaginary landscape.

Schiele enriched his drawing by applying different degrees of pressure to his pencil and by providing it with an off-center focal point in the one window he completely blackened. The delicate short lines beneath the curve of the bridge directly below that window reappear in a very similar context in the drawing of the model Poldi reproduced in plate 117.

Pencil on paper, 17 1/4 x 12 5/8"
(43.7 x 32.1 cm)
Signed and dated lower right:
"EGON SCHIELE 1914"
Leopold Museum Inv. 1428

Provenance:
Rudolf Leopold, Vienna.

Literature:
Leopold 1972, pp. 396, 658;
K 1694.

Exhibitions:
Berlin 1960; Tokyo 1991;
Tübingen 1995.

117 *Poldi*
 ("Poldi")
 1914

Pencil on paper, 18 5/8 x 12 1/8"
(47.4 x 30.9 cm)
Signed and dated lower right:
"EGON SCHIELE 1914"
Inscribed lower left: "POLDI"
Collector's stamp bottom left
Leopold Museum Inv. 1427

Provenance:
Heinrich Böhler, Vienna, later
Lugano; Mabel Böhler, Lugano;
Rudolf Leopold, Vienna.

Literature:
Leopold 1972, pl. 162; K 1519.

Exhibitions:
Berlin 1960; Tokyo 1991;
Tübingen 1995.

There are a number of known drawings of this model named Poldi. The depiction of her face here is one of the most brilliant examples of Schiele's masterful draftsmanship. The clarity and sensitivity of these lines are unsurpassed. In addition, Schiele superbly captured her expression; one sees in it the strain of having to maintain a specific pose for a long time. Poldi doubtless bent her left thumb in such an artificial way at Schiele's request.

Everything has been omitted that might have detracted from the ornamental outline of this seated figure. Some of the folds of the blouse she has shrugged off are rendered with double lines. Roughly parallel lines such as these are common in the drawings Schiele executed between 1914 and 1916, and occasionally appear in his paintings as well. They are generally found in the description of fabrics, but are also sometimes used to mark contours important to a composition. See, for example, the one at the bottom of *Transfiguration (The Blind II;* p. 26), or the ones in the figure of the woman in front in *Lesbian Couple* (pl. 134). Again, the rows of short or longer strokes placed close together next to important contours can be seen in architectural studies from this same period (see pls. 114–16).

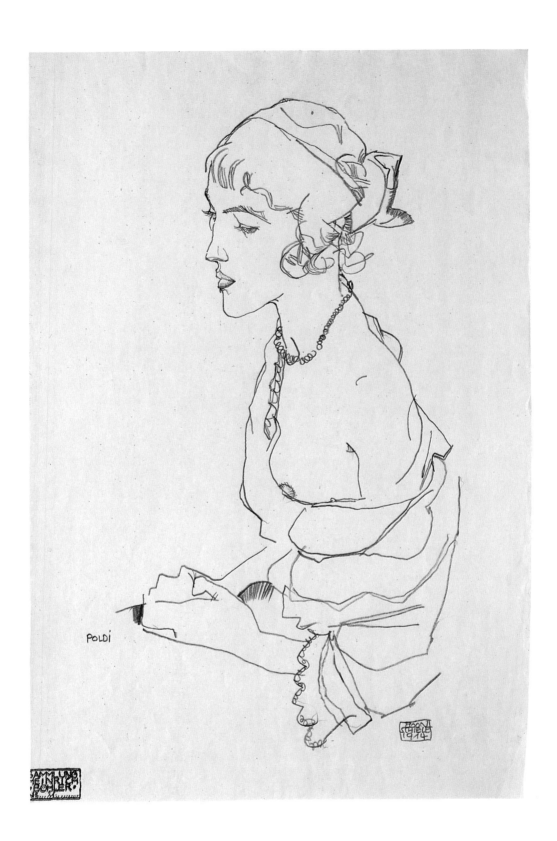

POLDI

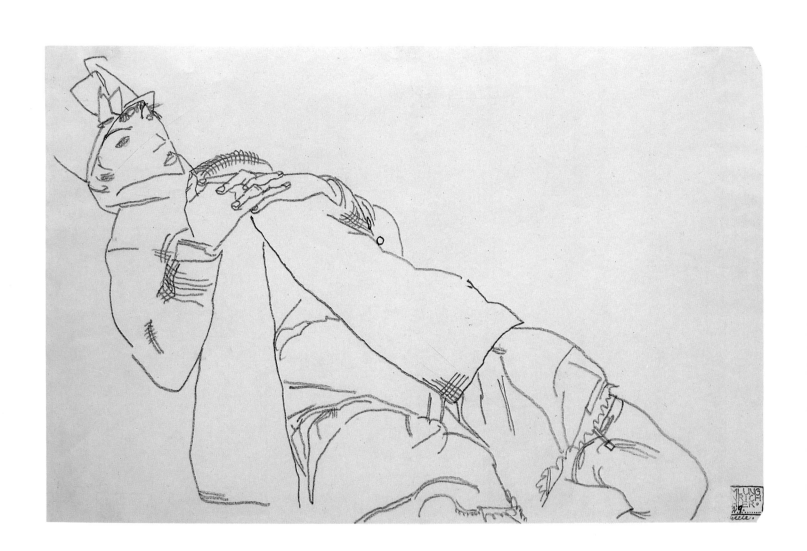

118 *Young Woman in Undergarments with Jacket and Hat*
(Junge Frau in Unterwäsche mit Jacke und Hut)
1914

Pencil on paper, 12 3/8 x 18 1/8″
(31.2 x 46 cm)
Not signed, not dated
Leopold Museum Inv. 1394

Provenance:
Rudolf Leopold, Vienna.

Literature:
Leopold 1972, pl. 163; K 1727.

Exhibitions:
Tokyo 1991; Tübingen 1995.

The diagonal arrangement of this female figure is fascinating in itself. The compositional axis corresponds to the jacket's edge that roughly indicates the body's center, but it also continues across the fingers to the chin, visible only as a sharp angle behind the jacket collar, the lips, and nose–indicated by only two short lines–ending finally in the delicately drawn bow of the hat. All other contours are related to this central axis. Every detail, like the overall form, has been subordinated to a distinct pictorial concept. Richly detailed areas alternate with empty ones, light lines with darker ones. The essential elements are thereby perfectly described and placed in space; the soft folds of the undergarments, for example, are clearly distinguished from those of the stiffer fabric of the jacket.

Groupings of crossed lines are carefully distributed throughout the composition, again almost symmetrically arranged around the center axis. One of these, at the bottom corner of the jacket, calls to mind the pubic hair that lies just beneath it, and Schiele could not refrain from suggesting the rima pudendi with a heavy pencil line. The woman's odd combination of garments–a hat and costume jacket over her underclothing–reveals Schiele s determination to include an erotic dimension even in such a carefully structured drawing.

119 *Lovers*
(Liebespaar)
1914/15

Gouache, watercolor, and
pencil on paper, 18 5/8 x 12″
(47.4 x 30.5 cm)
Not signed, not dated
Collector's stamp bottom left
Leopold Museum Inv. 2321

Provenance:
Heinrich Böhler, Vienna, later
Lugano; Mabel Böhler, Lugano;
Rudolf Leopold, Vienna.

Literature:
Leopold 1972, pl. 167; Mitsch 1974;
Eschenburg 1995; K 1784.

Exhibitions:
Götzis 1965; Des Moines 1971;
Munich 1975; Brussels 1981; Zurich
1988; Tokyo 1991; Munich 1995;
Tübingen 1995; Tokyo 1997.

This pair of lovers is shown in sexual abandon. The man is sitting down; the woman, apparently kneeling in front of him, has flung her arms around his waist. His hands are digging into her hair and his legs are pressed tightly against her.

The two figures together form a sculptural column, the angular projections on either side suggestive of their excitement. The man's contorted pose abruptly changes the course of its center axis in two places.

The color of the woman's blouse contrasts with the darker clothes of the man, but it is also keyed to them. Schiele managed this by adding a trace of blue to both the reds of her blouse and the basically brownish tones of his vest and trousers. In addition, the areas of deep shadow have also been overpainted with blue. The several concentrations of brown, beginning with the man's trousers and ending with his bluish-tinged hair, hold the dynamic composition together. The woman's face is its center. Her pale color and half-open mouth, raised eyebrows, and crazed stare suggest intense arousal. The man's gaze and the position of his head and body communicate something different, but a response no less ecstatic. These are typical Schiele lovers, rooted in his own sexual experience. The man is, of course, Schiele himself, the woman his longtime companion Wally Neuzil. All of this aside, a number of details in this work suggest that it was done in connection with the painting *Death and Girl* (L 266), in which the subject matter is given a tragic turn.

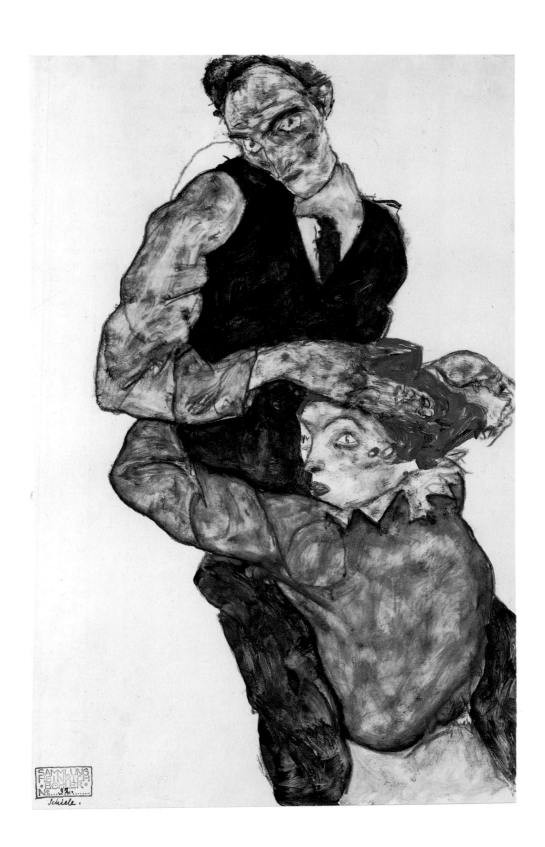

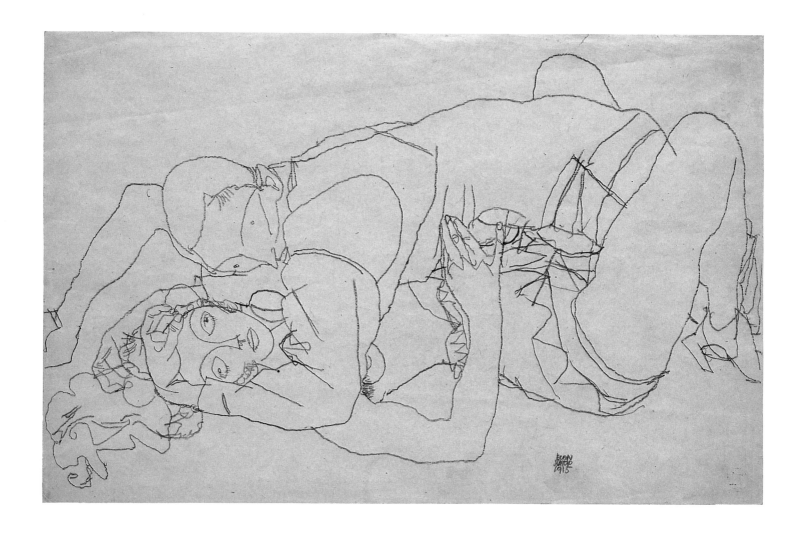

120　*Act of Love* (study)
　　(Liebesakt [Studie])
　　1915

Pencil on paper, 13 x 19 1/2″
(32.9 x 49.6 cm)
Signed and dated lower right:
"EGON SCHIELE 1915"
Leopold Museum Inv. 1406

Provenance:
Rudolf Leopold, Vienna.

Literature:
Leopold 1972, p. 372; K 1785.

Exhibitions:
Zurich 1988; Tokyo 1991;
Tübingen 1995.

Schiele did this drawing in preparation for his depiction of the sexual act in plate 121. His paper obviously turned out to be too narrow (see also pls. 127 and 135). The woman's calf and shoe, especially, appear to have been later additions. Though wholly fascinating in itself, the drawing reveals that the artist was still searching for formal clarification, as in the woman's left arm.

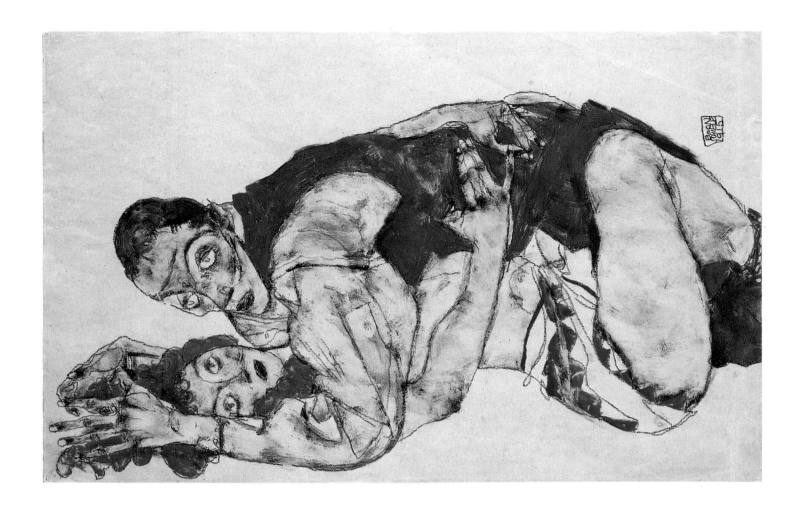

121 *Act of Love*
(Liebesakt)
1915

In this more finished version of the same motif as that of plate 120, Schiele changed a number of details–even the placement of his signature (see pl. 23). The woman's legs now project only slightly beyond the contour of the man's back. They appear to grip him tightly, as do her arms and hands. The splayed fingers of the man's left hand lie atop her hair, and his right hand clutches a portion of it. The heads are juxtaposed not only formally but also in their differing expressions.

There is a certain compulsiveness about the whole procedure. The man–clearly a self-portrait–is taking advantage of a doll-like creature. Sexuality, eroticism, and world-weariness have become somehow blurred.

Gouache and pencil on paper,
13 1/8 x 20 1/2″ (33.5 x 52 cm)
Signed and dated upper right:
"EGON SCHIELE 1915"
Leopold Museum Inv. 1419

Provenance:
Rudolf Leopold, Vienna.

Literature:
Leopold 1972, pl. 170; Friesenbiller 1985; Eschenburg 1995; K 1786.

Exhibitions:
Zurich 1988; Tokyo 1991;
Munich 1995; Tübingen 1995;
Tokyo 1997.

122 *Seated Woman Clasping Her Feet*
 (Sitzende, die Füsse mit den Händen fassend)
 1915

Pencil on paper, 18 7/8 x 12 1/4"
(48 x 31.5 cm)
Signed and dated lower right:
"EGON SCHIELE 1915"
Collector's stamp bottom right
Leopold Museum Inv. 2318

Provenance:
Heinrich Böhler, Vienna, later
Lugano; Mabel Böhler, Lugano;
Rudolf Leopold, Vienna.

Literature:
Leopold 1972, pl. 175; K 1747.

Exhibitions:
Berlin 1960; Tokyo 1991; Tübingen
1995.

Schiele drew this seated figure with strong pencil strokes. As in the following work, the board on which he placed his paper was not very smooth, and as a result the broad lines of his soft graphite pencil took on an interesting texture. He frequently used such a technique in his drawings from the years 1913 to 1916.

The center of the composition is the woman's sex, visible below folds in her slip and surrounded by a web of shorter and longer lines. The angle of the slip's edge as it stretches between her knees is opposed to that of its lower edge and the roughly parallel line of the right heel. The supporting knee, the summarily sketched hair, and the fingers of the right hand constitute essential, asymmetrical elements in the composition. The contours of the left arm and calf descend steeply from the head. They are juxtaposed by the angle of the right knee. That angle is balanced, in turn, by the head and the hand grasping the left foot–an especially beautiful demonstration of draftsmanship. Overall, this clear composition combines tremendous dynamism and great self-containment.

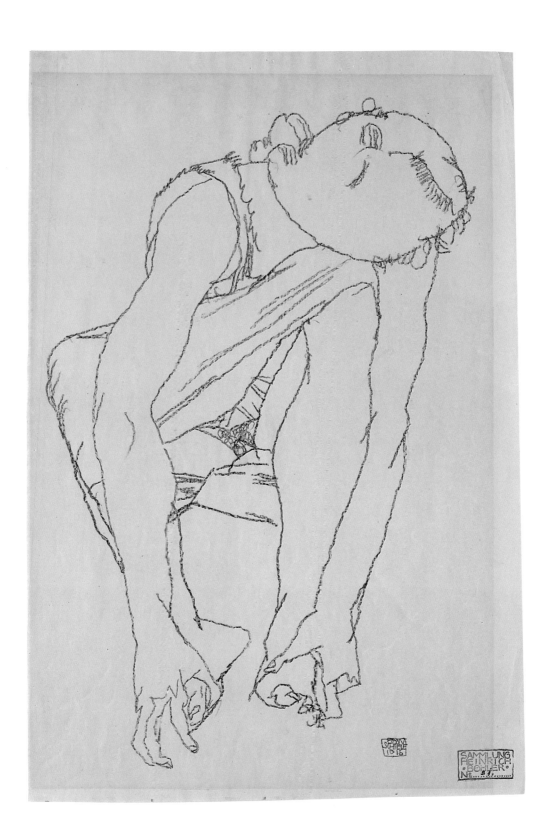

123 *Standing Girl with Braid (Seen from the Back)*
(Stehendes Mädchen mit Zopf [Rückenansicht])
1915

Pencil on paper, 18 7/8 x 12 3/8"
(47.9 x 31.1 cm)
Signed and dated lower right:
"EGON SCHIELE 1915"
Collector's stamp bottom right
Leopold Museum Inv. 2322

Provenance:
Heinrich Böhler, Vienna, later
Lugano; Mabel Böhler, Lugano;
Rudolf Leopold, Vienna.

Literature:
Leopold 1972, pl. 176; K 1748.

Exhibitions:
Des Moines 1971; Tokyo 1991;
Tübingen 1995.

This girl, standing in her undergarments, is rendered by the simplest of means. Her head is bent forward, and below the more angular shoulders, her buttocks and thighs are described in broad curves beginning at her hips. The contour of her right side has been changed to match the one on her left, as the original line curved outward too far.

Within this harmonious overall form, the almost abstract internal lines display great sensitivity; the ones that appear above the left thigh, especially, as indicated by the folds of the undergarments, seem filled with tension.

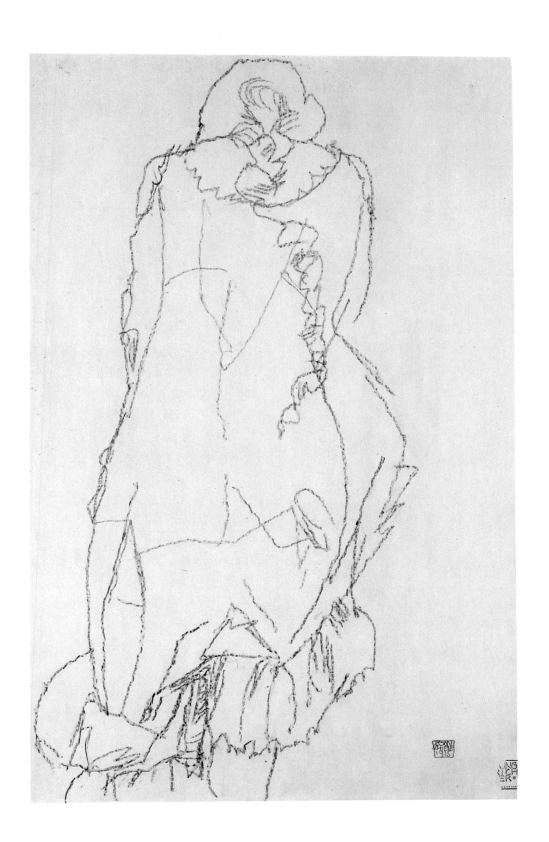

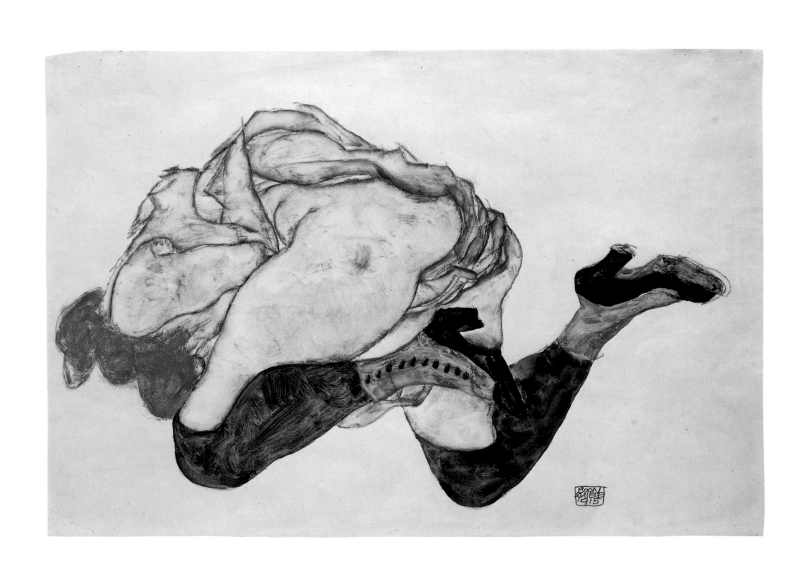

124 *Kneeling Woman with Head Bent Forward*
(Kniende mit hinuntergebeugtem Kopf)
1915

This woman appears to have suddenly bent forward from a kneeling position. Her violet-colored slip billows outward in her movement. Her feet and calves lift up from the floor.

The different manner of handling paint in these legs suggests their distance in space. The color in the left stocking is graphically structured, and therefore it appears more detailed and closer to us; in the right one the colors are blurred, so that it appears to be farther away. The stockinged legs with their high-top shoes are formally balanced by the shock of hair, which appears higher on the page than it would actually have been, right next to the shoulder. The head and neck appear to be missing, which only intensifies the sense of delirium suggested by her pose. Because of the position of the hand between her legs–the left foot hides most of it–and the visible labia beneath the slip (Schiele has erased the tip of one of the girl's fingers), one gets an impression of almost compulsive abandon. Such a combination of delirium and sexuality is nothing new in Schiele's art.

Capturing motion in an artistic way was one of Schiele's major concerns in this period. Here the flowing curves that outline the exposed parts of the body and the billowing slip above them enhance the sense of movement. The drawing and painting of the latter are equally magnificent.

Gouache, watercolor,
and pencil on paper,
11 1/4 x 18 1/8″ (28.6 x 46 cm)
Signed and dated lower right:
"EGON SCHIELE 1915"
Leopold Museum Inv. 2371

Provenance:
Rudolf Leopold, Vienna.

Literature:
Schmidt 1956; Leopold 1972,
pl. 174; K 1750.

Exhibitions:
Tokyo 1991; Tübingen 1995.

125 *Mother with Two Children II*
 (Mutter mit zwei Kindern II)
 1915

Oil on canvas, 58 7/8 x 63"
(149.5 x 160 cm)
Not signed, not dated
Leopold Museum Inv. 457

Provenance:
Heinrich Böhler, Vienna;
Estate of Heinrich Böhler, Vienna;
Sergius Pauser, Vienna;
Rudolf Leopold, Vienna.

Literature:
Malafarina 1982, no. 287;
Nebehay 1989; L 261; K 287.

Exhibitions:
Vienna, Österreichische Galerie
1968; Munich 1975; Zurich 1988;
Tokyo 1991; Tübingen 1995.

In 1915 Schiele worked on two paintings depicting a mother with infants, this one and another one that is in the Österreichische Galerie in Vienna (L 273), which he completed only in 1917. In his 1966 catalogue raisonné, Otto Kallir erroneously presented the work reproduced here as an unfinished preparatory study for the other painting. It could hardly have been a study, for Schiele never painted one in such a large format. A small sketchbook that Kallir himself published in a facsimile edition proves that this picture cannot have served as any kind of preparation for the other painting. In the sketchbook one discovers numerous designs–including detail studies of children–for both paintings side by side. Moreover, two different full-page designs for the child on the right in each of the two works are known (see illustration, below right). I have discussed the entire issue elsewhere in detail (Leopold 1972, L 261 and L 273).

This large composition was left unfinished for various reasons, but Schiele's intentions in the work are fully realized nonetheless. Once again he sought to create a pictorial metaphor for a borderline situation between life and death. The mother's head resembles a skull, and the child lying in her lap looks as though it has died. These two figures constitute a kind of *Pietà*. The colors of the background and the mother's garments enhance this impression: in contrast to the warm oranges of the surrounding space,

right: *Study*. 1914/15.
Pencil on paper

far right: *Infant in Swaddling
Clothes.* 1915. Pencil and gouache
on paper

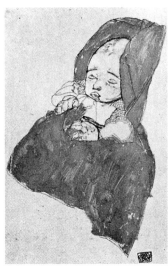

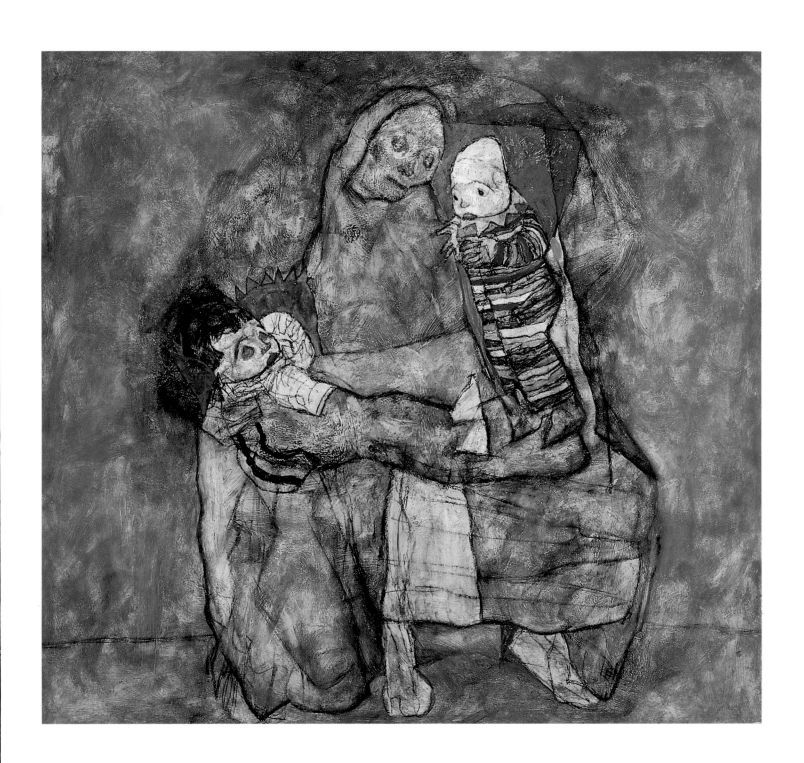

her robe is rendered in a cooler, yellowish-olive, her face in gray and blue-gray. The garment of the child held upright is unusually colorful. Schiele worked out its cretin-like, whitish mask of a face in the study (see illustration, below left, on page 288), but there its head, unlike the one in the painting, rests quite naturally in its wrappings, which have not yet been abstracted into a complex of brightly colored stripes.

126 *Woman Running*
 (Laufende)
 1915

Gouache, watercolor, and
pencil on paper, 18 1/2 x 12 1/8"
(47 x 30.9 cm)
Signed and dated lower right:
"EGON SCHIELE 1915"
Leopold Museum Inv. 1424

Provenance:
Wolfgang Gurlitt, Munich;
Galleria Galatea, Turin;
Rudolf Leopold, Vienna.

Literature:
Leopold 1972, pl. 178; K 1735.

Exhibitions:
Vienna, Albertina 1948; Linz 1949;
Salzburg 1950; Munich 1957;
Baden-Baden 1958; Heidelberg
1962; Turin 1963; Vienna, Albertina
1968; Tokyo 1991; Tübingen 1995.

Although an interest in motion is apparent in numerous works from this period, sometimes even in depictions of stationary objects–the painting *Curving Line of Houses* (L 260), for example–Schiele rarely attempted movement as dramatic as this. It is quite wonderful how he captured the woman's speed formally and by the unusual rhythm in the contours of her legs. Although her movement threatens to burst through the boundaries of the sheet, his carefully plotted composition manages to contain it. One sees how far Schiele was willing to deviate from natural forms, when the subject matter demanded it, in order to achieve the desired expression.

Equally unnatural is the coloring: the flesh tones rendered mainly in bluish-pink and greens, the dress she holds up out of her way in cinnabar-red with touches of blue-green and blue. The way the artist applied his strokes and spots of color with an only slightly moistened brush reveals the distinctly Fauvist quality of this painting.

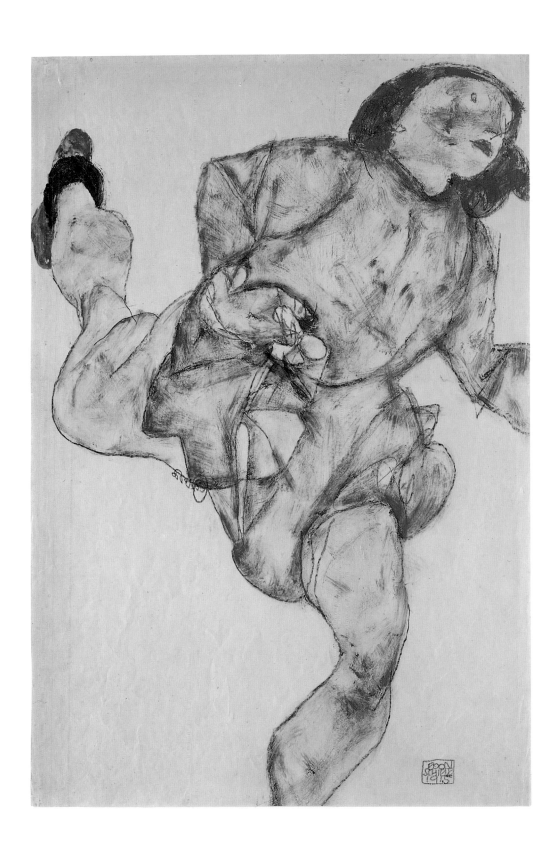

Reclining Woman with Braced Legs and Raised Hands
(Liegende mit aufgestellten Beinen und erhobenen Händen)
1915

Pencil on paper, 13 7/8 x 19 5/8"
(35.4 x 49.7 cm)
Signed and dated bottom center:
"EGON SCHIELE 1915"
Leopold Museum Inv 1405

Provenance:
Estate of Egon Schiele, Vienna;
Melanie Schuster, Vienna;
Rudolf Leopold, Vienna.

Literature:
K 1752.

Exhibitions:
Tokyo 1991; Tübingen 1995.

This drawing has the feeling of a playful étude. It is essentially a mere sketch; only the legs with their stockings and fancy garters were rendered in more detail. The rest is captured with a minimum of lines: the closed eyes with only a few lashes, the arms and hands, the outlines of the body, and the garment that partly covers it. The lines that describe the folds of that garment appear to continue without interruption in the form of a tiny spiral that almost seems playful. Yet with that spiral Schiele not only suggested the appearance of the pubic hair, but he also defined its location quite precisely. The position of the legs in space is also clearly indicated. They are nearly identical in form—a common feature in this period. The abrupt ending of the left calf can be understood as the line of a high-topped shoe, or again it may be that the sheet had become too small for the drawing (see also pls. 120 and 135).

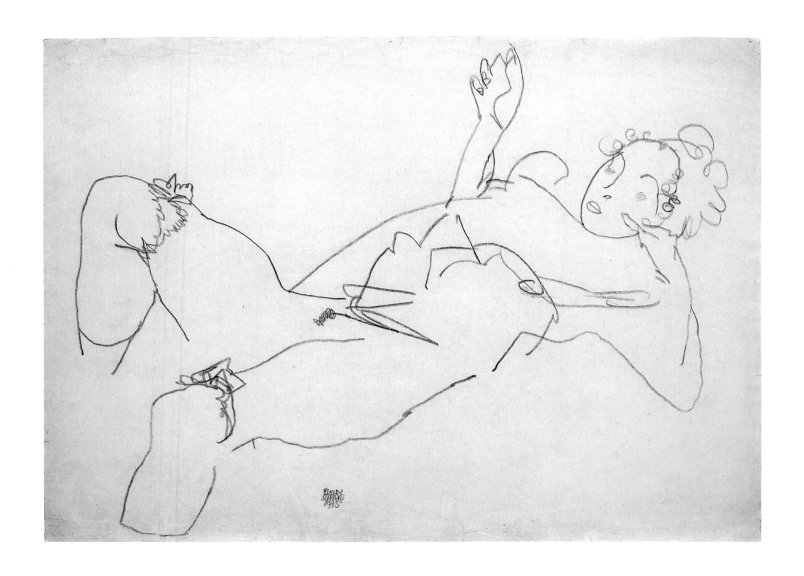

128 *Nude with Raised Right Leg*
 (Akt mit hochgezogenem rechtem Bein)
 1915

Gouache and pencil on paper,
18 1/2 x 12 3/8″ (47.1 x 31.5 cm)
Signed and dated lower left:
"EGON SCHIELE 1915"
Leopold Museum Inv. 1421

Provenance:
Rudolf Leopold, Vienna.

Literature:
Leopold 1972, pl. 169; K 1741.

Exhibitions:
Tokyo 1991; Tubingen 1995.

Schiele was fond of exploiting unusual foreshortenings to give tension to his compositions. One can see them occasionally even in 1908, but beginning in 1910 they became more common. They were best captured by the harder lines of his drawing style from the years 1913 to 1915. In the present drawing, as in many other works from this period (see, for example, pl. 102), sharply intersecting lines become dividing edges between planes.

This contorted figure with its astonishing perspective has been placed on the sheet at an angle. Her skin appears to be almost transparent, for the coloring, while suggesting the volume of her limbs, serves mainly to accentuate their contours. In this way Schiele emphasized their complex arrangement still further.

The few orange accents of the mouth, the nipple, the shoe, and the stockings contrast with the mainly ocher tones of the flesh and hair. Even her labia have been toned down, an unusual touch for Schiele. The coloring thus becomes subordinate to the work's masterful draftsmanship.

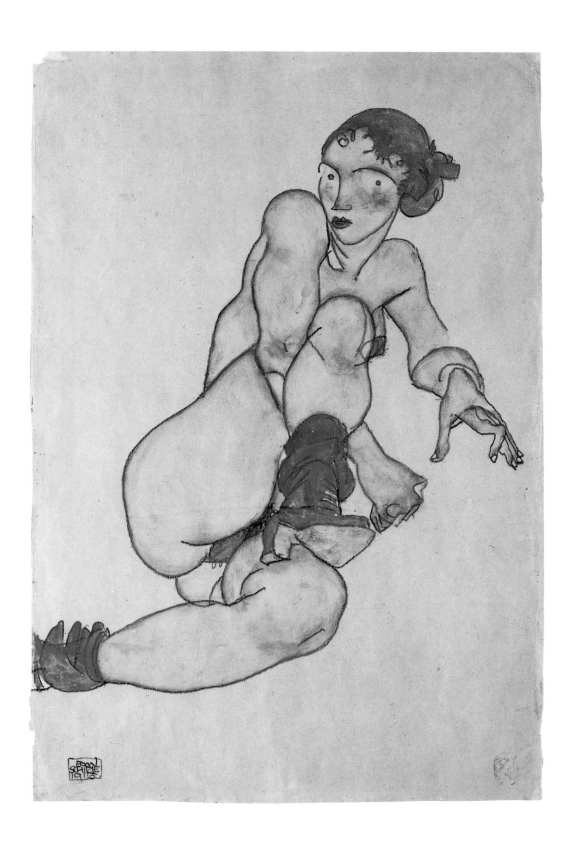

129 Self-Portrait with Striped Armlets
(Selbstdarstellung mit gestreiften Ärmelschonern)
1915

Gouache and pencil on paper,
19 3/8 x 12 3/8" (49 x 31.5 cm)
Signed and dated lower left:
"EGON SCHIELE 1915"
Leopold Museum Inv. 1422

Provenance:
Carl Mayländer, Vienna;
Etelka Hofmann, Vienna;
Rudolf Leopold, Vienna.

Literature:
Leopold 1972, pl. 171; Comini 1974,
fig. 107; K 1780.

Exhibitions:
Linz 1949; Tokyo 1991;
Tübingen 1995.

In this self-portrait Schiele presents himself as a social misfit, a kind of clown or fool. He has colored his hair a bright orange-red and his wide-open eyes have a look of madness about them. His head tilts precariously atop an unusually slender neck. The armlets with their vertical stripes recall the typical costume of a court jester. The shirt and vest are rendered in tones of the same olive-green, but the contrast between light and dark is most apparent in the armlets, so that they stand out more. Even more prominent are his face and hands, with their accents in a bright cinnabar-red and blue-green. Schiele used the latter even for his irises and pupils, which only enhances the sense of clownishness and the grotesque.

The artist may have borrowed from this self-portrait for the lower figure in his large painting *Transfiguration* (p. 26). Although Schiele's intentions in the two works were very different, and although this face is seen straight on and the right arm here is not positioned like the one of the figure in the painting, the shoulders and body, the left arm, and the fingers of the left hand are essentially identical.

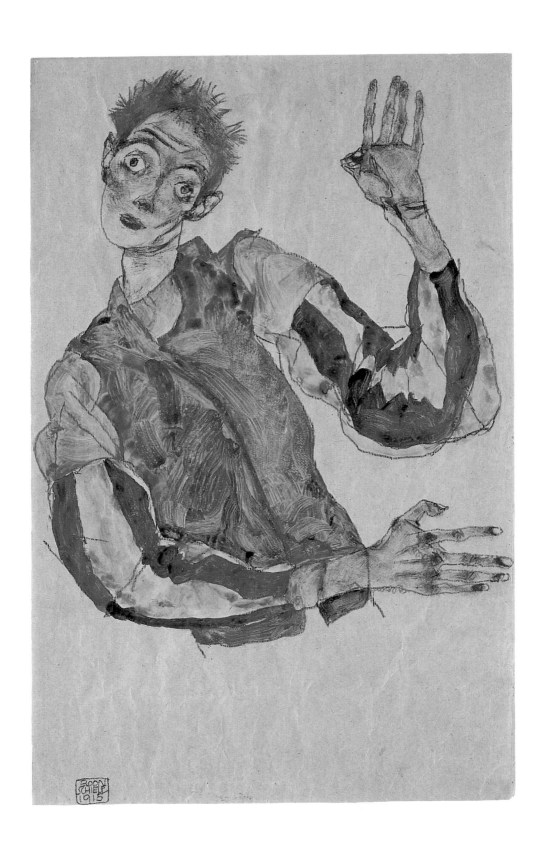

130 *Edith Schiele in a Striped Dress, Seated*
 (Edith Schiele in gestreiftem Kleid, sitzend)
 1915

Gouache and pencil on paper,
20 3/8 x 15 3/4" (51 x 40 cm)
Signed and dated center right:
"EGON SCHIELE 1915"
Leopold Museum Inv. 4147

Provenance:
Sotheby's, London (auction), 1993;
Rudolf Leopold, Vienna.

Literature:
O. Benesch 1964; Comini 1974,
pl. 131; K 1717.

Exhibitions:
London 1964; London 1972;
Brussels 1981; Tübingen 1995.

In the 1960s, the model's sister, Adele Harms, wrote me that in 1915, because good fabric was hard to come by during the war, she and her sister made dresses for themselves out of the striped curtain hanging in Schiele's studio. In the oil painting of his wife executed a short time after this drawing, Schiele changed the stripes into different colors, but in his works in pencil and gouache he rendered them in their true black and white. He did not do this slavishly, of course; he added nuances of blue or brown to the black. But what is most impressive is Schiele's disposition of them, essentially drawing them with his brush. The result is a wonderful structure of lines that accurately reflects the three-dimensional form of the skirt and at the same time creates a delightful surface pattern.

The hair and the jacket are rendered in subdued colors so that the black stripes and the various reds in the face and hands and on the collar dominate the drawing. To these he added only the dark blue-green of the ring and necklace and a lighter tint of the same color in the eyes and the skin. Edith Schiele's eyes were not this color, but the blue-green in combination with the red of her cheeks and especially of the lips seems perfectly natural. The slight sideways gaze of these light blue-green eyes causes her to look both questioning and withdrawn.

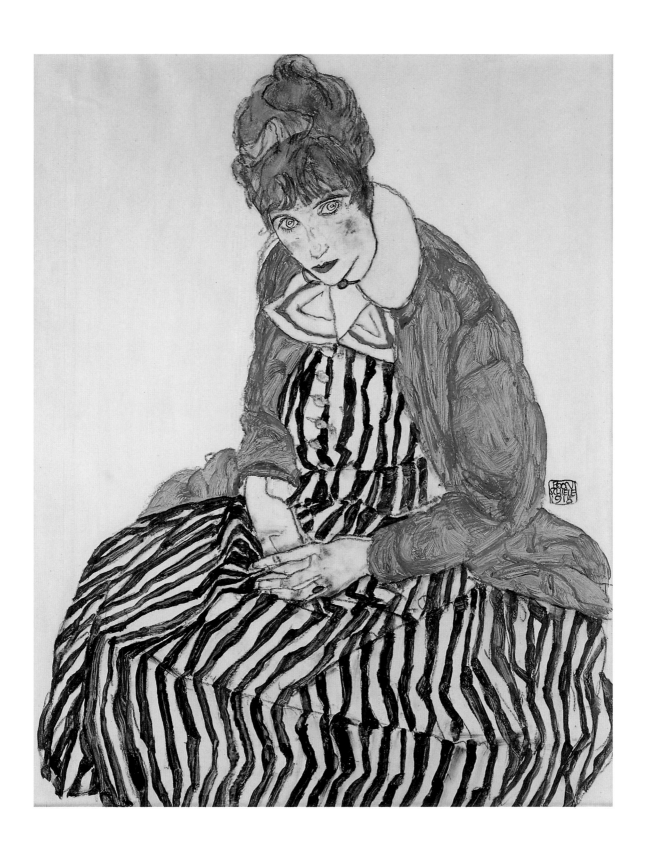

131 *Edith Schiele in a Striped Dress, Standing*
(Edith Schiele in gestreiftem Kleid, stehend)
1915

Pencil on paper, 19 1/2 x 12 1/4″
(49.5 x 31.1 cm)
Not signed, not dated
Leopold Museum Inv. 1420

Provenance:
Bruno Grimschitz, Vienna;
Viktor Fogarassy, Graz;
Hans Dichand, Vienna;
Rudolf Leopold, Vienna.

Literature:
Künstler 1946, fig. 10; Grimschitz
1960; Koschatzky 1968; Leopold
1972, p. 408; Comini 1974, fig. 132;
Malafarina 1982, no. 293b;
Marchetti 1984; Nebehay 1989;
K 1720.

Exhibitions:
New York, Guggenheim Museum
1965; Vienna, Albertina 1968;
Innsbruck 1973; Lucerne 1974;
Munich 1975; Venice 1984; Tokyo
1991; Tübingen 1995.

This preliminary study was the basis for a portrait of Schiele's wife in oil on canvas (L 267).[1] Here, unlike in other studies of her, she is looking straight at the viewer, that is to say, her artist husband. The fixedness of her gaze is caused in part by the very slight difference in the sizes of her eyes.

Schiele produced a number of studies of both his wife and her sister in striped dresses in 1914/15, but in none of the others did he manage to translate the folds and stripes of the dress into such a superb graphic structure as he did here.

[1] In the painting, Edith Schiele's arms hang down at her sides. As is natural, her fingers, curling inward toward the thumb, form an opening. In her left hand this is obscured by a small object she is holding. Alessandra Comini (1974, p. 147) explains that the opening in her right hand represents her deflowered condition, whereas that of her left represents her virginal state–also that the notches in her white collar may well refer, in Schiele's "obvious symbolism," to her torn hymen.

I would counter these claims by reminding the reader that the marriage of Edith and Egon Schiele had taken place months before, and that at this point they had been intimate for a full year–as her sister, Adele Harms, reported both to me and to Comini. Considering the physiology of human muscles, the arms would hang down and both the flexors and extensors of the fingers would be relaxed, the fingers would naturally curl inward, and the thumb would point straight down. Schiele only emphasized this as part of his style, just as he showed her holding something in her left hand simply for variety, not so as to effectively "block her opening," as Comini suggests.

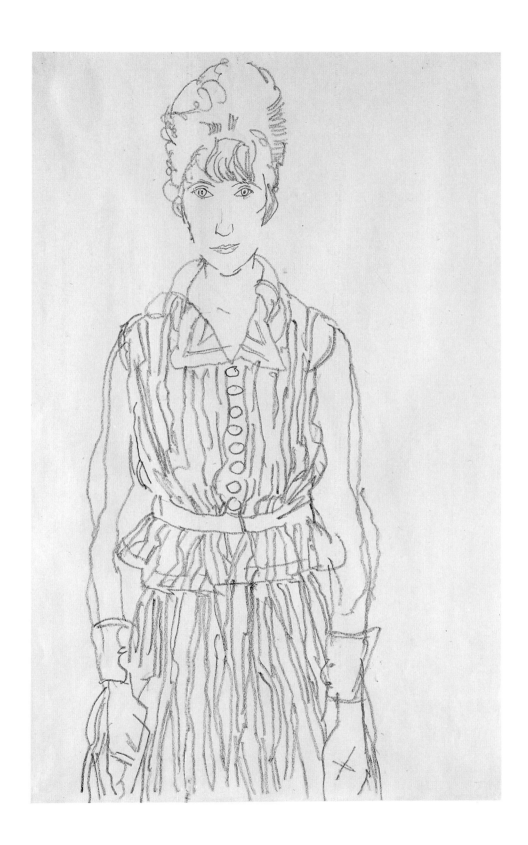

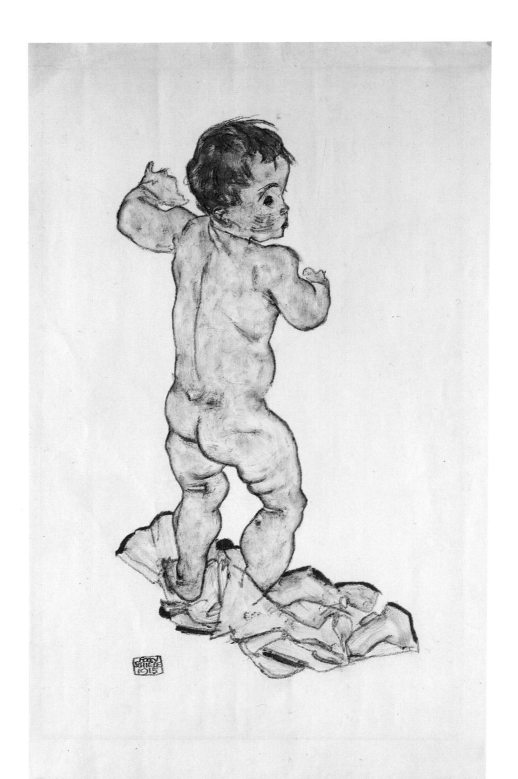

132 *Putto*
(Putto)
1915

Schiele produced two drawings of his little nephew, the first-born son of his younger sister. In this highly successful depiction he looks like a putto.

The outlines have been emphasized by the coloring. The almost straight vertical contour of the left side of the body, which continues without interruption in the left leg, is opposed on the right by a much more complex line–one that is even broken at the hip where the color has been omitted. This charming linear structure, in places suggestive of drawn bows, perfectly captures the naked body of a small child. Even its fatty wrinkles are precisely described.

The slightly angled long axis of the cloth on which the child is standing runs parallel to an imaginary line drawn through his arms. The slight backward tilt of the head stabilizes the arrangement.

Despite its complicated pose, the child, wearing an expression of delightful innocence, seems perfectly natural.

Gouache, watercolor, and pencil on paper, 20 3/8 x 12 3/8" (51.9 x 31.3 cm)
Signed and dated lower left: "EGON SCHIELE 1915"
Leopold Museum Inv. 1423

Provenance:
Wolfgang Gurlitt, Munich;
Viktor Fogarassy, Graz;
Hans Dichand, Vienna;
Serge S. Sabarsky, New York;
Rudolf Leopold, Vienna.

Literature:
Comini 1974, pl. 22; K 1705.

Exhibitions:
Linz 1949; Zurich 1949; Salzburg 1950; Munich 1957; Baden-Baden 1958; Darmstadt 1967; Vienna, Albertina 1968; Innsbruck 1973; Munich 1975; Tokyo 1991; Tübingen 1995.

Reclining Woman Exposing Herself
(Liegende Entblösste)
1916

Gouache, watercolor,
and pencil on paper,
12 1/8 x 17 1/2" (30.9 x 44.4 cm)
Signed and dated upper left:
"EGON SCHIELE 1916"
Leopold Museum Inv. 2359

Provenance:
Bey Behcet Özdoganci;
Rudolf Leopold, Vienna.

Literature:
Leopold 1972, p. 502; K 1833.

Exhibition:
Tübingen 1995.

Schiele's wife served as the model for this semi-nude with her lower body exposed. In this same year, 1916, the artist depicted her in a seated pose with one leg raised and her genitals emphasized in a similar way. Both works were intended for a portfolio of five reproductions of erotic drawings. From the faces in the two drawings it would be difficult to determine that this woman is, in fact, Edith. Schiele certainly used other models who represented the same type as his wife. More telling is the way she wears her hair. Edith Schiele's sister, Adele Harms, assured me that in these particular works Schiele changed the face out of consideration for his wife.

What I have said in my text for plate 23 about Schiele's habitual placement of his signature may not be entirely relevant in this case. Here he may have changed the horizontal format of the work into a vertical one deliberately so as to make it more explicit–it was to appear, after all, in a portfolio of erotic drawings.

What is much more important is that a year later Schiele incorporated the naked thighs and legs from this drawing almost unchanged into his painting *Reclining Woman* (pl. 142). There they are balanced by the similarly positioned arms, but here it is the bulk of the hairdo that echoes the angle of the right thigh and knee. One could point out a number of such formal relationships. This juxtaposition of forms is supported by the coloring. Schiele used the same unnatural ocher to highlight the contours of the thighs and those of the jacket and the raised skirt, also some of the internal structures of the two garments. For a contrasting color he chose blue-green. The highly expressive drawing and the sensitive coloring complement each other, and the combination is altogether satisfying.

Schiele allows a portion of the raised skirt to reappear below the woman's spread thighs, thereby virtually framing and further emphasizing her nakedness (see also pl. 36).

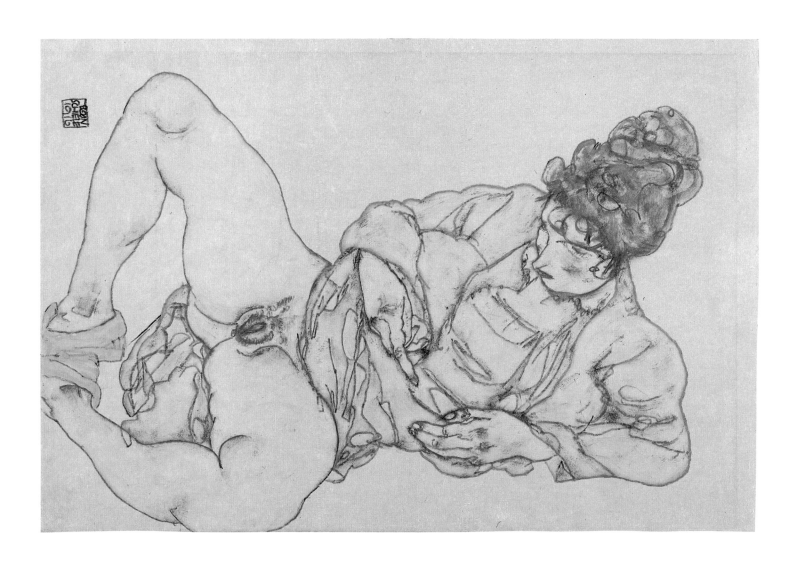

134 Lesbian Couple
(Lesbisches Paar)
1916

Pencil on paper, 19 3/8 x 12 3/4"
(49 x 32.5 cm)
Signed and dated bottom center:
"EGON SCHIELE 1916"
Leopold Museum Inv. 2362

Provenance:
Estate of Egon Schiele, Vienna;
Melanie Schuster, Vienna;
Rudolf Leopold, Vienna.

Literature:
Leopold 1972, pl. 190; K 1824.

Exhibition:
Tübingen 1995.

This is one of the masterful drawings from 1916–both in its composition and in its deft use of line. The main axis of this towering arrangement is a gentle curve that extends downward from the two women's heads along the right side of the body of the one in front and into her right thigh. Her raised garment billows still farther to the right. This is balanced on the left by an approximately straight contour. The clear lines of the drapery folds extend upward at a slight angle from the concave left side of the woman's body, and an opposing angle is described by the raised hem of her slip.

Schiele was never put off by ugliness in a motif. Not only did he include it, but he also exaggerated it–even in his later development–so as to present a specific type. In this drawing he communicated the corpulence of the figure in front by showing us not only her massive figure and naked buttocks, but even more tellingly by suggesting the wrinkles of fat on her right thigh beneath her underclothes. The woman behind, by contrast, seems almost emaciated, and the foreshortening of her face makes her appear even less attractive than she may have been. She has a long nose and her lips, indicated by only two parallel lines, seem to be pressed together. There is a certain rigidity in her upward gaze; perhaps it expresses indifference.

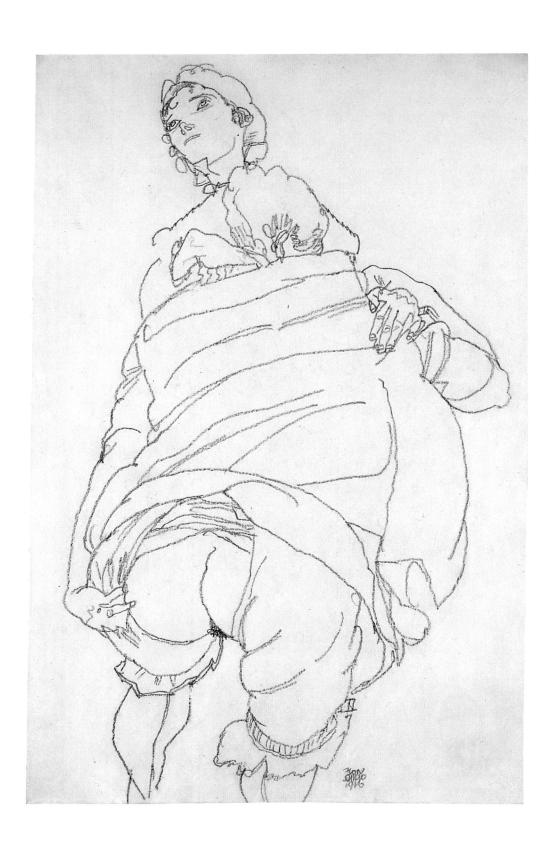

135 Russian Officer, Prisoner of War
(Kriegsgefangener russischer Offizier)
1916

Gouache, watercolor,
and pencil on paper,
18 5/8 x 12 3/8" (47.3 x 31.4 cm)
Signed and dated lower left:
"EGON SCHIELE 1916"
Inscribed lower right
Verso: *Male Figure in a Curving
Pose*. 1914. Pencil on paper.
Signed bottom center:
"EGON SCHIELE 1914"
Leopold Museum Inv. 1417

Provenance:
Karl Grünwald, Vienna;
Johann Piering, Vienna;
Marlborough Fine Art, London;
Christie's, London (auction), 1982;
Rudolf Leopold, Vienna.

Literature:
O. Benesch 1958 (2); Malafarina
1982, no. D88; Nebehay 1989;
K 1838.

Exhibitions:
Vienna, Albertina 1948; London
1964; New York 1968; Tokyo 1986;
Tokyo 1991; Tübingen 1995.

Male Figure in a Curving Pose (verso of pl. 135). 1914. Pencil on paper

The omission of the right hand is easily explained. Schiele always worked out the arrangement of a composition before beginning a painting, but in his drawings, even in smaller studies in oil, he simply plunged in without calculating how much space he might need. Often enough the sheet proved too small. Here the edge of the picture would have cut off the man's right hand (see also pls. 120 and 127). Omitting the hand was the right thing to do in terms of composition, even though its absence detracts from the portrait.

If one compares this depiction of a Russian officer with works from 1914, either the *Seated Woman with Blue Headband* (pl. 111) or the male figure on the verso of this same sheet (see illustration below), one cannot help but notice its greater realism. The portrait of the *One-Year-Volunteer Private* (pl. 137) and works from the following years show this to be a definite change in Schiele's style. In his drawings he used fewer and fewer geometric shapes. Here they are found only in details, such as the rendering of the right cheekbone.

Schiele convincingly captured the prisoner's brooding expression, and with masterful painting he gave his subject a distinct three-dimensionality.

Although only a portion of the face is visible in the drawing on the verso of this sheet (see illustration below), one can assume, judging from similarly geometric sketches from the same year, that Schiele served as his own model. It is known that he had a large mirror that he used in such instances.

The figure assumes such an odd pose so as to produce a long curve from the left around to the left thigh, a shape stabilized by the downward thrust of the calf. The contours and internal lines appear taut. The small hatching lines abutting them serve to fix them in space (see the texts for pls. 98 and 110).

Otto Benesch considered the 1914 drawing to be a "war study," but that notion must be rejected. Quite apart from the fact that the artist used himself as a model (see above), Schiele, a committed pacifist, never put anything related to warfare in his art–least of all in 1914, when he still had nothing to do with the military. He was not called up until June 21, 1915.

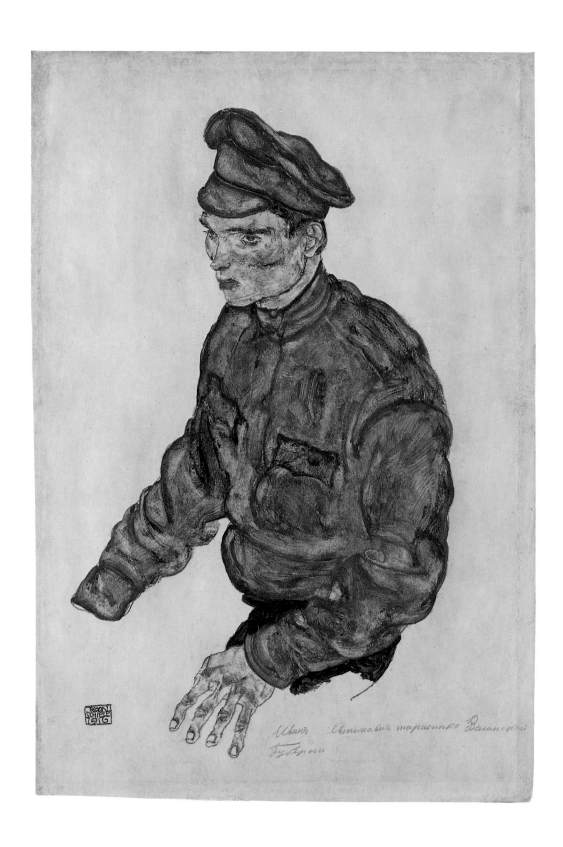

Иван Евтимович тарасенко Валинской
Губерни

136 *Writing Table at the Mühling Prisoner-of-War Camp*
(Schreibtisch im Kriegsgefangenenlager Mühling)
1916

Pencil, colored crayon, ink,
and watercolor on paper,
18 1/8 x 11 5/8″ (46 x 29.7 cm)
Signed and dated bottom center:
"EGON SCHIELE 1916"
Leopold Museum Inv. 2360

Provenance:
Estate of Egon Schiele, Vienna;
Melanie Schuster, Vienna;
Rudolf Leopold, Vienna.

Literature:
Leopold 1972, pl. 193;
Nebehay 1989; K 1871.

Exhibitions:
Vienna 1928; Vienna, Albertina
1948; Linz 1949; Innsbruck 1963;
Tübingen 1995.

In the prisoner-of-war camp at Mühling, Schiele not only did portraits of his superiors and a number of Russians, but he also drew the office spaces and–as here–his own workplace. This drawing, with its wonderfully clean lines, is perhaps the most beautiful of these interiors.

Depth is suggested by the wall seen in perspective, with its notices and the bookshelf, and the view from above across two desks placed next to each other. In addition, Schiele leads the eye back into space with an almost zigzag movement of lines at a slight angle from the horizontal. His depictions of individual objects reveal draftsmanship of an extraordinary delicacy. Their volumes are suggested not only by perspective but by alternating stronger and thinner lines and the occasional use of shading. The candle–to point out only one example–is clearly set apart from the wooden slat to the left of it and the match holder behind.

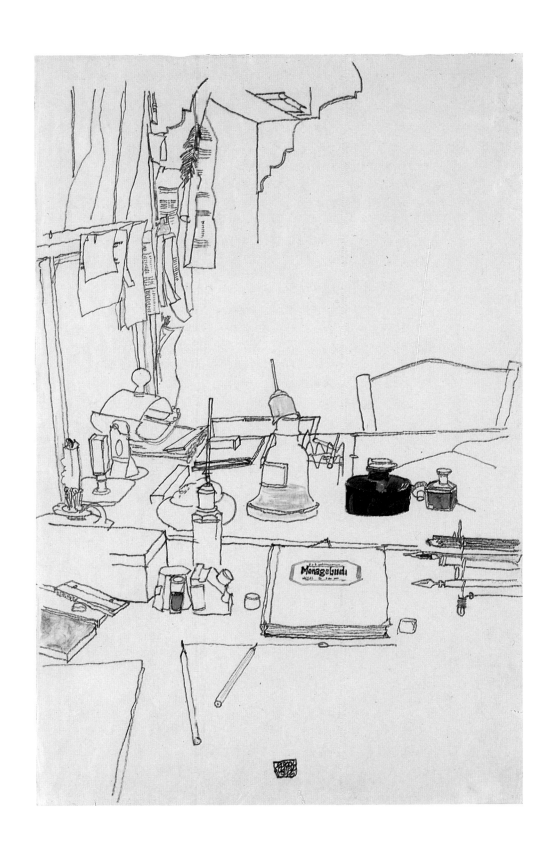

137 *One-Year-Volunteer Private*
(Einjährig freiwilliger Gefreiter)
1916

Gouache and pencil on paper,
18 7/8 x 12 3/8" (48 x 31.3 cm)
Signed and dated center right:
"EGON SCHIELE 1916"
Leopold Museum Inv. 1418

Provenance:
August and Serena Lederer,
Vienna; Erich Lederer, Geneva;
Rudolf Leopold, Vienna.

Literature:
Leopold 1972, pl. 194; Comini
1974, fig. 110; Nebehay 1989;
K 1849.

Exhibitions:
Zurich 1988; Tokyo 1991;
Tübingen 1995; Tokyo 1997.

This is a portrait of one of Schiele's superiors. The figure ends indistinctly below the soldier's left shoulder, at the bottom of his shirt–a counter-weight to the contour of the head–and along a roughly diagonal line leading down to the cuff of his right sleeve. The line of the hand, only partially sketched, points in the opposite direction, paralleling the less-pronounced axis of the slightly bent head.

The work is a fine example of Schiele's much more realistic approach at this time. He has even noted the distortion of the outline of the face through the glasses. Although he presented only a portion of the figure, he managed to make this fragment a full psychological portrait. In photographs the young man appears to have been more lighthearted and cheerful; Schiele–as was his habit–transformed him into an earnest person with an intense, inquisitive gaze. The artist probably emphasized the academic, intellectual look of this volunteer so as to indicate how basically unsuited such men were for military life.

The light face, painted mainly in reddish tones, is effectively set off by a darker blue uniform. Schiele freely invented the faint traces of red in the jacket and its varying shades of blue, as he doubtless did the yellow-olive of the shirt–a color he particularly favored. Here he placed it against the blue of the uniform and also related it to the man's blond hair. His rendering of the uniform is masterful. The lovely brushstrokes in various shades of blue are topped in a number of areas by highlights in opaque-white, gray-white, and reddish-white. Although his painting is uncommonly free, it precisely describes the garment in question.

Schiele chose this work for inclusion in a portfolio of twelve full-size reproductions. It was published in 1917 by the Richard Lányi bookshop in Vienna in an edition of 400, and was the only such portfolio to appear during Schiele's lifetime.

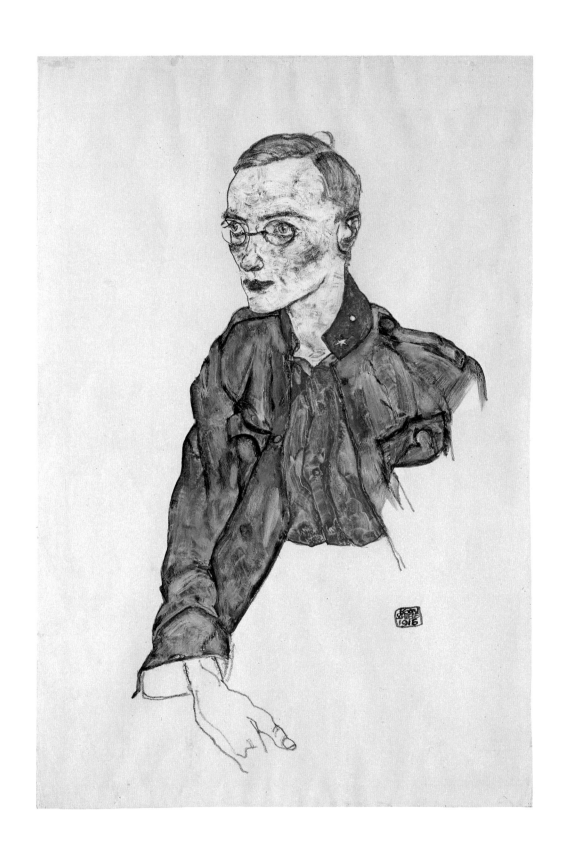

138 *Street Corner (Krumau)*
 (Strassenecke [Krumau])
 1916

Pencil on paper, 19 x 12 3/8"
(48.3 x 31.3 cm)
Signed and dated lower left:
"EGON SCHIELE 1916"
Leopold Museum Inv. 2361

Provenance:
Estate of Egon Schiele, Vienna;
Melanie Schuster, Vienna;
Rudolf Leopold, Vienna.

Literature:
Leopold 1972, pl. 196; K 1867.

Exhibitions:
Vienna 1954; London 1964;
Tübingen 1995.

The building at the right edge of the picture is only indicated by the outline of its cornice and a line extending down from it at a slight angle. These serve to set the building across the street from it in a proper spatial context.

The combination of rough paper and a very soft pencil resulted in a pleasing, wavy line. Schiele drew the foreshortened front of the building with greater pressure on his pencil, and its darker lines imply that this wall is in full sunlight, while the one facing us to the right lies in semi-shade. The shadows visible in two of the chimney tops confirm that this was the case.

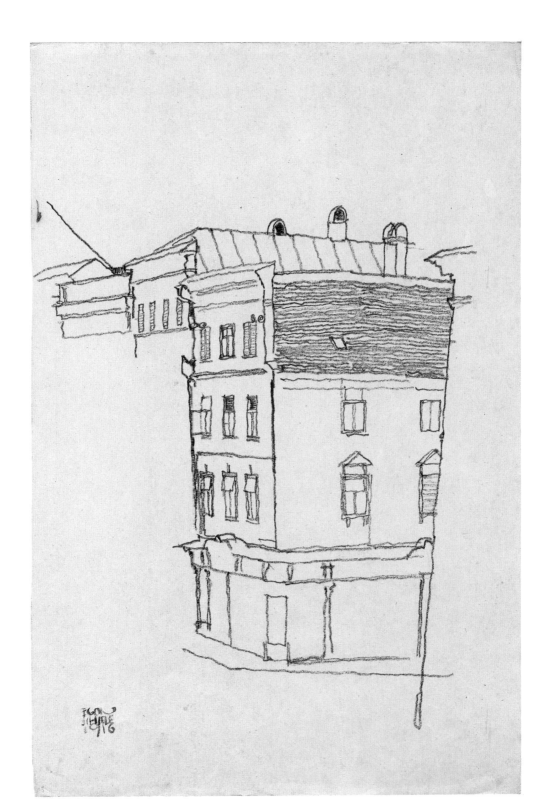

139 *Packing Room ("Packraum")* 1917

Black crayon on paper,
18 1/8 x 11 5/8" (46.2 x 29.5 cm)
Signed and dated lower right:
"EGON SCHIELE 1917"
Inscribed lower left: "PACKRAUM"
Leopold Museum Inv. 1416

Provenance:
Hans Rosé, Vienna,
later Isle of Man;
Sotheby's, London (auction), 1991;
Rudolf Leopold, Vienna.

Literature:
K 2161.

Exhibitions:
London 1969; Tokyo 1991;
Tübingen 1995.

Schiele's military superior at this time, Dr. Hans Rosé, commissioned him to make drawings of the most important quarters of the Imperial and Royal Military Supply Depot for army employees in the field, both in Vienna and in its twenty-eight branches strewn throughout the monarchy.

As in the other works from his final period, Schiele executed these drawings with much greater realism than one associates with him before this time. One sees this in a number of the details in the present example, notably the brush hanging in the foreground or the bottles on the table. The odd bundles of pencil lines next to the latter seem more abstract; one does not at first recognize that they indicate more bottles in protective wrappings. With roughly parallel rows of lines, Schiele very beautifully described both the physical appearance of the woven basket in the foreground and its volume, contrasting it perfectly against the table behind yet never succumbing to pedantic naturalism.

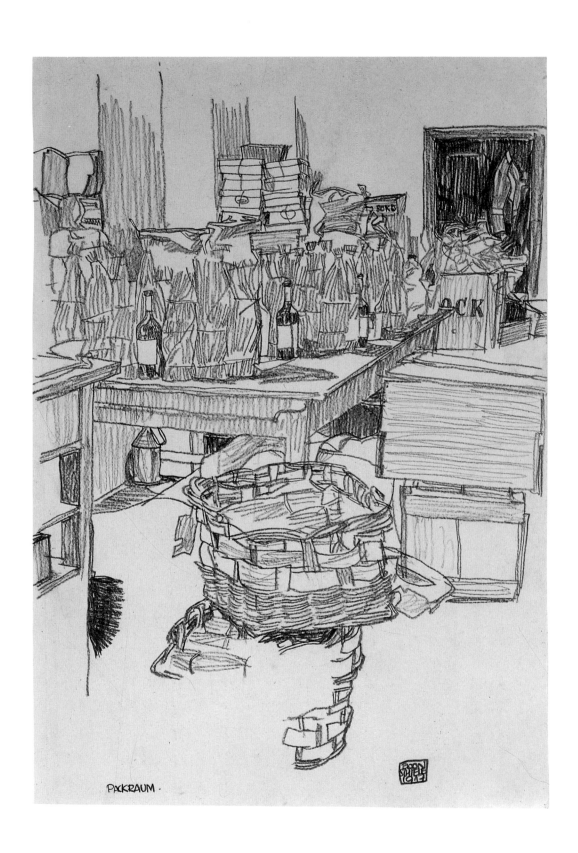

PACKRAUM.

140 *Supply Depot, Brixlegg Branch*
(Filiale Brixlegg der k. u. k. Konsumanstalt)
1917

Black crayon on paper,
11 5/8 x 18 1/8" (29.5 x 46.2 cm)
Signed and dated lower right:
"EGON SCHIELE 1917"
Inscribed lower right: "BRIXLEGG"
Leopold Museum Inv. 1400

Provenance:
Hans Rosé, Vienna,
later Isle of Man;
Sotheby's, London (auction), 1991;
Rudolf Leopold, Vienna.

Literature:
K 2156.

Exhibitions:
London 1969; Tokyo 1991;
Tübingen 1995.

Schiele used heavy strokes to draw this exterior wall with its windows and open shutters, suggesting with great verve the bright sunlight striking it. His rendering of the two soldiers is less successful.

BRIXLEGG.

Woman in Undergarments Leaning on Her Arms
(Sich Aufstützende in Unterwäsche)
1917

Black crayon on paper,
11 1/2 x 17 7/8" (29.1 x 45.3 cm)
Signed and dated lower left:
"EGON SCHIELE 1917"
Leopold Museum Inv. 1399

Provenance:
Rudolf Leopold, Vienna.

Literature:
Leopold 1972, pl. 198; K 1922.

Exhibitions:
Tokyo 1991; Tübingen 1995.

This woman sits casually, propping herself up with her left arm. The result is a composition filled with contrary movement–in the legs, for example, or in the head and the arm below it. Yet the line of the arm parallels that of the right calf, and an imaginary line drawn from the peak of the kerchief through the nose roughly continues the axis of the left calf. Correspondences such as these give the composition its solidity.

A degree of mannerism enters into Schiele's art in this period. Here it is evident only in minor details, such as the lacy hem of the woman's undergarments and the internal lines on her back. In other respects the drawing is altogether clear and sensitive. By varying the pressure on his crayon, Schiele managed to create lines of different thicknesses shading from black to gray. His brilliant draftsmanship is particularly apparent in his rendering of the face. In terms of composition, the way the sharply turned head presses against the shoulder and the arm extending downward from it is most impressive.

This drawing was reproduced before the artist died, in an issue of the publication *Der Anbruch*, dated January 15, 1918.

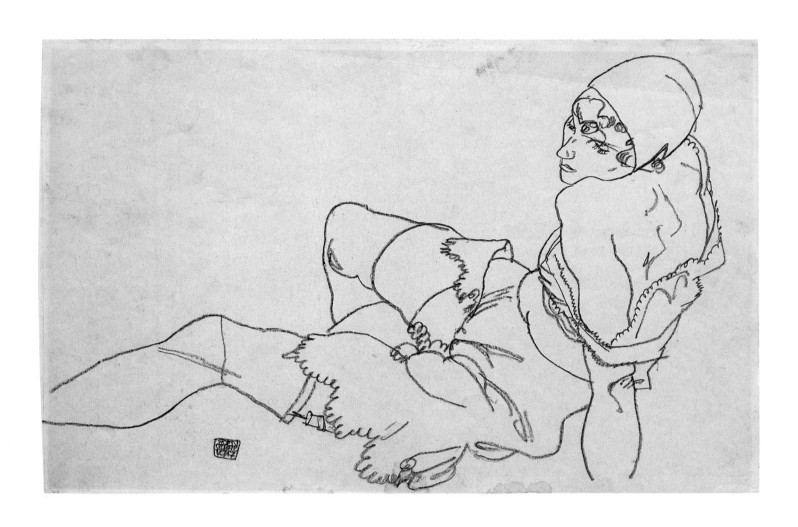

Oil on canvas, 37 7/8 x 67 3/8"
(96 x 171 cm)
Signed bottom center:
"EGON SCHIELE 1917"
Leopold Museum Inv. 626

Provenance:
Karl Grünwald, Vienna;
Richard Lányi, Vienna;
Otto Kranz, Vienna;
Fritz Wolff, Vienna;
Frederick Knize, Vienna;
Kamm, Zug, Switzerland;
Rudolf Leopold, Vienna.

Literature:
Karpfen 1921; Roessler 1922
(1948); Vergo 1975; Wilson 1980;
Whitford 1981; Malafarina 1982, no.
307; Nebehay 1989; Stefano 1992;
L 278; K 306.

Exhibitions:
Vienna 1918; Vienna 1925; Dresden
1926; Vienna 1928; Vienna, Neue
Galerie 1948; Düsseldorf 1959;
Innsbruck 1963; London 1964;
New York, Guggenheim Museum
1965; Vienna, Österreichische
Galerie 1968; London 1971; Rome
1984; Zurich 1988; Tokyo 1991;
Tübingen 1995; Tokyo 1997.

The undulating white cloth with its agitated folds appears to have been spread out on a sheet of gold foil. On it lies a nude woman with dark reddish-brown wavy hair masterfully drawn and painted with the brush. Her somewhat melancholy, severe expression is convincingly rendered. This is the loveliest head in all of Schiele's paintings from 1917 and 1918.

The bent arms and legs correspond to one another, as do the one hand and one foot. To emphasize this, some of the white cloth has been draped across the woman's waist, effectively dividing her body in two. For much the same reason, Schiele had painted the trunks of trees white, as though they had been limed, in his landscapes from 1911 and 1912, thereby separating the limbs from the ground below (see pls. 61 and 80). Like the body, the cloth widens out vertically on either side of the composition. But so as not to push the symmetry too far, Schiele created small deviations. The axis of the figure, unlike that of the cloth, is not horizontal but slightly angled. This brings the left knee much closer to the edge of the cloth than the right one, and the right elbow even reaches beyond it.

The distribution of lighter and darker colors also helps to break the symmetry. Whereas the upper body and the cloth lying across the waist are almost equally light-colored, the legs are somewhat darker, and the white of the cloth visible between them is very prominent, producing an interesting negative shape. It was to emphasize this shape that Schiele chose to use a darker color for the legs than for the upper body. The discrepancy was intended; it has nothing to do with the fact that the painting was based on studies drawn from different models. The spread legs come from a drawing of Schiele's wife (pl. 133), while the head is borrowed from a study[1] made with a professional model.[2] Schiele's ability to combine different motifs into a wholly convincing single image was remarkable. One sees it in a number of his cityscapes, such as the second version of his *View of Stein* (L 240), from 1913. In his painting *Embrace* (L 276), also from 1913, he did not set off the fabric convincingly from either the bodies or the background, but here the delicate drawing of the cloth and the contours of the body are successfully combined; the figure is as though interwoven into the fabric.

A number of subtle contrasts enrich the composition. One perceives a difference in warmth of color between the upper body and the cloth, but between the cloth and the legs the distinction is mainly between lighter and darker–the delicate coloring of the thighs shimmering like mother-of-

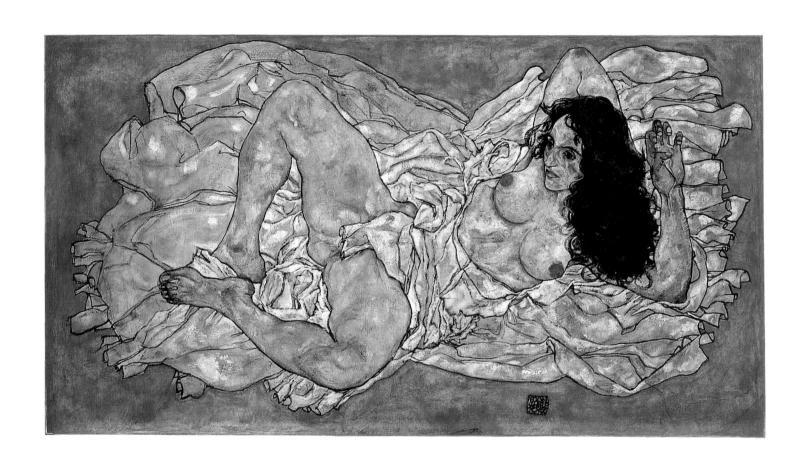

pearl. The nude body stands out against the cloth because the latter is rendered mainly with line, and exquisite folds fill the cloth with graphic interest. The coloring in the above-mentioned *Embrace* is not altogether successful, but here the harmonies set up between the blue and yellow of the cloth and between that same blue and the various reds and bright oranges of the woman's body are exquisite. This work is unquestionably one of the most important achievements of the artist's final years.

[1] This work is in a private collection, New York.

[2] There are also a separate drawing of the left hand and arm (formerly in the Heinrich Rieger Collection, Vienna) and several larger and smaller designs on a sketchbook page measuring only 4 1/4 x 7 1/8″ (10.8 x 18 cm) (Graphische Sammlung Albertina, Schiele Archive, sketchbook 10, sheet 21).

143 *Kneeling Girl Propped on Her Elbows*
(Kniendes Mädchen, auf beide Ellbogen gestützt)
1917

Gouache and black crayon on paper, 11 3/8 x 17 1/2″ (28.7 x 44.3 cm)
Signed and dated lower right: "EGON SCHIELE 1917"
Leopold Museum Inv. 1397

Provenance:
Rudolf Leopold, Vienna.

Literature:
Leopold 1972, pl. 203; Werkner 1994 (1); K 1952.

Exhibitions:
Munich 1975; Zurich 1988; Tokyo 1991; Tübingen 1995; Tokyo 1997.

This is another of the drawings that Schiele later signed in such a way that it would appear he had executed it in vertical format (see pl. 23). The girl, however, is clearly kneeling on the floor, braced on her elbows.

The sculptural effect of this figure is already assured by her placement on the page, at an angle running from the left foreground back and to the right. Her elevated buttocks dominate the image. They clearly inspired Schiele to create this erotic drawing, for his lines seem to caress their fleshy contours.

The colors are restrained and applied with a relatively dry brush. With them each area is given its appropriate volume. The cooler greens and blues of the bunched-up slip are exquisitely contrasted to the warm tones of the skin and the dark red-brown of the hair.

This drawing is one of the relatively few drawings from his late period in which Schiele achieved the same level of artistry that one finds in so many of his earlier ones. With this much more realistic style, he managed to imbue his figure with a wonderful vitality.

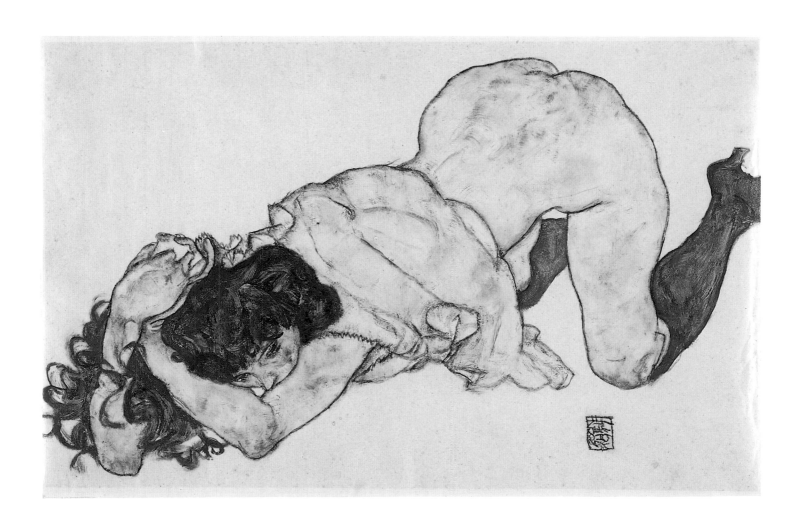

GUSTAV KLIMT

144 *Head of the Dead Klimt*
(Kopf des toten Klimt)
1918

Gustav Klimt died on February 6, 1918. The next day Schiele made three drawings of him in the morgue of the Allgemeines Krankenhaus, where he had been shaved. He indicated the date on this drawing.

Schiele presumably did this drawing in a horizontal format, but then inscribed, signed, and dated it as though it were to be viewed vertically (see text for pl. 23). The facial expression becomes more believable and more powerful if one simply turns the drawing back to the horizontal. What makes it so successful is Schiele's masterful internal drawing. Schiele never erased. If he corrected a line, as he did here with the contour of the nose, he left the original as well, for he felt that any line he had drawn had a value of its own.

I agree with the Albertina's late Schiele expert, Erwin Mitsch, that of the three drawings of the dead Klimt, the present one, despite the correction to the line of the nose, is the most impressive.

Black crayon on paper,
18 1/2 x 11 7/8" (47.1 x 30 cm)
Signed and dated bottom center:
"EGON SCHIELE 7.II.1918"
Inscribed center left:
"GUSTAV KLIMT"
Leopold Museum Inv. 1415

Provenance:
Estate of Egon Schiele, Vienna;
Melanie Schuster, Vienna;
Rudolf Leopold, Vienna.

Literature:
Koschatzky 1968, pl. 59;
Leopold 1972, p. 678; Comini 1974,
pl. 198a; K 2443.

Exhibitions:
Vienna, Albertina 1948; Linz 1949;
Vienna, Albertina 1968; Tokyo
1991; Tübingen 1995.

145 *Nude Girl with Lowered Head*
(Kauerndes Mädchen mit gesenktem Kopf)
1918

Gouache, watercolor,
and black crayon on paper,
11 5/8 x 18 1/8" (29.7 x 46.2 cm)
Signed and dated lower left:
"EGON SCHIELE 1918"
Leopold Museum Inv. 2372

Provenance:
Estate of Egon Schiele, Vienna;
Melanie Schuster, Vienna;
Rudolf Leopold, Vienna.

Literature:
Leopold 1972, pl. 215; K 2204.

Exhibitions:
Vienna, Albertina 1948; Innsbruck
1963; Munich 1975; Tübingen
1995.

With the placement of his signature, Schiele attempted to turn this drawing, which was certainly executed as a horizontal format, into a vertical one (see pl. 23).

The style of these sharp, almost calligraphic lines betrays this drawing as a work from the artist's last year. To suggest the flesh tones, Schiele used carmine-red, yellow-ocher, and a light blue-green. The delicate pinkish tones provide a color link to the cloth, painted a gleaming carmine. The color harmony produced by that red and the rich red-brown of the hair is most unusual.

The various elements are combined in such a way as to produce a perfectly clear and very self-contained composition. Aside from its formal delights, the drawing communicates something of the subject's feelings. The deeply bowed head and the wistful melancholy in this face, framed by long, loose strands of hair, might suggest that she looks for protection.

Schiele submitted this drawing to the Gesellschaft für vervielfältigende Kunst for potential publication as a lithograph, but it was rejected, just as the portrait of Paris von Gütersloh had been that he had submitted for the same purpose not long before. Both are superb examples of Schiele's late style. At his request, both drawings were then passed along to the Viennese lithographer Albert Berger.

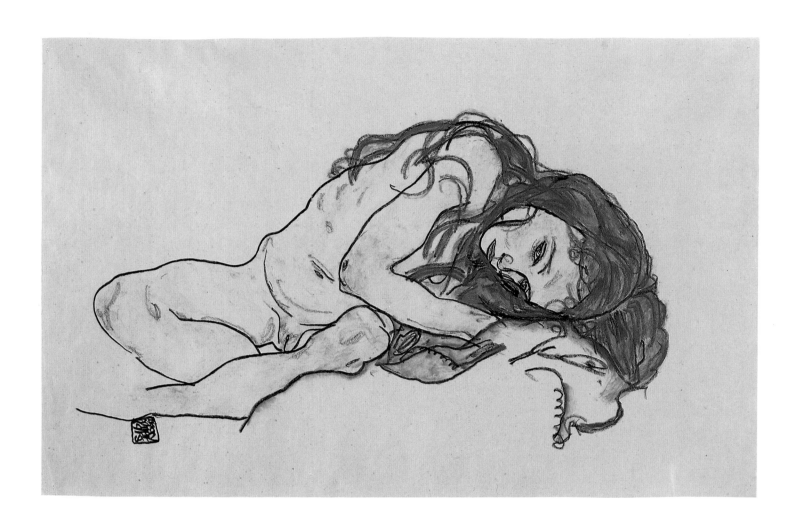

146 *Female Nude with Long Hair Propped up on Her Arm*
(Sich aufstützender weiblicher Akt mit langem Haar)
1918

Black crayon on paper,
11 1/4 x 18″ (28.6 x 45.6 cm)
Signed and dated lower right:
"EGON SCHIELE 1918"
Leopold Museum Inv. 2384

Provenance:
Rudolf Leopold, Vienna.

Literature:
Leopold 1972, pl. 217; K 2406.

Exhibitions:
London 1964; Tübingen 1995.

This voluptuous young woman was a perfect model for Schiele in his last period, when he clearly showed a fondness for lovely, curving contours. She also probably sat for the figures of *Two Crouching Women* (pl. 147). In a number of these curves one notes a certain mannerism–those describing the inside of the arm, for example, or the one tracing the body on the left, which was drawn in a single stroke from the top and repeats a portion of the outline of the breast. This is also true of the line that cuts into the right knee from below. It is difficult to see, but this is actually the contour line of the left calf. In this area the artist was less interested in describing the reality before him than in providing his composition with an ornamental termination. One frequently sees a certain detachment from the actual forms of his motif in Schiele's early works as well, but there he tended to transform them into more exciting ornamental shapes.

It is true that those earlier compositions, brilliant as they are, do not always display the degree of technical mastery that he demonstrates so fully in his last year. And it would be unfair to suggest that the greater movement and especially the heightened realism of his final works are somehow less than positive developments. In contrast to the above-mentioned curve of the calf on the left side of the present composition, the contour of the thigh and pelvis, drawn in a single stroke, is not only elegant, but it also perfectly describes the woman's form. The imposing realism in this rendering of a female nude is in no way lessened by the fact that Schiele shows us the left thigh only where it lies next to the right one and omits the left arm altogether.

The arrangement of the composition is extremely clear. Its center axis, virtually dividing it in two, is formed by the arm descending at an angle. The steplike sequence of the head, shoulder, and pelvis creates added interest.

Internal painting was hardly necessary here: the soft shading executed with the side of the crayon fully supplants it. One has the impression that light is playing over the naked skin. The shading in the face and the subtle drawing of its contours create an expression amazingly full of life.

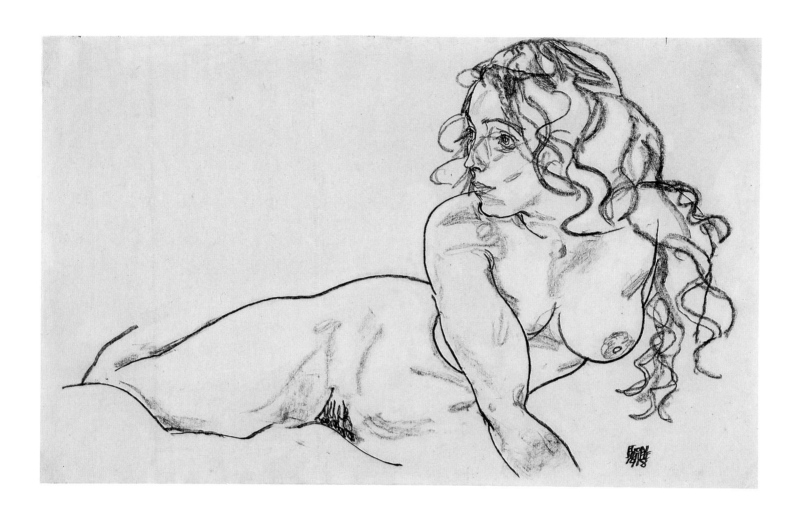

147 Two Crouching Women
(Hockendes Frauenpaar)
1918

Oil on canvas, 43 3/8 x 55 1/8"
(110 x 140.5 cm)
Not signed, not dated
Leopold Museum Inv. 464

Provenance:
Estate of Egon Schiele, Vienna;
Arthur Stemmer, Vienna, later
London; Österreichische Galerie,
Vienna; Rudolf Leopold, Vienna.

Literature:
Karpfen 1921; Malafarina 1982, no.
327; Nebehay 1989; L 296; K 327.

Exhibitions:
Vienna 1920; Vienna 1925; Berlin
1926; Frankfurt 1926; Vienna 1928;
Prague 1928; London 1964; New
York, Guggenheim Museum 1965;
Vienna, Österreichische Galerie
1968; Munich 1975; Zurich 1988;
Tokyo 1991; Tübingen 1995.

There is a drawing of a female nude in a similar pose, wearing olive-green laced shoes, from 1917 (K 2065), but there the woman's knees are raised higher and partially cover her breasts.

Schiele made several design sketches incorporating two crouching nudes side by side (Graphische Sammlung Albertina, Schiele Archive, sketchbook 7) before settling on this "well-balanced composition in which its inherent spirituality gives it a symbolic quality" (Kurt Rathe). The proportions of the crouching figures, the slight space that separates them, and the larger spaces between them and the four edges of the painting are precisely calculated. Their bodies and poses are very similar, and they have been placed symmetrically in the picture space, both gazing forward. Their faces are deliberately generic, apparently only representing types. All of these features contribute to the monumentality of the image.

Despite their great similarity, there are a number of subtle differences between the women's poses and expressions. The look in the eyes of the one on the left, the way her head is turned slightly to the side, and the way she holds her legs slightly closer together suggest a trace of shyness, one that seems confirmed by the bit of cloth covering her sex. The woman on the right, by contrast, gazes fixedly at the viewer, her legs spread farther apart, and her genitals fully exposed. Still, there is no hint of the erotic. She appears to be the quintessential female. It was only in the last year of his life that Schiele created nudes such as this.

The V-shaped openings created by the spread legs and accented by the inner contours of the thighs are harmoniously closed off by the configurations of the arms, shoulders, and heads. The overall outer contour of each figure, much like that of the crouching woman in *The Family* (L 289), takes the form of an oval. Here this is even clearer, since there is no child blocking off the lower end of it. Here, too, the lines of the shoulders describe steeper angles, as in the portraits of Robert Müller (L 295) and Paris von Gütersloh (L 294). The formation of these shoulders is prefigured in the drawing of a nude torso mentioned earlier. More important, however, and immediately apparent, is the treatment of the background, which is quite similar to that of the Gütersloh portrait. The area of the background closest to the woman on the left–like that next to the male portrait–has been darkened so as to lend her greater corporeality. This shading has not yet been added to the outline of the right-hand woman; except for her face, she is not as finished as her partner. (In the original,

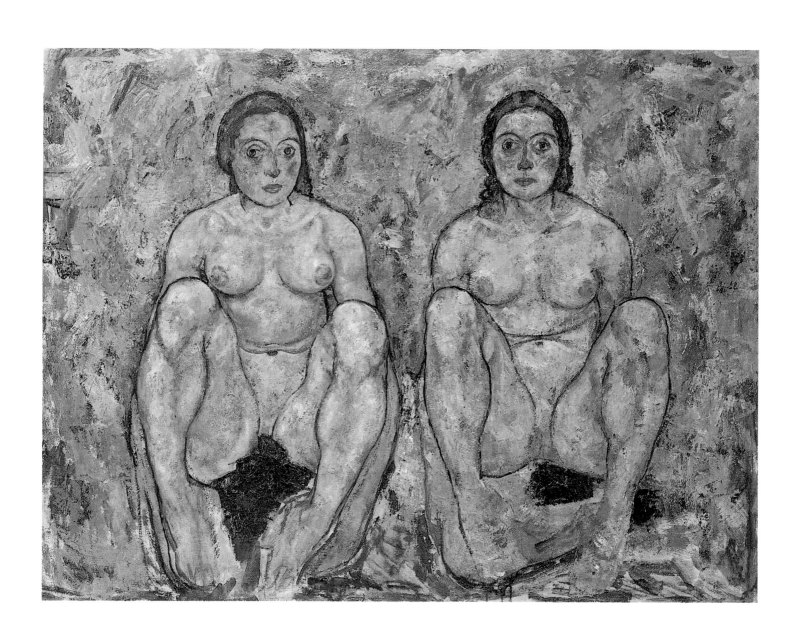

this head presents an extremely interesting and most unusual color harmony. The dark brown of the hair, the eyes, and the contour lines of the face form a dramatic contrast to the pale, greenish flesh tone, and this, in turn, to the various reds of the cheeks and the lips.) Even the outlines of this woman's body show that Schiele was not done with her. They are still somewhat hard, unrelated to the rest of the body, whereas in the figure on the left, completely finished except for the hands and feet, they have been softened in the final painting.

Both of these figures–more obviously the one on the left, as she is more finished–are extraordinarily three-dimensional, as is to be expected in Schiele's late style. He commented that in this work he meant to enhance the sculptural quality of the figures by contrasting them to the brightly colored background, and in this he was wholly successful.

148 *Crouching Woman with Spread Thighs*
 (Hockende Frau mit gespreizten Schenkeln)
 1918

Black crayon on paper,
18 1/8 x 12" (46 x 30.6 cm)
Signed and dated lower right:
"EGON SCHIELE 1918"
Leopold Museum Inv. 2341

Provenance:
Rudolf Leopold, Vienna.

Literature:
Leopold 1972, pl. 222; K 2417.

Exhibition:
Tübingen 1995.

This woman's gaze appears to devour us, and her revealing pose and unruly hair are all in character with it.

Her expression is as fascinating as the bravura drawing of her hair or the sure lines describing the rest of her body. Although there are again traces of mannerism, Schiele has varied his lines with great delicacy, from incisive hardness to broad smudges, from deepest black to a warmer gray.

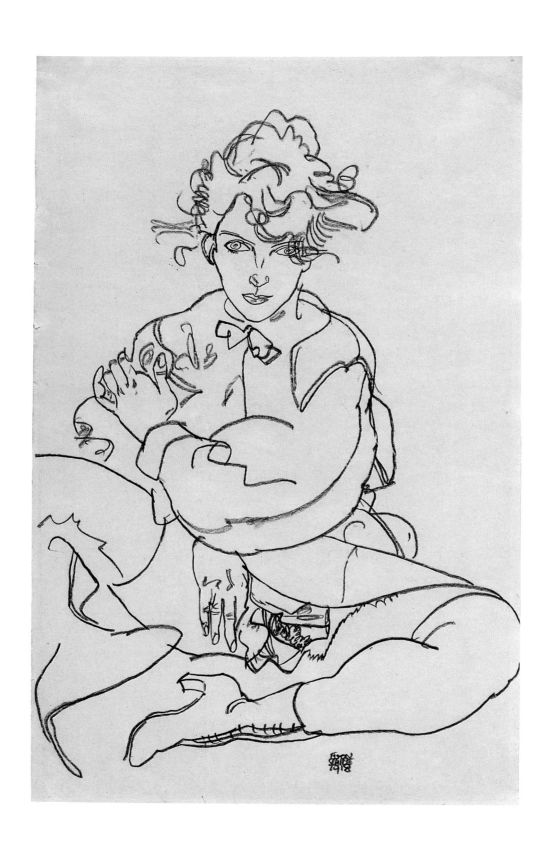

149　*Three Standing Women* (fragment)
　　　(Drei stehende Frauen [fragment])
　　　1918

Oil on canvas,
39 3/4 x 42 3/4″
(101 x 108.5 cm)
Not signed, not dated
Leopold Museum Inv. 463

Provenance:
Estate of Egon Schiele, Vienna;
Rudolf Leopold, Vienna.

Literature:
Malafarina 1982, no. 331; L 300;
K 330.

Exhibitions:
Vienna 1923; Vienna 1930;
Innsbruck 1963; London 1964;
Vienna, Österreichische Galerie
1968; Munich 1975; Rome 1984;
Charleroi 1987; Tübingen 1995;
Tokyo 1997.

Schiele made a number of sketches in preparation for this painting (Graphische Sammlung Albertina, Schiele Archive, sketchbooks 7 and 8). In some of them the grouping of female nudes stands alone, in others they are placed next to a male figure. In one of the latter (p. 26, verso, of sketchbook 7), the arrangement of the three women is very similar to what we see here, but in this painting Schiele decided to leave out the man.

The woman in the middle serves as the calm center of the composition, and to that end is presented in a frontal pose. The one on the right embraces her; the one on the left has turned her face to the side and protects herself with her raised arms and hands. (The painting of her fingers is unfinished, but their arrangement is highly intriguing.) The expressions of the three women, like their poses, are very different. The one on the left, turned to the side, seems resigned. As is only appropriate, given the center one's almost ceremonial pose, the outline of her face and its internal drawing are altogether harmonious, and she gazes calmly at the viewer with wide eyes. The woman on the right pressing against her seems much more relaxed, and her eyes are closed. The harsher brush drawing in her face–like that of some of the outlines of the three bodies and their arms–is a clear indication that the work is unfinished (see text for pl. 147). Even so, the painting of this face seems just as inspired as that of the completely finished one on the left. The somewhat darker tone of the latter, with occasional impasto highlights, is appropriate to her melancholy expression–just as the more vivid coloring of the face and body of the woman on the right accords with her more voluptuous figure. Schiele painted the face of the woman in the center in a wholly different way: here he incorporated the light ground color, as he did in the same figure's breasts or in the faces of the *Two Crouching Women* (pl. 147).

The painting of the bodies of these three women is astonishingly spontaneous and vivid. Note especially the back and rib cage of the one on the right and the area between the bent arms and neck of the one on the left–or, in the middle figure, the belly between the pubic hair and the navel, which was essentially finished and in which Schiele achieves a highly three-dimensional effect. Schiele sets off the hair of the right- and left-hand figures against the adjacent background, in the one case making it darker, in the other lighter. The hair of the woman on the right is painted in browns in contrast to the surrounding black; that of the one of the left a darker brown against a slightly lighter one mixed with green.

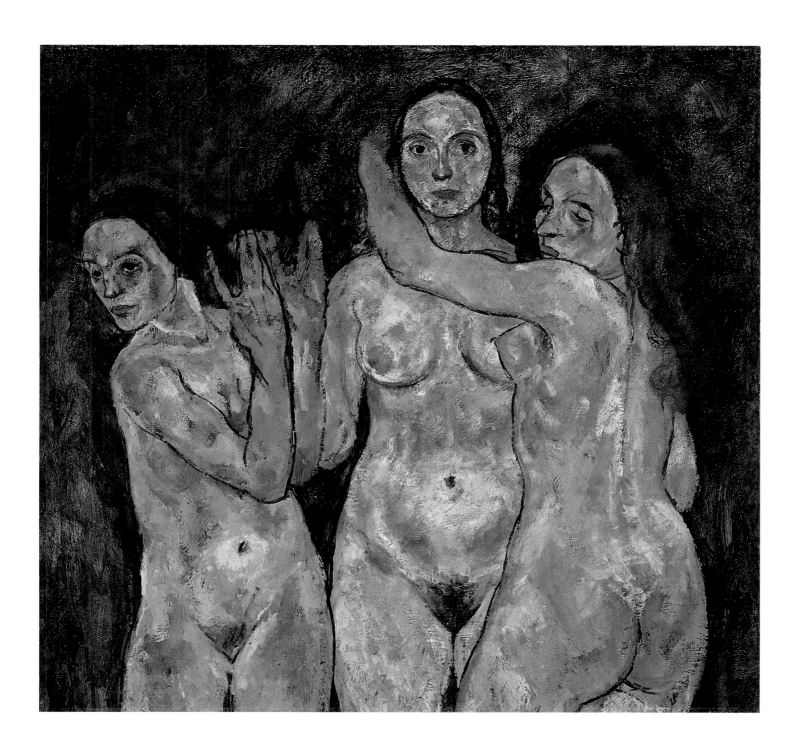

The dark background, contrasting to the considerably lighter figures, only superficially resembles that of many of the portraits and some of the cityscapes from 1916 to 1918. With its shadings of warmer and cooler tonalities, it is much more painterly than the backgrounds of most of Schiele's pictures from the previous few years.

The painting is unfinished, to be sure, and is only a fragment (see note 1 to L 300 in Leopold 1972), yet it is a superb example–like the *Lovers III*, also uncompleted owing to the painter's early death–of the new painting style characteristic of Schiele's work from the last year of his life.

150　*Reclining Girl with Bow in Her Hair
(Liegendes Mädchen mit Haarmasche)*
1918

Black crayon on paper,
11 1/4 x 16 1/2″ (28.5 x 41.9 cm)
Signed and dated lower right:
"EGON SCHIELE 1918"
Leopold Museum Inv. 1391

Provenance:
Rudolf Leopold, Vienna.

Literature:
Leopold 1972, pl. 224; K 2424.

Exhibitions:
Tokyo 1991; Tübingen 1995.

The foreshortening of this figure seen at an angle from above demonstrates Schiele's superior draftsmanship. The girl is lying down, her head resting on her hands and her thighs pointing to the left. Schiele captured this pose with only a very few lines, at the same time establishing a clear compositional framework. Inside the firmly drawn contours, open areas alternate with shading, some lighter, some heavier. The darkest areas are the bow in her hair, which was first shaded, then covered with close-set black lines, and the ornamental edging on the fabric below the left arm. These dark areas emphasize the diagonal axis of the composition, which would otherwise be less obvious, as the right elbow, like the left one, extends far to the side.

The gradations of gray in the internal spaces replace the earlier watercolor. It was no longer needed; the artist was now capable of exploiting the full potential of the single medium with great virtuosity.

151 *Girl Lying on Her Back with Crossed Arms and Legs*
 (Am Rücken liegendes Mädchen mit überkreuzten Armen und Beinen)
 1918

Black crayon on paper,
17 5/8 x 11 5/8" (44.6 x 29.5 cm)
Signed and dated lower right:
"EGON SCHIELE 1918"
Leopold Museum Inv. 2383

Provenance:
Rudolf Leopold, Vienna.

Literature:
Leopold 1972, pl. 227; K 2419.

Exhibition:
Tübingen 1995.

The body of this woman lying on her back looks like a roughly conical bundle of some kind placed at an angle on the page. Out of it loom the right arm and left forearm, from which the quickly sketched left hand extends horizontally to the right. Above them appear the crossed legs and feet in high heels. The limbs create a diagonal opposed to that of the main axis.

The gray-black lines of the wonderfully drawn loose hair have a tonality roughly halfway between the black of the outlines and the gray of the internal shading. All of these are evidence of the mastery Schiele achieved in such drawings in his last year.

152 *Edith Schiele on Her Deathbed
(Edith Schiele, sterbend)*
1918

Black crayon on paper,
17 3/8 x 11 5/8" (44 x 29.7 cm)
Signed and dated lower left:
"EGON SCHIELE gez. 27.X. abds.
[drawn in the evening of October
27] 28. Oktober 1918"
Leopold Museum Inv. 2382

Provenance:
Wolfgang Gurlitt, Munich;
Galleria Galatea, Turin;
Rudolf Leopold, Vienna.

Literature:
Reisner 1960; Leopold 1972,
pl. 228; Mitsch 1974; Malafarina
1982, no. D112; K 2233.

Exhibitions:
Zurich 1949; Salzburg 1950;
Munich 1957; Baden-Baden 1958;
Heidelberg 1962; Vienna, Albertina
1968; Munich 1975; Tübingen
1995.

Schiele made two drawings of his wife on the evening of October 27, 1918 (see illustration below). She died at about 8 o'clock the following morning. The approach of death is much more apparent in the drawing reproduced in plate 152 than in the one shown on this page.

Just as he had in the case of the dead Klimt, Schiele more than likely drew this likeness in horizontal format (somewhat at an angle on the page), but then turned it into a vertical one with the placement of his signature and the inscription. He had begun doing this very early in his career (see pl. 23). The beginnings and endings of some of the lines make it clear that his wife was lying down, and he was seated next to her bed. So does the style of the drawing. Note, for example, the curls in her hair (she is lying on an invisible pillow), the bridge of her nose, and the inner margins of the lower lip. All of these fall into their proper position as part of an organic whole only when one turns the sheet to the side. The drawing then becomes much more expressive. One now sees how the mouth is slightly open, the lips dry with fever. The eyes take on their proper perspective, the right one clearly closer to the viewer than the left.

Schiele's rendering of these eyes is profoundly moving. One senses the exhaustion of this woman who, deathly ill, gazes somewhat fearfully at her husband. In this, his last drawing, Schiele produced an unforgettable document.

Edith Schiele. 1918. Black crayon on paper

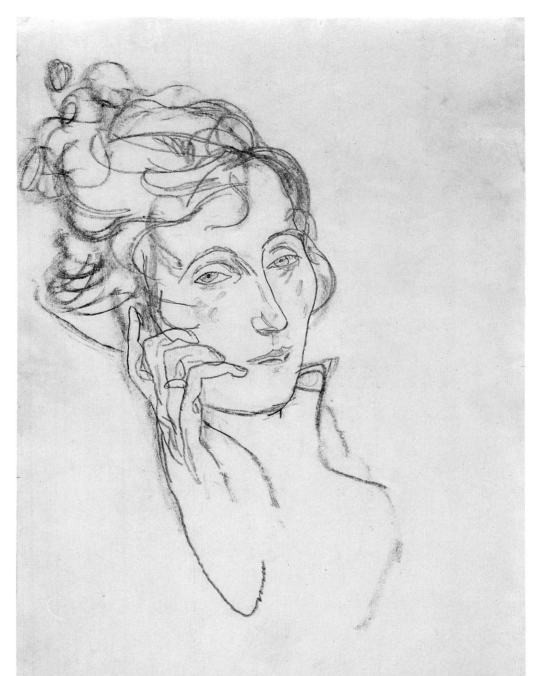

Biography

Like those of so many of Vienna's creative giants, Schiele's forebears were not proper Austrians, but had found their way to the capital from the farther reaches of the Habsburg empire and even from abroad, so that he was a mix of nationalities. His father (1850–1905), though born in Vienna, was of North German ancestry. He came from a line of respectable and solidly bourgeois pastors, military officers, and government officials of whom Schiele was rightly proud. In a sketch for an autobiography, he once wrote: "Old German blood flows in me, and I often feel within me the presence of my ancestors. A great-grandson of Friedrich Karl Schiele, the privy councillor … I was born to a Viennese father and a mother from Krumau." The son of the privy councillor, Schiele's grandfather Karl Ludwig Wilhelm (Ballenstedt), was by profession an architect, and in 1844 became the engineer of the Kaiser Ferdinand North Railway in Moravia. He then went on to build the Bohemian West Railway and served as its first inspector general, by which time he was a definite subject of the Austro-Hungarian monarchy. Schiele's mother (1862–1935) was born Marie Soucup (Soukop) in Krumau, in Bohemia. Her people had been farmers, craftsmen, and tradesmen in southern Bohemia, some of them Czech. In contrast to the family tree on Schiele's father's side, hers represented a whole spectrum of society.

Melanie Schiele, ▷
seated, with her
sister Gerti and
her brother Egon

Egon Schiele as
a child, c. 1892/93

1890
Egon Schiele, the third child of Adolf Eugen Schiele, a superintendant of the imperial railway, and Marie Schiele, is born on June 12 in the Lower Austrian town of Tulln. He is baptized Egon Leo Adolf. There are two older sisters: Elvira, born in 1883, who dies at the age of ten, and Melanie, born in 1886. A final child, Gertrude, is born in 1894. This sister will often pose for Schiele early in his career, even nude. She later marries the painter Anton Peschka.

1890–1905

Schiele's father, having previously served as a railway official in Lannsdorf, in Carinthia, functions as overseer of the train station in Tulln. The family lives in the manager's apartment in the station. By the time Schiele enters primary school, he is already producing drawings, mainly of Tulln's train station and the trains either passing through or standing on the siding.

Train station at Tulln on the Danube

At ten Schiele begins secondary school in Krems. His performance is poor, however, and in 1902 his father transfers him to the larger provincial *Gymnasium* in Klosterneuburg. There his teachers soon complain that Schiele is disrupting their classes with his drawing. A letter Schiele writes to his friend Max Karpfen confirms his early interest in art, reporting that he is busy producing "works" for their planned "Union Exhibition," a collaborative effort.

Since his father's health has declined to the point that he can no longer keep his job, the family moves to Klosterneuburg as well. Adolf Schiele dies on New Year's Eve, 1905, most likely from some kind of progressive paralysis. (He is thus not actually insane, as scholars would have us believe.) The fourteen-year-old Schiele's sense of loss is described in a letter written many years later to Anton Peschka

1906

Schiele's uncle and godfather, the engineer Leopold Czihaczek-his father's sister's husband-is named his guardian. It had been his father's wish that Schiele attend the local polytechnic school, and Leopold Czihaczek concurs. Schiele's progress is poor, however-it appears that he will again have to repeat a grade-and his mother therefore appeals to one of her sisters, Olga Angerer, whose husband owns a chemigraphic plant, hoping that Schiele might be given work there as a draftsman. The sister's reply, dated June 9, dashes any such hope: "It strikes my husband as a serious fault that a boy should cause his mother such worry … I would have no sympathy for such a rascal. A boy must study and behave … Only *dependable* people manage to make something of themselves."

There is thought of sending Schiele to the School of Applied Arts in Vienna. Czihaczek opposes the idea. However, two of Schiele's instructors, drawing teacher Ludwig Karl Strauch and the Augustinian choirmaster Dr. Wolfgang Pauker, and the Klosterneuburg painter Max Kahrer recommend that the boy be given artistic training. The drawings Schiele submits to the School of Applied Arts are so impressive that he is advised to think of the Academy of Fine Arts instead. His guardian relents after Schiele passes the entrance examination. On October 13 he joyously telegraphs his wife: "Egon passed splendidly."

Egon Schiele's identification booklet at the Vienna Academy of Fine Arts, 1908

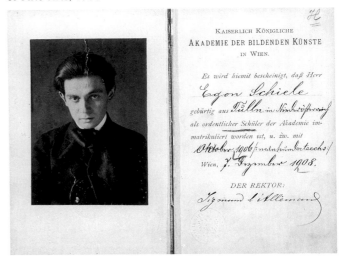

1907

Schiele brings great enthusiasm to the new challenge, but in no time his relations with his teachers turn sour. They are hopelessly reactionary, still deeply mired in the "Ringstrasse style." The young artist tries to befriend Gustav Klimt. With his younger sister, Gertrude, he goes on holiday to Trieste, where he produces a number of drawings of the harbor quarter. On his return, he moves into his first studio at 6, Kurzbauergasse in Vienna's second district.

1908

Schiele takes part in his first exhibition, a show in the Kaisersaal of the Augustinian monastery in Klosterneuburg that runs from May 16 to the end of June. He is represented by ten works.

1909

The exhibition committee for the *Internationale Kunstschau 1909*, headed by Gustav Klimt, selects four works by the young Schiele for inclusion. On this occasion Schiele gets to know the architect Josef Hoffmann as well, and through him becomes affiliated with the Wiener Werkstätte. His teachers at the Academy, however, give him poor marks in all his subjects. He has an especially violent falling out with a Professor Griepenkerl. Finally, Schiele–now in his third year–withdraws from the Academy. With a number of like-minded artists he establishes the New Art Group. Among its members are Anton Faistauer, Rudolf Kalvach, Franz Wiegele, and Hans Ehrlich, also the composer Arthur Löwenstein and the painter of theater sets Erwin Dominik Osen, who is a major influence on Schiele for a time. Hans Böhler and Albert Paris von Gütersloh eventually join the group as well. Schiele serves as both president and secretary. The New Art Group holds its first exhibition in December, at the Salon Pisko in Vienna. Schiele provides a manifesto for the show, which he publishes with various changes in 1914 in the journal *Die Aktion* ("Die Kunst–Der Neukünstler," *Die Aktion* 4, no. 20), and at his behest Faistauer designs a poster–a weak Schiele imitation. During this exhibition Schiele becomes acquainted with a number of Vienna's cultural elite, the collectors Carl Reininghaus and Dr. Oskar Reichel, the publisher Eduard Kosmack, and the art critic for the *Arbeiterzeitung*, Arthur Roessler.

1910

The Wiener Werkstätte publishes three Schiele fashion designs as postcards. Its director, Josef Hoffmann, also arranges for Schiele's participation in the *Internationale Jagd-Ausstellung*, presented from May to September. There Schiele shows a life-size seated female nude, now unfortunately lost, the preliminary study for which–presently in the Historisches Museum der Stadt Wien–is bought from the artist himself by the architect Otto Wagner. At the show's opening, Emperor Franz Josef–well known for his pedestrian artistic tastes–expresses his displeasure with the painting.

On May 12 Schiele travels with his friend Erwin Dominik Osen to Krumau, where he stays until June 1. On June 6, his uncle, offended by Schiele's request for 40 kronen, resigns his guardianship, which he has exercised for five years.

Back in Vienna, Schiele lives in a studio at 39, Alserbachstrasse in the ninth district, until October, then moves to 31, Grünbergstrasse in the twelfth.

According to Roessler, Otto Wagner advises Schiele to paint life-size portraits of noted Viennese personalities, volunteering to pose for one himself. After only a few sittings, however, he runs out of patience, so only the head is finished. The most important of the six large portraits Schiele does complete are those of Roessler, the painter Zakovsek, and the publisher Kosmack.

Schiele once more exhibits in the monastery at Klosterneuburg in the fall. Heinrich Benesch, a high railway official, is so taken by a painting of a sunflower (L 139) that he determines to make the young artist's acquaintance. He will become the most aggressive collector of Schiele's drawings and watercolors, and his purchases will ultimately form a major part of the Schiele collection in the Albertina.

1911

In the previous year–at the age of twenty–Schiele had achieved his independence as an artist, but not public recognition. Now this begins to come to him as well. Paris von Gütersloh's text *Egon Schiele: Versuch einer Vorrede* appears, and Arthur Roessler publishes an article on him, with illustrations, in the monthly *Bildende Künstler*. Vienna's Galerie Miethke also mounts a first major showing of his work, from April to May. In this same year, however, the Wiener Werkstätte rejects five lovely designs for postcards.

Schiele's studio and apartment in the so-called garden house in Krumau

Schiele had already announced his intention to leave Vienna in 1910, in a letter (now in a private collection, Vienna) to his future brother-in-law Anton Peschka: "I'd like to get out of Vienna soon. It's so ugly here. Everyone's jealous of me and devious; my onetime fellow students raise their eyebrows at me. It's gloomy in Vienna, the city is black, everything has to be done by the rules. I want to be alone. I'd like to move to Bohemia."

In early spring he does just that, settling in his mother's home town of Krumau. He has met the model Wally Neuzil a short time before and begun a relationship with her. He takes her along.

In Krumau Schiele is extremely productive, creating among other things a number of imaginary, visionary cityscapes. He is soon forced to leave, however, as Krumau's small-town proprieties are offended at his having young local girls pose for him in the nude and at his keeping Wally as

his "concubine." After a brief stopover at his mother's in Vienna, he settles in Neulengbach, a small town just outside the city.

Through Roessler, Schiele meets the Munich art dealer Hans Goltz, Ulrich Putze's successor, in September. In November he becomes a member of the Munich Sema group, an artists' association to which Kubin and Klee also belong.

1912

The New Art Group exhibits in the Künstlerhaus in Budapest at the beginning of the year. From February 15 to March 15, Hans Goltz shows paintings and drawings by Schiele along with works of *Der Blaue Reiter* in Munich. He then forwards Schiele's pieces, along with graphics by the now completely forgotten Frenchman Emile Zoire, to the Museum Folkwang, where Karl Ernst Osthaus presents an imposing exhibition in April and May. Schiele had also been represented in the exhibition by Munich's Secession in March and April. A lithographed nude self-portrait of Schiele's is published in the Sema portfolio.

Schiele's studio and dwelling at 48, Au in Neulengbach

This delightful upswing in the artist's career is brought to a sudden halt when, on April 13, Schiele is arrested in Neulengbach, accused of having seduced a minor. He is held pending an appearance before the district court in Sankt

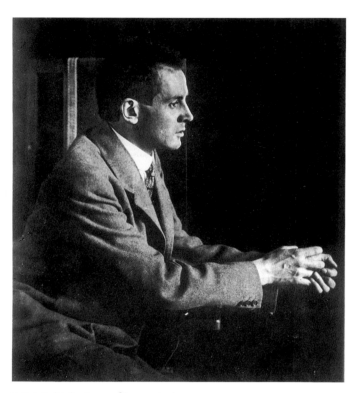

Egon Schiele, in profile, seated

(In 1922, four years after Schiele's death, Arthur Roessler will publish what he claims are Schiele's "notes" from prison—a forgery, for they were written by Roessler himself.)

In part so as to take his mind off his troubles, Schiele travels to Klagenfurt and Trieste, then to Lindau and finally Bregenz, where he stays for some time. He stops over in Munich for only two days. He then rents for a short time what he claims is the cheapest studio in Vienna, the one belonging to his fellow-painter Osen, who is spending the summer in Krumau.

The important *Internationale Kunstausstellung des Sonderbundes* takes place in Cologne from May 25 to September 30. Three works by Schiele are included. He also participates in an exhibition at the Arnold Gallery in Dresden. In July Schiele is well represented in an exhibition of the Hagenbund, with seven paintings, including his *Hermits* (L 203). Through this exhibition Schiele becomes acquainted with a new collector, the hotelier Franz Hauer.

District courthouse and jail in Neulengbach

Pölten, where he is transferred on April 30. In early May the court acquits him of the main charge against him, but finds him guilty of "distributing obscene drawings," inasmuch as minors had been exposed to studies of nudes in his studio. Schiele is sentenced to three additional days in jail, so that he is held a total of twenty-four days, including pre-trial detention.

The entire episode is shattering to Schiele. His stay in Neulengbach, one of his most productive periods, is thus brought to a close. On May 18 he writes to Arthur Roessler, who had not been in Vienna at the time of his arrest: "I am still completely shaken. During the trial a drawing of mine, the one I had hanging on the wall here, was burned. Klimt is hoping to do something. He assured me that the same thing could happen to one of us one day, another the next, that we're none of us free to do as we will."

In November he finds a suitable studio, at 101, Hietzinger Hauptstrasse in Vienna's thirteenth district, that he will then continue to use until his death.

Since Schiele is one of the very few Austrian artists to genuinely admire him, Gustav Klimt introduces him to one of his wealthiest collectors, the industrialist August Lederer. Lederer invites Schiele to visit him in Gyor (Raab), where he spends Christmas and New Year's. Lederer's son Erich, whom he paints (L 223), becomes his pupil.

1913

On January 17 the League of Austrian Artists votes to name Schiele a member. Schiele exhibits four paintings and twenty drawings with that group in Budapest in March. As in the previous year, he is represented in the *Frühjahrsausstellung*

Schiele's last studio at 101, Hietzinger Hauptstrasse in Vienna's thirteenth district

Egon Schiele with fingers interlocked, 1914
Photo by Anton Josef Trčka

of the Munich Secession. The Galerie Goltz in Munich presents a major Schiele retrospective from June 26 to July 15. Paintings of his are also shown this year in Berlin and in Düsseldorf's *Grosse deutsche Kunstausstellung*. In Vienna, Schiele takes part in the *Internationalen Schwarzweissausstellung* and the *XLIII Ausstellung der Wiener Sezession*.

Schiele also travels a great deal, often up into the Wachau, where he produces paintings of the town of Stein (L 232, 233, and L 239, 240), and also to Krumau, Villach, and Tarvis. He spends the first part of the summer with Roessler on the Traun See and the later part with his mother and Wally on the Ossiach See, in Carinthia.

Schiele becomes a contributor to the Berlin journal *Die Aktion*, a "weekly on politics, literature, and art" published by Franz Pfemfert, in which he publishes both drawings and prose poems.

1914

Schiele takes part for the first time in exhibitions in non-German-speaking countries, first in Rome–at the *Internationale Sezession*–then in Brussels and Paris. In Germany works of his are shown at two galleries in Dresden, in the Hamburg Kunstverein, in the Munich Secession, and in the Cologne *Werkbund-Ausstellung*.

In the spring, Schiele has Robert Philippi teach him how to make woodcuts and engravings, and by the summer he has produced six of the latter. Experimenting with the photographer Anton Josef Trčka, he produces some highly unusual portraits of himself (see frontispiece). In Heinrich Böhler, a cousin of the painter Hans Böhler, the artist acquires not only a wealthy new collector but also a pupil.

The house just across from Schiele's studio belongs at this time to the machinist Johann Harms, who lives there with his wife and his daughters Adele and Edith. It is possible that Schiele may have tried to introduce himself to the family in January, but he only gets to know the two sisters toward the end of the year. His letters to them, most of which are preserved in the Schiele Archive at the Albertina, frequently begin with wordplay on their names: "Liebes Fräulein Ed. [Edith] & Ad. [Adele]," or "Ad. & Ed.," or even "Liebes Fräulein EDADEDAD."

At first the outbreak of war in July has little effect on his creative work, for on two occasions he is found to be unfit for military service and is allowed to continue his career.

1915

An impressive Schiele retrospective is presented at the Viennese gallery Guido Arnot in January.

On May 31 Schiele is again required to report to his draft board, and this time he is declared fit for active service.

In the meantime, he has determined to wed Edith Harms. On June 17, four days before he is to report for duty in Prague, they are married, and she follows him to Prague a short time later. A month later Schiele is transferred to Vienna, where he can fulfill his military duties in the city and its immediate environs.

In December the Berlin Secession invites Schiele to participate in the *Wiener Kunstschau* with three large paintings and a number of drawings. Among the former is his *Levitation* (L 265), which, according to a letter of Schiele's (now in a private collection, Vienna), is hung in the foyer opposite Klimt's *Death and Life* (Dobai 183).

1916

Die Aktion publishes a special Egon Schiele issue (vol. 6, nos. 35–36) containing, in addition to a number of reproductions of his drawings, the woodcut *Male Bathers* and his poem "Abendland." Issue number 39–40 includes his woodcut *Male Head* as well.

Edith Schiele in a striped dress, with her husband and her nephew Paul Erdmann, 1915/16

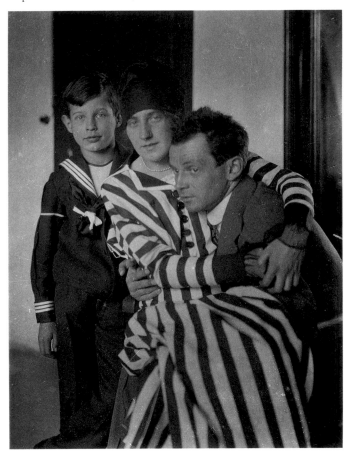

Schiele keeps a war diary from March 8 to September 30 (now in the Schiele Archive in the Albertina). In his free time he is permitted to work in his Hietzing studio. At the beginning of May he is assigned to a camp for captured Russian officers at Mühling. His wife joins him two days after he reports to his new posting. His hours of office work leave him little time for his art. He produces drawings of prisoners of war, as he had already done in Vienna, and also portraits of his superiors. He manages to finish only a single larger painting, *The Decaying Mill* (L 271).

1917

In January Schiele is permitted to return to Vienna, where he is detailed to the Imperial and Royal Military Supply Depot

Egon Schiele with military comrades; the one on the right is portrayed in Schiele's *One-Year-Volunteer Private* (pl. 137)

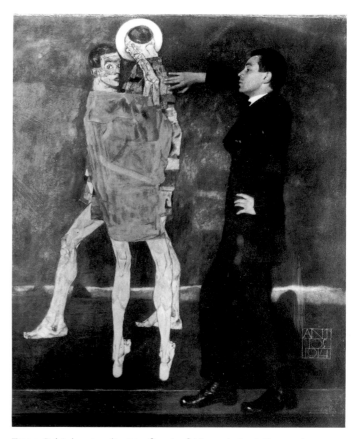

Egon Schiele standing in front of his painting *Encounter* (L 243)

for army employees in the field, under the command of First Lieutenant Hans Rosé. Rosé commissions Schiele to make drawings of the depot's quarters in Vienna as well as of those of its twenty-eight branches throughout the country (see pls. 139 and 140).

Schiele is asked, together with Paris von Gütersloh, to organize the *Kriegsausstellung 1917* in the Prater. On May 30 Schiele informs his brother-in-law Anton Peschka that he has been given the job of making selections for the Bund Österreichischer Künstler, the League of Austrian Artists, and describes the trouble he is having including pictures by Gütersloh, Faistauer, Kolig, Jungnickel, and others, since none of them are war painters and yet everything is supposed to have at least some connection to the war. As for his own work, he changes the title of his picture *Resurrection* (L 236) to *Resurrection from the Heroes' Graves*.

Edith Schiele with her dog in her husband's studio, between the paintings *Reclining Woman* (L 278) and *Girl* (L 277)

In the fall Schiele is granted his long-standing wish and is transferred to the Imperial Army Museum. There he is able to fulfill his military obligations and still have considerably more time for his art.

Exhibiting Austrian art outside the country is technically impossible, owing to the war, but, in fact, Schiele is invited to take part in exhibitions in Amsterdam, Stockholm, and Copenhagen in this year and the following one.

1918

Gustav Klimt dies on February 6. The next day Schiele makes three drawings of him in the Allgemeines Krankenhaus (see pl. 144). He publishes a memorial tribute to Klimt in *Der Anbruch*. The first two numbers of this series of "broadsheets from our time" had contained reproductions of Schiele drawings.

The Viennese Secession places its building at the disposal of Schiele and his group in March, reserving its main gallery for Schiele himself. He contributes nineteen large paintings and twenty-nine drawings to the exhibition, some of them with added watercolor. Artistically and financially, this is his first triumph.

In the exhibition *Ein Jahrhundert Wiener Malerei*, presented in the Kunsthaus in Zurich only a short time later, Schiele is represented by four paintings and numerous drawings.

The Art Union of Bohemia and Prague exhibits two hundred graphic works by Schiele and his New Art Group in the Künstlerhaus Rudolphinum in Prague, and the same show is then presented in Dresden at the Arnold Gallery.

Richard Harlfinger, the president of the Vienna Secession, asks Schiele if he would like to take part in the portrait exhibition scheduled for the fall.

On July 5 Schiele moves into a new studio at 6, Wattmanngasse in Hietzing, although he also keeps his former one on Hietzinger Hauptstrasse.

In July and August Schiele negotiates for suitable exhibition space for his New Art Group, which maintains an office at the gallery belonging to Gustav Nebehay in Vienna's first district. On August 21 Carl Moll invites Schiele, at Nebehay's behest, to put together a small collection of his works for an exhibition at the Nassauisches Kunstverein in Wiesbaden.

However, this was not to be. On September 30 Schiele writes to both Albrecht Harte and Broncia Koller that much as he likes his new studio, it is becoming increasingly unpleasant because of its dampness, and he hopes it will not be bad for his health.

From one of Schiele's letters we learn that his wife, then six months pregnant, comes down with Spanish influenza on October 19. She dies nine days later, on October 28, at eight o'clock in the morning. The previous evening Schiele has

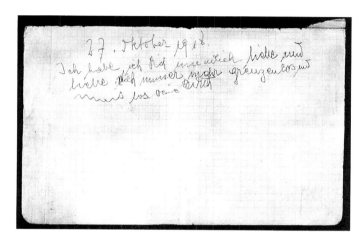

A last assurance of her love penned by Edith Schiele at her husband's request

made two drawings of her (see p. 342 and pl. 152). These are his last works. He too has the flu, and at one o'clock in the morning on October 31 he succumbs at the age of twenty-eight.

Martha Fein photographs him on his deathbed and Anton Sandig takes a death mask. Schiele is buried on November 3 in the cemetery at Ober-Sankt-Veit.

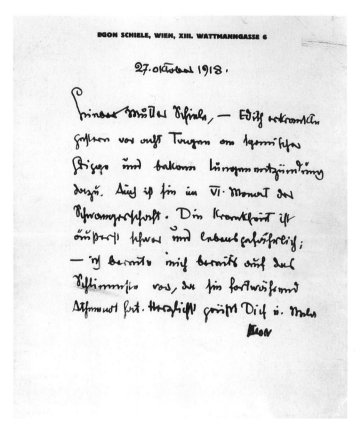

Letter from Schiele to his mother, dated October 27, 1918, the day before his wife's death

Egon Schiele on his deathbed, October 31, 1918

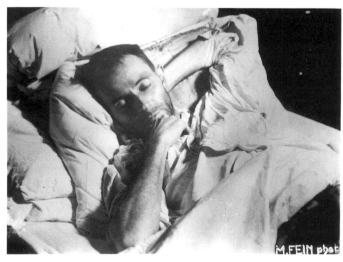

Bibliography

Akademische Druck-
und Verlagsanstalt
1985, 1986

Akademische Druck- und Verlagsan-
stalt. *Egon Schiele: Blätter aus
Privatbesitz.* Graz, 1985 (pt. 1) and
1986 (pt. 2).

H. Benesch 1965

Heinrich Benesch. *Mein Weg mit
Egon Schiele.* New York, 1965.

O. Benesch 1951

Otto Benesch. *Egon Schiele als
Zeichner.* Portfolio. Vienna: Druck
und Verlag der Österreichischen
Staatsdruckerei, 1951.

O. Benesch 1958 (1)

Otto Benesch. "Egon Schiele." *Art
International* 2, nos. 9–10 (December
1958): 37–38, 75–76.

O. Benesch 1958 (2)

Otto Benesch. "Egon Schiele und die
Graphik des Expressionismus." In
*Continuum: Zur Kunst Österreichs in
der Mitte des 20. Jahrhunderts.*
Vienna, 1958.

O. Benesch 1964

Otto Benesch. "Egon Schiele 2: The
Artist." *Studio International* 168, no.
858 (October 1964): 171–75.

Berger 1988

John Berger. *Glanz und Elend des
Malers Picasso.* Hamburg, 1988.

Borowitz 1974

Helene O. Borowitz. "Youth as Meta-
phor and Image in Wedekind,
Kokoschka, and Schiele."*Art Journal*
33, no. 3 (1974): 219–25.

Braun 1912

Felix Braun. "Wiener Frühjahrsaus-
stellung." In *Kunst für Alle.* Vienna,
1912.

Breicha and
Fritsch 1964

Otto Breicha and Gerhard Fritsch.
*Finale und Auftakt: Wien 1898–1914:
Literatur, Bildende Kunst, Musik.*
Salzburg, 1964.

Clair 1986

Jean Clair, ed. *Vienne, 1880–1938:
L'apocalypse joyeuse.* Paris, 1986.

Comini 1973

Alessandra Comini. *Schiele in Prison.*
Greenwich, Conn., 1973.

Comini 1974

Alessandra Comini. *Egon Schiele's
Portraits.* Berkeley, 1974.

Comini 1976

Alessandra Comini. *Egon Schiele.*
New York, 1976.

Comini 1978

Alessandra Comini. *The Fantastic Art
of Vienna.* New York, 1978.

Dichand 1986

Hans Dichand. *Die Künstler der klas-
sischen Moderne in Österreich.* Graz,
1986.

Dobai 1968/69

Johannes Dobai. "Egon Schieles
*Jüngling vor Gottvater kniend." Jahr-
buch des Schweizerischen Instituts
für Kunstwissenschaft* (1968/69):
53–68.

Dube 1983

Wolf-Dieter Dube. *Expressionists
and Expressionism.* Geneva,
1983.

Dufour 1993

Philippe Dufour. *Egon Schiele,
Oeuvres sur papier.* Monaco, 1993.

Eschenburg 1995

Barbara Eschenburg. *Der Kampf der
Geschlechter,* ed. Helmut Friedel.
Cologne and Munich, 1995.

Fischel 1918

Hartwig Fischel. "Egon Schiele."
Kunst und Kunsthandwerk (Vienna)
21 (1918): 152–53.

Fischer 1994

Wolfgang G. Fischer. *Egon Schiele
1890–1918: Pantomimen der Lust,
Visionen der Sterblichkeit.* Cologne,
1994.

Fournier 1992

Jean-François Fournier. *Egon Schiele,
La décadence de Vienne, 1890–1918.*
Editions Jean-Claude Lattès, 1992.

Friesenbiller 1985

Elfriede Friesenbiller, ed. *Egon
Schiele, "Ich ewiges Kind": Gedichte.*
Munich and Vienna, 1985.

Fuchs 1991

Rainer Fuchs. *Apologie und Diffamie-
rung des Österreichischen Expressio-
nismus.* Vienna and Cologne, 1991.

Gordon 1987

Donald E. Gordon. *Expressionism:
Art and Idea.* New Haven, 1987.

Gradisch and
Nebehay 1979

Norbert Gradisch and Christian M.
Nebehay. *Zur Erinnerung an Melanie
Schuster-Schiele.* Vienna, 1979.

Grimschitz 1960

Bruno G. Grimschitz. *Ars Austriae.*
Vienna, 1960.

Gütersloh 1911

Paris von Gütersloh. *Egon Schiele:
Versuch einer Vorrede.* Vienna, 1911;
reprinted in A. Roessler, ed., *In
Memoriam Egon Schiele,* Vienna,
1921, 24–29.

Hertlein 1967 — Edgar Hertlein. "Frühe Zeichnungen von Egon Schiele." *Alte und moderne Kunst* (Vienna) 12, no. 95 (1967): 32–41.

Hobhouse 1988 — Janet Hobhouse. *The Bride Stripped Bare.* London, 1988.

Hofmann 1968 — Werner Hofmann. *Egon Schiele: "Die Familie."* Stuttgart, 1968.

Hofmann 1987 — Werner Hofmann. "Egon Schiele: Alles ist lebend tot." *Art, Das Kunstmagazin* 10 (October 1987): 28–50.

Johnston 1980 — William M. Johnston. *Vienna, Vienna.* New York, 1980.

J. Kallir 1980 — Jane Kallir. *Austria's Expressionism.* New York, 1980.

J. Kallir 1990 (also K) — Jane Kallir. *Egon Schiele: The Complete Works.* New York, 1990.

J. Kallir 1994 — Jane Kallir. *Egon Schiele.* Exhibition catalogue. New York, 1994.

O. Kallir 1930 — Otto Kallir (Nirenstein). *Egon Schiele: Oeuvre Catalogue of the Paintings.* New York and Vienna, 1930; 2nd ed., 1966.

O. Kallir 1970 — Otto Kallir (Nirenstein). *Egon Schiele: The Graphic Work.* New York and Vienna, 1970.

Karpfen 1921 — Fritz Karpfen, ed. *Das Egon Schiele Buch.* Vienna, 1921.

Karpfen 1923 — Fritz Karpfen. *Österreichische Kunst.* Vienna, 1923.

Knafo 1993 — Danielle Knafo. *Egon Schiele: A Self in Creation.* Cranbury, N J., 1993.

Köller 1965 — Ernst Köller. *Moderne Kunst in Österreich.* Vienna, 1965

Koschatzky 1968 — Walter Koschatzky, ed. *Egon Schiele: Aquarelle und Zeichnungen.* Salzburg, 1968.

Kuchling 1982 — Heimo Kuchling *Egon Schiele und sein Kreis.* Ramerding, 1982.

Künstler 1946 — Gustav Künstler. *Egon Schiele als Graphiker.* Vienna, 1946

Lampert 1975 — Wolfgang Lampert. "Egon Schieles Wiener Zeit: Seine Ateliers und seine Begegnungen." *Alte und moderne Kunst* (Vienna) 20, no. 140 (1975): 33–35.

Leopold 1959 — Rudolf Leopold. "Egon Schiele: Ein Genie aus Österreich." *BP Querschnitt* 1 (spring 1959): 19–20.

Leopold 1972 (also L) — Rudolf Leopold. *Egon Schiele: Gemälde, Aquarelle, Zeichnungen.* Salzburg, 1972.

Leopold 1985 — Rudolf Leopold. "Egon Schiele und Biographie." In *Traum und Wirklichkeit: Wien 1870–1930,* edited by Robert Waissenberger, 79–99. Exhibition catalogue. Vienna, 1985.

Malafarina 1982 — Gianfranco Malafarina. *L'Opera di Egon Schiele.* Milan, 1982.

Marchetti 1984 — Maria Marchetti, ed. *Le Arti a Vienna.* Venice and Milan, 1984.

Marinovic 1993 — Alexander Marinovic. "Zum 75. Todestag des Wiener Expressionisten Egon Schiele: Radikal, visionär, illusionslos." *Kunst und Antiquitäten* (Munich) 10 (1993): 6–7.

Markowitz 1921 — Alfred Markowitz. "An der Wende zweier Weltanschauungen–Zur neuesten Egon Schiele Literatur." *Arbeiterzeitung* (Vienna) (June 30, 1921): 5–6.

Mitsch 1961 — Erwin Mitsch. *Egon Schiele: Zeichnungen und Aquarelle.* Salzburg, 1961.

Mitsch 1974 — Erwin Mitsch. *Egon Schiele, 1890–1918.* Salzburg, 1974.

Mizue 1969 — "Egon Schiele." *Mizue,* no. 776 (September 1969): 1–35.

Mizue 1977 — "Egon Schiele." *Mizue,* no. 870 (September 1977): 6–51.

Nebehay 1977 — Christian M. Nebehay, ed. *Egon Schiele (1890–1918): Die Gedichte.* Vienna, 1977.

Nebehay 1979 — Christian M. Nebehay. *Egon Schiele, 1890–1918: Leben, Briefe, Gedichte.* Salzburg and Vienna, 1979.

Nebehay 1980 — Christian M. Nebehay. *Egon Schiele: Leben und Werk.* Salzburg, 1980.

Nebehay 1989 — Christian M. Nebehay. *Egon Schiele: Von der Skizze zum Bild.* Munich and Vienna, 1989.

Oberhuber 1984 Oswald Oberhuber. *Abbild und Emotion: Österreichischer Realismus 1914–1944*. Vienna, 1984.

Patka 1986 Erika Patka, ed. *Oskar Kokoschka*. Vienna, 1986.

Plank 1991 Hans Plank. *Klimt, Schiele, Kokoschka: Expressionismus in Österreich*. Kirchdorf/Inn, 1991.

Reisner 1960 Jakob Reisner. "Zum zeichnerischen Werk des Österreichers Egon Schiele." In *Beiträge zur Kunstgeschichte: Eine Festgabe für Heinz Rudolf Rosemann*, edited by Ernst Guldan, 337–48. Munich, 1960.

Roessler 1918 Arthur Roessler. *Kritische Fragmente: Aufsätze über österreichische Neukünstler*. Vienna, 1918.

Roessler 1922 Arthur Roessler. *Erinnerungen an Egon Schiele: Marginalien zur Geschichte des Menschentums eines Künstlers*. Vienna, l922; 2nd ed., 1948.

Roessler 1928 (1) Arthur Roessler. "Egon Schiele." *Der neue Pflug* 3, no. 11 (November 1928): 3–8.

Roessler 1928 (2) Arthur Roessler. "Egon Schiele: Zu den Gedächtnisausstellungen im Hagenbund und in der Neuen Galerie." *Bühne, Welt und Mode*, no. 158 (November 4, 1928): 546–50.

Roessler 1929 Arthur Roessler. "Egon Schiele zum Gedächtnis." *Österreichische Monatshefte* 5 (June 1929): 283–92.

Sailer 1975 Anton Sailer. "Egon Schiele." *Die Kunst und das schöne Heim* (April 1975): 223.

Schmidt 1956 Gerhard Schmidt. *Neue Malerei in Österreich*. Vienna, 1956.

Schmied 1979 Wieland Schmied. *Nach Klimt: Schriften zur Kunst in Österreich*. Salzburg, 1979.

Sotriffer 1963 Kristian Sotriffer. *Malerei und Plastik in Österreich: Von Makart bis Wotruba*. Vienna and Munich, 1963.

Sotriffer 1982 Kristian Sotriffer. *Das grössere Österreich*. Vienna, 1982.

Stefano 1992 Eva Stefano. "Schiele." *Arte e Dossier* (Florence) 64 (1992).

Tully 1985 Judd Tully. "Egon Schiele." *Horizon* 28, no. 10 (December 1985): 20–28.

Vergo 1975 Peter Vergo. *Art in Vienna, 1898–1918*. London, 1975.

Wagner 1975 Franz Wagner. "Egon Schiele im Münchner Haus der Kunst." *Alte und moderne Kunst* (Vienna) 20, no. 140 (1975): 31–32.

Weiermair 1968 Peter Weiermair. *Egon Schiele*. Innsbruck, 1968.

Werkner 1986 Patrick Werkner. *Physis und Psyche: Der österreichische Frühexpressionismus*. Vienna and Munich, 1986.

Werkner 1994 (1) Patrick Werkner, ed. *Egon Schiele: Art, Sexuality, and Viennese Modernism*. Palo Alto, 1994.

Werkner 1994 (2) Patrick Werkner. "Frauenbilder der Wiener Moderne und ihre Rezeption heute." In *Expressionismus in Österreich, Literatur und die Künste*, edited by Klaus Amann and Armin A. Wallas. Vienna, Cologne, and Weimar, 1994.

Whitford 1979 Frank Whitford. *Expressionist Portraits*. New York, 1979; 2nd ed., 1987.

Whitford 1981 Frank Whitford. *Egon Schiele*. London, 1981.

Wilson 1980 Simon Wilson. *Egon Schiele*. Ithaca, N.Y., 1980.

Exhibitions

Only those exhibitions in which works from the present show were presented are included in this listing.

1912 Munich, Neue Kunst Hans Goltz, February 15-March 15, 1912. *Die zweite Ausstellung der Redaktion: Der Blaue Reiter/Schwarz-Weiss.*
Munich, Secession, spring 1912. *Frühjahrsausstellung.*
Vienna, Hagenbund, spring 1912. *Frühjahrsausstellung.*
Cologne, Städtische Ausstellungshalle, May 25-September 30, 1912. *Internationale Kunstausstellung des Sonderbundes westdeutscher Kunstfreunde und Künstler.*

1913 Budapest, Müvészház, March 1913. *Bund Österreichischer Künstler es Gustav Klimt/Gyüjtenényes Kiállitásara.*
Munich, Secession, spring 1913. *Frühjahrsausstellung.*

1914 Munich, Secession, March 3-April 19, 1914. *Frühjahrsausstellung.*
Berlin, Kunsthandlung Feldmann, July 1914. *Sommerausstellung.*
Vienna, Galerie Arnot, December 31, 1914-January 31, 1915. *Kollektiv-Ausstellung Egon Schiele, Wien.*

1917 Amsterdam, Stedelijk Museum, October 14-November 1917. *Tentoonstelling van Werken van Oostenrijksche en Hongaarsche Schilders en Beeldhouwers* Catalogue by Hans Tietze.

1918 Vienna, Secession, March 1918. *XLIX. Ausstellung der Vereinigung bildender Künstler Österreichs.*

1919 Vienna, Gustav Nebehay, Kunsthandlung, April 1919. *Die Zeichnungen: Egon Schiele.*

1920 Vienna, Österreichisches Museum für Kunst und Industrie, June-September 1920. *Kunstschau.*

1923 Vienna, Neue Galerie, November 20-December 1923. *Egon Schiele.* Catalogue by Kurt Rathe.

1924 Vienna, Künstlerhaus, December 1924. *Bildnis und Selbstbildnis österreichischer Künstler seit 100 Jahren.*

1925 Vienna, Kunsthandlung Würthle, December 1925-January 1926. *Egon Schiele.* Catalogue by Arthur Roessler.

1926 Frankfurt am Main, M. Goldschmidt & Co., 1926. *Egon Schiele.*
Berlin, Kunsthandlung Fritz Gurlitt, April 1926. *Tsugouharu Foujita, Egon Schiele.*
Dresden, Städtischer Ausstellungspalast, June-September 1926. *Internationale Kunstausstellung.*

1927 Vienna, Österreichisches Museum für Kunst und Industrie, October-November 1927. *Das Werden des Kunstwerks.*

1928 Prague, Národni Galerie, September 8-October 7, 1928. *Moderni umeni Rakouské.*
Vienna, Hagenbund und Neue Galerie, October-November 1928. *Gedächtnisausstellung Egon Schiele.* Catalogue by Bruno Grimschitz.

1930 Zurich, Kunsthaus, March 23-April 21, 1930. *Ausstellung.*
Vienna, Neue Galerie, October 1930. *Unbekanntes von Egon Schiele.*

1932 Vienna, Hagenbund, January 24-February 7, 1932. *Sammlung Carl von Reininghaus.*
Vienna, Neue Galerie, April 1932. *Frühjahrsausstellung.*

1933 Vienna, Neue Galerie, June 1933. *Anton Faistauer, Gustav Klimt, Oskar Kokoschka und Egon Schiele.*

1937 Paris, Musée du Jeu de Paume, May-June 1937. *Exposition d'Art Autrichien.* Catalogue by Jean Mistler and Alfred Stix.
Bern, Kunsthalle, August 20-September 20, 1937. *Österreichische Kunst im 20. Jahrhundert.*

1939 Paris, Galerie St. Etienne, February 10-March 1, 1939. *L'Art Autrichien.*

1941 New York, Galerie St. Etienne, November 7-December 5, 1941. *Egon Schiele.*

1948 Vienna, Akademie der bildenden Künste, March-April 1948. *Entwicklung der österreichischen Kunst von 1897*

bis 1938: Malerei, Plastik, Zeichnungen. Catalogue by
Alfred Stix.
New York, Galerie St. Etienne, April 1948. Egon Schiele:
Paintings, Watercolors, Drawings. Catalogue by Joseph
von Sternberg.
Venice, Austrian Pavilion, summer 1948. XXIV.
Biennale di Venezia. Catalogue by Fritz Novotny.
Vienna, Graphische Sammlung Albertina, autumn
1948. Egon Schiele: Gedächtnisausstellung.
Vienna, Neue Galerie, October-November 1948. Egon
Schiele: Gedächtnis-Ausstellung zum 30. Todestag.
Catalogue by Otto Kallir-Nirenstein.

1949 Linz, Neue Galerie der Stadt Linz, March 1949. Egon
Schiele. Catalogue by Ernst Köller.
Zurich, Graphische Sammlung der Eidgenössischen
Technischen Hochschule, May 28-August 14, 1949.
Gustav Klimt–Egon Schiele: Zeichnungen und
Aquarelle.

1950 Salzburg, Künstlerhaus, 1950. Egon Schiele (from the
Wolfgang Gurlitt Collection).

1953 New York, Galerie St. Etienne, 1953.

1954 Vienna, Neue Galerie, February-March 1954. Egon
Schiele.

1956 Basel, Kunstmuseum, May-June 1956. Sammlung
Rudolf Staechlin.
Bern, Gutekunst & Klipstein, September 8-October 6,
1956. Egon Schiele: Bilder, Aquarelle, Zeichnungen,
Graphik. Catalogue by Otto Benesch and Arthur
Roessler.
Amsterdam, Stedelijk Museum, November
16-December 16, 1956. Kunst uit Oostenrijk. Catalogue
by Werner Hofmann. Traveled to Stedelijk van Abbe
Museum, Eindhoven, December 22-January 26,
1957.

1957 New York, Galerie St. Etienne, January 21-February 23,
1957. Egon Schiele: Watercolors and Drawings.
Catalogue by Otto Benesch.
Munich, Galerie Wolfgang Gurlitt, February 14-March

11, 1957. Egon Schiele (based on the 1950 Salzburg
exhibition).
Bern, Kunsthalle, February 16-March 24, 1957. Kunst
aus Österreich (based on the 1956 Amsterdam
exhibition). Catalogue by Klaus Demus.
St. Gallen, Kunstmuseum, April 6-May 12, 1957. Kunst
aus Österreich (based on the 1957 Bern exhibition).
Catalogue by E. Naegeli and R. Hanhart.
Salzburg, Residenz-Galerie, June-September l957.
Expressionismus: Malerei in Österreich,
Deutschland, Schweiz. Catalogue by Hans
Ankwicz-Kleehoven.
Stuttgart, Württembergischer Kunstverein, November
1957. Die Klassiker der österreichischen modernen
Kunst von Klimt bis Wotruba.

1958 Baden-Baden, Staatliche Kunsthalle, January-February
1958. Gustav Klimt und Egon Schiele. Catalogue by
Leopold Zahn.

1959 Düsseldorf, Städtische Kunsthalle, May 16-June 28,
1959. Meisterwerke der österreichischen Malerei
1800-1930. Catalogue by Fritz Novotny.
Recklinghausen, Städtische Kunsthalle, May 23-July 5,
1959. Die Handschrift des Künstlers.
New York, Galerie St. Etienne, September 22-October
17, 1959. European and American Expressionists.

1960 Berlin, Hochschule für bildende Künste, 1960.
Graphikausstellung der Wiener Secession in Berlin
1960. Catalogue by Paul Meissner.
New York, Bayer Gallery, 1960. Egon Schiele.
London, Arts Council Gallery, May 4-June 4, 1960.
Austrian Painting and Sculpture 1900 to 1960.
Catalogue by Werner Hofmann.
Boston, Institute of Contemporary Art,
October 6-November 6, 1960. Egon Schiele.
Catalogue by Otto Kallir and Thomas M. Messer.
Traveled to Galerie St. Etienne, New York,
November 15-December 15, 1960; J. B. Speed
Art Museum, Louisville, Kentucky, January 3-31,
1961; Carnegie Institute, Pittsburgh, March 2-April 2,
1961; Minneapolis Institute of Arts, April 19-May 21,
1961.

1961 Brussels, Palais des Beaux-Arts, April-May 1961. *Art Autrichien du vingtième siècle*. Catalogue by Werner Hofmann.
Vienna, Galerie im Griechenbeisl, June 20-July 15, 1961. *Egon Schiele*.

1962 Heidelberg, Heidelberger Kunstverein, February 18-March 18, 1962. *Gustav Klimt, Egon Schiele* (based on the 1957 Munich exhibition).
Cologne, Wallraf-Richartz-Museum, September 12-December 9, 1962. *Europäische Kunst 1912*. Catalogue by Günter Aust and Gert von der Osten.

1963 Berkeley, University Art Gallery of the University of California, February 5-March 10, 1963. *Viennese Expressionism 1910–1924*. Catalogue by Herschel B. Chipp. Traveled to Pasadena Art Museum, March 19-April 21, 1963.
Innsbruck, Tiroler Landesmuseum Ferdinandeum, May-June 1963. *Egon Schiele*. Catalogue by E. During.
Turin, Galleria Galatea d'Arte Contemporanea, June 8-July 15, 1963. *Schiele*. Catalogue by Luigi Carluccio.

1964 Bern, Kornfeld & Klipstein, 1964. *Ausstellung 1864–1964: Zeichnungen-Aquarelle*.
Munich, Haus der Kunst, March 14-May 10, 1964. *Secession: Europäische Kunst um die Jahrhundertwende*.
Florence, Palazzo Strozzi, May-June 1964. *Secession: Europäische Kunst um die Jahrhundertwende*.
Vienna, Museen der Stadt Wien, June 5-August 30, 1964. *Wien um 1900*. Catalogue by Franz Glück, Hans Mandl, and Fritz Novotny.
London, Marlborough Fine Art, October 1964. *Egon Schiele: Paintings, Watercolors, and Drawings*. Catalogue by Wolfgang Fischer and Rudolf Leopold.

1965 New York, Solomon R. Guggenheim Museum, February-March 1965. *Gustav Klimt and Egon Schiele*. Catalogue by Alessandra Comini, James T. Demetrion, Johannes Dobai, and Thomas M. Messer.
Götzis, Austria, Galerie Hämmerle, February 20-March 20, 1965. *Egon Schiele: Aquarelle, Zeichnungen*. Catalogue by Oswald Oberhuber.

New York, Galerie St. Etienne, March-April 1965. *Egon Schiele (1890–1918): Watercolors and Drawings from American Collections*. Catalogue by Thomas M. Messer.

1967 Darmstadt, Mathildenhöhe, July 16-September 9, 1967. *2. Internationale der Zeichnung*. Catalogue by Werner Hofmann.

1968 Vienna, Graphische Sammlung Albertina, April 5-June 16, 1968. *Gustav Klimt–Egon Schiele: Zum Gedächtnis ihres Todes vor 50 Jahren*. Catalogue by Otto Benesch, Paris von Gütersloh, Walter Koschatzky, Erwin Mitsch, and Alice Strobl.
Vienna, Österreichische Galerie, April 5-September 15, 1968. *Egon Schiele-Gemälde*. Catalogue by Hans Bisanz and Fritz Novotny.
Salzburg, Museum Carolino Augusteum, July-August 1968. *Egon Schiele (1890–1918)*. Catalogue by Otto Benesch and Otto Kallir.
New York, Galerie St. Etienne, October 31-December 14, 1968. *Egon Schiele (1890–1918)*. Catalogue by Otto Benesch and Otto Kallir.

1969 London, Marlborough Fine Art, February-March 1969. *Egon Schiele: Drawings and Watercolors, 1909–1918*. Catalogue by Wolfgang Fischer and Hans Rosé.

1970 Vienna, Künstlerhaus, June 10-August 30, 1970. *Motive: Stadt- und Ortsbilder österreichischer Künstler seit 1910*.

1971 London, Royal Academy of Arts, January 9-March 7, 1971. *Vienna Secession: Art Nouveau to 1970*. Catalogue by Horst-Herbert Kossatz, Wilhelm Mrazek, John Muschik, Nicolas Powell, and Robert Waissenberger.
Bregenz, Künstlerhaus Palais Thurn und Taxis, July 23-September 30, 1971. *Jugendstil-Wiener Secession*.
Des Moines Art Center, Iowa, September 20-October 31, 1971. *Egon Schiele and the Human Form: Drawings and Watercolors*. Catalogue by James T. Demetrion. Traveled to Columbus Gallery of Fine Arts, Ohio, November 15-December 15, 1971; Art Institute of Chicago, January 3-February 13, 1972.

1972 London, Fischer Fine Art, November-December 1972. *Egon Schiele: Oils, Watercolors, Drawings, and Graphic Work.* Catalogue by Wolfgang Fischer.

1973 Innsbruck, Galerie im Taxispalais, July-August 1973. *Gustav Klimt, Egon Schiele: Zeichnungen und Aquarelle.* Catalogue by Otto Breicha. Traveled to Kulturhaus, Graz, September-October 1973.
Zurich, Kunsthaus, September 15-November 11, 1973. *50 Jahre Kunsthandelsverbund der Schweiz.*

1974 Lucerne, Kunstmuseum, July 14-September 8, 1974. *Kunst in Österreich 1900-1930.* Catalogue by Werner Fenz.

1975 Munich, Haus der Kunst, February 22-March 11, 1975. *Egon Schiele.* Catalogue by Thomas M. Messer.
London, Fischer Fine Art, June-July 1975. *Egon Schiele: Watercolors, Drawings, Graphics.*

1977 Wörgl, Austria, Bundes-Realgymnasium, March 1977. *Egon Schiele: Aus dem Besitz der Neuen Galerie Graz.* Catalogue by Werner Fenz.
Innsbruck, Galerie Annasäule, June-July 1977. *Egon Schiele* (works from the Norbert Gradisch Collection). Catalogue by Peter Weiermair.

1978 New York, Cooper-Hewitt Museum, November 27, 1978-February 4, 1979. *Vienna Moderne: 1898-1918.* Catalogue by J. E. Adlman. Traveled to Sara Campbell Blaffer Gallery, University of Houston, March 2-April 29, 1979; Portland Museum of Art, Maine, June-July 1979; Art Institute of Chicago, September-November 1979.

1979 Tokyo, Seibu Museum of Art, April 27-June 6, 1979. *Egon Schiele.* Catalogue by Serge Sabarsky.
London, Marlborough Fine Art, June-August 1979. *Egon Schiele: An Exhibition of Watercolors and Drawings.* Catalogue by Serge Sabarsky.
Vienna, Niederösterreichisches Landesmuseum, October 19-December 30, 1979. *Egon Schiele: Werke aus dem Familienbesitz* (works from the Norbert Gradisch Collection and the Niederösterreichisches Landesmuseum). Catalogue by Peter Weninger.

1980 Tulln, Austria, Rathaus, March 1980. *Egon Schiele 1890-1918: Heimkehr nach Tulln 1980* (based on the 1977 Innsbruck exhibition). Catalogue by Norbert Gradisch, Arnulf Rainer, and Peter Weninger.
Vienna, Galerie Würthle, May 6-June 7, 1980. *60 Jahre moderne Kunst in Österreich.*

1981 Brussels, Palais des Beaux-Arts, April 3-May 17, 1981. *Klimt, Schiele, Kokoschka.* Catalogue by Otto Breicha.
Hamburg, Hamburger Kunsthalle, April 10-May 31, 1981. *Experiment Weltuntergang: Wien um 1900.* Catalogue by Werner Hofmann and Peter-Klaus Schuster.
Vienna, Historisches Museum der Stadt Wien, September 24-November 1, 1981. *Egon Schiele: Zeichnungen und Aquarelle.* Catalogue by Peter Baum, Hans Bisanz, Serge Sabarsky, and Robert Waissenberger. Traveled to Neue Galerie der Stadt Linz, Linz, November 19, 1981-January 16, 1982; Museum Villa Stuck, Munich, March-April 1982; Kestner-Gesellschaft, Hannover, April 23-June 13, 1982.

1982 Kirchheim unter Teck, Germany, Kulturring, May 23-June 13, 1982. *Egon Schiele: Der künstlerische Nachlass* (based on the 1977 Innsbruck exhibition). Catalogue by Norbert Gradisch and Peter Weninger.

1983 New York, Bellmann Gallery, January-February 1983. *German Expressionists.*
Edinburgh, National Museum of Antiquities of Scotland, summer 1983. *Vienna 1900.* Catalogue by Hugh Cheape, George Dalgleish, John Drummond, Jane Kidd, Peter Vergo, and Elizabeth Wright.

1984 Vienna, Akademie der bildenden Künste, January-March 1984. *Egon Schiele, vom Schüler zum Meister: Zeichnungen und Aquarelle 1906-1918.* Catalogue by Serge Sabarsky and Robert Waissenberger. Traveled to Accademia di Belle Arti di Brera, Milan, March 16-May 10, 1985; Villa Zito, Palermo, February 28-April 14, 1985; Tel Aviv Museum, April 20-May 23, 1985;

Hamburger Kunsthalle, Hamburg, May 31-July 14, 1985; Rupertinum, Salzburg, July 27-September 19, 1985; Schloss Plankenwirth, Graz, October-November 1985; Tiroler Landesmuseum Ferdinandeum, Innsbruck, January 7-February 7, 1986; Josef Albers Museum, Bottrop, February 16-April 13, 1986; Nürnberger Kunsthalle, Nürnberg, April 23-June 22, 1986.

Venice, Palazzo Grassi, May 20-September 16, 1984. *XLI. Biennale di Venezia: Le Arti a Vienna, dalla sezesione alla caduta dell' Imperio Asburgico.* Catalogue by Maria Marchetti.

Rome, Pinacoteca Capitolina, Campidoglio. June 21-August 5, 1984. *Egon Schiele.* Catalogue by Rudolf Leopold, Achille Bonito Oliva, Serge Sabarsky, and Robert Waissenberger. Traveled to Galleria Internazionale d'Arte Moderna, Ca' Pesaro, Venice, August 25, 1984-January 12, 1985; Fondation Pierre Gianadda, Martigny, Switzerland, November 26, 1986-January 25, 1987.

1985 Vienna, Künstlerhaus, March 28-October 6, 1985. *Traum und Wirklichkeit: Wien 1870-1930.*

1986 Tokyo, Isetan Museum, March 1-April 1, 1986. *Egon Schiele und Wien zur Jahrhundertwende.* Catalogue by Rudolf Leopold, Tsutomu Mizusawa, and Robert Waissenberger. Traveled to Aichi Prefecture Art Museum, April 9-24, 1986; Nara Prefecture Art Museum, May 17-June 29, 1986; Yamanashi Prefecture Art Museum, July 18-August 17, 1986; Kamakura Museum of Modern Art, September 20-November 3, 1986.

1987 Charleroi, Belgium, Palais des Beaux-Arts, September 18-December 16, 1987. *Egon Schiele.* Catalogue by Otto Breicha, Laurent Busine, Max Eisler, Paris von Gütersloh, Rudolf Leopold, and Serge Sabarsky.

1988 Zurich, Kunsthaus, November 25, 1988-February 9, 1989. *Egon Schiele und seine Zeit: Österreichische Malerei und Zeichnung von 1900 bis 1930, aus der Sammlung Leopold.* Catalogue by Felix Baumann,

Antonia Hoerschelmann, Rudolf Leopold, Klaus Albrecht Schröder, Harald Szeemann, and Patrick Werkner. Traveled to Kunstforum, Vienna, March 16-June 23, 1989; Kunsthalle der Hypobank-Kulturstiftung, Munich, September 28, 1989-January 8, 1990; Von der Heydt-Museum, Wuppertal, January-March 1990; Royal Academy of Arts, London, November 1990-February 1991.

1991 Tokyo, Bunkamura Museum, October 12-December 8, 1991. *Egon Schiele aus der Sammlung Leopold, Wien.* Catalogue by Rudolf Leopold. Traveled to Nagoya City Art Museum, January 11-February 23, 1992; Daimaru Museum, Umeda, Osaka, March 4-16, 1992; Yamanashi Prefecture Art Museum, April 4-May 12, 1992.

1994 Tobu, Japan, Museum of Art, December 20, 1994-February 12, 1995. *Japonisme in Vienna.* Catalogue by Johannes Wieninger, Akiko Mabuchi, Angela Völker, Hanna Egger, Miyake Ri'ichi, and Susanna Bichler. Traveled to Yamaguchi Prefecture Art Museum, February 21-March 26, 1995; Aichi Prefecture Art Museum, April 11-May 14, 1995; Takamatsu City Art Museum, May 23-June 25, 1995; Museum of Modern Art, Kamakura, July 1-August 6, 1995.

1995 Munich, Städtische Galerie im Lenbachhaus, March 8-May 7, 1995. *Der Kampf der Geschlechter.* Catalogue by Barbara Eschenburg, Reinhard Heydenreuter, Ellen Maurer, Peter Nitsche, Katrin Schmersahl, and Hans Ottomeyer.
Tübingen, Kunsthalle, September 2-December 3, 1995. *Egon Schiele: Die Sammlung Leopold, Wien.* Traveled to Nordrhein-Westfalen, Düsseldorf, December 21, 1995-March 3, 1996; Hamburger Kunsthalle, Hamburg, March 13-June 16 1996; Neue Galerie am Landesmuseum Joanneum, Graz, June 18-September 14, 1997.

1997 Tokyo, Seiji Togo Memorial Yasuda Kasai Museum of Art, January 18-April 13, 1997. *Egon Schiele: Die Sammlung Leopold, Wien.* Traveled to Mie Prefecture Art Museum, April 19-May 25, 1997; Sogo Museum, Yokahama, March 15-May 5, 1997.

Index of Names

Angerer, Olga 345
Arnot, Guido 350

Bahr, Hermann 16
Beer, Friederike Maria 23
Benesch, Heinrich 23, 346
Benesch, Otto 38, 62, 64, 89, 176, 224, 308
Berg, Alban 8
Berger, Albert 328
Bleuler, Eugen 15
Böcklin, Arnold 18
Böhler, Hans 346, 350
Böhler, Heinrich 350
Borée, Albert 15
Bourneville, D. M. 16
Braque, Georges 22, 39
Breuer, Josef 16

Charcot, Jean-Martin 16
Comini, Alessandra 16, 17, 19, 21
Czihaczek, Leopold 11, 345

Ehrenstein, Albert 36
Ehrlich, Hans 346
Elsen, Albert 9, 20

Faistauer, Anton 346, 351
Fein, Martha 353
Flöge, Emilie 126
Franz Josef 8, 346
Freud, Sigmund 8, 16, 36

Gogh, Vincent van 9, 20, 126
Goltz, Hans 347
Graff, Erwin von 13, 80
Griepenkerl, Christian 346
Gütersloh, Albert Paris von 328, 332, 346, 351

Haberditzl, Franz Martin 28
Harlfinger, Richard 352
Harms, Adele 24, 26, 28, 304, 350
Harms, Edith; see Schiele, Edith

Harms, Johann 350
Harte, Albrecht 352
Hauer, Franz 348
Hodler, Ferdinand 9, 36
Hoffmann, Josef 8, 346
Hofmannsthal, Hugo von 8, 36
Horst, Franz 50

Ibsen, Henrick 36
Jungnickel, Ludwig Heinrich 351

Kahrer, Max 345
Kallir, Jane 13, 20, 22
Kallir, Otto 288
Kalvach, Rudolf 346
Karpfen, Max 345
Kirchner, Ernst Ludwig 74
Klee, Paul 347
Klimt, Gustav 8, 9, 10, 11, 14, 18, 19, 21, 29, 33, 34, 36, 57, 76, 117, 129, 149, 168, 191, 192, 327, 346, 349, 352
Knafo, Danielle 11
Kokoschka, Oskar 10, 16, 25, 29, 33, 34, 35, 36, 37, 62, 68, 74, 117, 194
Kolig, Anton 351
Koller, Broncia 352
Kosmack, Eduard 346
Kraus, Karl 8
Kubin, Alfred 36, 347

Lanyi, Richard 312
Lavater, Johann 15
Lederer, August 23, 349
Lederer, Erich 23, 206, 234, 349
Leopold, Rudolf 10
Lodzinsky, Poldi 273, 274
Löwenstein, Arthur 346
Loos, Adolf 8, 15

Mahler, Gustav 8
Manet, Edouard 15
Matisse, Henri 13
Minne, George 9, 92
Mitsch, Erwin 327

Moll, Carl 352
Mondrian, Piet 20
Müller, R. 332
Munch, Edvard 9, 14, 36
Munkácsy, Michael von 188
Musil, Robert 8

Nebehay, Gustav 352
Neuzil, Valerie (Wally) 20, 21, 25, 172, 188, 195, 278, 347, 349

Oberhuber, Konrad 32
Osen, Erwin Dominik 12, 92, 93, 346, 347
Osthaus, Karl Ernst 347

Pauker, Wolfgang 345
Peschka, Anton 146, 344, 345, 347, 351
Peschka, Gertrude; see Schiele, Gertrude
Pfemfert, Franz 350
Philippi, Robert 350
Picasso, Pablo 22, 39
Putze, Ulrich 347

Rathe, Kurt 332
Régnard, Paul 15, 16
Reichel, Oskar 23, 32, 346
Reininghaus, Carl 23, 168, 170, 202, 346
Richer, Paul 16
Rodin, Auguste 9, 20, 25, 246, 248
Roessler, Arthur 23, 144, 202, 346, 347, 348, 349
Romako, Anton 36
Rosé, Hans 316, 351

Saint Denis, Ruth 16
Sandig, Anton 353
Schiele, Adolf Eugen 344, 345
Schiele, Edith 24, 25, 26, 28, 29, 298, 300, 304, 342, 350, 352
Schiele, Elvira 344
Schiele, Friedrich Karl 344
Schiele, Gertrude (Gerti) 13, 24, 90, 116, 121, 344, 346
Schiele, Marie 44, 344, 345, 349

Schiele, Melanie 344

Schnitzler, Arthur 8, 36

Schoenberg, Arnold 8

Seurat, Georges 126

Soucup (Soukop), Marie; see Schiele, Marie

Soutine, Chaim 191

Strauch, Ludwig Karl 345

Strindberg, August 36

Toulouse-Lautrec, Henri de 9, 36

Trakl, Georg 37

Trčka, Anton Josef 23, 350

Wagner, Otto 8, 346

Weber, Edouard 41

Webern, Anton von 8

Weininger, Otto 36

Werkner, Patrick 16, 17

Wiegele, Franz 346

Wiesenthal, Grete 16

Wittgenstein, Ludwig 8

Zakovsek, Karl 126, 346

Zoire, Emile 347

Zweig, Stefan 8

Photograph Credits

All photographs not listed below have been provided by Archiv Prof. Dr. Rudolf Leopold and Bildarchiv des Leopold Museums, Vienna.

Bildarchiv der Österreichischen Nationalbibliothek, Vienna: frontispiece (photo by Anton Josef Trčka, Inv. 526.315); p. 344, left (Inv. 514.052); p. 349, right (Inv. 513.717); p. 353, below right (photo by Martha Fein, Inv. 517.317); fig. 4

Courtesy Alessandra Comini and Galerie St. Etienne, New York: fig. 16

Courtesy Galerie St. Etienne, New York: figs. 3, 12

Graphische Sammlung Albertina, Vienna: figs. 5, 9

L. Grillich, Vienna: p. 344, left

Musée Rodin, Paris and ©photo Bruno Jarret/ADAGP: fig. 11

The Museum of Modern Art, New York: figs. 1, 2: Soichi Sunami; fig. 7: Mali Olatunji

Öffentliche Kunstsammlung Basel, Martin Bühler fig. 14

Österreichische Galerie, Vienna: figs. 6, 13

Rare Book Collection of the A. A. Brill Library, The New York Psychoanalytic Institute: fig. 8

Heinpeter Schreiber, Cologne: 46, 51, 56, 83, 88, 95, 101, 103, 107, 109, 119, 131, 133, 135, 139, 143, 151, 157, 162, 169, 173, 179, 181, 199, 201, 212, 215, 227, 233, 241, 255, 265, 271, 272, 299, 305, 307, 311, 315, 325, 329, 331, 335, 341, 343